Adobe Photoshop 6.0 for Photographers

A professional image editor's guide to the creative
use of Photoshop for the Macintosh and PC

Martin Evening

Focal Press

OXFORD · AUCKLAND · BOSTON · JOHANNESBURG · MELBOURNE · NEW DELHI

Focal Press
An imprint of Butterworth-Heinemann
Linacre House, Jordan Hill, Oxford OX2 8DP
225 Wildwood Avenue, Woburn, MA 01801-2041
A division of Reed Educational and Professional Publishing Ltd

℞ A member of the Reed Elsevier plc group

First published 2001
Reprinted 2001 (twice)

British Library Cataloguing in Publication Data
A catalogue record for this book is available from the British Library

Library of Congress Cataloguing in Publication Data
A catalogue record for this book is available from the Library of Congress

ISBN 0 240 51633 8

Printed and bound in Italy

FOR EVERY TITLE THAT WE PUBLISH, BUTTERWORTH-HEINEMANN
WILL PAY FOR BTCV TO PLANT AND CARE FOR A TREE.

Adobe Photoshop 6.0 for Photographers

For my mother Marjorie and Margaret

Contents

Introduction

In 1996, a group of self-proclaimed 'digital' photographers met together at Ian McKinnell's studio in Holborn, London, to discuss the formation of a Digital Imaging Group. At first, this was a small gathering of professional photographers. The one thing we all had in common was a shared interest in using computers and their potential as a photographic medium of the future.

Back then, to edit your photographs digitally was regarded as a very strange business. If nothing else, we were to be marvelled at for our patience – to manipulate anything bigger than a 10 Mb file on a desktop computer could be a notoriously slow process. At worst we were to be distrusted as the harbingers of doom, bringing about the end to photography as we know it. At one point it was seriously suggested by a photographic gallery committee that 'digital' photographs could not be exhibited unless accompanied by a sticker to signify that these pictures were not real photography. Maybe now it is true to say that because of digital technology, the photographic profession never will be the same again. But this has more to do with the way images are being marketed rather than the means by which those images are captured. Photographers are under increasing pressure to sign away their valuable rights and the pressure of competition has never been greater.

When image editing work stations used to cost a cool half million, digital retouching was the preserve of an exclusive elite. Photoshop has played an important role in bringing professional image editing within the reach of many. That is one of the great virtues of Photoshop – almost anyone can have a go now. Photoshop brings the power of professional image editing within the reach of the many. And as I have toured around Britain and the United States presenting seminars, I meet so many

people who are just beginning to get started using Photoshop and discovering for themselves the enjoyment that can be gained from being able to manipulate and control their own photographs up to and beyond the confines of what could once be achieved in the darkroom.

From a technical standpoint, dipping one's toes in the digital stream embodies taking on much more responsibility for the production process. For that reason this book is not solely about Photoshop but also delves into the technical implications surrounding the program's use and working in the digital domain. You are about to venture into new territory. The photographers whose work appears in this book, like myself, came to use Photoshop with no great knowledge of computers. We all had to learn to use this new technology from scratch. So in planning this book I considered carefully what could be packed into 448 pages that would be relevant to someone wanting to use Photoshop as a digital darkroom tool. Techniques which show you how to create 3D type effects and illustration graphics have been deliberately scaled down – there are other great Photoshop books which can service those interests. Presented here is a guide packed with the Photoshop features you'll really want to use and need to become familiar with. One special feature is the inclusion of some of the book tutorials in movie form on the CD-ROM. From my own experience, movies are a helpful way to learn and assimilate Photoshop techniques.

Adobe Photoshop 5.0 for Photographers was first published in October 1998. This and the subsequent Adobe Photoshop 5.5 for Photographers were bestselling Photoshop titles on the Amazon.com book selling lists in the United States and here in the UK. Thank you to all the readers who wrote in with their comments and suggestions. In this updated edition I have been able to increase the size of the book and include extra tutorials relating to Photoshop 6.0 and revise the earlier passages to help the book flow more and take into account recent technical developments in computer hardware. Photoshop 6.0 is bundled with Adobe ImageReady 3.0. I felt that ImageReady, although a great program, is not so relevant to photographers. Of course there are quite a few new web features which have been added since version 5.0, and these are all covered in the book. A special ImageReady section has been incorporated in the Appendix. A few people wrote and asked if it would be possible to include the images illustrated in this book on the CD-ROM? I am afraid that this is one wish that is going to be hard to satisfy at present. The majority of the photographs that appear in this book either feature professional models, belong to other photographers or appear by permission of a commercial client. Permission has been obtained for the pictures to be reproduced in the book, but obviously this does not include royalty-free usage on the CD disc. Even if we could have gained such permissions it would not have been impossible to achieve within the book's production budget. However, a few of the pictures – the non-commercial shots – are now contained on the CD-ROM.

I use an Apple Macintosh system to run Photoshop, but have included keyboard equivalents for PC users and special instructions throughout. If you are running the Windows 98 operating system or later, the translation between Mac and PC is not too dissimilar. My advice to anyone is use the computer system you feel most comfortable with. It is a sign of maturity when one can mention the words Macintosh and PC in a sentence without claiming superiority one way or the other. Platform wars and speed comparisons prove very little. When analyzing these differences, Photoshop performance hinges more on the skill and speed of the operator and not the hardware or computer system they use.

Being British born I use UK English spelling in the normal course of my writing. However, Adobe are a US company and the international, English language Photoshop interface uses US spelling. As this book is being distributed throughout many English speaking countries, we settled on the US English spelling conventions throughout. In addition, I believe it is important for everyone that all the interface terms and definitions are used precisely. There are many confusing and incorrect terms in use – like the Photoshop user who on an Internet mailing list described an action called 'Pretzel-clicking'. In Germany apparently, the Apple Command key is also known as the Pretzel key.

Acknowledgments

I must first thank Andrea Bruno of Adobe Europe for her suggestion that I write a book about Photoshop aimed at photographers. I would like to give a special mention to my publishing editors: Marie Milmore, Jennifer Welham, Beth Howard and Jane Reid at Focal Press. Also thanks to Adam Woolfitt and Mike Laye who helped form the Digital Imaging Group (DIG) forum for UK digital photographers and all the other DIG and Association members, in particular: Julian Calder, Laurie Evans, Jon Gibson-Skinner, Peter Hince, Ed Horwich, Bob Marchant, Ian McKinnell, David Wood (who compiled and authored the CD-ROM), and Rod Wynne-Powell, who reviewed the final manuscript and provided much useful guidance. Also Andrew Wood Mitchell for organizing the sound recording and music on the CD and Paul Price for his design input on the cover and all the inside mastheads.

The following clients, companies and individuals should also be mentioned for the help they gave me: Adobe, Amateur Photographer, Binuscan, Bookings, Russell Brown, Camera Bits, Clippers, Clipso, Jeremy Cope, Chris Cox, Tom Fahey, Bruce Fraser, Karen Gauthier, Nick Haddon, Mark Hamburg, Leon Herbert, Thomas Knoll, Ricky Liversidge, MacUser UK, Brian Marshall, M&P, Models One, Nevs, Marc Pawliger, Tim Piazza, Profile, Clair Rawlings, Herb Paynter of ImageXPress, Red or Dead Ltd, Eric Richmond, Andrew Rodney, Jeff Schewe, Schwarzkopf Ltd, Michael

Smiley, The Smithsonian Institution, Susanne Sturton, Paul Smith, Martin Soan, Storm, Tapestry, Tresemme, Carl Volk, Jim Williams, Russell Williams, Mark Williford and YU salon. And lastly, thanks to friends and family, my mother for her love and encouragement and Sara too for all her support and patience. There is a web site set up to promote this book where you can find active links mentioned in the book and late-breaking news on Photoshop 6.0.

<http://www.bh.com/focalpress/evening6>

Getting started

I aimed to make this book a comprehensive guide to the use of Photoshop as a photographers' tool. The early chapters introduce important subjects such as how digital images are captured, digital image resolution and the all-important topic of color management. You will doubtless want to refer to this first section when you need to find out more about different file formats and print proofing methods, but it is not absolutely necessary that you begin reading here. If you want to dive in and learn the Photoshop basics, you could easily bypass these early chapters and start at Chapter Six on 'The Work Space'. Here you will be introduced to all the Photoshop 6.0 tools and palettes. Chapter Eight deals with basic image correction controls and from thereon as you progress through the book, you will be shown how to incorporate some of Photoshop's more powerful features and apply sophisticated techniques. But to begin with, here is what you will find that is new in this latest version of Photoshop.

What's new in Photoshop 6.0

The most noticeable changes in Photoshop 6.0 can be seen in the program interface. A lot of subtle improvements have been made, like the way the palettes can now dock together, making them easier to manage, especially for users working with a single monitor. The new Options bar can be conveniently situated either just under the main menu or at the bottom of the screen. The options bar has a palette well which allows you to place selected palettes there and this enables you to work with a reduced screen of just the tools palette plus Options bar and be able to access palettes by clicking on the tab in the well. All the usual tool options can be quickly accessed and the Options bar is context-sensitive to the chosen tool mode you are working in. Whenever one of the painting tools is chosen, a new brush shape can be selected by Control/right mouse click+Shift dragging in the document window. This action will open the brush presets window next to the cursor. It is quite impressive how a simple bit of reorganization can bring about significant speed improvements.

Photoshop 6.0 tools

New items have been added to the tools palette. ImageReady tools such as the slice and shape tools have been included. For example, it is useful to be able to edit slices inside Photoshop as you add things like a drop shadow effect style to a type layer. The annotation tool will allow you to add text or audio notes to a Photoshop document and even record these within an action. Because of these new additions, the tools palette has grown in height slightly and some of the old tool positions and shortcuts have had to be rearranged. Consequently, the lesser-used paint bucket has been hidden beneath the gradient tools and the pencil has been grouped with the paintbrush.

The move tool can assume a transform tool mode of operation by checking the Show Bounding Box in the tool options and the crop tool incorporates a perspective cropping mode. This is very useful for correcting converging verticals in a photograph prior to cropping. The crop tool features an outer shaded mask – this can be customized to provide shading at any opacity and color. This is a very useful visual clue as to how the cropped image will look after executing the crop. You can choose to hide the cropped data instead of deleting it and the Reveal All command will enlarge the canvas to reveal concealed image layer data, also known as 'big data'.

The new Liquify command is a lot of fun to use and is prominently featured in the Image menu. The Liquify interface provides a comprehensive set of distortion tools with which you can bend, magnify and twist pixels to your heart's content. The Extract command, which was introduced in Photoshop 5.5, now has smart highlight edge detection, which works like the magnetic lasso and pen tools, plus new clean-up tools with which you can refine the extraction in the preview window before applying.

Layer management

Those of you who find Photoshop layers indispensable, will be advised to devote a fair amount of time to absorbing all the new capabilities built into Photoshop 6.0. Layers can now be managed more efficiently. You can group layers within Layers palette folders called 'sets'. You can also color code layers, which will help you to identify them more easily. Layers can be locked in various ways: Lock transparency; Lock pixels; Lock layer position; and absolute locking. There are advanced layer options such as 'Knockout blending' which will enable any layer to 'punch through' all the layers beneath, as if it were the lowest layer in the layer stack above the Background layer.

Layer effect combinations can be saved as Styles and adjustment layers get their own buttons in the Layers palette. The new layer effects include: Satin; Gradient Overlay; Pattern Overlay; Color Overlay; and Stroke. The layer effect menus have undergone a major overhaul and there are now a staggering number of options to choose from, such as a choice of editable contours which govern the rendering of effect edges and enable you to simulate chrome-like effects on type and filled layers. The new adjustment/fill layers include: Gradient fill; Pattern fill; and Gradient map.

There are now two ways of masking a layer. The layer mask remains as a method of adding a mask based on pixel data, while the new layer clipping paths use vector path outlines to do the masking. Layer masks and layer clipping paths essentially do the same thing: they mask the contents of the image layer. You can edit a layer clipping path using the pen path tools, while you will continue to use the fill and paint tools to edit a pixel-based layer mask. And the other thing to say here about layer clipping paths is that they are resolution-independent. Layer clipping paths can be used on their own or in combination with layer masks.

Shapes

The old line tool, with its ability for you to add custom arrowheads, was actually a shape tool and the line tool has essentially now been expanded to become a larger suite of powerful Photoshop tools. You can load custom vector shapes that are shipped with Photoshop 6.0, or you can import custom vector art such as a regularly used corporate logo and add this to the Shape presets. Shapes can be added as either: a solid filled color; a work path; or a solid filled layer, masked with a clipping path. The type tool has been updated so that you can place and edit text directly inside the image document window. You can enter text as either a single line or a paragraph entry complete with comprehensive formatting options. You can even distort text live, with a number of editable warp modes (and still be able to edit the text), or convert type to outlines and enjoy the power of being able to transform the shape of the text and have it remain scalable within a Photoshop document. Other features to note are individual character level coloring and extensive text formatting options. Documents which contain type layers can additionally be saved in the TIFF and PDF formats and type can be output from a PDF file at any resolution.

Now if you combine all these layer features together, we have a program in which it is possible to create graphical objects which can have any number of styles applied to them and the style presets in Photoshop 6.0 can add all sorts of interesting textures to the shapes and text. A graphical document like this can be created in Photoshop 6.0 at a relatively low resolution and yet be scaled up to output at any size, just as you can do with a purely vector-based program such as Adobe Illustrator™.

Image adjustments

The Gradient map can be applied as either an image adjustment or adjustment layer. The Gradient map converts the pixel lightness values of an image to a tonal ramp of color defined by the gradient chosen in the gradient dialog. So if you pick a red/blue linear gradient, the gradient will map red to the shadow point and blue to the highlight (or reversed) and the in-between colors will be mapped to the corresponding lightness values. Very cool coloring effects can be produced with this tool! The gradient map utilizes new gradient features such as the noise gradient editor which can produce some very interesting gradient patterns. The screen redrawing code has been revised in 6.0 to provide us with a more accurate display and better monitor color conversions. This also means that you can carry out a threshold analysis of the image from inside the Levels dialog on both Mac and PC now and this threshold mode is also available in the Levels adjustment layers – just Option/Alt+mouse down on the shadow or highlight sliders to locate the shadow or highlight point inside the image window. You no longer have to deselect the Preview box first.

Color management

In previous editions of this book I went into some detail explaining how the new ICC-based color management system in Photoshop worked and how photographer users should configure their color settings. The Photoshop 5.0 system offered a more precise way of sharing color files with other Photoshop users and if set up wisely, would produce better CMYK color separations from RGB files. But the main problem was the way all the color settings were organized. In Photoshop 6.0, the ICC-based color management interface has been completely redesigned. The color settings are conveniently available within a single easy-to-use interface. Photoshop 6.0 takes a lot of the guesswork out of configuring your system color settings. The Color Settings dialog suggests several presets for different types of Photoshop work, from web design to prepress publishing. You can choose which of these options most suits your workflow and Photoshop customizes everything accordingly. The Color Settings presets are loaded and saved from within the Edit > Color Settings dialog. These settings can then be shared with other Adobe applications or other Photoshop users.

Although you still have default RGB and CMYK work spaces in Photoshop, you are no longer obliged to face the choice between converting or not converting colors every time you open a file which does not match your current color work space. Instead you can continue to color manage in whatever color space the incoming file is in. It is possible to have several documents open at once and all of them can be in different color spaces. The soft proofing preview options enable you to soft proof an image in the color space of any output device (providing you have a profile for that

device), or you can simulate on screen the expected output using any saved CMYK setup setting. And there is also a well-designed Print Preview option with which you can customize how an image is placed when you print it. You can either do this visually, dragging the image preview, or with millimetric precision.

Presets

The Preset Manager contains preset options for tool variables such as the Brush sets, Swatches, Gradients, Patterns and new items like Styles, Contours and Custom Shapes. For example, you can save any number of preset configurations for the Brushes and Swatches palette. These can be saved and archived for future use. The Preset Manager is a useful organizer of all the various Photoshop settings. Many of the settings have improved thumbnail displays. Pattern presets can be saved and displayed with a thumbnail icon in the Preset Manager.

File formats

As you might expect, all the new Photoshop features such as layer clipping paths, layer sets, new adjustment layers and layer effects are not backwards compatible. Documents which include these new items will ideally need to be saved in the native Photoshop 6.0 format. Photoshop 6.0 TIFF files are saved using the new TIFF 7 format standard. TIFF 7 is able to save all Photoshop features, it also has new compression options and includes the ability to save using a pyramid file structure. The TIFF 7 format is backwards compatible, as a composited version of the image is always saved. Accessing and locating documents is easier thanks to Navigation Services being fully implemented in Photoshop for the Macintosh platform. Adobe have sorted out the Kodak Photo CD dialog interface, which is now much simpler to work with and will automatically open the Photo CD images to either the Kodak YCC or your default RGB color space, in 24-bit or 48-bit color. The Save for Web feature includes some new refinements, such as zone optimization for applying JPEG compression.

Miscellaneous

There is more extensive support for editing in 16 bits per channel, allowing you to use Photoshop's more commonly used plug-ins like the unsharp mask filter. The Web Photo Gallery has been improved, offering a choice of page layouts and color schemes and you can even create your own custom templates. Contact Sheet II has remedied the fixed font size problem and there are enhanced batch processing options, including Photoshop Droplets and the ability to save Photoshop Actions as text files.

Chapter One

Digital Capture

I reckon it is probably fair to say every photographer I know now involved with digital imaging came from the position of being a one-time digital skeptic. The conversion has in some cases been dramatic which was no doubt linked to the speed of changes which took place in our industry during the eighties and nineties. One colleague commented that in the early days he used to tease his retouching bureau that you could see the pixel structure of a digital image. 'When they started working with 200–300 Mb images and you saw the grain structure of the film before the pixels – I finally conceded my argument!'

The point is that digital imaging has successfully been employed by the printing industry for over fifteen years now and if you are photographing anything which is destined for print media, one can say with certainty an image will at some stage be digitized. At what point in the production process that digitization takes place is up for grabs. Before, it was the sole responsibility of the scanner operator working at the printers or high-end bureau. The worldwide sales success of Photoshop is evidence that prepress scanning and image editing now takes place more commonly at the desktop level.

So this book commences with the digital capture or digitization of a photographic image. It is self-evident that the quality of your final output can only be as good as the quality of the original. Taking the digitization process out of the hands of the repro house and closer to the point of origination is quite a major task. Before, your responsibility ended with the supply of film or prints to the client. Issues such as image resolution and CMYK color conversion were not your problem, whereas now they can be.

It is worth bearing in mind the end product we are discussing here: digital files which have been optimized for reproduction on the printed page. The media by which the images are processed are irrelevant to the person viewing the final product. Those beautiful transparencies are only ever appreciated by a small audience – you, the art director and the client. Pretty as they might be, transparencies are just a means to an end and it is odd that clients may still insist on digital files being 'proofed' as transparency outputs when a four color wet proof or Iris print would give a better impression of how the job will look in print. I am not knocking film – I myself mostly use transparency film to capture my photographs and then have these scanned. A roll of film has the potential to record and store gigabytes of data at high quality quickly, and for a very reasonable cost. The majority of my work involves shooting live action. In my opinion, digital cameras and the hardware and software used to preview the images captured has some way to go before it will be able to rival the versatility of shooting and editing with conventional film, although I am sure it will happen soon one day. As far as still life photography is concerned, digital capture is definitely the way to go – the superior quality speaks for itself.

Scans can be made from all types of photographic images: transparencies, black and white negatives, color negatives or prints. Each of these media is primarily optimized for the photographic process and not for digital scanning. The tonal density range of a negative, for example, is narrow compared to that of a transparency. This is because a negative's density range is optimized to match the sensitometric curve of printing papers. Therefore the task of creating a standardized digital result from all these different types of sources is dependent on the quality of the scanning hardware and software used and their ability to translate different photographic media to a standard digital form. If one were to design an ideal film with CMYK print reproduction in mind, it would be a transparency emulsion which had a slightly reduced density range and an ability to record natural color without oversaturating the blues and greens. What looks good on a lightbox is not necessarily the best image for print reproduction. On the other hand, a negative emulsion is able to capture a wider subject brightness range than a transparency emulsion.

Structure of a digital image

A digital image is a long string of binary code (like the digital code recorded and translated into an audio signal on your music CDs). It contains information which when read by the computer's software displays or outputs as a full tone image. A digital image is a high-fidelity original, capable of being replicated exactly, any number of times.

Each picture element or 'pixel' is part of a mosaic of many thousands or millions of pixels and each individual pixel's brightness, hue and saturation is defined numerically. To understand how this works, it is best to begin with a grayscale image where there are no color values, just luminosity. Grayscale images are made up of 256 shades of gray – this is what is known as an 8-bit image. A 1-bit or bitmapped image contains black or white colored pixels only. A 2-bit image contains 4 levels (2^2), 3-bit 8 levels (2^3) and so on, up to 8-bit (2^8) with 256 levels of gray. An RGB color image is made up of three color channels. Each channel contains 8-bit grayscale information defining the amount of each color component of the full color image. The overlaid color channels mean a single pixel of an RGB color image contains 24-bit color information, which can define up to 16.7 million colors.

Confusion arises when the color bit depth of monitors is discussed. The principles are the same but it is the display capabilities of the monitor that are being referred to here and not the color depth of the image viewed on it. A very old computer may only be able to display at 8-bit or 256 colors on the monitor, but with additional video memory installed, higher bit depth display becomes possible. So an RGB image in Photoshop can only be viewed in as many colors as are available on the monitor but the digital image itself will still be in 24-bit or 48-bit color. Likewise with scanners – the specification for a particular model may state that it captures color at 30 or 36-bit color. As will become apparent later, this is a good thing, but the imported image will still be no more than 24-bit in Photoshop. Although now that Photoshop can support 16 bits per pixel for each channel, it is possible to import a high-bit image of more than 24 bits per channel and edit it in 16-bit per channel mode and export as a 48-bit RGB image. Photoshop 6.0 has extended its support for 16 bits per channel editing. You can now crop, clone, adjust the color and apply certain filters like the unsharp mask in 16 bits per channel mode.

Scanners

A scanner does two things: it reads information from a photographic original – print, negative or transparency – and converts this to digital information at the preferred output size, and in the preferred color space ready for image editing. High-end drum scanners as used by professional bureaux produce the best quality. The optical recording sensors and mechanics are superior, as is the software, and of course you are paying a skilled operator who will be able to adjust the settings to get the finest digital results from your original. Desktop drum scanners are available at a slightly more affordable price, but hot on the heels of these are the top of the range flatbeds, in particular the Agfa, Umax and Linotype-Hell models. The reason for this improved performance is largely due to the quality of the professional scanning soft-

ware now bundled (i.e. Linotype and Binuscan). In fact it has been rumored that these flatbed scanners have for quite a while been capable of improved output. They were hindered from achieving their full potential by software limitations which maintained a division in the market between these and the more pricey desktop drum scanners. It rather reminds me (and I am told this is a true story) of an electrical goods manufacturer in the process of testing their latest budget 'all in one' phono/ tuner/cassette and CD player prototype. The sound quality from the CD was no better than phono or cassette, so the CEO suggested adding a few extra components to distort the output from everything but the CD player, after that the CD always sounded superior.

With a drum scanner, the image is placed around the surface of a transparent drum. To avoid Newton rings, the transparency is oil mounted – a very thin layer of a special oil ensures perfect contact with the drum surface. Fastening the transparencies in place is quite a delicate procedure, and demands skillful handling of the film originals. High-end drum scanners are often sited in an air-controlled room to minimize on dust. In the case of the Kodak Premier, films are held in a perfect arc not touching any surface.

The image on the drum is rotated at high speed and a light source aligned with a photomultiplier probe travels the length of the film. This records the image color densities digitally at very fine detail. Drum scanners have long been the choice of the repro profession for many good reasons: mechanical precision and advanced features such as the ability to make allowance for microscopic undulations in the shape of the drum and thereby guaranteeing perfectly even focussing. From the bright point light source, the photomultiplier is able to record shadow detail in the densest of transparencies (this is where inferior scanners are usually lacking). Drum scanners often have a separate photomultiplier (PMT) head to record tonal values in advance of the recording RGB heads and intelligently calculate which pixels should be sharpened.

Flatbed scanners work a bit like a photocopying machine. The better models record all the color densities in a single pass and have a transparency hood for transparency scanning. One or two high-end flatbeds use a method of three pass scanning, which provides better color accuracy. Flatbeds fall mostly into the cheap and cheerful class of equipment, but there are professional ranges of flatbed which are gaining popularity in bureaux due to the true repro quality output which can be obtained and the ease of placing images flat on the platen, compared to the messiness of oil mounting on a drum.

Other CCD (charge coupled device) variants are designed to scan film emulsions at high resolutions. Polaroid, Nikon and Kodak make good models for scanning from 35 mm formats up to 5 × 4 sheet film. In addition it is worth checking out the Flextight CCD scanner which has a high optical scanning resolution and reasonably good dynamic range. In fact, the Flextight is one of the best quality CCD scanners around and offers excellent value compared to a desktop drum scanner and can scan 35 mm, 120 and 5 × 4 film formats. Basically these devices record the image information onto the CCD chip, which is like an electronic film plate. CCD scanners tend not to emphasize dust and scratches the way a drum scanner (used in a normal dusty air environment) would. The reason for this is the light source is much softer in a CCD scanner and it is a bit like comparing a diffuser with a condenser printing enlarger. The latter has a softer light source and therefore doesn't show up quite so many marks. The Nikon LS 2000 was the first 35 mm CCD scanner to employ ICE image processing. This is a clever filtering treatment which automatically removes dust and scratches, with little softening of the image scan.

If you are going to buy a scanner for repro quality output, then purchase the very best you can afford. The Linotype Saphir Ultra II flatbed, for example, has a true optical resolution of 1000 × 2000 pixels per inch. It represents good value and for scanning in 5 × 4 transparencies this would yield files of 4000 × 5000 pixels at 1000 ppi scanning resolution. In a still-life studio, this would be a useful device for scanning images to reproduce at A3 size. Or you could just get a basic flatbed. The Umax Vista S8 I bought many years back is fine for lots of little jobs, even though it is far from being a repro quality scanner. I can scan in Polaroids and e-mail them to the client as an attachment, or scan in prints at a good enough quality for web design work. Even for high-end retouching, it is sometimes satisfactory when I require to scan in a simple element or a texture. If you want a repro quality scanner to scan 35 mm and 120 originals only, then check out the Baby Flextight scanner.

What to look out for

The only way to truly evaluate a scanner is to try it out for yourself with a sample scan and to test the advanced models properly, a certain amount of experience using the software helps in order to obtain the very best results. The manufacturer's technical specifications can guide you to a certain extent when whittling down your selection. Here is what to look for:

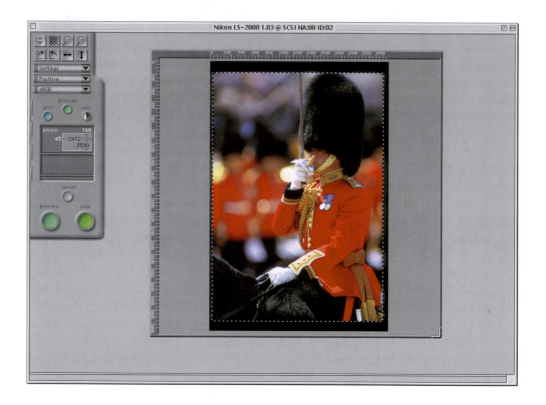

Figure 1.1 The Nikon LS 2000 35 mm film scanner is sold with Nikon Scan software. The stand-alone application interface is shown here with a preview scan. Image courtesy of Julian Calder.

Resolution

Specified as pixels per inch, this indicates how precisely the scanner can resolve an image. It is the optical resolution that counts and not the interpolated figures. Some manufacturers claim scanning resolutions of up to 9600 ppi when in fact the maximum optical resolution is only 600 ppi. This is a bit like claiming you possess a video of your car breaking the sound barrier and you prove it by playing the tape back at a faster speed. Photoshop is capable of interpolating (resampling an image to make it bigger than the original) and with better results. The low-end flatbed machines begin with resolutions of 400 × 800 ppi, rising to 3048 × 3048 for the high-end models like the Linotype Saphir High-Res. The Nikon Coolscan LS 2000 CCD scanner has a resolution of 2700 ppi. Higher resolutions still can be attained with drum scanners. Flatbed resolutions are expressed by the horizontal resolution – the number of linear scanner recording sensors – and vertical resolution – the mechanical accuracy of the scanner. My advice when using a flatbed is to set the scanning resolution no higher than the 'optical' resolution and interpolate up if necessary in

Photoshop. There is also a good case to be made for scanning at the maximum optical resoultion and reducing the file size in Photoshop, as this will help average out and reduce some of the scanner noise pixels which are typically generated by the cheaper flatbed scanners. For critical jobs – scanning detailed line art, for example – it may be worth rotating the page 90 degrees and comparing the quality of the two scans. For the best optical quality, position the original around the center of the platen, known as the 'sweet spot'.

Dynamic range

This critical benchmark of scanner quality is usually left out of the specifications list of lower priced machines, probably because they are not very good! A photographic print has a reflectance range of about 2.2 which is beyond the capabilities of a standard scanner and when it comes to scanning transparencies the ludicrous density ranges of modern E-6 emulsions are way beyond the scope of these poor electronic eyes (Ektachrome transparencies have a typical dynamic range of 2.85–3.6). The telltale signs are lost highlight detail – no matter how much you tweak the scanner settings or play around in Photoshop, there is nothing there on the scan except pure white (255, 255, 255) or black (0, 0, 0). A scanner capable of capturing a higher

Figure 1.2 The Linotype Saphir Ultra software offers professional quality scanning with an easy to operate interface.

Photograph: Adam Woolfitt.

dynamic range is essential for repro work. Look for a dynamic range of 3.0 or higher. Once again, it has been suggested that the dynamic range specified by some manufacturers may be a little optimistic. A good quality drum scanner should be able to attain a dynamic range of 3.8.

Bit depth

If you are scanning from negatives, then dynamic range won't be such a problem, but capturing enough detail within that narrow range and expanding it to produce a smooth continuous tone positive is. An increased scanning bit depth expands the range of tones captured in a scan. A 36-bit scanner records 12 bits per channel, which amounts to 4096 levels compared with 256 levels per 8-bit channel. 24-bit Photoshop files need 256 levels per channel, so even if your original has a compressed range of tones to scan from, a 36-bit scanner will be able to discern enough subtle tonal gradation in order to produce a full-tone 24-bit image. If the original is scanned on just a 24-bit scanner, you may lose important information when setting the levels – the resulting histogram will reveal gaps and instead of smooth tones you will see posterization or ugly color banding. If the scanner you are buying boasts a high bit depth, fine, but do also check the dynamic range. For retouching and manipulation purposes it is very important to have a full-tone image yet having said that, even quality color separations are unable to reproduce more than around 50 levels of distinguishable tone across the shadow to highlight range in each color plate.

Scanning speed

Scanning in a large file can take a very long time so check the reviews for comparative times as buying a slow scanner could really stall your workflow. Again, the manufacturer's quoted scan times are probably a bit on the optimistic side. Do take into account the preview scan, the time it takes to set up and remove the original (like on a drum scanner) and the time it takes to scan at higher resolutions (as with the Nikon Coolscan).

Visual assessment

All scanners are RGB devices. CCD chips are arrayed in a 2×2 mosaic with one red, two green and one blue sensor (the extra green is there to match the sensitivity of the CCD to that of the human eye). When evaluating the quality of a scan, check each individual channel but pay special attention to the blue channel because this is

Low cost digital cameras achieve low file storage sizes through hefty compression. This is particularly evident in the blue channel. Note the checkered pattern – a typical sign of excessive compression.

Without a wide dynamic range, shadow and highlight detail will be clipped. Faint highlights fail to be picked up and appear burnt out.

Even a more expensively priced flatbed scanner with 1000 x 2000 ppi scanning resolution may have difficulty capturing dense shadow detail. The accompanying example shows a close-up view of the blue channel which has been lightened slightly.

Figure 1.3 Close inspection and examination of the individual color channels reveals the shortcomings of a poor quality scan.

always the weakest. Look for excess noise and streaking. The noise will not always be noticeable with every subject scanned, but if you had lots of underwater pictures or skyscapes to process, this failure would soon become apparent.

Scans from black and white negatives or prints are a good test of any scanner. These are the hardest originals of all to record and low-end models are just not up to the task. When you scan a color image, the result is usually quite pleasing to the eye, even though on closer inspection there may be much wrong in one or more of the channels. The illusion that everything is all right is due to the overlapping of these three channels which creates maybe not millions, but enough shades of color to give the appearance of continuous tone. If this image were then converted to a grayscale or desaturated (Image > Adjust > Desaturate) in RGB mode, the resulting grayscale would be all right too. On the other hand, if the original information to be scanned is monochromatic, then the problem stems from a lack of differentiation between the color channel sensors and consequently the weakness is easier to spot. Whether you scan in RGB or grayscale mode, the scan will only be as good as the weakest channel. The giveaway signs are posterized tonal information and gaps in the Levels histogram display. There is nothing really you can do to correct this other than having the image rescanned using a better quality scanner – you cannot create information which was not there in the first place. If you use a flatbed to scan in prints, one way round the problem is to make the print match the recordable density range of your scanner. For example, if the device you are using is unable to record the full tonal range of a standard bromide print, then select a soft grade of printing paper, increase the print density for the highlights and reduce the D-max for the shadows. Print several versions and find which scans best with your equipment. Or as was just mentioned, make the grayscale images using scans from color originals. Try also converting to Lab mode and using the grayscale information in the Lightness channel.

Software

The software is what controls the scanner. The scanner driver may be in the form of a stand-alone application which will import the image and save as a TIFF file ready to open in Photoshop, or the scanner software may come in the form of a plug-in or TWAIN driver designed to be incorporated within Photoshop. The installer will automatically place the necessary bits in the Plug-ins folder. The scanner will be accessed by choosing File > Import > *name of scanner device*.

A well-designed scanner driver should be easy to use. A good, clear scan preview will help you make adjustments prior to capturing the full resolution scan. The ideal situation is one where the scanning device faithfully captures the original with minimal tweaking required in Photoshop to get an accurate representation in the master

file. Modern scanner software should be using ICC-based color management to take care of interpreting the color from the scan stage to opening in Photoshop. Even the 'canned' scanner ICC profiles supplied with every machine regardless of individual characteristics should get you into the right ball park. For really accurate color management you'll need to investigate creating customized profiles. If your scanner or capture device does not have an ICC color management facility, the instructions in Chapter Four describe how to convert from the scanner color space to the Photoshop color work space.

Purchasing bureau scans

To get your images into Photoshop, you obviously need a good quality digital camera or a decent desktop scanner. The low-end models discussed are all right for basic image-grabbing work and scans to go on a web site – anyone can find a good use for one of these. My advice to the professionals though is purchase a repro quality scanner and if you can't afford to do that, then buy bureau scans instead. The cost may seem prohibitive, but you are getting the best that modern digital imaging technology can offer.

If you are buying a bureau scan, you first need to know what to ask for. All scanners scan in RGB, period. The person supplying the scan may say 'our scanners only scan in CMYK'. What they mean is, the scanner software automatically converts the RGB scan data to a CMYK file (for more information on RGB to CMYK, see Chapter Four on color management). Bureaux which supply scans for going direct to press, supply a file which is 'repro ready', i.e. converted to the correct CMYK color space and pre-sharpened. If you want to do more than just adjust the color, then for photographic type retouching, you are better off with an RGB scan, which can be converted to CMYK later and sharpened at the very end. A lot of Photoshop editing is best performed using an RGB file without any unsharp masking. You can edit and composite in CMYK, so long as you don't mind not being able to access many of the plug-in filters. The unsharp masking can be a real killer though – make sure you ask them to leave the image unsharpened and apply the unsharp masking (USM) yourself.

Kodak Photo CD

Kodak launched Photo CD in 1992 as a platform-independent storage medium of digitized images for use with desktop computers and for display on TV monitors via a CD player. The initial expectations were that Photo CD would become popular with the amateur market. That did not happen, but there was soon considerable interest

among the professional photographers and DTP industry, who were eager to adopt Photo CD as an alternative to expensive drum scans or the purchase of a desktop scanner. The product development has of late been directed towards improving quality and to continue satisfying this professional market. The main advantages of Photo CD are:

Cost

Labs/bureaux offering the Kodak Photo CD service can supply the processing of a roll of film, transparency or negative plus transfer of all the images to a Master CD disc as an inclusive package. Depending on where you go, it can work out at around a dollar per scan including the film processing, although in addition you will have to purchase the CD disc. A Master disc can store up to 100 standard resolution (18 Mb) 35 mm scans, while the Pro disc can store 25 individual high resolution (72 Mb max) scans from either 35 mm, 120 or 5 × 4 films. Pro Photo CD scans can cost anywhere between $10 and $30 each plus $10–$30 for the Pro Photo CD disc. These charges compare with $60–$150 for high-end drum scans.

Image quality

Is it any good? Kodak have worked closely with professional bureaux with the aim of constantly improving the quality. Leading bureaux are prepared to offer Pro Photo CD scans as a cheaper alternative to drum scans. At Tapestry in Soho, London, I was shown examples of CMYK Cromalin proof outputs from both a Hell Color scanner and Kodak Pro Photo CD. There is a perceptible difference between the two when they are compared side by side, but it is hard to fault the Photo CD scans when the printed results are viewed in isolation. Quality is dependent too on the operator who is preparing your scans, but I'll come to this later.

Archive storage

Digitized images are written to disc in a lossless (compressed without loss of detail) proprietary format, making Photo CD an efficient and cheap storage medium for archiving images. Scanned images consume precious disk space, which adds to production costs, especially if you are having to store both original and manipulated versions. With the cost of process + scan package deals being as cheap as they are, one can easily build an archive library of skies, elements and textures etc.

The Image Pac

The Photo CD format contains a pyramid structure of five resolutions from Base/16 (used to create the thumbnail index card images), up to 16 Base (18 Mb) for output as a 10×8 photographic quality print. The Pro Photo CD disc can also store 64 Base (72 Mb) images scanned from any film format up to 5×4 sheet film. The advantage of the Image Pac structure is that you can easily access the appropriate resolution required for any usage without having to open the very largest sized file and resample down. The Kodak software enhancements for opening Photo CD images also optimize the image detail for whichever resolution you choose.

Photo CD is device and platform independent. The Photo CD Imaging Workstation (PIW) operated by the bureau, scans transparencies, B/W and color negatives and matches the data output for all these different input sources ready for access by a computer running either the PC or Macintosh system.

The images are scanned at the bureau on the PIW and converted to Kodak's Photo CD YCC storage format. This format stores color information using a method based on the CIE or Lab color model (see Chapter Four). Almost all the image detail is recorded in the Y (luminance) channel. The two chroma (CC) channels record the color information – these contain little image detail and can be compressed to a smaller size. Finally a hierarchy of resolutions is created which forms the Image Pac.

Optimum Photo CDs

The scanner operator working on the PIW has limited control over the making of PCD scans. Included with every workstation is a Scene Balance Algorithm (SBA) control, which will automatically read an image and make adjustments for incorrect camera exposure or variations in color temperature (just like the automated devices used in optical printers at photo finishing labs). The operator can override or reduce the SBA to taste. Or as is more likely, in the case of handling professionally shot reversal films, stick to using the 'Universal Film Terms'. This will retain the original appearance of the image as it appears on film. To explain this more clearly, the PIW records the information from the film on the basis that it is correctly exposed and has the correct lighting color balance, retaining the original film's unique characteristics.

The aspect ratio of the scanning area is 2:3. Therefore 35 mm or 6×9 cm film formats make best use of the available area. The PIW mask holders will accept any other format up to 5×4 but bear in mind that with 6×4.5 cm or 6×6 cm transparencies where you want to crop to a portrait or landscape format, you will make use of only half the total scanning area. A 35 mm full framed image scanned at standard

resolution will yield a maximum image size of 18 Mb, while with a 6 × 4.5 cm image you only get 9 Mb of usable data. For these film formats you will certainly only want to have high-res 72 Mb Pro Photo CD scans done, which will provide a 36 Mb image (less if you want to crop within the full frame).

Profiles

ICC profiles (also known as Precision Transforms in the context of Kodak PhotoCD) are fundamental to the Photo CD concept of 'device independence'. All types of film format are scanned with the aim of near enough mapping the digitized information to fill a standard color space. When opening a PCD file, select the profile which most closely matches the film original. The very latest profiles are the Pro format 4050 E-6 and 4050 K-41 for E-6 transparency and Kodachrome films respectively. Selecting either of these (see Figure 1.4) will improve the quality of the imported image, particularly in the shadow detail of reversal films.

Opening a Photo CD image

I don't know why, but in the past Kodak were not particularly helpful directing their customers as to the correct way of opening a PCD image. You would think it was fairly straightforward. In response to consumer demand, many bureaux took it upon themselves to produce their own leaflets explaining how this should be done. The main things to be aware of are: first, not to go near the PHOTOS folder (see below), and second, seek a supplier with the very latest PIW (4220 workstation) and make sure you have the above profiles installed. However, Kodak are going to be supplying better customer guidelines in the future. But in the meantime...

The standard Photoshop installation will install all the plug-ins needed to open an image from a PCD disc (also check these extensions have not been temporarily switched off or disabled). First, go to the extensions manager (Mac system) and check to see that all the KODAK PRECISION and CD-ROM extensions are switched on. If not, do so now and reboot the computer.

NB: The easiest mistake Macintosh users can make is to go direct to the folder marked 'PHOTOS' either direct from the CD or opening within Photoshop. These PICT format images (for TV monitor display) are not suited for reprographic output as the highlight tones tend to be clipped.

Figure 1.4 The Photo CD interface for Adobe Photoshop 6.0. Note some of the new changes. The Image Info on the left tells you which film emulsion type the photograph was shot on and the type of scanner used. This information will help you determine which source Profile setting to use. This latest, much simplified interface is a great improvement on those found in previous versions of Photoshop. It is now possible to set the pixel resolution you want the file to open at and you can now open a PhotoCD file as a 48-bit RGB. This overcomes the previous limitations of bringing files in at 24-bit color. It is claimed that the luminance channel in a YCC file contains 12 bits of information, so bringing a file in at 48-bit RGB will make the most of all the information captured in the original Photo CD scan.

- Insert the Photo CD disc into the CD-ROM drive.
- With Photoshop loaded, open the image required via the File > Open menu.
- Click to select desktop and open the PCD icon.
- Go to the 'Photo_CD' folder. Open the folder marked 'IMAGES'.
- Check the indexed print on your CD for the image number and click 'Open'.

The dialog box which now appears offers several choices. Go to Pixel Size and choose the resolution size for output, i.e. 2048 × 3072 which will yield a file size of 18.4 Mb. Where it says Profile, choose the one which closely matches the film type of the original and the scanner model used. The Image Info section on the left will inform you of the film emulsion and scanner type used. Pro PhotoCD scans use the 4050 profiles. Standard PhotoCD scans use the 'Universal' profiles. The color negative profile is common to all PhotoCD scanners.

You have a choice of opening the PhotoCD image in either YCC (Photoshop Lab) mode or as an RGB. Since the advent of Photoshop 5.0, the risk of clipping when opening a Photo CD in RGB has diminished. If you select RGB, the file will automatically convert and open to whatever is your current default RGB space. But note you can also choose to open the Photo CD file in 48-bit RGB.

In conclusion

Photo CD is a well-established service for the digitizing and storage of photographs. When weighing up the cost of buying a decent scanner, it is worth calculating the comparative cost of Photo CD scans, taking into account the costs of archiving all the data likely to be accumulated. On the downside, the Kodak profiles are in my opinion not really precise enough. Some intervention will nearly always be required to get a perfect color match. The Kodak web site (see link below) contains lots of useful extra information. One of the new developments introduced by Kodak includes a 30 Mb CMYK TIFF scan output either to a general standard or to your custom printer specifications. This service is supplied at specialist bureaux only and is costed at the same price as a Pro Photo CD scan.

Photo CD web site: www.kodak.com/US/en/digital/products/photoCD.shtml

Automated scanning

In an effort to make scanning easier to manage, there are a couple of independent, automatic scanning packages which will guide the Photoshop user to achieve optimum separation results, without having to know anything about four-color printing. Silverfast in Germany make such Import plug-ins for Photoshop which can be used to drive various scanners, digital cameras and Photo CD.

ScanPrepPro

ScanPrepPro 3.5.5 by ImageXpress is an award-winning software program which was designed to provide smart image processing with Photoshop from versions 3.05 to 5.5. ScanPrepPro is able to interact with a number of specified scanner and digital camera drivers and basically drive Photoshop for you. At the simplest level, the user has only to enter basic information about the source image and if scanning, the scanner type and the program will from there on take the reigns and intelligently process the image from scan through to the separation stage, applying up to twenty-six prepress Photoshop operations along the way.

Figure 1.5 The ScanPrepPro 3.5.5 Photoshop plug-in interface.

At the heart of ScanPrepPro is an interactive database – after you enter the input and output information, the program cross-references its database of different prepress scenarios and prepares a unique processing routine for each image. It has the built-in flexibility to handle source images in various conditions, including halftone screened originals. The dialog interface uses easy to understand terms to describe the condition of the image to be processed.

ScanPrepPro was able to drive the Photoshop 5.0 and 5.5 color engine, but now that Photoshop 6.0 has a revised color system, ScanPrepPro 3.5.5 will no longer be compatible with this latest version of Photoshop. All things must progress and we can therefore expect to see a brand new version of ScanPrepPro emerge soon after the launch of Photoshop 6.0. This new program will be called 'Make it so' and will be developed by Total Integration Software, Chicago, Illinois.

For the latest information about release dates and pricing for AutoPilot 6, visit the ImageXpress web site at: www.ixsoftware.com. You can also download software from this site for a free seven-day trial evaluation period.

Digital cameras

These are exciting early days, when high resolution digital image capture has become a reality. Granted, there are still obstacles to overcome before digital cameras come remotely close to matching the versatility of film cameras, but for certain professional setups digital cameras are able to fulfil a useful role in the studio and on location. Digital cameras have arrived at a time when digital press technology is well and truly established. Digital camera development has therefore been designed very much with the needs of press output in mind. Film scanners have had to be designed to cope with the uneasy task of converting continuous tone film originals of different types to a standard digital output. Digital camera design has been invented from the ground up to meet the specific needs of repro.

Figure 1.6 The above picture was taken by Jon Gibson-Skinner using the Leaf digital camera back.

A Nikon rep was once asked how many customers in Europe had bought their very expensive 8 mm fisheye lens. Apparently they had sold just one, and that was to a rich businessman who had had it converted into a novelty desk lamp (I suppose the aperture ring was used as a dimmer control). Some of the currently available high-end digital cameras are beyond the reach of all individual photographers. High-end digital camera systems come with a premium price tag and that's before taking into account the purchase of major peripherals such as special lighting, image editing workstation and a proof printer. To evaluate the effectiveness of purchasing an all digital system, one could begin by calculating the savings made in film and processing, but this factor on its own is not enough. A really important benefit of running a digital studio is increased productivity. It is possible for the client to attend a shoot, approve the screen image after seeing corrections, then the picture can be transmitted by ISDN to the printer (or wherever) and the whole shoot be 'signed off' the same day. In all probability clients will look for the material savings to be passed on to them. As photographic studios are getting involved in the repro process at the point of origination, there is no reason why they should not consider selling and providing an extra menu of services associated with digital capture, like CMYK conversions, print proofing and image archiving.

At present, digital cameras used in product shot or catalog studios are a very efficient substitute for shooting with film. Digital makes sense where the photography is happening every day, using the same type of lighting equipment and the size of output and printing quality are known in advance. Going digital is not suited to a studio which shoots different types of subject matter and uses varying lighting techniques. With advertising clients, the digital output size is usually not known till the end of a production schedule. Without this vital information being made available beforehand, the only answer is to record the image at very high resolution, which is a limitation on most digital camera backs. There are individual cameras to suit these different ways of working but none that can do all.

Doubtless, at some time in the future there will be a digital camera capable of capturing images under different working conditions, with rapid shooting, that is also lightweight and economical to buy. We have such a system now of course and it's called 'film' – it is extremely versatile and costs around $8.00 per gigabyte in storage after processing.

Digital capture is all too often being promoted as an easy solution, and it is interesting to note that of professional digital camera sales, a large number have been to repro houses looking to save on external photography costs and provide an all-in-one service to their clients. This has led to a drop in standards, because the people using these cameras are not trained photographers. Unfortunately there are end clients who view the advantages of digital photography purely on the basis of cost

savings: increased productivity, fast turnaround and never mind the creativity. It is likely that photographers with professional lighting skills will be brought in to work as employees, or that digital studios of the future will be collectives of freelance photographers sharing the equipment between them. Far from making life easier, the future of digital is going to involve major financial investment that will have to be recouped within a maximum time span of two to three years.

Scanning backs

These record a scene similar to the way a flatbed scanner reads an image placed on the glass platen. A row of light sensitive elements travels in precise steps across the image plane, recording the digital image. The digital backs are designed to work with large format 5×4 cameras, although the scanning area is slightly smaller than the 5×4 format.

Because of their design, daylight or a continuous light source must be used. HMI lighting is recommended (although not necessarily essential) for the exposure, because this produces the necessary daylight balanced output and lighting power. Some manufacturers of flash equipment like the Swiss firm Broncolor, now make HMI lighting units which are identical in design to the standard flash heads and accept all the usual Broncolor lighting adaptors and accessories. In reality, many photographers are actually using tungsten lights, providing the camera software is able to overcome the problem of light flicker. The other thing to be careful of here is that lower light levels may require a higher film speed capture setting and this can lead to increased blue shadow noise. Bright highlights and metallic surfaces can sometimes cause streaking known as 'blooming' to occur. It is best avoided, but such artifacts can at least be retouched out if necessary. Some devices contain anti-blooming circuitry in the equipment hardware.

The exposure time depends on the size of final image output. It can take anything from under a minute for a preview scan to almost 10 minutes to record a 100 Mb+ image. The latest BetterLight scanning back can now scan a high-resolution image in just a few minutes. Everything has to remain perfectly still during exposure. This limits the types of subject matter which can be photographed. You can use a scanning back on location, but sometimes you get unusual effects similar to the distortions achieved with high-speed focal plane shutters. A colleague photographing a scene on the River Thames with a scanning back had to retouch out the stretched boat passing through the frame during exposure! Despite such technical difficulties, the US landscape photographer, Stephen Johnson, has proved that a digital scanning back can in many ways be superior to film capture. Johnson is a pioneer in this type of digital

location photography. His beautiful landscapes are captured at high resolution using a BetterLight scanning back and the technical quality and detail in the images is outstanding.

CCD chip cameras

If scanning backs follow the principles of a flatbed scanner, CCD chip cameras are analogous to the CCD scanners I described earlier. A small wafer containing an array of millions of light sensitive elements are the electronic film which records the image exposure. You find this mechanism adopted in custom digital backs for medium format roll film cameras as well as built into 35 mm camera bodies of Canon and Nikon cameras.

The image is recorded instantaneously; therefore flash, daylight and tungsten light sources can all be used. The CCD chip is monochrome though, so to record a color image, there have to be three sequential exposures made through a red, then a green and lastly a blue filter. As a live action camera, it can only record in monochrome. The filtering process is achieved with a large rotating disc of colored filters in front of the camera lens. It is a bit cumbersome in appearance, but works automatically. Where flash is used to illuminate the subject, the flash output must be consistent with each exposure, otherwise you will get a color cast. With some flash systems, it is advisable to fire the flash off once just prior to the series of color exposures.

The output files are not as large as those produced by the scanning back. The CCD chip in the Leaf DCB camera produces a 4 Mb sized rectangular scanned image. An RGB composite is therefore 12 Mb. This does not sound very impressive, but with digital cameras you have to think differently about the meaning of megabyte sizes or more specifically pixel dimensions and the relationship with print output file size. Digitally captured images are pure digital input, while a high-end scanned image recorded from an intermediate film image is not. Good as drum scans may be, the latter are always going to contain some electronic or physical impurity, be it from the surface of the film, the drum or grain in the film image. The recommended resolution for scanned images prepared for print output is double the printing screen frequency or sometimes 1.5:1 is recommended as the optimum ratio. In either case the film image must be scanned at the correct predetermined pixel resolution to print satisfactorily. If a small scanned image file is blown up, the scanning artifacts will be magnified. Because digital files are so pure and free of artifacts, it is possible to enlarge the digital data by 200% or more and match the quality of a similar sized drum scan.

It's hard to take on board at first, I know. It came as a shock to me too when I was first shown a digital picture: an A3 print blowup from a 4 Mb grayscale file! Not only that, but digital images compress more efficiently compared to noisy film scans. The full-frame Leaf 12 Mb image will compress losslessly to around a few megabytes (less with high quality JPEG) and transmit really quickly by ISDN or fast modem. Catalog and product shot studios prefer to have the Leaf back attached to something like the Fuji GX68 III camera, because it provides a limited range of movements in the lens plane and can reasonably handle the same type of photography tasks as monorail plate cameras.

Striped chips

Full RGB color capture is possible with variations on the CCD chip design. The CCD is coated with an RGB pattern of filters so that each grayscale pixel records either red green or blue light. Nearest pixel interpolation software determines all intermediate values. The color information is recorded in a single exposure. The most familiar examples are those bulkily designed 35 mm cameras based on the Kodak/Nikon N90 (F90 in the UK) and Canon EOS-1 body designs. The early models recorded small 4.5 Mb RGB images on a chip equivalent to about half the 35 mm frame area. This meant an effective doubling of the 35 mm lens focal lengths in terms of the angle of view. On such cameras, a 50 mm standard lens effectively became a 100 mm equivalent telephoto and the wide angle 24 mm was equivalent to a standard lens. These models are still available, but attention is now focussed on the latest Kodak DCS 520, DCS 560 and D1 cameras by Nikon. The DCS 560 has a 6 million pixel 15 Mb chip covering nearly all of the 35 mm frame area and the angle of lens coverage close to what one is used to with a conventional 35 mm film camera. The immediacy of capture is a bonus to the reportage photographer, who is then able to transmit the data by modem to the newspaper or press agency. The picture agency Reuters would normally expect to secure around 18% of picture sales at any major sporting event. During the soccer World Cup France 1998, they managed to command a massive 52% share of the market which they attributed directly to all its photographers shooting with the Kodak DCS 520.

A 15 Mb RGB image is perfectly suited to full page high quality reproduction and the comments made in the last section about digital image purity do not apply to striped chips, because there is a discernible mosaic structure to the image when viewed closeup. Even so, such a camera could happily be used for magazine fashion and portraiture work. Images are stored in the hard drive of the camera body and downloaded to the computer, so it can be used remotely on location, maybe downloading periodically to a laptop computer to clear the hard drive in order to shoot further fresh images. Can you spot a drawback? How many 15 Mb exposures would it take

to fill up your computer's hard disk? Seventy-two frames (two rolls of film) would occupy about a gigabyte. If you are still inclined to get carried away shooting lots of frames, where are you going to save all your images to and how are you going to archive them? Forty exposures could be fitted onto a recordable CD, but think how long it would take to transfer and record all that data? Clearly digital capture photography is going to alter the way we work. So maybe it won't be necessary to shoot so many exposures once we have the approved image 'in the bag' so to speak. The D1, however, has not only broken the $5 000 price barrier but provides sensational image quality to rival more expensive digital cameras. Colleagues report being able to blow up the output from the D1 to A3 print size. As was suggested earlier, the only hindrance in the all-digital process is the time it takes to review and edit pictures captured digitally. How long does it currently take to scan through a contact sheet or roll of transparencies, compared to the time it takes to open and close an equal number of digital captures? On the other hand, what price the immediacy of having your photograph instantly displayed on the computer and ready to send off to print?

Medium format one-shot cameras

In an earlier edition of this book I mentioned the Dicomed Bigshot camera – with its monster sized 48 Mb chip. The Bigshot back I saw being tested then was attached to the back of a Hasselblad camera body and provided a full frame, square 48 Mb RGB file. There are now quite a few products competing in this market. For fashion, portraiture and studio-based work, you should consider looking at examples such as the Megavision S3, Jenoptik Eyelike and Betterlight LightPhase. These are tethered devices, usually hooking up to a studio-based computer or laptop, with, more commonly these days, a speedy Firewire™ connection. I tested the Megavision S3 and very much liked the way one could shoot quickly and have the captured shots appear almost immediately on screen as a contact sheet of up to 12 sustained captures, after which you have to pause to allow time to store the raw captured data, before proceeding to capture another set of photos.

Hot mirror filters

The spectral sensitivity of many CCDs matches neither the human eye nor color film and extends awkwardly into the infrared wavelengths. This is partly inherent in their design and partly due to their original development for military uses. To overcome the extreme response to the red end of the spectrum, Kodak advise the use of hot mirror filters; for the professional their 410, 420, EOS 3, EOS 1N and Nikon 460 cameras have this filter built in behind the lens. These high quality glass filters are made by Tiffen in the USA and are costly and inconvenient, since each lens used will

require one, unless the photographer is happy to spend time fitting it to each lens in turn prior to shooting – unlikely at a football match. The EOS and Nikon lens systems have about four common filter sizes (52, 62, 72 and 77 mm) so at over $150 each, these filters alone will cost much the same as a low-end digital camera. Kodak's newest chip technology, first seen in the DCS 520 and also found in the DCS 560, delivers a dramatic improvement in color response and purity in the blue channel and a much more controlled response at the red end of the spectrum. Despite this the Kodak software retains the option to process files as either 'product' shots or 'portraits'.

And as a further precaution Kodak fit a hot mirror filter immediately inside the throat of the camera body in their DCS 315, 520 and 560 models. This filter, which is very thin and fragile, serves not only to reduce still further the infrared wavelengths reaching the CCD but also to reduce the color noise generated by high contrast fine detail in the image. This aliasing noise is generated by interference between fine detail and the mosaic of color filters applied to the chip. It is most visible in fabric textures or fine detail such as print. The Kodak anti-aliasing filter works by very slightly unsharpening the image, but a better method may be to use software such as Quantum Mechanic from Camera Bits or the new processing software from Binuscan (see Figure 1.8). Most other camera manufacturers overcome the infrared problem by fitting a hot mirror type filter to the face of the CCD itself, but within the engineering confines of the existing Canon and Nikon bodies; this option is not available to Kodak.

Low-end cameras

Not to be dismissed as toys, there are many professional uses for a simple digital camera. The basic design is based around the chip used in the latest digital video cameras like the Sony DVC. These still cameras are all available for under $1000 and some produce 'high' resolution images which would fill a 17 inch monitor screen, in some cases larger, plus they can capture low resolution images when you want to shoot and store a larger number of shots on the camera's card.

Digital cameras excel in providing an affordable way to capture an image of 'photo snap' quality, which at a push could be published in a magazine. You can instantly email photographs while on location via a laptop computer or find any number of practical uses where the quality is less of an issue. For example, estate agents use digital cameras to get property photos onto their web sites as soon as they come onto the market. As a final footnote, while recently reviewing the Fuji MX-2900 zoom digital compact, I received a request from a potential client to take a portrait photograph of herself. The MX-2900 would have been a perfect candidate for the job, but for the fact that the client's budget was just $3. Who says digital is killing off photography?

Image processing plug-ins

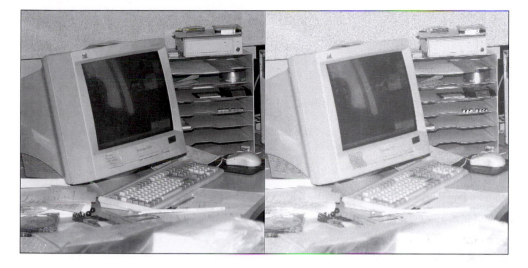

Figure 1.7 Instant capture digital cameras (with the exception of those using three CCDs and beam splitters) all share the problem of color aliasing. Camera Bits explain the problem thus – color fringing artifacts (or 'Christmas tree lights') are created by many digital cameras that use a color filter mask to take instantaneous pictures. The filter mask allows only one color value (e.g. red, green or blue) for each pixel, and the other colors must be estimated. Errors made in this estimation cause color fringing artifacts, especially along sharp luminance edges, such as highlights and along black and white edges. The same estimation errors can show up as moiré patterns in some fabrics. In extreme cases this problem is practically unfixable. Camera Bits, who manufacture the Quantum Mechanic software, have been able to resolve some of these problems with their plug-in software for Photoshop, which is available from their web site on a 14-day free trial. For RGB color images, the Quantum Mechanic internally converts the image to a color space that separates luminance from chrominance. The chrominance is filtered using an adaptive median-like filter, and the image is then converted back to RGB color. The latest version of the software has been available since October 1999, promising even more effective elimination of moiré patterns.

Also of significance is software distributed by Binuscan. The first version to be available will work with Kodak's DCS 420 and DCS 460 cameras and shows extraordinary improvements in the quality of the acquired images, in particular, the purity of information recovered in the blue channel. Binuscan is also remarkable at rebuilding burned-out areas while eliminating the noise in the blue channel and minimizing the color sparkle artifacts in highlights. The Binuscan software used to be priced at around $450 to $900 per camera (do check the latest prices), in addition to the basic ColorPro Version 5.0 package. It is early days, but if the dramatic image quality improvements apparent in the test files stand up to close scrutiny, this could be a 'must have' for professionals, despite the cost.

Camera Bits. Tel: 001 (503) 531 8430 www.camerabits.com
email: info@camerabits.com
Binuscan. Tel: +377 97 98 55 55 www.binuscan.com

Chapter Two

Resolution

This chapter deals with the issues of digital file resolution, and two of the first questions everyone wants answered – how do you define it and just how big a file do you really need? When we talk about resolution in photographic terms, we normally refer to the sharpness of the lens or fineness of the emulsion grain. Digital images are made up of picture elements called 'pixels' and every digital image contains a finite number of these blocks of tonal information. In the digital world, resolution relates to the number of pixels, the more pixels in an image, the finer its resolving capacity. If you took a frame of 120 roll film 6 × 6 cm and wanted to preserve all the detail digitally, including the emulsion grain, a scan producing a 5700 × 5700 pixel image or 92 Mb of RGB data should do the trick. With a digital image that size, there would be enough pixel information to reproduce a photographic quality print of 50 × 50 cm – one which would withstand minute inspection.

The pixel dimensions of a digital image are an absolute value: a 3000 × 2400 pixel image would reproduce at high quality in a magazine at 10" × 8" at 300 pixels per inch and the file size would be around 18 Mb RGB or 24 Mb CMYK. An A4 or full bleed magazine page would be around 3500 × 2500 pixels and roughly 23 Mb RGB (30 Mb CMYK) in size using the same number of pixels per inch. Pixel dimensions are the surest way of defining what you mean when quoting digital file size. Megabyte sizes are a less reliable way of describing things because document file sizes are also affected by the number of layers and alpha channels present and whether the file has been compressed or not. Nevertheless, referring to image sizes in megabytes has become a convenient shorthand when describing a standard uncompressed TIFF file.

The digital resolution therefore refers to the fineness of the output – the number of pixels per inch or centimeter used to construct the final print. So if we have a digital image with a dimension of 3000 pixels, the same image can be output either 10 inches at a resolution of 300 pixels per inch or 12 inches at a resolution of 250 pixels per inch. This can be expressed clearly in the following formula: pixel size = physical dimension × (ppi) resolution. In other words, there is a reciprocal relationship between pixel size, the physical dimensions and resolution.

Pixels versus vectors

Digital photographs are constructed with pixels and as such are resolution-dependent. You can scale up a pixel image, but as you do so, the finite information can only be stretched so far before the underlying pixel structure becomes apparent. Adobe Illustrator™ is a vector-based program. Objects drawn in Illustrator are defined mathematically, so if you draw a rectangle, the proportions of the rectangle edges, the relative placement on the page and the color it is filled with can all be expressed using mathematical expressions. The rectangle can be output at any resolution, whether it is at 72 pixels per inch on the screen or at 300 pixels per inch on an A1 blowup print. It will always be rendered as a crisply defined shape. Photoshop 6.0 is now a combined vector and pixel-editing program, because it also contains a number of vector-based features which can be used to generate images.

Figure 2.1 Digital images are made up of a mosaic of pixels. A digital image therefore has a fixed resolution and if you enlarge the image, the pixel structure will soon become evident – a pixel-based image is therefore resolution-dependent. However, a graphic image which has been created in a program like Adobe Illustrator™, using vector paths is resolution-independent and can be scaled to any size.

Photographer: Davis Cairns Client: Red or Dead Ltd.

Although Photoshop is regarded as a pixel-based program it has always contained a few vector-type tools in its arsenal, most notably the pen path tool. Photoshop 6.0 now features custom shape tools and layer clipping paths. This raises some interesting possibilities – with Photoshop 6.0 you can now create various graphical elements like: type, shape layers, layer clipping paths which are all resolution-independent. A Photoshop document such as this can be scaled up in size without any loss of detail, just as you can with a graphic created in Illustrator.

Terminology

Before proceeding further let me help clarify a few of the confusing terms used when describing resolution and their correct usage.

ppi: pixels per inch. Describes the digital, pixel resolution of an image. You will notice the term dpi is often inappropriately used to describe digital resolution. Scanning devices are sometimes advertised with their scanning resolution expressed in dots per inch. Strictly speaking, this is an incorrect use of the term 'dpi', because input devices like scanners produce pixels and only output printers produce dots. However, it's fallen into common parlance now and unfortunately added to the confusion. Monitor resolution is also specified in ppi: Macintosh monitors had a resolution of 72 ppi, whereas PC monitors are usually 96 ppi. One of the reasons for the Macintosh default resolution of 72 ppi (which dates back to the era of the first Apple Macs) is that it helps graphic designers get a better feel for the weight of their fonts when laying out a page. With the advent of Multisynch monitors, the current resolution exceeds these earlier definitions.

lpi: lines per inch. The number of halftone lines or 'cells' in an inch, also described as the screen ruling. The origins of this term go back way before the days of digital desktop publishing. To produce a halftone plate, the film exposure was made through a finely etched crisscross screen of evenly spaced lines on a glass plate. When a continuous tone photographic image was exposed this way, dark areas formed heavy halftone dots and the light areas, smaller dots, giving the impression of a continuous tone image when printed on the page and viewed from a normal distance.

dpi: dots per inch. Refers to the resolution of a printing device. An output device such as an imagesetter is able to produce tiny 100% black dots at a specified resolution. Let's say we have an imagesetter capable of printing at a resolution of 2400 dots per inch and the printer wished to use a screen ruling of 150 lines per inch. If you divide the dpi of 2400 by the lpi of 150, you get a figure of 16. Within a matrix of 16×16 printer dots, an imagesetter can generate a halftone dot varying in size from 0 to 256 print dots. It is this variation in halftone size (constructed from the

1 The halftone screen shown here is angled at zero degrees. If the pixel resolution were calculated at x2 the line screen resolution, the RIP would use four pixels to calculate each halftone dot.

2 To reproduce a CMYK print output, four plates are used, of which only the yellow plate is actually angled at zero degrees. The black plate is normally angled at 45 degrees and the cyan and magenta plates at less sharp angles. Overlay the same pixel resolution of x2 the line screen and you will notice that there is no direct relationship between the pixel and line screen resolutions.

The pixel resolution (ppi) is the number of pixels per inch in the input digital image.

The line screen resolution (lpi) is the frequency of halftone dots or cells per inch.

4 Each halftone dot is rendered by a PostScript RIP from the pixel data and output to a device called an imagesetter. The halftone dot illustrated here is plotted using a 16 x 16 dot matrix. This matrix can therefore reproduce a total of 256 shades of gray. The dpi resolution of the image setter, divided by 16, will equal the line screen resolution. 2400 dpi divided by 16 = 150 lpi screen resolution.

3 There is no single empirical formula that can be used to determine the ideal 'half toning factor'. Should it be x2 or x1.5? The black plate is the widest at 45 degrees and usually the black plate information is more prominent than the three color plates. If a halftoning factor of x1.41 (the square root of 2) were used, the pixel resolution will be more synchronized with this angled halftone screen. There is no right or wrong halftoning factor – the RIP will process pixel data at any resolution. If there are too few pixels, print quality will be poor. Having more than the optimum number does not necessarily equate to better output, it is just more pixels.

smaller dots) which gives the impression of tonal shading when viewed from a distance. Desktop inkjet printers produce an output made up of small dots at resolutions of between 360 and 1440 dots per inch. Remember, an inkjet output is not the same as the reprographic process – the screening method is quite different.

At the very least what you need to understand is that an image displayed on the screen at 100% does not represent the actual physical size of the image, unless of course your final picture is designed for screen use only, such as for the web or CD-ROM display.

Repro considerations

You can see from the above description where the term 'lines per inch' originated. In today's digital world of imagesetters, the definition is somewhat archaic, but is commonly used nonetheless. You may hear people refer to the halftone output as dpi instead of lpi, as in the number of 'halftone' dots per inch. Imagesetter resolution can therefore be referred to as having so many spi, or spots per inch. I think we can all logically agree on the correct use of the term pixels per inch, but the mixed use of the terms dpi, lpi and spi has no clear definitive answer I am afraid. It is an example of how the two separate disciplines of traditional repro and those who developed the digital technology chose to apply different meanings to these terms.

The structure of the final print output appearance bears no relationship to the pixel structure of a digital image. A pixel in a digital image does not equal a cell of halftone dots on the page. To explain this, if we analyze a CMYK cell or rosette, each color plate prints the screen of dots at a slightly different angle, typically: Yellow at 0 or 90 degrees, Black: 45 degrees, Cyan: 105 degrees and Magenta: 75 degrees. If the Black screen is at a 45 degree angle (which is normally the case), the (narrowest) horizontal width of the black dot is 1.41 (square root of 2) times shorter than the width of the Yellow screen (widest). If we extend the width of the data creating the halftone cell, then multiplying the pixel sample by a factor of 1.41 would mean that there was at least a 1 pixel width of information with which to generate the black plate. The spacing of the pixels in relation to the spacing of the 45 degree rotated black plate is thereby more synchronized.

For this reason, you will find that the image output resolution asked for by printers is usually at least 1.41 times the halftone screen frequency used, i.e. multiples of ×1.41, ×1.5 or ×2. This multiplication is also known as the 'halftone factor', but which is best? Ask the printer what they prefer you to supply. Some will say that the 1.41:1 or 1.5:1 multiplication produces crisper detail than the higher ratio of 2:1. There are also other factors which they may have to take into account such as the screening

method used. Stochastic or FM screening, which, it is claimed, permits a more flexible choice of ratios ranging from 1:1 to 2:1. If you want the very best results, then trust your printer's advice.

Image size is therefore determined by the final output requirements and at the beginning of a digital job, the most important information you need to know is:

- How large will the picture appear on the page, poster etc.?
- What is the screen frequency being used by the printer – how many lpi?
- What is the preferred halftone factor used to determine the output resolution?

This information needs to be known ideally before the image is scanned (or digitally captured). Because at the end of the day maybe only 10 Mb worth of RGB data will actually be used. If the specification is not available, then the only alternative is to scan or shoot at the highest practical resolution and resample the image later. The downside of this is that large image files consume extra disk space and take longer to process on the computer. If a particular project job requires none of the images to be larger than 10 Mb, then you'll want to know this in advance rather than waste time and space working on unnecessarily large files. On the other hand, designers like to have the freedom to take a supplied image and scale it in the DTP layout to suit their requirements. Use the ×2 rule, and there will be enough data in the supplied file to survive any extra unforeseen enlargement without compromising the print quality. And lastly, if a picture is destined for screen publishing, like preparing a picture to go on a web page, then the only thing that matters is the actual number of pixels.

Altering the image size

If the image pixel dimensions are not quite right, it is no big deal to trim the size up or down to the exact pixel. This process is known as resampling. Image data can be enlarged or reduced by an interpolation method which approximates the missing pixels – creating new ones, guessing their correct tonal values. With an image open in Photoshop, choose Image > Image Size (or choose File > Print Preview – see Chapter Five). The dialog box shows all the information relating to file size: the pixel dimensions, physical dimensions and resolution. Any of these values can be changed. Of the three interpolation methods available, Bicubic provides the best quality for resampling continuous tone images. I consider 'interpolating up' an image in Photoshop to be preferable to relying on the interpolation found in basic scanner software. On the other hand, there are other solutions like Resolut and ColorShop which are used to good effect when interpolating digital capture files. Interpolation works most effectively on a raw scan – one that has not already been pre-sharpened. Unsharp masking should always be applied last as the file is being prepared for

repro. Interpolating after sharpening will enhance the image artifacts introduced by the sharpening process. Here is another useful tip: to get the best results, do the interpolation in stages. Increase or decrease the resolution by 50 ppi at a time. For instance, start with an image at 300 ppi (or make it 300 ppi in the Image Size dialog box) and reduce to 250 ppi, then to 200 ppi, till the pixel dimensions get close to the desired number. Digital files captured from a scanning back or multi-shot digital camera are extremely clean. There is no grain present and therefore if the subject matter will allow, it is possible to magnify a digitally captured image much more than you would a scanned image of equivalent size.

There are no definitive answers to the question how large does a file have to be to print at 'X' size. High-end bureaux process their images for advertising at around 7000 × 5000 pixels (approx. 100 Mb in RGB) or larger and supply proofs to the client on 10 × 8 film interpolated up to 200–300 Mb. Working from the master file, they can create the color separations to reproduce the advert in either a quarter page newspaper or on a bus shelter poster site using different conversion specifications. For them, working with large file sizes is the only way to guarantee being able to meet clients' constantly changing demands. The resolution required to illustrate a glossy magazine double-page full-bleed spread is around 60 Mb RGB or 80 Mb CMYK. Some advertising posters may even require smaller files than this, because the print screen is that much coarser. Once an image has been scanned at a particular resolution and manipulated there is no going back. A digital file prepared for advertising usages may never be used to produce anything bigger than a 35 Mb CMYK separation, but you never know – that is why it is safer to err on the side of caution – better to sample down than have to interpolate up. It also depends on the manipulation

Figure 2.2 To change the image output resolution without altering the physical size, check the 'resample image' box and enter a new resolution. To change image output dimensions without altering the resolution, leave the 'resample' box unchecked. Auto resolution will help you pick the ideal pixel resolution for repro work based on the line screen resolution.

work being done – some styles of retouching work are best done at a magnified size and then reduced. Suppose you wanted to blend a small element into a detailed scene. To do such work convincingly, you need enough pixels to work with to be able to see what you are doing. Therefore, to do the master retouching on a 100–200 Mb RGB file is not such an extravagance if your system can cope with the strain. But this is the exception rather than the rule. In theory the larger a picture is printed, the further away it is meant to be viewed and the pixel resolution does not have to alter in order to achieve the same perception of sharpness. There are limits though below which the quality will never be sharp enough at normal viewing distance (except at the smallest of print sizes). It also depends on the image subject matter – anything containing a lot of mechanical detail will need more pixels to do the subject justice and reproduce successfully. If you had a picture of some clouds, you could quite easily get away with magnifying a small image beyond the normal constraints.

Practical conclusions

Amidst all the conflicting opinions on how large a digital file should be, I find the guidelines given by some of the photographic picture libraries instructive. Photographers who submit digital work are asked to supply digital files of around 40–50 Mb RGB. The thinking is that for the vast majority of picture purchases, these file sizes will be ample and in fact the majority of pictures purchased are probably printed using 20 Mb of RGB data or less anyway. One can be sure of this though, that in any magazine publication you care to look at, there is probably just as wide a variety in original digital file sizes in use as with the formats of film on which the photographs were taken. At the end of the day, all these pictures – however they are mastered – have to be resampled to suit the resolution and color space limitations of the magazine print press. There are photographers and clients who insist nothing less than a 10 × 8 sheet of film will provide good enough quality for advertising work. I do believe an over-obsession with 'pixel correctness' gets in the way of appreciating just how good the technical output quality can be from smaller format cameras or what can be created on a modern computer desktop setup in the hands of a talented artist.

An enormous industry was based around photographers supplying films to clients, who made positional scans for layout purposes. They in turn then sent the film for repro scanning at the bureau to make the final separations. Along comes a photographer armed with his or her desktop computer loaded with Photoshop, offering to cut out a large chunk of the repro process, supplying repro quality digital files themselves. Tread on somebody's toes once and they won't like you very much. Stamp all over them and they begin to squeal (loudly), especially if they believe you don't have a clue what you are talking about. Obviously, repro specialists know best when

it comes to getting the best printed results, but remember they have a vested interest too in keeping the likes of you out of the equation. This leads to occasional 'second-hand car salesman' type tactics, designed to make you look foolish in front of the end client, but I reckon companies with attitudes like these are dying out now. The smart businesses recognize the digital revolution will continue apace with or without them and they have to continually adapt to the pace of modern technology and all its implications. Besides, repro companies are getting into digital photography themselves. The boundaries between our industries are constantly blurring.

Output use	Resolution	Pixel size	MB (RGB)
35 mm transparency	2400 ppi	3400 x 2270	22
6 x 6 cm transparency	1200 ppi	2650 x 2650	20
5 x 4" transparency	1000 ppi	5000 x 4000	57
10 x 8" transparency	1000 ppi	10000 x 8000	230
A5 postcard print	267 ppi	1560 x 1100	5
10 x 8" print	267 ppi	2670 x 2140	16
A4 Pictrograph print	267 ppi	3120 x 2210	20
A3 Pictrograph print	267 ppi	4420 x 3120	40

Figure 2.3 How large does a digital file need to be? Above examples indicate the RGB megabyte size and pixel resolution for various film transparency and Pictrograph print output uses.

Output use	Output resolution	Screen ruling	MB (RGB)	MB (CMYK)
Screen resolution display	72 ppi		900 K	
Newspaper single page	170 ppi	85 lpi	22	30
Magazine single page	300 ppi	150 lpi	25	33
Magazine double page	300 ppi	150 lpi	50	66
6 sheet poster	75 ppi	150 lpi	30	40
48 sheet poster	75 ppi	150 lpi	75	100

Figure 2.4 When it comes to reproducing digital files for printed use here is a rough guide to the sort of file sizes required. A 48 sheet poster does not require that much more data than a full-bleed, double-page glossy magazine spread. These are approximate figures and apply to RGB files (for comparison with the above table).

Chapter Three

Configuring Photoshop

In order to get the best Photoshop performance from your computer, you need first to ensure that everything is configured correctly. First item on the agenda – which operating system to recommend, PC or Macintosh? Or Windows NT? I guess that for most of you, the decision of which system to adopt has already been taken. Your allegiance is solid and who am I to direct you otherwise? As you will realize by now, I use Macintosh computers and have done so for many years. I like the simple clear design of the graphical user interface. Throughout my computerized career, it's what I have grown up with and it feels like home. The same arguments apply if you're a Windows PC user and apart from anything else, once you have bought a bunch of programs, you are locked into that particular system. If you switch it means facing the prospect of buying your favorite software packages all over again. The battle of the operating systems is such a bore: my Pentium III is better than your Mac G4 and similar playground squabbles. The only certainty is that a Pentium III is faster than a Pentium 486 and an Apple Power Mac G4 is faster than a Power PC 601. Comparing like for like between the two systems may reveal marginal speed benefits one way or the other as one system leapfrogs another, but the cost of buying all the hardware for a Macintosh or PC system is about the same these days, especially since many of the peripherals share the same interface connections.

Buying a system

Later in this chapter I shall go into more detail about RAM and scratch disks etc. Let me start off though by outlining the basic list of features to look for in a setup designed to run Photoshop.

Today, the choice of which new computer to buy is a lot simpler than it was, say, a few years back. As a beginner you want to buy a computer that will allow you to experiment freely in Photoshop and develop your basic skills. By the time you are trained up to a competent level and ready to take on professional retouching work, that is the time when you should consider splashing out on a top of the range system. So if you have never touched Photoshop before, I would suggest you get an entry level system now that can do everything you want at this learning stage. If you later decide image editing is not for you, then at least you can make use of your computer for general purpose office use, linking to the Internet or shooting down rogue asteroids. In a year or two you can either upgrade your current system or purchase a machine that will probably be at least twice as fast as the most powerful computers around today.

The chances are that today's entry level computer will contain everything you need. Take the Apple 400 MHz iMac DV SE, for example. It has a fast processor, includes a 15" monitor and has 128 Mb of RAM which can be upgraded to a maximum of 512 Mb. It's got a fast 13 Gb hard drive and the video performance is good. I would prefer working with a larger screen, but otherwise it's got plenty to get you started. If you purchased the basic 400 MHz G4 Macintosh, then this too has excellent specifications for Photoshop work and the processor can be upgraded. Add to this the cost of a separate monitor and at least another 64 Mb of RAM to take the memory up to 128 Mb total. On the PC side there are many more choices and I would say that without being able to pinpoint any particular model, nearly all the basic packages will, like the iMac and the G4, be able to satisfy your basic Photoshop requirements. I will be dealing with the specifics shortly but would assume that at the very least your entry level computer would have: a fast Pentium III processor, a 4 Gb hard drive, 4 Mb of video RAM (but more likely an even faster video card), 24x CD-ROM drive and 32 Mb of fitted RAM, which can be expanded to at least 192 Mb. If you are able to get all of this and more, then you have yourself the beginnings of a powerful image editing system. The only circumstances I can think of where you might end up buying a computer that would limit what you can do in Photoshop is if you were to buy an older, lower spec, reconditioned PC or Mac. I would advise against this, especially since Photoshop 6.0 will not run on an older 64K Mac system.

Monitor display

The monitor is the most important part of your kit. For Photoshop work, a multiscan Trinitron or Diamondtron tube is best. There are plenty of affordable 17" monitors of this type on the market. You get what you pay for of course and it is worthwhile checking the computer press for recent product test reports before deciding which model to buy. Try not to get anything smaller than a multiscan 17" screen. Remember

that extra Video RAM (VRAM) is always going to be needed to display anything more than hundreds of colors on even a small sized display. The minimum requirement is usually 2 Mb of VRAM, which is enough to display 32 000 colors at a pixel resolution of 832 × 624. All modern computers seem to be fitted with at least 6 Mb of VRAM as standard or, as was just mentioned, a powerful video card. Many older Macs and PCs cannot be expanded to accommodate more VRAM. To display millions of colors on a large screen, your computer with need to have either spare VRAM slots (to add extra VRAM modules) or at least one PCI expansion slot, which will accept a video accelerating PCI card.

Extras

An internal 24× or faster CD-ROM drive is standard issue these days. Other things to buy could include a second hard drive to use as a scratch disk plus a removable media storage device such as the Iomega Zip drive or a CD writer. You need these to back up your main hard disk and store all your image documents (the hard disk should be kept as empty as possible). Removable media disks are ideal for transferring documents to a bureau for printing. Bureaux will be able to satisfactorily read Mac and PC format files. If you are going to rely on using any SCSI devices, check to see if you need to install a SCSI card interface. SCSI is not always going to be supported as standard on all new desktop computers. USB and FireWire™ are the latest connection standards for such peripherals. If you are buying from scratch then you need not worry about SCSI. Users who are making a transition to the latest computer hardware will probably have to purchase a SCSI card in order to connect up their existing peripherals. You can have up to 127 USB devices linked to a single computer and you can plug and unplug USB devices while the machine is switched on, which you were most definitely advised not to do with SCSI. However, the USB is rather slow. FireWire™ is a new Apple connection standard. It promises astonishingly fast data transfer rates of 100 Mb+ per second. Few peripherals other than professional level digital cameras have as yet appeared on the market to take advantage of this blistering speed potential.

A digitizing pad or graphics tablet is highly recommended. It replaces the mouse as an input device, is easier to draw with and pressure responsive. Big is not necessarily best. Some people use the A4 sized tablets, others find it easier to work with an A5 or A6 tablet like those in the Wacom Intuos™ range, which feature a cordless mouse and switchable pens. You don't have to move the pen around so much with smaller pads and therefore these will be easier for painting and drawing. Once you have sampled working with a pen, using the mouse will seem like trying to draw while wearing a pair of boxing gloves.

Retailers

Mail order companies (commonly referred to as 'box shifters', which says it all really) are hard to beat on price, although in my experience service ranges from excellent to appalling. Always try to find out if anyone else has had a bad experience with a particular dealer before parting with your cash. Under UK consumer law, any claim on your warranty will require you take up the matter via the company which sold the equipment to you. Legally your consumer rights are protected. For extra protection, use your credit card to make mail order purchases. In practice, suppliers make small margins on cut-price equipment sold from a warehouse and the procedure for handling complaints can be very lax. If you do have a problem, ensure your complaint is dealt with swiftly. Always be persistent but firmly polite, otherwise tempers flare or your complaint may easily get ignored. Computer trade shows are a good place to find special offers, but again check who you are dealing with. Remember prices are always dropping – the system you buy today could be selling for half that price next year, assuming it is still manufactured! Your capital investment is not going to hold its value.

Businesses which rely on their equipment to be working every day of the week will choose to buy from a specialist dealer – someone who will provide professional advice and equipment tailored to their exact needs and, most important of all, instant backup in case things go disastrously wrong.

Improving Photoshop performance

Keep the imaging workstation free of unnecessary clutter – the more applications and files you load up, the more the machine will slow down. It is best to have a separate computer to run all the office software Internet/modem connections and games etc. Switch off non-essential extensions, this will reduce startup times and improve overall operating speed. Make sure you understand what you are doing and can correctly identify what each extension does (you'll need to refer to a system book). Some extensions are essential to run software and external drives but most you don't really need. Photoshop can run without any extensions at all, but you will definitely want to have things like the Adobe Gamma, ColorSync, Kodak Color Management System extensions, CD-ROM control panels and High Sierra access etc.

Chip speed

Microchip processing speed is expressed in megahertz, but performance speed also depends on the chip type. A 400 MHz Pentium II is not as fast as a 400 MHz Pentium III chip. Speed comparisons in terms of the number of megahertz are only valid

between chips of the same series. Apple have only just begun to make multiprocessor computers. In the days when Apple licensed third-party manufacturers to compete with Apple, Daystar built the Genesis which ran with four Power PC 604 150 MHz processors. You will find some of the latest Pentiums and NT computers have twin processing. To take full advantage of multiprocessing, the user must run enabled software. Adobe make Photoshop, Premiere and After Effects available to run on multiprocessor computers. The latest Macintosh G4 processor includes what is described as a 'velocity engine', which helps in providing several instructions per clock cycle to enabled programs such as Photoshop 6.0. This it is claimed, can boost performance speeds of certain operations by at least a third.

Another factor is bus speed. No, this has nothing to do with action packed movies about runaway vehicles. It refers to the speed of data transfer from RAM memory to the CPU (the central processing unit, i.e. the chip). High performance computers have faster bus speeds and therefore are faster at Photoshop work, where large chunks of data are being processed. CPU performance is mostly restricted by slower bus speeds. 100 MHz would be considered reasonable on a modern desktop PC.

Chip acceleration

Upgrading the processor chip is the most dramatic way you can boost the system performance. Not all computers will allow this, but if you have either what is called a daughter card slot or some other processor upgrade slot then you may be able to upgrade your old computer and give it a new lease of life. The upgrade card will probably include an increase of backside cache memory to further enhance performance. If you are aiming to upgrade an older machine though, add a level 2 cache, which will add a 10–30% speed increase. Say you have just 256k cache – if you have lots of RAM memory installed (over 50 Mb) then its worth getting a 512k level 2 cache. Cache memory stores frequently used system commands and thereby take the strain away from the processor chip allowing faster performance on application tasks.

RAM memory and scratch disks

When it comes to image editing, the amount of RAM memory you have installed is a key factor – a minimum of 32 Mb application memory is recommended for Photoshop, and the suggested size is 96 Mb. As I mentioned earlier, when buying a computer, you want something that may be upgraded with more RAM at a later date, so ideally you will want to install as much RAM memory as you can afford. Most computers can be upgraded one module at a time – Power Macs and modern PCs use

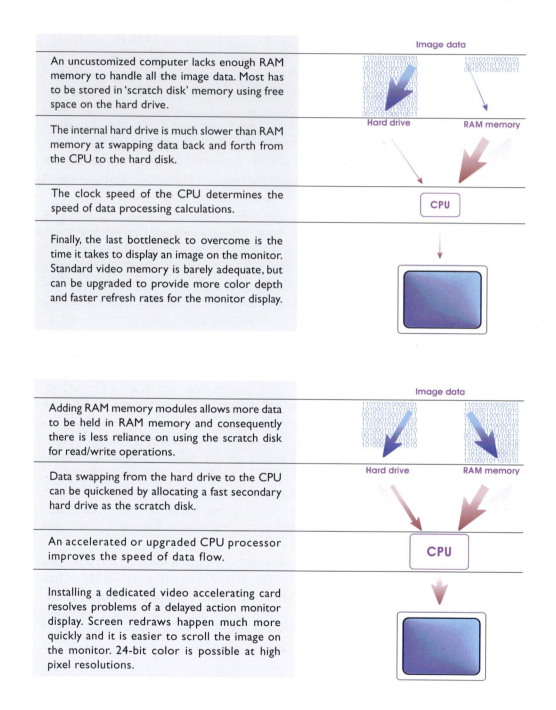

Figure 3.1 Above illustration compares the performance of a standard issue desktop computer before and after optimizing for Photoshop use.

DIMMs (Dual Inline Memory Modules). Lastly there are EDO RAM modules – primarily PC modules but which were also to be found in the Macintosh clone computers. The newest SDRAM DIMMs are faster still and soon we will have another even faster memory standard called RIMM.

The general rule used to be that Photoshop requires available RAM memory of 3–5 times the image file size to work in real time. That will still hold true for version 6.0 except under certain circumstances where the History options are set to allow a great many multiple undos and you are performing global changes, with each operation affecting the entire image (like applying a filter). If you do that the memory requirements will soon escalate to many times the document file size. Let's say you have just 64 Mb of RAM memory fitted, of which 48 Mb is allocated to Photoshop. The program eats up another 28 Mb and that leaves you with only 20 Mb, or in theory just enough RAM to work on a 4–7 Mb file in real time. To get round this memory devouring problem, Photoshop utilizes free hard disk space as an extension of RAM memory. It uses all the available free hard disk as 'virtual memory'. In Photoshop terms, this is known as a 'scratch disk'.

The Apple Macintosh operating system pulls off a similar trick with its own memory management system. The RAM doubler extension does the same kind of thing as well. But the important thing to note here is that when it comes to running Photoshop, Photoshop's own virtual memory management system is best and having two virtual memory systems working at the same time will lead to reduced performance and more likelihood of system crashes. That is why the Adobe Photoshop manual recommends you not use other virtual memory utilities with Photoshop. Since the advent of OS 8.6, Macintosh virtual memory can now be switched on when using Photoshop and this may free up a few precious extra megabytes of RAM, but on the downside, virtual memory may still cause problems when trying to run other disk intensive programs, such as Adobe PageMaker. I still keep it switched off.

The free hard disk space must be at least equivalent to the amount of RAM allocated for Photoshop. If you have 96 Mb of RAM allocated to Photoshop and 40 Mb of free disk space, the program will use only 40 Mb of the RAM. For optimal image editing, at least 400 Mb of free hard disk space is recommended. Under these conditions, Photoshop will use all the RAM for real time calculations (mirroring the actual RAM on the scratch disk) and when it runs out, use the extra space on the scratch disk as a source of virtual memory.

Photoshop is designed always to make the most efficient use of real RAM memory. There are slight differences between the way this works on Windows PC and Macintosh systems respectively, but essentially the program tries to keep as much RAM as possible free for memory intensive calculations. Low level data like the

'last saved' version of the image are stored in the scratch disk memory giving priority to the current version and last undo versions being held in RAM. Photoshop continually looks for ways to economize the use of RAM memory, writing to the hard disk in the background, whenever there are periods of inactivity.

With all this scratch disk activity going on, the hard disk performance plays an important role in enhancing Photoshop speed. A fast internal hard disk is adequate for getting started. For best results, install a second hard drive, dedicated as the scratch disk (assign this as the primary scratch disk in the Photoshop preferences). AV (audio visual) designated drives are regarded as being slightly faster than a standard drive, but actually there is not a lot in it. You can either connect one of these externally via the SCSI port or on some models internally, if space permits. Internal drives can usually operate faster via the internal bus than an equivalent external drive. This is because the external SCSI port is usually of a SCSI 1 standard, suited for connecting all types of SCSI devices. Internal SCSI connections are often SCSI 2, which provides a quicker data transfer standard (data transfer not data access time is the measure of disk speed to look out for). For the very fastest data transfer use a wide array RAID disk connected via a SCSI accelerating PCI card like a SCSI 3 standard.

Green: MO disk; Red: ZIP disk; Blue: External AV HD; Black: Internal AV HD; Cyan: RAID SCSI 3 drive

Figure 3.2 The above chart shows a comparison of hard disk sustained data transfer rates measured using the ATTO Performance Utility. The test results show data transfer speed on the vertical axis against increasing data block sizes on the horizontal axis. The slowest test result was for a Magneto Optical media disk. The ZIP proved slightly faster. The internal AV hard disk demonstrates a faster sustained speed, while the RAID performance figures dwarf everything else.

Specifications vary according to the drives and the PCI card, but Figure 3.2 quite clearly shows that the sustained performance of a 25 Mb per second RAID system is a huge improvement over a standard AV drive. But whichever type of drive you allocate as a scratch disk, you should ensure that it is a separate discrete hard drive and is not shared with the disk which is running either Photoshop or the operating system. There is provision in Photoshop for as many as four ×2 gigabyte scratch disks. So if you installed an 8 gigabyte drive, you could divide the partitions in four and as the scratch disk memory requirements went beyond the limits of the first disk, the scratch disk usage would spill over to the next partition and so on. This makes for more efficient and faster disk usage.

FireWire™ is Apple's latest connection standard and will be beneficial for video editing and so far has been implemented with some still digital capture devices. A few FireWire™ hard drives are beginning to appear, but so far none have the fast data transfer rates we were promised. One benefit of FireWire™ is the ability to hot swop a drive between one computer and another. This is particluarly useful when you wish to shuttle very large files around quickly.

Clearing the clipboard memory

Allocate all the RAM available to Photoshop and run the application on its own. If you need to swap a file with Quark or PageMaker, say, save the file, close Photoshop and then open in the other program. This may at first seem long winded, when you could have both programs open simultaneously. Unless you are working with small screen sized images, Photoshop is going to need all the memory it can get. In the long run you will always save time by running Photoshop in isolation this way. Whenever you perform a Photoshop task that uses up a lot of scratch disk memory, you can see this in the file information box `Scr: 109M/204.1M` in the lower left window display. The right hand figure shows the amount of memory available and the left, the amount used so far. Photoshop stores the undo version in clipboard memory on the scratch disk. Copying a large selection to the clipboard also occupies a lot of memory. From time to time, if you are happy with the way your image is looking, purge the clipboard of data to minimize the loss in performance. To do this, choose Edit > Purge > Undo, Clipboard, Pattern, Histories or All.

Configuring the RAM memory settings (Macintosh)

In the Finder desktop, go to the Apple menu and choose 'About this Macintosh'. The dialog box will show you how much RAM is used by the system and how much application RAM remains – see Largest Unused Block. Next, find the unopened applica-

tion icon and choose File > Get Info from the desktop menu. Change the Preferred Size setting to the largest unused block figure minus 5–10 Mb. This is the largest amount of RAM you can safely allocate to Photoshop.

Configuring the RAM memory settings (Windows)

When you first install Adobe Photoshop 6.0, 60% of all available system RAM is automatically allocated for Photoshop use (50% on Windows NT 4). You can improve upon this memory allowance by increasing the partition. Go to the Memory and Image Cache Preferences and increase the percentage to as high as 90% (but only if you have a serious amount of RAM memory), but make sure there is an adequate amount of memory assigned to the permanent swap file. This should be as large as the amount of RAM memory installed or 10 Mb, whichever is bigger. If you want to run other programs simultaneously with Photoshop, lower the percentage of RAM allocated to Photoshop.

PCI cards

If Photoshop has been accused of being slow, that is not so much a fault of the software, but rather the architecture of the computer running it. Desktop computers are designed to perform all types of tasks. This jack-of-all-trades compromise is one thing which separates the desktop computer from other dedicated high-end systems. Most modern desktop computers have PCI expansion slots on the motherboard. These allow you to add dedicated cards to the basic computer, thereby converting it to a customized workstation for broadcast video editing, 3D modelling or professional image editing.

Video display

Displaying a digital image on the monitor is another bottleneck to overcome. This can be solved either by installing more video RAM or preferably fitting an accelerated PCI video graphics card with 16 Mb or 32 Mb of memory. Doing this will both accelerate display redraw times and increase the color depth to millions of colors and at finer resolutions. The increased memory means that the off-screen image data remains in memory, so image scrolling is enhanced. There is a lot to be said for graphics quality 17" monitors. The screen size is adequate and if you upgrade the video graphics as suggested, you can run at the highest resolution allowable in millions of colors. It is a big leap between that and purchasing a 20" or 21" monitor. Some large monitors have noticeably curved screens – they are fine for business use,

but not graphics work. Large monitor screens require a lot more video memory. That is why fast video acceleration is essential. With accelerated 24-bit video boards now starting at less than $200, they are no longer such an expensive option. The Matrox Millennium, ATI Rage and the Formac ProFormance III (16 Mb) PCI cards are recommended good buys.

Screen display in Photoshop is faster than it used to be, but you'll still appreciate working with a decent sized screen. Add an extra monitor if your system allows and use the smaller screen to display the palette windows. The monitor must be carefully calibrated as is described later in Chapter Four.

System software

A computer that is in daily use will after a month noticeably slow down without some housekeeping. You should regularly rebuild the desktop file by holding down the Command and option keys (Macintosh) simultaneously at startup. This maintenance operation makes it easier for the computer to locate files (just as when you tidy up your own desk). PC users should search for temporary files whilst no applications are running, using the Find command and entering '*.tmp', to search for any files that have the .tmp (temporary) file extension. These should then be deleted. Norton Utilities is a suite of programs that add functionality. Image files continually read and write data to the hard disk, which leads to disk fragmentation. Norton's Speed disk (which has to be run from a separate start up disc), will defragment files on the main hard disk or any other drive. Windows users should also look out for a program like Windows Disk Defragmenter. This is essential on the drives you allocate as the scratch disks in Photoshop. If you're experiencing bugs or operating glitches and want to diagnose the problem, run Norton's Disk Doctor. This will hunt out disk problems and fix them on the spot.

On the subject of Norton, Rod Wynne-Powell has this extra advice to offer: I have never read it in print or in Norton's literature, but an essential procedure for running Norton is that you run it more than once, if you find that it reports any error at the end. On the second or subsequent runs you may ignore the search for bad blocks, as if they occur you have more than a simple glitch, but in this way you find out whether any 'fixed' item has caused any other anomalies. If you are unlucky enough to have 'bad blocks' do not assume that their reallocation has solved the problem; it may well have reassigned the faulty block, but it could be that the data present in that area are now invalid, and could be a vital system component, which will now start to corrupt more of your disk. The advice is simple, and not welcome; the hard disk must be reformatted, and the System and Applications all reloaded. If bad blocks recur the drive needs replacement.

Efficient work routines

To quickly navigate through nested folders on the Mac, make an alias of the hard disk and place this in the Apple Menu items folder. When you mouse down on this alias icon in the Apple, a sub-menu of folders or documents will appear. Note that Navigation Services are now fully implemented on the Macintosh version of Photoshop 6.0. Learn how to make the most of these navigation controls and how to access your most used folder locations.

Think ahead, don't just dash in and start manipulating. Work out what you want to do and plan the session in logical stages. If the file to be created is going to put a strain on your computer because of either slow chip speed or lack of RAM memory, then do a low resolution test first, noting down the settings used as you go along. Even better, record an Action of what you do and save these settings automatically. Of course many of the filter settings will then need to be adjusted for a larger sized document – leave a pause in the recording and set accordingly.

Adjustment layers allow you to change your mind at a later date, so you can undo Levels, Curves, Color Balance etc. adjustments. You can even have more than one adjustment layer. For example, you could have a file saved with four different Hue/Saturation settings. The Hue/Saturation adjustment layers would only add a few kilobytes each to the overall image file size. You could quickly demonstrate to a client several color variations in succession, without having to open four separate files.

Figure 3.3 The Navigation Services File > Open dialog. This Mac system feature is now fully implemented in both Photoshop 6.0 and ImageReady 3.0. Windows users have already had the benefit of efficient folder navigation before, but Mac users are now able to quickly navigate directly to mounted volumes, save and locate favorite folders and keep separate preferences for the save and open locations.

Chapter Four

Color Management

Photoshop was justifiably praised as a ground-breaking upgrade when it was released in the summer of 1998. The changes made to the color management setup were less well received in some quarters. This was because the revised system was perceived to be extremely complex and unnecessary. Some color professionals felt they already had reliable methods of matching color and you did not need ICC profiles and the whole kaboodle of Photoshop ICC color management to achieve this.

The aim of this chapter is to introduce the basic concepts of color management, starting with the basic question: 'how do we make the color on the monitor match what someone else sees on their monitor?' Then we shall go on to look at how all the other bits of the color management jigsaw can all work in harmony together. This introduction will help you to better understand the workings of the Adobe Photoshop color engine and the color policies. The latter half of this chapter describes the new Photoshop 6.0 color management interface. Readers who are already familiar with the ICC color may therefore wish to skip this first section and go straight to page 64 where the new interface changes are described in detail.

An advertising agency art buyer was once invited to address a meeting of photographers for a discussion about photography and the Internet. The chair, Mike Laye, suggested we could ask him anything we wanted, except 'Would you like to see my book'. And if he had already seen your book, we couldn't ask him why he hadn't called it back in again. And if he had called it in again we were not allowed to ask why we didn't get the job. And finally, if we did get the job we were absolutely forbidden to ask him why the color in the printed ad looked nothing like the original transparency!

That in a nutshell is a problem which has haunted us all our working lives. And it is one which will be familiar to anyone who has ever experienced the difficulty of matching colors on a computer system with the original or the print output. Figure 4.1 has two versions of the same photograph. One shows how the Photoshop image is previewed on the monitor and the other is an example of how a printer might interpret and reproduce those same colors. Why is there such a marked difference between what is seen on the screen and the actual printed result? It should not be so odd that this can happen. After all, whenever you visit a TV showroom, you will know from experience how each television can display identical broadcasts differently. Exactly the same thing occurs between individual digital devices such as scanners, cameras and the monitors with which we view our digital images. Of course the computer monitor has manual controls which allow you to adjust the brightness and contrast, so we have some element of basic control there. But which settings should you use though? And will the colors in the image you are seeing appear the same on another person's monitor?

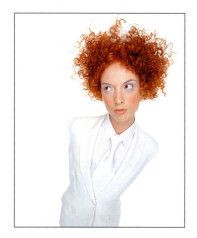 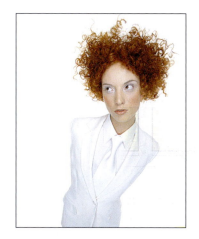

Figure 4.1 The picture on the left shows how you would see the Photoshop image on your screen and the one on the right represents how that same image will print if sent directly to a proofing printer without applying any form of color management. This is an actual simulation of what happens when raw RGB data is sent without any form of compensation being applied to balance the output to what is seen on the screen.

You might think it is merely a matter of making the output color less blue in order to successfully match the original. Yes, that would get the colors closer, but when trying to match color between different digital devices, the story is actually a lot more complex than that. The color management system that was first introduced in Photoshop 5.0 will enable you to make use of ICC profiles and match these colors from the scanner to the screen and to the print proofer with extreme accuracy.

Client: Clipso. Model: Sheri at Nevs.

1 The Adobe Gamma Control Panel is located in the Application/Goodies/Calibration folder (Mac), Program files/Common files/Adobe/Calibration folder (PC). Install a copy in your system folder. On the Macintosh, this would be inside the Control Panels folder. When opened you have a choice between using the Control Panel method of operation or the Wizard.

2–3 In Control Panel mode the interface option settings will be familiar to Photoshop users who knew the Thomas Knoll Gamma Control Panel. You can load existing ICC profiles or make your own custom profile and save as an ICC profile.

Figure 4.2 The Adobe Gamma Assistant will begin by asking you to set the monitor contrast button to the highest setting and adjust the monitor brightness so that the dark gray box is just visible inside the outer black box.

Figure 4.3 Then you will want to choose the phosphors which most closely match those of your monitor. If you began with a canned profile supplied by the manufacturer, leave this as is, or check the monitor manual and see if one of the other descriptions in the list matches.

Figure 4.4 At the next prompt, deselect the View Single Gamma Only box and use the slider at the bottom of each of the three colored boxes to visually match the density of the colored stripes in the outer boxes. Squint your eyes as you do this.

Figure 4.5 Again, you may want to check with the monitor specifications, but in most cases a white point of 6500 K will provide the optimum white point setting to provide the brightest and cleanest white point and match the color balance of a calibrated daylight-balanced lightbox.

Figure 4.6 Unless you have a good reason to alter the hardware white point setting entered in the previous box, leave this set to 'Same as Hardware'.

Figure 4.7 That is it, you have now successfully calibrated your monitor's brightness, contrast and color balance. You can see the before and after adjustments and compare how the monitor looked beforehand. When you finish and save, you will have created an ICC profile which describes the current characteristics of the monitor and which Photoshop will automatically recognize.

Monitor calibration

There is a lot more to color management than simply standardizing the monitor, but this is a good enough place to start configuring your system. The steps on the preceding pages will enable you to set the brightness, contrast and color balance to a standardized display. Before you carry out this calibration procedure, the monitor should be left switched on for at least half an hour to give it a chance to warm up and stabilize. When you installed Photoshop, a small utility called Adobe Gamma was added to the Control Panels (located inside the System folder which can be accessed via the Apple menu on the Mac and if using a PC, by going to My Computer and selecting 'Control Panels'). Adobe Gamma will now work with most PC computers, providing the video card will allow Adobe Gamma to interact with the monitor tube. Do not use the older 'Gamma' control panel which shipped with Photoshop 4.0 or earlier. This older control panel should be discarded. When you launch Adobe Gamma, you have a choice of using it in either Control Panel or Step By Step (Assistant) mode. Select the Assistant radio button and click Next. If you already have a monitor profile, such as a canned profile supplied by the manufacturer, click the Load... button, locate this profile and use it as your starting point. The monitor profiles should be located in the ColorSync Profiles folder. If not, any will do as a starting point here.

The dialog instructions will ask you to set the monitor contrast control to its maximum setting. Then you will be asked to adjust the monitor brightness control so that the dark gray box inside the larger black box just becomes visible. This step optimizes the monitor to display at its full dynamic range and establishes the optimum brightness for the shadow tones. That's the first stage complete, you will next be asked to describe the monitor tube type. If you were able to load the manufacturer's profile at the beginning of the procedure, then there should be no need to override this. If you are starting from scratch and know the monitor type used (many popular graphics monitors use the Sony™ Trinitron type design) select it from the pop-up list. If you are in doubt as to which to select here, check the information and instructions which were (hopefully) supplied by the monitor manufacturer.

Neutralizing the color

Now you will be asked to adjust the relative brightness and color balance of the screen display. The single gamma display box will only allow you to adjust the relative brightness. You will want to neutralize the color as well. Uncheck the 'View Single Gamma Only' box – you should see the dialog display shown in the second window on the previous page. The Macintosh default gamma setting is 1.8. If you intend using Photoshop on the Mac to produce work which is destined for print, then you should use this gamma setting. The Windows default is 2.2 – this is the best

monitor gamma setting for most Windows graphics cards, so choose the 2.2 setting. The reasons for this discrepancy will become clearer later. Basically the Photoshop color engine will recognize this difference and the screen display will be compensated, such that Macs and PCs will actually display images at the same brightness. You can now adjust the gamma of the individual red, green and blue color components which make up the full color monitor display. Squint your eyes as you adjust the individual color gamma sliders, so that the patterned stripes in the boxes appear to blend with the solid color box in the middle.

People often ask 'how can I be sure that the color I see is the same as what someone else is seeing?' How reliable are an individual person's eyes when it comes to determining how to neutralize the display? There are several factors which can determine color perception, not least the health of a person's eyes. As you get older the color vision of your eyes will change, plus some people are color blind and may not even be aware of this. For the most part, younger people in their twenties and with healthy vision will perceive colors more consistently and with greater precision. Then there is also the question of how we interpret color – human vision is adaptable and we tend to accommodate our vision to changes in lighting and color temperature and can be influenced by the presence of other colors around us.

You should get rid of any distracting background colors or patterns on the computer desktop. You should ideally have a neutral gray desktop background and this is especially important when you are calibrating the screen by eye. One way to achieve this is to open an image up in Photoshop and set the screen display to full screen mode with the gray pasteboard filling the screen. Consider also the impact of lighting conditions and the viewing environment. The walls of the room you are working in should be neutral gray and the light levels kept low. This will help preserve the contrast of the monitor and lessen unwanted reflections on the screen.

White Point

Lastly, we come to the white point settings. I would advise choosing a white point of 6500 K. You might be guided to choose a white point of 5000 K, because this is the color temperature of a calibrated, proofing lightbox. A computer monitor set to 5000 K might look rather dull and have a slightly yellow cast. Try a 6500 K white point. If still unsure, try clicking on the Measure... button and following the on-screen directions. The next screen asks if you want to work with a different white point other than that entered in the previous screen. Unless you have a particular need to alter the white point, leave this set to Same as Hardware. When finished, save the monitor profile you have just created. Photoshop will now utilize this profile information in the color management process without further intervention.

The value of a calibrated display

If you follow the steps just described, using the Adobe Gamma control panel, you will now have yourself a calibrated monitor. On the Macintosh, the profile should be saved in the System/ColorSync Profiles folder. On a PC machine, save to the Windows/System/Color folder. The Adobe Gamma utility is the simplest way of checking that your screen is neutral and is making full use of the display contrast to fully render the shadow and highlight tones correctly. This does not yet completely resolve the 'why does the printer print differently to what I see on the screen?' problem, but it does get us on the right track with regards being able to open up an image in Photoshop and seeing it with the same brightness and color neutrality as on someone else's system.

Figure 4.8 If you are using a third-party method of profiling the monitor on the Macintosh, other than Adobe Gamma, you will need to manually load this profile in the ColorSync Control Panel next to where it says System Profile. On a PC, you will need to remove Adobe Gamma completely and carefully consult the instructions which came with the calibration device. These should guide you through the intricacies of how to configure the Windows 98 and NT4/NT5 system setups.

Adobe Gamma is effective, but it's still rather basic. There are other, better solutions to consider using. For example, the Apple Studio ColorSync monitor has a built-in ColorSync calibrator. When you press the ColorSync button, this initiates a sequence of self-tests which will culminate in an optimized screen display and the creation of an up-to-date monitor profile (Photoshop makes use of this profile, as shall be explained later). Other systems include hardware calibration devices, such as those which are attached to the screen via rubber suckers and read color patches off the screen and use this information to build a monitor profile. In every case, you use the best calibration method at your disposal to create an accurate monitor profile. If you have a third-party device or built-in calibration, always use this instead of Adobe Gamma. The state of the monitor will fluctuate over time as well as on a daily basis. It is therefore important to check and calibrate the monitor at regular intervals. The way Photoshop 5.x and 6.0 handles color is rather complex. But suffice to say, the monitor calibration plays an essential part in establishing a first link in the chain of the overall system.

Not all RGB color devices are the same

Consider for a moment the scale of the color management task. We wish to capture a full color original subject, digitize it with a scanner or digital camera, examine the resulting image via a computer screen and finally reproduce it in print. It is possible with today's technology to simulate the expected print output of a digitized image on the screen with remarkable accuracy. Nevertheless, one should not underestimate the huge difference between the mechanics of all the various bits of equipment used in the above production process. Most digital devices work using RGB color and just like musical instruments, they all possess unique color tonal properties, such that no two devices are identical or will be able to reproduce color exactly the same way as another device can. Some equipment is capable of recording colors which are beyond the limits of human vision. Nor is it always possible to match in print all the colors which *are* visible to the human eye. Converting light into electrical signals via a device such as a CCD chip is not the same as projecting pixels onto a computer screen or the process of reproducing a photograph with colored ink on paper.

The way things were

Prior to Photoshop 5.0, many users had assumed that all RGB color was the same, or it might be more correct to say that some had thought that the Photoshop RGB color we edited in was a standard space, when in fact it was based on the individual's monitor setup. Remember, the monitor color space is just another example of a variable, device-dependent color space. Color professionals have always been aware of this problem. The traditional approach has been to create a closed color loop. To achieve this, you need to calibrate the high-end scanner and scanner software using a calibration pack of a transparency emulsion and reflective print test strip and build customized tables with which to convert the RGB data into custom CMYK files, ready for print. With this type of closed-loop color management system, the color display is made to match the proof output. When working in an all-CMYK workflow, many color professionals prefer to judge color 'by the numbers'. A closed loop can evidently work very well, and the vast majority of four color print work is still managed this way.

With a closed loop system, anyone who works outside of the bureau and intends supplying digital work for output will have to synchronize their color to that of the bureau. If you are outputting a file to bureau X, then you need to be able to simulate the color loop of bureau X on your system, in order to visualize how the output would look. Now while you may be able to use this method to balance your monitor to match the skin tones in a beauty photograph, it does not follow that this method of calibration will work consistently with every other type of photograph you preview in Photoshop. If the next image is an underwater photograph, the output device may

have a completely different bias in the blue portions of the spectrum and you are back to having to match the screen to the output again – not a very satisfactory way of working, especially as Photoshop 6.0 has the potential to make the process of matching colors that much simpler.

Photoshop 5.0 introduced a bold shake-up of the traditional color management system. The old method of visually matching the monitor to the output was considered too fallible and rightly so. The key component of Photoshop is the Adobe Color Engine (ACE) and the use of a 'device-independent' RGB work space. Photoshop 6.0 carries out all its color calculations in this virtual (independent of the monitor) RGB color space. The RGB color space you edit within can be exactly the same as the work space set on another user's Photoshop system. Everything else coming into Photoshop, which is displayed on the monitor or output to print, can be interpreted accurately using the new proof setup and the profile information for each device.

The profiled approach

Consider the problem of matching digital capture devices. We are all familiar with magazine reviews of digital cameras. At some point the magazine may print a spread of photos where a comparison is made of all the different models and the results achieved from photographing the same subject. The object of this exercise being to emphasize the difference in the capture quality of each camera when each file is brought directly into Photoshop, without any compensation being made. If you could quantify or 'characterize' those differences and build a profile of each camera, as was done during the monitor calibration process, then it should be possible to accurately describe the color captured by a camera or a scanner. Similarly, by running out standard proofs to test the variance in color output from different proof printers, we can build a profile of how we can expect a proof printer to output a print.

The Adobe Gamma step-by-step procedure built you a basic profile which described the monitor's color behavior. More detailed color sampling of a larger range of colors and tonal values will yield an even more accurate profile of any particular device you wish to measure. Figure 4.9 is an example of a Kodak test target which is used to build an ICC profile. A target like this can either be scanned or photographed with a digital camera and the input color values compared using special software. In this case, I printed out the targets without using any color management – this gave a picture of how the printer would reproduce raw digital data directly from Photoshop. The printed targets were then measured using a photo spectrometer, the results evaluated and used to build a color profile for the color printer. As you can see, the profiling method will tell us so much more about the characteristics of a digital device like a camera or a scanner than could ever be achieved by just tweaking the monitor RGB

gamma values to match the color balance of a specific output. If you rely on that method, is it any wonder the color balance will appear to shift as you edit different pictures? For example, if you successfully match the color of a skin tone portrait on your monitor to the print and then try to do the same with a landscape where green is the predominant color, I can guarantee you will end up having to modify the monitor's color balance again. Photoshop 6.0 allows you to achieve the same objective of matching the color input and output to what you see on the monitor, but you don't have to mess up your monitor's color in order to achieve this. Profiling will help you achieve consistent color management not just on your own system, but when working and sharing files with other ICC-savvy Photoshop users as well.

Figure 4.9 This is an example of a Kodak color target which is used to construct a color ICC profile. Thomas Holm of Pixl in Denmark sent me five separate files, including the one above. Each file was opened in Photoshop without any color conversion and the file was sent directly to the printer, again without any color modification. The print outputs, which contained over 800 color reference swatches, were then sent back to Pixl. They then measured all the color data information using an X-Rite spectrophotometer and from this constructed an accurate profile for my Pictrograph printer using Kodak ColorFlow 2.1 software and emailed the profile back to me.

<email@pixl.dk>

Figure 4.10 reexamines the problem encountered at the beginning of this chapter. The skin tones in the original digital file printed too blue. The profile created for this particular printer describes such variance. The (normally hidden) color shifting which occurs during the profile conversion process will compensate by making the skin tone colors more red, but apply less color compensation to other colors. The result is an output which more closely matches the original. That is a simple illustration of the ICC-based color management system at work. Basically, all color can be managed this way in Photoshop 6.0 from capture source to the monitor display and the final proof.

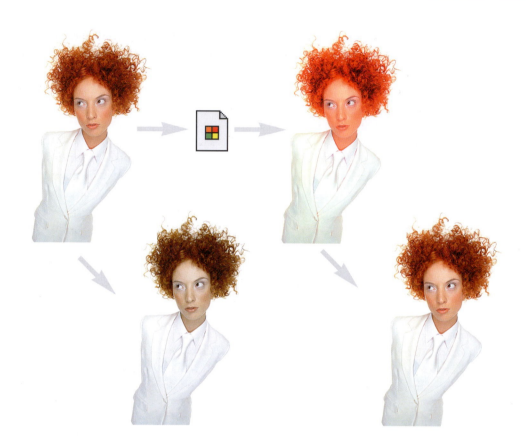

Figure 4.10 As was shown in Figure 4.1, sending the color data direct to the printer without applying any compensation will produce an incorrect color result. But applying a profile conversion with a custom profile for the proof printer will invisibly convert the colors to compensate for the specific characteristics of the printer and thereby produce a much more representative print of the original. The bright red 'profile converted' image will compensate for the color space deficiencies of the output device.

The versatility of RGB

There are those who remain critical of the introduction of ICC-based color management in Photoshop. They look at the needs of their own setup and figure that what works well for them has got to be right for everyone else. Bureaux and printers work exclusively with the final stage of the print process and if your main area of business revolves around the preparation of CMYK separations for print, then I recommend you invest in a training course or book which deals mainly with these CMYK repro issues. Conversely, photographers are mainly involved in the RGB capture end of the business. This is one of the reasons why I devote so much attention to the managing of RGB color, here and elsewhere in the book.

The proliferation of Photoshop use and the advent of high quality digital cameras is also another important factor to consider. If photographers are more likely to want to supply a digital file at the end of a job, how will this fit in with existing workflows? Printers have argued in the past that they would prefer the digital files turned back into transparencies, so they can maintain the opportunity to scan it again themselves. Most of their work is currently handled using original transparency film and therefore this is more convenient for them (and of course they maintain the scanning business). But at what cost to the client? If digital capture takes off, that option will no longer exist, so one way or another the RGB to CMYK issue will have to be resolved. The early adopters of digital camera systems were repro houses and they are therefore having to investigate ways and means of handling RGB files and the use of independent hardware/software solutions to carry out the conversion to CMYK. If as is expected, professional quality digital cameras become more widely used, photographers will either be turning those digital files back into transparencies to be scanned again by the printer, or supplying digital files direct. As I see it, the latter is the only viable option and the real issue is whether the files should be converted to CMYK by the originator or the printer.

A major advantage of working in RGB is that you can access all the bells and whistles of Photoshop which would otherwise be hidden or grayed out in CMYK mode. Mixed final usage also needs to be taken into account – a photograph may get used in a variety of ways and multiple CMYK separations will need to be made to suit several publications, each requiring a slightly different CMYK conversion because CMYK is not a 'one size fits all' color space. High-end retouching for advertising usage is usually done in RGB mode and a large format transparency output produced. That transparency can be used as an original to be scanned again and converted to CMYK but the usual practice is to use the transparency output for client approval only. The CMYK conversions and film separations are produced working directly from the digital file to suit the various media usages. When you think about it, a transparency proof for all its glory is actually quite useless considering the end product is to be printed on paper. The ideal proof should be a CMYK output printed to match the expected output of the final publication.

There is life beyond CMYK, I should not forget to mention Hexachrome printing: a six-color ink printing process which extends the range of color depth attainable beyond conventional CMYK limitations. This advanced process is currently available through specialist print shops and is suitable for high quality design print jobs. Millions have been invested in the presses currently used to print magazines and brochures, so expect four-color printing to still be around for a long time to come, but six-color Hexachrome will open the way for improved color reproduction from RGB originals. Photoshop supports six-color channel output conversions from RGB, but you will need to buy a separate plug-in utility like HexWrench to do so. Spot color

channels can be added and previewed on screen – spot color files can be saved in DCS 2.0 or TIFF format. How about screen-based publishing – multimedia CD-ROMs and the Internet? Viewers who have monitors displaying more than the basic 256 colors will appreciate the color depth of a fuller RGB color range. Again, if you are working in these areas or are producing images for mixed media, there is no reason to limit yourself exclusively to CMYK editing.

Device independent RGB

The most significant change to the Photoshop color management system has been to make the RGB work space independent of the system or monitor you are using. The Photoshop 6.0 RGB work space is device-independent. The monitor profile is important as a means of interpreting how the RGB data is displayed on your particular monitor, while the actual RGB you are editing in can be a recognized standard space like Adobe RGB or ColorMatch RGB. All people have to do is calibrate their monitors as described earlier to generate a profile description of the viewing monitor. Photoshop will then read the RGB information from the work space and display the color correctly on the screen, using the monitor profile information.

What you view on your screen should be the same for someone looking at the image on another monitor regardless of the operating system they are using or make of monitor, provided that they have also followed the correct calibration procedure. To visualize what is happening, you have to imagine that all Photoshop operations take place in an RGB color space which can be one of several recognized standards. This is what is called the 'work space'; it is the color space within which Photoshop does all its calculations in. Activities surrounding the Photoshop RGB work space, like the importing of images, the display of RGB data on screen and CMYK conversions, are moderated by ICC profiles to maintain color consistency throughout the workflow. Therefore, if you import an image which has an embedded ICC profile, this is recognized upon opening, and this profile information will tell Photoshop everything it needs to know about the color values represented in that file (and what they mean). The ICC profile of your monitor is taken into account and the RGB display values are calculated on the basis of the work space primaries plus monitor profile. The RGB to CMYK conversion will use the profile information contained in the CMYK setting – this can be a pre-supplied ICC profile (see Edit > Color Settings: CMYK Work Space) or a custom separation setup where you enter the information as supplied by the printer (see later sections of this chapter).

Choosing an RGB work space

We are looking at a color management system in which the user only has to regularly calibrate their monitor and everything else will fit into place. That is assuming that every file you bring into Photoshop is tagged with a profile and the profile is accurate. To handle profile mismatches, you will need to read on. But when everyone working on the production process adopts the same system of color management – the potential is there to maintain color accuracy from input to output.

There is nothing to prevent you basing your own studio/office system loop on an ICC profiled system and it is highly recommended you do so, but don't assume everyone else will. What about bureaux running outputs from your files, who are still using version Photoshop 4.0 or earlier, and are not bothering to calibrate their systems properly? Also, which RGB color space should we all be using? Among Photoshop 6.0 users it matters less individually which RGB color space you choose in the RGB setup, as long as you stick to using the same space for all your work. Photoshop 6.0 can safely convert between RGB spaces with minimal loss of data, but the space you plump for does matter. Once chosen you should not really change it, except when preparing images to go on the web. Whichever work space you select in the RGB color settings, you will have to be conscious of how your profiled Photoshop RGB files may appear on a non-ICC savvy Photoshop system. What follows is a guide to the listed RGB choices.

Apple RGB is the old Apple 13" monitor standard, while the sRGB space is the choice for Windows PC users and is based on the high definition TV color standard (for broadcast). sRGB might be the color space to use for web design projects but is quite unsuitable for repro quality work. The sRGB space clips the CMYK gamut and you will never get more than 75%–85% cyan ink in your CMYK separations. ColorMatch RGB is an open standard monitor RGB space used by Radius, which was around for a while. The space formerly known as SMPTE-240M was based on a color gamut proposed for HDTV production. As it happens, the coordinates Adobe went ahead with did not exactly match the actual SMPTE-240M standard. Nevertheless, it proved such an ideal space for prepress editing that it has been officially adopted as the Adobe standard space for repro work and is now known as Adobe RGB (1998). I originally adopted Adobe RGB as the RGB default, because it was a large enough space to accommodate both CMYK print and RGB transparency output. Despite being renamed Adobe RGB, the coordinates are nevertheless identical to the former space.

Figure 4.12 illustrates the concept behind choosing an ideal work space. This is not a technically accurate drawing, but it gets across the idea that the RGB work space can be larger than the actual RGB monitor. Figure 4.13 examines the same issue

Figure 4.11 The CD-ROM accompanying the *Adobe Photoshop 6.0 for Photographers* book contains a short movie which helps to explain the RGB space issue by graphically comparing some of the main RGB spaces.

Figure 4.12 Just because a monitor is an RGB device does not mean that it is displaying the entire RGB spectrum, or that the RGB colors one monitor displays are identical to those of another monitor. Every RGB device has its own individual color characteristics and a monitor is usually weak in not being able to display RGB greens and cyans. Photoshop can operate in an RGB color space that is larger than the average monitor's display limits.

Figure 4.13 A CMYK color space is mostly smaller than the monitor RGB color space. Not all CMYK colors can be displayed accurately due to the physical display limitations of the average computer monitor. This screen shot shows a continuous spectrum going through shades of cyan, magenta and yellow. The image was then deliberately posterized in Photoshop. Notice how the posterized steps grow wider in the Yellow and Cyan portions of the spectrum. This sample gradient pinpoints the areas of the CMYK spectrum which fall outside the gamut of a typical RGB monitor.

from the perspective of displaying CMYK color on an RGB monitor screen. If you select an RGB work space which is the same size as the monitor space, you are not using Photoshop to its full potential and more importantly you are probably clipping parts of the CMYK gamut. Select too wide a space and you are stretching the work space gamut unnecessarily beyond the normal working requirements. Figure 4.14 summarizes the basic color workflow scheme in Photoshop 6.0, it shows how documents are managed as they are read into Photoshop and sent for output. Notice that the monitor is shown as another form of output device and is separate to the central work space in which the color data is actually processed.

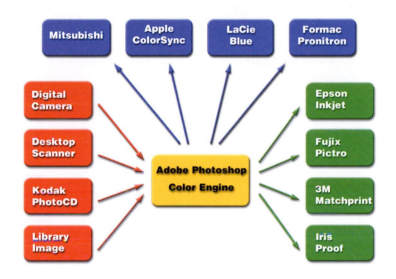

Figure 4.14 Photoshop's ICC color management system revolves around the use of profile information which will ideally accurately describe the characteristics of each digital device used in the chain from capture to print. In the above example, Photoshop can read or make use of the profile relating to any type of input source (the devices listed in the red boxes) and apply a conversion to the destination or output (the devices listed in the green boxes) and maintain consistent color throughout. Profiling the monitor (such as one of the monitors listed in the blue boxes at the top), using Adobe Gamma or other third-party measuring device ensures accuracy of the display of the color data on screen.

When an RGB image is opened in Photoshop and it matches the current work space, no conversion is necessary. If there is a profile mismatch, you will mostly want to convert to the default RGB work space. Although in Photoshop 6.0, you can choose to open in the document's color space instead and the image will still be color managed correctly. The monitor profile information converts the RGB color on-the-fly, to display correctly on the profiled monitor.

Open-loop ICC color management

The digital imaging industry has expanded enormously during the latter part of the nineties and is set to grow even more rapidly this decade. Everybody is now able to access digital image files, whether they are from CD discs, home scanners, digital cameras, Photo CD or the Internet. At the professional level, many photographers and illustrators are now scanning or capturing their own digitized images. Seen in this context, the closed-loop argument is looking less flexible considering the way professional and consumer digital imaging industries are continuing to evolve.

Today there is an enormous proliferation of digital images being exchanged daily, coming from different devices, and they have all originated in RGB color. This potentially allows clients the freedom to repurpose an image from a single digital master many times for different types of end usage and in less turnaround time too. Instead of having a transparency scanned over and over again, one can have a single digital file as the master and this has only to be scanned or digitally captured once. It is inevitable that clients will demand this level of flexibility, especially as the momentum to use digital cameras grows and will make such a workflow more cost effective. For example, digital capture is already well established in news gathering. Many picture library images are sourced digitally instead of from a borrowed film dupe. It is in response to this market need that an open color management system has evolved. If you do any work in RGB color, then you need ICC color management to maintain color accuracy. If you only work in CMYK, then ICC color management is going to be less effective, because you cannot profile for the shifting variations of a printing press (although there are attempts being made to automate this). But as far as photographers should be concerned it is important that we are able to achieve color consistency at the first stage of the process through to the point where the job is signed off and taken to the next step in the print process. RGB to CMYK conversions may or may not be part of the job you are commissioned to do, but in any case I shall be discussing the subject of CMYK conversions at the end of this chapter.

Photoshop 6.0 color management

By now you should be acquainted with the basic principles of Photoshop ICC color management. Previous users of Photoshop 5.0 will already be familiar with the workings of the Adobe Photoshop Color engine. The changes introduced to Photoshop 6.0 may seem a little disconcerting at first sight. The good news though is that the basic color engine remains unchanged. But the interface, however, has been substantially rearranged, in order to make the color management system more accessible and at the same time more foolproof.

The Color Settings

The Color Settings command is located in the Edit menu along with the Preferences settings (which used to be in the File menu). This Color Settings interface is more or less identical to that found in Illustrator 9.0 and Figure 4.15 shows the basic dialog controls and options. The first item you will come across is the Settings pop-up menu. Photoshop 6.0 helpfully provides a range of preset configurations for the color management system. These can be edited (see Managing the Color Settings, page 69) if you wish them to meet your own specific requirements. If you know that you want to edit your photographs with a view to outputting color separated CMYK files for prepress in Europe, you would select the Default Prepress – Europe setting from this list. That is all you need to concern yourself to start with, but if you wish to make customized adjustments, then you can select custom settings in the Working Spaces section below. Refer back to the section on RGB spaces for guidance on select-ing the most appropriate RGB space here. The CMYK and Grayscale settings shall be covered later. Note that Photoshop loads a default setting for Web Graphics use only, and color management is switched off. If you intend using Photoshop to edit files for prepress, you will want to change this to a prepress setting. The following instructions assume Photoshop has been configured to one of these prepress settings.

Color Management Policies

When a document is opened, Photoshop 6.0 checks to see if an ICC profile is present. If so, the default policy is to preserve the embedded profile information. So whether the document has originated in sRGB, Adobe RGB or ColorMatch RGB, it will open in that RGB color space and after editing be saved as such (although with these default settings the opening profile mismatch dialog offers you a chance to convert to the current work space or discard the profile). You can have several files open at once and each can be in an entirely different color space. If you have only just adapted to the Photoshop 5.0 and 5.5 way of doing things, this might take a little getting used to. A good tip is to set the Status box to show 'Document profile' (on the Mac this is at the bottom left of the image window; on the PC at the bottom of the system screen palette). This will give you a constant reminder of each individual document's color work space.

The default policy of Preserve Embedded Profiles allows Photoshop users to use the ICC color management system straight away, without confronting the puzzling 'Con-vert Colors' dialog. So long as there is a profile tag embedded in the file you open, Photoshop will give you the option to open the file in that same color space without converting it. So if someone asks you to open their Apple RGB file, the default choice offered to you upon opening is to open it in the Apple RGB color space and

Figure 4.15 The Photoshop 6.0 Color Settings. All the Photoshop color settings can be managed from with this single dialog. Photoshop 6.0 conveniently ships with seven preset settings which are suited to various publishing workflows. As you move the cursor pointer around the Color Settings dialog, help messages are provided in the Description box area below – these provide useful information which will help you learn more about the Photoshop color management settings and the different color space options.

after saving it, the file will remain in and be tagged with this same Apple RGB color space. This is despite the fact that your default RGB work space might in fact be Adobe RGB. Photoshop will automatically adjust the monitor display to take into account the monitor ICC profile created with Adobe Gamma (or other selected monitor profile). There is no Display Using Monitor Compensation button to check or uncheck in this version and a good thing too! So many people innocently played around with the RGB settings and ended up with bizarre configurations which only served to confuse matters (these are still accessible, but are safely hidden away under the Advanced settings). Now, you simply choose an appropriate RGB color work space and that's it. There is no Gamma or Primaries option to meddle with. You are shown only the necessary range of options.

If you select the Convert to Working RGB policy, then Photoshop 6.0 will behave more like Photoshop 5.0 and 5.5. If the incoming profile does not match the work space, then the default option will be to ask Photoshop to carry out a profile conversion from the embedded profile space to your current work space. The same policy rules apply to CMYK and grayscale files. When Preserve Embedded Profiles is selected, Photoshop 6.0 will read the CMYK or Grayscale profile, preserve the numeric data and not convert the colors. And the image will remain in the tagged color space – this is going to be the preferred option when editing incoming CMYK files.

You normally do not want to change the CMYK colors, a CMYK file may already be targeted for a specific press output and you don't really want to alter those CMYK numeric color values. When the incoming profile matches the RGB work space CMYK or grayscale setup, there is of course no need to convert the colors.

The third option is Color Management: Off. With this configuration, Photoshop 6.0 will not attempt to color manage incoming documents. If there is no profile embedded, then it will stay that way. If there is a profile mismatch between the source and work space, the profile will be removed (with a warning alert, pointing out that the embedded profile information is about to be deleted). If the source profile matches the work space, there is no need to remove the profile, so in this instance the profile tag will not be removed (even so, you can still remove the ICC profile at the saving stage).

Figure 4.16 If Preserve Embedded Profiles is selected as the RGB color management policy, the above dialog will appear, asking if you want to use the embedded profile. This happens whenever a profile mismatch occurs and you have checked the Profile Mismatch: Ask When Opening box in Color Settings (see Figure 4.15). If the color management policy is Convert to Work space color, the second radio button will be highlighted in this dialog, asking if you wish to convert the colors to the current work space.

Figure 4.17 If you attempt to paste image data from a document whose color space does not match the destination space, the above dialog warning will appear, providing the Profile Mismatch: Ask When Pasting box in the Color Settings dialog is checked (see Figure 4.15).

A change for the better

So, considering all the upheaval caused the last time Adobe altered the color management behavior in Photoshop, has this further modification to the color management system been worth it? The underlying color management system is essentially the same as it was in Photoshop 5.0. I very much welcome the new interface as it clears up quite a number of issues where the previous implementation of ICC-based color management in Photoshop was lacking. For example, the default RGB color setting may still be the sRGB color space, but is now clearly labelled as a Web design default setting. When users select a prepress setting they will be guided to use Adobe RGB. This in my opinion is a more suitable space with which to edit RGB color.

The prepress settings make it easier for users to select an appropriate combination of color setting configurations with a single mouse-click. Also, the default color management policy will allow you to open up documents which if they do not match your current work space, you can still continue to edit in that source space and save them with the original profile accurately intact. A newcomer does not necessarily have to fully understand how Photoshop color management works in order to successfully start working in an ICC color managed workflow. They can open up legacy files tagged in sRGB (or any other space), edit and save them as such, even though the work space is Adobe RGB. And if they choose to convert the colors on opening, the file will be converted and saved with the new profile. This really makes the system far more foolproof – it is adaptable enough to suit the individual user's Photoshop skill level. Whichever option you select – convert or don't convert – the saved file will be always be correctly tagged. Hiding the advanced color options is also a good move. The simplified Color Settings dialog gives you everything you need to get started with and hides all the controls which could trap the unwary. The advanced settings can only be reached by clicking on the Advanced mode checkbox.

Experienced Photoshop 5.0 users will probably have to spend a little time adjusting to what the new color management policies mean as these now replace the previous Profile Setup settings. Basically you will probably find yourself opening existing, tagged Photoshop 5.0 files with no problems or unexpected warnings other than a reminder that the file is in a color space other than your default work space and 'would you like to carry on editing in that space or convert now?'

The ability to save and load custom settings is an excellent feature. Savvy users were able to record custom color settings actions in Photoshop 5.0, but now you can clearly configure Photoshop to suit any workflow you require and save and name this setting for future projects which require you to use the same press settings. If you look again at the default color settings, you will notice how the list includes useful

options such as 'Web Graphics defaults' (the default setting on installation) and 'Emulate Photoshop 4'. The new interface is a logical progression from the first Photoshop 5.0 implementation of ICC color management and in my opinion, all users will find this to be a definite improvement.

Managing the Color Settings

As your confidence increases you will be able to customize and create your own color settings. You might want to start by loading one of the presets present in the Color Settings menu and modify this for a given job and customize the CMYK settings to match the conditions of your repro output. You will note that with the prepress settings, Adobe RGB is pre-chosen as the default prepress work space and that the CMYK setups are fairly similar to the previous CMYK setup defaults, except now there are two CMYK separation options available in the CMYK work space options for Euro and US printing: one for coated and another for uncoated print stock.

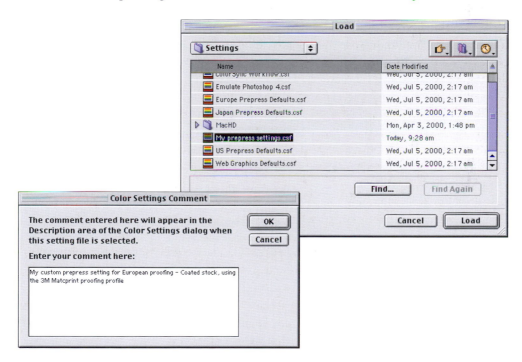

Figure 4.18 Custom color settings can be loaded or saved via the Color Settings dialog. The relevant folder will be located in the System/Application Support/Adobe/Color/Settings folder (Mac), Program files/Common files/Adobe/Color/Settings folder (PC). When you save a custom setting it must be saved to this location and will automatically be appended with the '.csf' suffix. When you save a color setting you have the opportunity to include a brief text description in the accompanying dialog. Color Settings files can be shared between some Adobe applications and with other Photoshop users.

The default prepress setups in Photoshop 6.0 are a pretty good starting point. The minimum you need to know is which of these listed color settings will be appropriate for the work you are doing. And to help in this decision, read the text descriptions which appear in the Description box at the bottom of the Color Settings dialog.

To save a color setting, configure the settings to suit your intended workflow and click on the Save... button. Locate the System/Application support/Adobe/Color Settings folder (Mac), Program files/Common files/Adobe/Color/Settings folder (PC) and name the setting. The file will be appended with a .csf suffix. Enter any relevant comments or notes about the setting you are saving in the text box which appears. This information will appear in the Color Settings dialog text box. You might name the setting something like 'Internal annual report' and the note will say 'Use this setting for editing and separating the digital photographs to go in the company's annual report'. The saved setting will now be listed in the main Settings menu.

Figure 4.19 Convert to Profile is similar to the old Profile to Profile command in Photoshop 5.0. Photoshop 6.0 color management is different in that you don't need to carry out a profile conversion in order to correctly preview a file in Photoshop. It is nevertheless an essential command for when you wish to convert color data from one profile color space to another profiled space, such as when you want to convert a file to the profiled color space of a specific output device.

Profile conversions

One problem with having multiple color spaces open at once concerns copying and pasting color data from one file to another. The Profile Mismatch: Ask When Pasting box in the Color Settings should ideally be checked. When you attempt to paste color data from one document to another (or drag with the move tool) and a profile mismatch occurs, the dialog shown in Figure 4.19 will appear, asking you if you wish to convert the color data to match the color appearance when it is pasted into the new destination document. If you select Convert, the appearance of the colors will be maintained when pasting between the two documents.

If you decide to use the Preserve Embedded Profiles policy and with the Profile Mismatch warning set to Ask When Opening, you will always be given the option of choosing whether to convert to the current work color space or continue editing in the document's own color space. If you choose to continue editing in the document's color space, this is fine if you wish to maintain that document in its original color space. As I mentioned earlier, there are very good reasons for always keeping CMYK files in their original color space (because if the file has been targeted for a specific press output, you don't want to go changing this), but with RGB files, you will often wish to convert everything to your default RGB work space. The Convert to RGB option will do this automatically. In the Image > Mode menu there used to be an item called Profile to Profile. That has now been replaced with the Convert to Profile command. Even when you choose to preserve the embedded profile on opening, you may still want to have the means to convert non-work space files to your current work space. I quite like the Preserve Embedded Profile option, because it allows me the freedom to open up any document straight away, regardless of the space it is in, without converting. If I want to carry on editing but eventually save the file in the current work space, I can do so at the end, using the Convert to Profile command.

Let's suppose I was to open a photograph which had been captured digitally and it was tagged with the profile of the camera's color space. I can open this digital photograph immediately without a conversion, do all the RGB editing in this space and yet still be able to preview the colors on the screen as they are meant to appear. If I carry out a Convert to Profile command, I can instruct Photoshop to convert the image from the tagged camera RGB space to the current work space, or indeed, to any other color space. Convert to Profile is also useful when you wish to output to a printer for which you have a custom-built profile but the print driver does not recognize ICC profiles. You can have such a custom profile built for the printer by a color management service provider and choose this profile as the space you wish to convert to. The profile conversion will convert the color data to match the space of the output device, but at the same time Photoshop's color management system will convert the colors on-the-fly to produce a color managed screen preview. You will probably see only a slight change in the on-screen color appearance. Photoshop also attaches a warning asterisk (*) after the color mode in the title bar to *any* document which is not in the current work space. A Convert to Profile is just like any other image mode change in Photoshop, such as converting from RGB to Grayscale mode and it is now much safer to use than the old Profile to Profile command ever was. However, if you use Convert to Profile to produce targeted RGB outputs and overwrite the original RGB master, be warned. Photoshop 6.0 will have no problem reading the embedded profiles and displaying the file correctly and Photoshop 5.x will recognize any profile mismatch (and know how to convert back to the original work space), but 'custom' RGB files such as this may easily confuse other non-ICC savvy Photoshop users (see: Figures 4.21 and 4.22 on page 75).

If you know the profile of an opened file to be wrong, then you can use the Image > Mode > Assign Profile command to rectify the situation. Let's suppose you have opened an untagged RGB file and for some reason decided not to color manage the file when opening. The colors don't look right and you have reason to believe that the file had originated from the Apple RGB color space. Yet, it is being edited in your current Adobe RGB work space as if it were an Adobe RGB color space file. The Assign Profile command can assign correct meaning to what the colors in that file should really be. By attaching a profile, we can tell Photoshop that this is not an Adobe RGB file and that these colors should be considered as being in the Apple RGB color space. You can also use Assign Profile to remove a profile.

Converting to the work space

If you choose either the Preserve Embedded Profiles or the Convert to Work Space policies, you should have the Ask When Opening boxes checked, to provide a warning whenever there is a profile mismatch or a missing profile. When the Missing Profile dialog appears on screen while you are opening a file, you can assign the correct profile and continue opening. Click on the pop-up menu and select the correct profile. Then check the box immediately below if you also want to convert the colors to your current work space. These settings will be remembered the next time a mismatch occurs and individual settings will be remembered for each color mode.

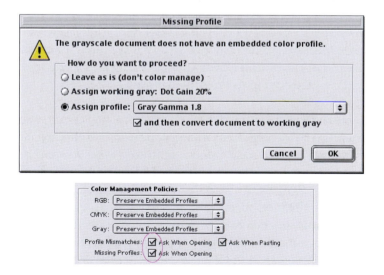

Figure 4.20 If the Preserve Embedded Profiles or Convert to Work Space option is checked in the Color Settings, Photoshop will allow you to assign a profile for the file being opened and follow this with a conversion to the current work space.

Handling Grayscale

The Grayscale setup has disappeared and this might seem odd at first until you realize that the new color settings provide all the necessary grayscale management for every situation. If you intend creating grayscale images to be seen on the Internet or in multimedia presentations, choose the Default Web Graphics color setting. The Grayscale work space will be a 2.2 gamma space, which is the same gamma used by the majority of PC computer screens. The truth is, you can never be 100% sure how anybody who views your work will have their monitor calibrated, but you can at least assume that the majority of Internet users will have a PC monitor set to a 2.2 gamma. This is a darker setting than the default 1.8 gamma used on the Macintosh system.

It is important to note that the grayscale work space settings are now independent of the settings entered in the CMYK setup. The Photoshop 6.0 prepress grayscale work spaces should correspond with the dot gain characteristics of the press. You will notice how the Grayscale work space options contains a list of dot gain percentages. Select the dot gain percentage which most closely matches the anticipated dot gain of the press. Figure 4.34 shows a range of dot gain values for different press settings. This is a rough guide as to which dot gain setting you should use on any given job. When the Advanced color settings option is checked you can enter a custom gamma value or dot gain curve setting (see 'Dot gain' later on in this chapter, page 86). The color management policy can be set to either Preserve Embedded Profiles or Convert to Grayscale work space and the Ask When Opening box should be checked. If the profile of the incoming grayscale file does not match the current grayscale work space, you will be asked whether you wish to use the tagged grayscale space profile, or convert to the current grayscale work space. If there is no profile embedded, you will be asked to either: 'Leave as is' (don't color manage), assign the current grayscale work space or choose a grayscale space to assign to the file and if you wish, convert from this to the grayscale work space.

Here is a test you can easily try yourself. Make a screen capture of something which is in grayscale, like a plain dialog box. When Photoshop 6.0 opens this screen grab, it will recognize it as being a grayscale file without a profile. In the absence of a profile and the color management policy is set as described above, which options should you use? Do you want to assign the current grayscale work space? No, because you would be assigning a prepress profile which takes into account dot gain. This is a raw screen grab without any dot gain compensation. You therefore want to assign a grayscale profile which matches the space it originated in – the monitor space. And if the monitor space has a gamma of 1.8, then choose that as the profile to assign to this grayscale screen grab. After opening, compare the color managed grayscale with the original dialog to see if the two both look the same. Do you want to know how any prepress grayscale image will look like on the Web as a grayscale? Select the View > Proof Setup and choose Windows RGB or Macintosh RGB.

Handling legacy files

When you adopt an RGB space as the preferred work space for all your editing, you have to take into account that this just might cause confusion when exchanging RGB files between your machine running Photoshop 6.0 and that of someone who is using Photoshop 4.0, where the RGB they use is based on a monitor RGB space. Figure 4.25 shows actual screen shot examples of how a profiled RGB file will be displayed on the monitor if this change in working procedure is not properly thought through. If you are sending an RGB file for someone else to view in Photoshop, then one of six things could happen.

- They open the file in Photoshop 6.0 with the RGB Color Settings set to Preserve Embedded Profiles. The file can be opened without a hitch and color managed correctly even if their RGB work space is not the same as yours.

- They open the file in Photoshop 6.0 with the RGB Color Settings set to Convert to RGB. If a mismatch occurs, the colors can be correctly converted to their RGB work space.

- They open the file in Photoshop 5.0/5.5 with the RGB Color Mismatch Settings set to the default of Convert Colors on Opening.

- They open the file in Photoshop 5.0/5.5 with the RGB Color Mismatch Settings changed to Ask on Opening and they click Convert Colors.

- Before sending, you convert RGB image to Lab mode in Photoshop 6.0. This does not lose you any image data and is a common color mode to both programs. The end user will need to convert back to their RGB.

- You convert the RGB image in Photoshop 6.0 from the RGB work space to match the RGB profile of the other user before saving. Go Image > Mode > Convert to Profile... and select the appropriate destination RGB space from the pop-up list. This could be something like Apple RGB. This is the profile which will be embedded when you save.

The last two examples take into account the limitations of Photoshop 4.0 (and earlier versions of Photoshop) not being able to understand and read a Photoshop 6.0 RGB file as being anything other than the monitor RGB color space. When you save a profiled RGB file, enclose a Read Me file on the disk which reminds the person who receives the image that they should not ignore the profile – it is there for a reason! If you are designing images for screen display – web design, for example – then convert your images to the sRGB profile using Image > Mode Convert to Profile. The

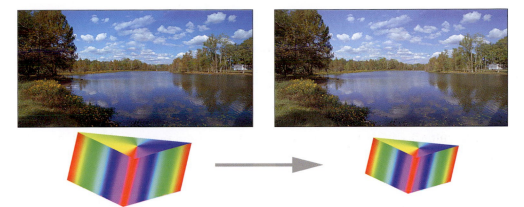

Figure 4.21 A Photoshop 6.0 image (left) opened in Photoshop 4.0 (right). If the RGB work space selected in Photoshop 6.0 is wider than the basic monitor RGB space in Photoshop 4.0, then the latter will interpret a Photoshop 6.0 file as being like any other 4.0 legacy file. The RGB colors will appear compressed and desaturated in version 4.0. The only way round this is to convert the version 6.0 RGB in Image > Mode > Convert to Profile to the monitor RGB color space used in Photoshop 4.0.

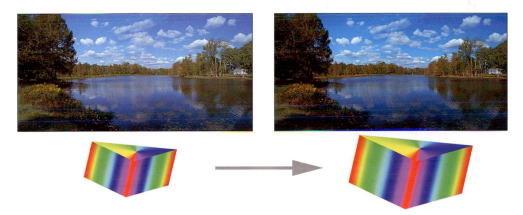

Figure 4.22 An untagged Photoshop 4.0 image opened in Photoshop 6.0 with color management switched off. If the RGB work space selected in Photoshop 6.0 is going to be wider than the monitor RGB work space used in Photoshop 4.0, then Photoshop 6.0 will expand the RGB color space as shown here, *unless* you have the Color management switched on and the Policy settings set to Preserve Embedded Profiles or Convert to Working RGB and the Profile Mismatch Ask When Opening box is checked.

reverse situation – opening a legacy file in Photoshop 6.0 – has potential pitfalls too, but these will only happen if you turn all the color management settings to 'Off', without appreciating how doing so will impact on the way the color data is going to be displayed within Photoshop 6.0. There are specific instances where you will find it necessary to switch color management off, but you must know what you are doing. The safe way to turn color management off is to select Emulate Photoshop 4 from the Color Settings menu.

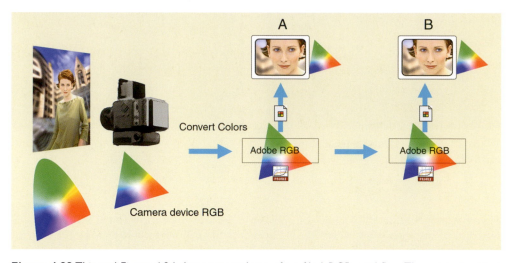

Figure 4.23 This and Figure 4.24 show a typical use of profiled, RGB workflow. The original subject is shot using daylight. The digital camera used to capture this scene has its own color characteristics and the gamut of the captured image is constrained by what colors the camera is able to capture in RGB. Photoshop 6.0 is able to read the embedded ICC camera profile tag and converts the colors to the Adobe RGB work space. This RGB file can now be shared directly with other Photoshop 5.0+ users editing in Adobe RGB color.

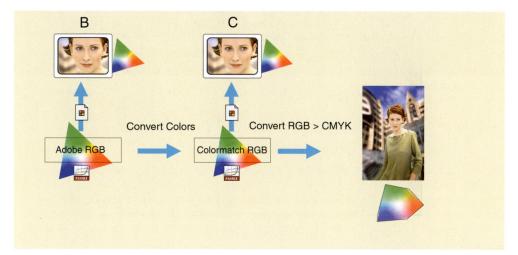

Figure 4.24 The Adobe RGB work space is a virtual space – you cannot actually see it. The monitor profile is generated by the Adobe Gamma control panel. This profile converts the Adobe RGB data 'on-the-fly' to render the monitor screen image. The monitor RGB space is smaller than the Adobe RGB space. Using the monitor alone as your guide, you may not be able to see all the colors that end up in print. Nonetheless, they are preserved in the Adobe RGB edit space. Another Photoshop 5.0+ user may be using a different RGB space, like ColorMatch RGB. No matter, Photoshop converts with high precision from one space to another. When the RGB to CMYK conversion occurs, it is made from an RGB file which has been carefully color managed throughout. In this example, CMYK gamut clipping is avoided, because the limiting monitor RGB space has been taken out of the equation.

Advanced color settings

The advanced settings will remain hidden unless you check the Advanced Mode box, then you will be able to see the expanded Color Settings dialog shown in Figure 4.25. The advanced settings unleash full control over the Photoshop color management system. I recommend that you do not adjust these settings until you have fully understood the intricacies of customizing the RGB, CMYK, Gray and Spot color spaces. Read through the remaining section of this chapter first before you attempt to customize any of these settings.

Figure 4.25 The Photoshop 6.0 Advanced Color Settings dialog. Switching to the advanced mode unleashes full control over all the Photoshop settings. The remaining sections of this chapter will show how you can customize the advanced color management settings.

Blend RGB colors using gamma

This item provides you with the potential to the override the default color blending behavior. There used to be an option in Photoshop 2.5 for applying blend color gamma compensation. This allowed you to blend colors with a gamma of 1.0, which some experts argued was a purer way of doing things, because at any higher gamma value than this you would see edge darkening occur between contrasting colors. Some users found the phenomenon of these edge artifacts to be a desirable trapping effect. In fact when blending colors at a gamma of 1.0, people complained of noticing light halos appearing around objects. Gamma compensated blending was removed at the time of the version 2.5.1 update. But if you understand the implications of adjusting this particular gamma setting, you can switch it back on if you wish. Figure 4.26 illustrates the difference between blending colors at a gamma of 2.2 and 1.0.

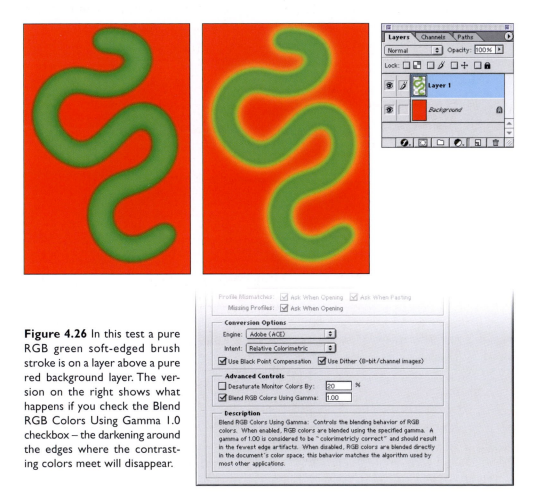

Figure 4.26 In this test a pure RGB green soft-edged brush stroke is on a layer above a pure red background layer. The version on the right shows what happens if you check the Blend RGB Colors Using Gamma 1.0 checkbox – the darkening around the edges where the contrasting colors meet will disappear.

Desaturate monitor colors

The desaturate monitor colors provides a means of visualizing a gamut space which is larger than the monitor RGB. Turning down the monitor colors saturation enables you to make a comparative evaluation between different color spaces. Color spaces such as Adobe RGB and Wide Gamut RGB have a larger gamut than the monitor space can show. If you want to try and visualize the comparative difference between color spaces, reducing the monitor colors saturation will enable you to see this.

Customizing the RGB and work space gamma

Expert users may wish to use an alternative work space in place of Adobe RGB. If you know what you are doing and wish to create a customized RGB color space, you can go to the Custom... option in the pop-up menu and enter the relevant information for the White Point, gamma and color primaries coordinates. My advice is to leave these expert settings well alone and do avoid falling into the trap of thinking that the RGB work space gamma should be the same as the monitor gamma setting. The RGB work space is not a monitor space.

Figure 4.27 The Custom RGB dialog. Use this option to create a custom RGB work space. The above settings have been named: 'Bruce RGB', after Bruce Fraser who devised this color space as an ideal prepress space for Photoshop 5.0.

Adobe RGB is a good choice as an RGB work space because its 2.2 gamma provides a more balanced, even distribution of tones between the shadows and highlights and this is an important consideration for a 'virtual' RGB editing space. Remember, you do not actually 'see' Adobe RGB. The Adobe RGB gamma has no impact on how the colors are displayed on the screen, so long as Photoshop ICC color management is switched on. In any case, these advanced custom color space settings are safely tucked away in Photoshop 6.0 and you are less likely to be confused by this apparent discrepancy between monitor gamma and RGB work space gamma.

RGB to CMYK

The RGB color space is very versatile. An RGB master can be repurposed for any number of uses. As we are mostly concerned with four-color print reproduction, it is always very important to keep in mind the limitations of CMYK reproduction when editing in RGB. Digital scans and captures all originate in RGB but they are nearly always reproduced in CMYK. A conversion from RGB to CMYK has to take place at some stage. The question is, at what stage should that conversion take place and who should be responsible for the conversion? And if you intend carrying out the conversion in Photoshop, how exactly should you configure the CMYK setup?

There are some people who will tell you that in their expert opinion, Photoshop does a poor job of separating to CMYK. And I bet if you ask these guys how they know this to be the case, they will be stumped to provide you with a coherent answer. The fact is that Photoshop *will* make lousy CMYK separations if the Photoshop operator who is carrying out the conversion has a limited knowledge of how to configure the Photoshop CMYK settings. As was demonstrated in the earlier sections, a wider gamut RGB space such as Adobe RGB is better able to encompass the gamut of CMYK and yield CMYK separations which do not suffer from gamut clipping. That is one big strike in favor of the Photoshop 5.0+ color system. But CMYK is not a one-size-fits-all color space. CMYK needs to be tailor-made for each and every job.

Don't let anyone try to convince you otherwise. Professional quality CMYK separations *can* be achieved in Photoshop, you *can* avoid gamut clipping and you *can* customize a separation to meet the demands of any type of press output.

CMYK setup

The CMYK separation setup settings must be established first before you carry out a conversion. Altering the CMYK setup settings will have no effect on an already-converted CMYK file. Note that in Photoshop 6.0, altering the CMYK setup does not now affect the on-screen appearance of an already-opened CMYK file or cause the wrong profile information to be embedded when you save it. However, the profile setting selected here will be the CMYK space which all future CMYK conversions will convert to and will also be the default space used to soft proof RGB files when you chose View > Proof Setup > Working CMYK.

Under the US Prepress default setting, the CMYK space says U.S. Web Coated (SWOP). This setting is by no means a precise setting for every US prepress SWOP coated print job, but is at least closer to the type of specification a printer in the US might require for printing on coated paper with a web press setup. If you mouse down on the CMYK setup pop-up list, you will see there are also US options for web uncoated, as well as sheetfed press setups. Under the European prepress default setting, there is a choice between coated and uncoated paper stocks. And more importantly, you can choose Custom CMYK... where you can create and save your custom CMYK profile settings to the System/ColorSync profiles folder (Mac), WinNT/System32/Color folder (NT/2000), Windows/System/Color folder (PC). The Custom CMYK dialog is shown is Figure 4.31.

Advanced CMYK settings

That's really all you can do with the standard CMYK settings – you can make a choice from a handful of generic CMYK profile settings. This is at least some improvement upon the preexisting single CMYK setup found in earlier versions of Photoshop. If you check the Advanced options box, you will readily be able to select from a more comprehensive list of CMYK profile settings in the extended menu.

Conversion options

You have a choice of four Color Management Modules (CMM): the Adobe Color Engine (ACE), Apple ColorSync, Apple CMM or Heidelberg CMM. The Adobe color engine is reckoned to be superior for all RGB to CMYK conversions. For example, the Adobe engine uses 20-bit per channel bit-depth calculations to calculate its color space conversions.

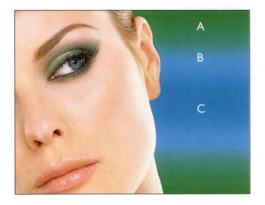

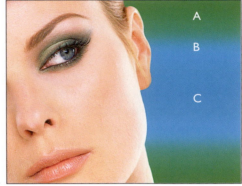

Figure 4.28 This example illustrates an RGB image which was acquired and edited in RGB using the Adobe RGB space. A CMYK conversion was carried out using an ICC profile conversion from Adobe RGB and the Perceptual (Images) rendering intent.

Figure 4.29 The image was assembled with a gradient chosen to highlight the deficiencies of sRGB. The master RGB file was then converted to fit the sRGB color space. A CMYK conversion was made using the same CMYK setup as in Figure 4.11. sRGB is weaker at handling cyans and greens. There is also a slight boost in warmth to the skin tones.

CMYK Info	A	B	C
Cyan	97	75	95
Magenta	10	6	9
Yellow	96	8	5
BlacK	0	0	0

CMYK Info	A	B	C
Cyan	84	72	75
Magenta	18	7	10
Yellow	80	8	6
BlacK	1	0	0

Figure 4.30 Each RGB image will have its own signature color space. In this example, imagine a scene with some blue sky and bright green colors going out of gamut. The middle example shows you the effect of a Relative Colorimetric conversion, which without some manual intervention, may clip the out-of-gamut colors. A perceptual rendering will squeeze the out-of-gamut colors to fit the CMYK space, while preserving the relationship between the out-of-gamut colors. This rendering intent may produce a less vibrant separation.

Rendering intent

Relative Colorimetric is identical to the manual built-in CMYK conversion method found in Photoshop 4.0 and earlier versions, and is the default rendering intent utilized in Photoshop 6.0. Relative Colorimetric rendering maps the colors which are out of gamut in the target color space to the nearest 'in-gamut' equivalent. When doing an RGB to CMYK conversion, an out-of-gamut blue will be rendered the same CMYK value as a 'just-in-gamut' blue. Out-of-gamut RGB colors are therefore clipped. This can be a problem when attempting to convert the more extreme range of out-of-gamut RGB colors to CMYK color and it is advisable that you consider using the soft proofing view of the space you are converting to, in order to check for possible gamut clipping. While in RGB mode, an image can be manually color adjusted to improve the quality of the final RGB to CMYK conversion.

Perceptual (Images) rendering is an all-round rendering method to use for photographic images. Perceptual rendering compresses the out-of-gamut colors into the gamut of the target space when colors are out of gamut, while preserving the visual relationship between those colors, so they are not clipped. More compression occurs with the out-of-gamut colors, smoothly ramping to no compression for the in-gamut colors. Figure 4.30 illustrates how these two different rendering methods work.

The Saturation (Graphics) rendering intent preserves the saturation of out-of-gamut colors at the expense of hue and lightness. Saturation rendering will preserve the saturation of colors making them appear as vivid as possible after the conversion. This is a rendering intent best suited to the conversion of business graphic presentations where retaining bright, bold colors is of prime importance.

Absolute Colorimetric maps in-gamut colors exactly from one space to another with no adjustment made to the white and black points. This rendering intent can be used when you convert specific 'signature colors' and need to keep the exact hue saturation and brightness, like the colors in a commercial logo design. This rendering intent is seemingly more relevant to the working needs of designers than photographers. However, you can use the Absolute Colorimetric rendering intent as a means of simulating a target CMYK output on a proofing device. Let's say you make a conversion from RGB to CMYK using either the Relative Colorimetric or Perceptual CMM and the target CMYK output is a newspaper color supplement printed on uncoated paper. If you use the Absolute Colorimetric rendering intent to convert these 'targeted' CMYK colors to the color space of the proofing device, the proofer will reproduce a simulation of what the printed output on that stock will look like. The Adobe PressReady™ program will help you achieve this type of targeted proofing with a select number of desktop inkjet printers. For more about targeted proofing and Adobe PressReady™, see the following chapter.

Black Point Compensation

This will map the darkest neutral color of the source RGB color space to the darkest neutrals of the destination color space. When converting RGB to CMYK, it is recommended you always leave this item checked when using Photoshop 6.0. If you happen to be using Photoshop 5.x, it can pay to experiment with BPC on and BPC off when you test a new profile – some RGB to RGB profile conversions may be adversely affected and you can end up with weak, muddy blacks. These Black Point Compensation issues have been corrected in version 6.0.

Use Dither (8-bit per channel images)

Banding may occasionally occur when you separate to CMYK, particularly where there is gentle tonal gradation in bright saturated areas. Banding which appears on screen does not necessarily always show in print and much will depend on the coarseness of the screen used in the printing process. However, the dither option will help reduce the risks of banding when converting between color spaces.

Creating a custom CMYK setting

If you wish to make precision separations, you can generate your own custom CMYK profile in the Color Settings in either the standard or advanced mode. Choose Custom CMYK... from the CMYK Work Space menu. Figure 4.31 shows the Custom CMYK dialog. This is better known as the familiar 'Classic' Photoshop CMYK setup. You can enter here all the relevant CMYK separation information for your specific print job. Ideally you will want to save each purpose-built CMYK configuration as a separate color setting for future use and label it with a description of the print job it was built for.

Once the CMYK setup has been configured, the View > Proof Setup > Working CMYK and the View > Gamut Warning (for the CMYK space selected in the Proof setup) will enable you to pre-adjust an image to ensure the out-of-gamut colors are manually brought into gamut while still in RGB mode and before making a conversion. If this CMYK preview suggests that the CMYK conversion is not going to give you the best color rendering of some of the image colors, you have the opportunity to override this. For example, while the master image is in RGB mode, you can choose Working CMYK in the Proof setup (or any other CMYK color space in the list) and make an image color adjustment to bring these out-of-gamut RGB colors into CMYK gamut. See Chapter Nine for more detailed advice on how to do this. See also Chapter Five for more information on the Photoshop 6.0 soft proofing options.

Figure 4.31 Select the Custom CMYK... option at the top of the pop-up menu list. This opens the dialog box shown opposite, where you can enter the specific CMYK setup information to build a custom targeted CMYK setting. When the advanced mode box is checked, you can choose from a wider range of pre-loaded CMYK profile settings. The various CMYK setup options are discussed in this chapter.

Ink Colors

Where it says Ink Colors, you should choose the setting recommended by your press for the paper stock to be used. For example, European Photoshop users can choose from Eurostandard (coated), (uncoated), or (newsprint). These generic ink sets will do fine for most print jobs. If your printer can supply you with a custom ink color setting, then select Custom... from the Ink Colors menu, this will open the dialog shown in Figure 4.32.

Figure 4.32 The Custom Ink Colors dialog. For special print jobs such as where non-standard ink sets are used or the printing is being done on colored paper, you can enter the measured readings of the color patches (listed here) taken from a printed sample on the actual stock that is to be used.

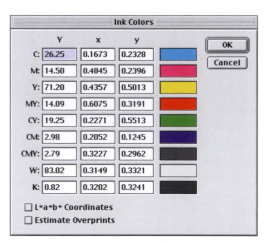

Dot gain

Dot gain refers to the spread of ink on the paper after it is applied and is very much dependent on the type of press and the paper stock being used. The dot gain value entered in the CMYK setup will affect the lightness of the color films generated from the CMYK file which will be used to make the final plates. The higher the dot gain, the lighter the film needs to be, this is because less ink needs to be laid down to produce the correct sized halftone dot. So therefore a high dot gain value, such as that used for newsprint, will cause the CMYK conversion to produce light-looking films. A lower dot gain value such as that used for a coated paper stock will mean that the films will look darker.

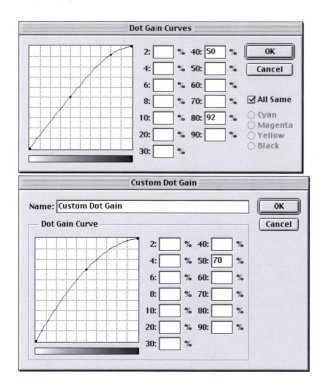

Figure 4.33 If you select Dot Gain: Curves... from the CMYK setup shown in Figure 4.30, you will open the Custom Dot Gain dialog shown opposite. If your printer is able to provide dot gain values at certain percentages, then you can enter these here. Dot gain may vary on each ink plate. If you deselect the All Same box, you can enter the dot gain for each individual plate.

Note that when you select Custom Dot Gain... from the Grayscale work space menu, a similar dialog appears. If you are preparing to save a color setting designed for separating prepress CMYK and grayscale files, you will want to check that the black plate dot gain setting is consistent. Note that dot gain can vary for each plate and that the black plate dot gain may be slightly different.

The dot gain value will not affect the way the image appears proofed on the screen. This is because Photoshop's color management system will always use the information entered in the CMYK setup to calculate the screen appearance and to provide you with an accurate soft proof of the expected output. But as was pointed out, if you were to compare the outputted films from the previous two examples, the films would actually have very different densities. Dot Gain Curves enable you to input more precise information about the dot gain (choose Curves from the pop-up menu next to Dot Gain). If you select the Dot Gain Curves option, you can enter custom settings for the composite or individual color plates. In the preparation of this book I was provided with precise dot gain information for the 40% and 80% ink values (see Figure 4.33).

Separation options

This controls what type of separation will be used and the total ink limits permitted. The default Photoshop setting is GCR, Black Generation: Medium, Black Ink Limit 100%, Total Ink Limit 300%, UCA Amount 0%. To know what should be entered here, check with the printer. Unfortunately it is not always that simple. In my experience, I am nearly always told to use the default Photoshop settings. So if you get quoted the above configuration by the printer, then you know they are just reading back to you the default Photoshop settings and they have not customized the CMYK setup in any way. That being the case, politely thank them for their time and use the Adobe CMYK setting which most closely matches the output (US Sheetfed/Web Coated/Uncoated) or refer to the table in Figure 4.34. The settings shown here are for guidance only.

UCR (Undercolor Removal) is said to be the preferred separation method in use today and a lot of commercial printers will use this separation method on their systems. UCR replaces the cyan, magenta and yellow ink in just the neutral areas with black ink. The UCR setting is also favored as a means of keeping the total ink percentage down on high-speed presses, although it is not necessarily suited for every job.

Low key subjects and high quality print jobs are more suited to the use of GCR (Gray Component Replacement) with a small amount of UCA (Undercolor Addition). GCR separations remove more of the cyan, magenta and yellow ink where all three inks are used to produce a color, replacing the overlapping color with black ink. The use of undercolor addition will add a small amount of color back into the shadows and is useful where the shadow detail would otherwise look too flat and lifeless. The percentage of black ink used is determined by the black generation setting (see next heading). In the case of Photoshop conversions, you are better off sticking with the default GCR, a light to medium black generation with 0–10% UCA. This produces a longer black curve and better image contrast.

Black Generation

This determines how much black ink will be used to produce the black and gray tonal information. A light or medium black generation setting is going to be best for most photographic images. I would advise leaving it set on Medium and only change the black generation if you know what you are doing. As a matter of interest, I always use a maximum black generation setting when I separate all the dialog boxes which appear printed in this book. When I separated the screen grab shown in Figure 4.32, a Maximum black generation separation was applied, so the black plate only was used to render the neutral gray colors. Consequently any color shift at the printing stage will have no impact whatsoever on the neutrality of the gray content.

Opening CMYK and Lab files

Files created in Photoshop 5.x or 6.0 and saved in Lab color or CMYK should be embedded with an ICC profile. In the case of Lab, it is a universally understood color space. In the absence of an ICC tag the file will open without interruption and saving in Lab mode is one (imperfect) way of surmounting RGB color space mismatch worries. The problem with using Lab as a master space is that it is so large and there can be a lot of gaps between one color and the next when you save in Lab mode using 8 bits per channel. CMYK files should not be converted back and forth to RGB. I always prefer to keep an RGB master and convert to CMYK using a custom conversion to suit each individual press requirement. Converting from one CMYK space to another is not normally recommended but in the absence of an RGB master, this will be the only option available. Photoshop 6.0 makes the process of CMYK to CMYK conversion easier to accomplish. Just specify the CMYK profile to convert to in the Convert to Profile dialog box. The Preserve Embedded Profiles policy means that incoming tagged CMYK files can always be opened without converting, thus preserving the numbers, while providing you with an accurate soft proofed screen preview.

Information palette

Given the deficiencies of the color display on a monitor, such as its limited dynamic range and inability to reproduce colors like pure yellow on the screen, color professionals will often rely on the numeric information to assess an image. Certainly when it comes to getting the correct output of neutral tones, it is possible to predict with

Separation settings	Ink colors	Separation method	Dot gain	Black generation	Black ink limit	Total ink limit	UCA
US printing							
Sheetfed (coated)	SWOP coated	GCR	10–15%	Light/Medium	95%	320–350%	0–10%
Sheetfed (uncoated)	SWOP uncoated	GCR	15–25%	Light/Medium	95%	260–300%	0–10%
Web press (coated)	SWOP coated	GCR	15–20%	Light/Medium	95%	300–320%	0–10%
Web press (uncoated)	SWOP uncoated	GCR	20–30%	Light/Medium	95%	260–300%	0–10%
Web press (newsprint)	SWOP newsprint	GCR	30–40%	Medium	85–95%	260–280%	0–10%
European printing							
Sheetfed (coated)	Euroscale coated	GCR	10–15%	Light/Medium	95%	320–350%	0–10%
Sheetfed (uncoated)	Euroscale uncoated	GCR	15–25%	Light/Medium	95%	260–300%	0–10%
Web press (coated)	Euroscale coated	GCR	15–20%	Light/Medium	95%	300–320%	0–10%
Web press (uncoated)	Euroscale uncoated	GCR	20–30%	Light/Medium	95%	260–300%	0–10%
Web press (newsprint)	Euroscale newsprint	GCR	30–40%	Medium	85–95%	260–280%	0–10%

Figure 4.34 These separation guidelines reflect a typical range of settings one might use for each type of press output. These are guidelines only and reflect the settings you will already find in Photoshop 6.0 for each of the above. For precise settings, always consult your printer.

greater accuracy the neutrality of a gray tone by measuring the color values with the eyedropper tool. If the RGB numbers are all even, it is unquestionably gray. Interpreting the CMYK ink values is not so straightforward. When printing a neutral gray, the color is not made up of an even amount of cyan, yellow and magenta. If you compare the color readout values between the RGB and CMYK Info palette readouts, there will always be more cyan ink used in the neutral tones, compared with the yellow and magenta inks. If the CMY values were even, you would see a color cast. This is due to the fact that the process cyan ink is less able to absorb its complementary color – red – compared to the way magenta and yellow absorb their complementary colors. This also explains why a CMY black will look reddish/brown, without the help of the black plate to add depth and neutrality.

Back to closed color loops

Not everyone you work with will be using ICC profiles in their color management system. You will find that there are bureaus who still prefer to run their own closed color loops and some are downright hostile to accommodating any other way of working. Anything that they scan for you and output themselves will reproduce reliably on their system with the same colors as the original providing you don't tamper with the color of the image data. So if you use such a bureau, they will supply you with a scan, you retouch it and pass it back for output, the colors are guaranteed to be faithful to the original, as if they had retouched it themselves. If the color loop they utilize does not match the way the color appears on your screen, the answer is to modify your display monitor profile to match their output. You don't want to mess up your carefully calibrated settings, so use the Adobe Gamma control panel to make a new custom monitor profile which matches the bureau color loop output. Load this monitor profile at the system level and alter the Color Settings to turn color management off whenever you are working with their supplied files. Any color changes you do happen to make will be relative to the original. In my opinion this is such a hideously clumsy way of working that I steer well clear of the bureaus who operate this way and who expect you to mess up your monitor to match their proprietary color loop.

Device dependent or independent?

Two choices, but both with the same outcome in mind – faithful four-color print reproduction. In a closed loop or traditional CMYK color management workflow, the advantages are that you are working within an established production process and you can specify precise CMYK values for the final print output. If you have the color expertise, Photoshop contains all the necessary tools for you to achieve precise color control. The downside though is that you are limited in the number of Photoshop filters you can use in CMYK mode, the file size is 25% larger and you are restricted as to how you can repurpose an individual CMYK file for other types of color output.

A CMYK workflow is therefore very much device dependent. Once the RGB data has been converted to a targeted CMYK space, your options are limited as to how you can repurpose that file. It is possible to do a CMYK to CMYK conversion, but you would mostly be far better off reseparating from an RGB master. This is the guiding principle of a device independent workflow. Photoshop 6.0 makes it possible for any other Photoshop 5.x or 6.0 users to share image files and maintain a fine degree of color control prior to deciding what to do with an image and how you are going to print it. This flexible workflow approach fits in better with the changes taking place in our industry today. It also takes account of the growing demand for

non-print media, where an RGB file is often the preferred choice. The problems associated with a device-independent, RGB workflow include the dependence on accurate device ICC profiling, the inability to set precise CMYK colors in the absence of any specific CMYK output information and the problems to do with how non-ICC savvy users are going to cope when they receive your files or the hassle of having to perform a color conversion should their program be unable to read ICC profiles and the other user is working in a different color space.

Even critics of ICC color management, who have reservations over its implementation in prepress work, have acknowledged that ICC color management is well suited to a photographer's RGB workflow. If you are interested in learning more about ICC and the Photoshop color management system, then I recommend you visit the Photoshop page on my web site. Go to: www.evening.demon.co.uk/photoshp.html, there you will find links to various papers on color management as well as other useful Photoshop links.

Chapter Five

File Output and Proofing

The preceding chapter considered the issues of color management and how to maintain color consistency between digital devices. Designers for multimedia and the Web are only concerned with getting the picture to look good on a 'typical' monitor. This section though will deal with the end process of converting digital files into a form of tangible print output and this can be broken down into several categories: proof prints, or composites which are intended to emulate the final printed output and are used for checking color and gaining client approval; high-end continuous tone, final art outputs such as Fuji Pictrographs, fine art Iris or transparency; and repro printing.

The standard of output available from digital continuous tone printers has improved enormously over recent years. Many people find they in fact prefer the print quality produced by these high-end bureau machines over conventional silver color prints. I see two reasons for this: the ability to finely control the color output yourself on the computer using Photoshop and the wider range of paper bases available, compared to the usual choice of plastic matt or plastic glossy. There are so many print methods and printer models to choose from, so it is therefore important to understand what are the strengths and weaknesses of each. To start with you need to consider your main print output requirements. Are you looking for speed or a high-quality final art finish? Do you require your print output to form the basis of a repro contract print? I know of no single printing device which is able to satisfy all of these requirements.

RGB output to transparency and print

Many photographers prefer to work in RGB throughout and supply an RGB output as the final art, the same way as one would normally supply a transparency or print. Writing to transparency film is quite a slow not to mention expensive process, but is one means of presenting work to a client where money is no object. High-end bureaux often work this way still. Such an output can either be scanned again or used as a reference for the printer to work from the digital file. A CMYK proof is regarded as a better reference in these situations, but nevertheless the transparency output is one with which some photographers may feel more at home.

Transparency writers use a scanning laser beam or LEDs to expose the light sensitive silver emulsion. The same technology is employed to make RGB photographic prints, particularly large blowups for exhibition display with print writers such as the Durst Lambda, CSI Light Jet 5000 and HK printers: Sphera PW30 and PW50. As with the transparency writers, these machines are intended to be installed in labs/bureaux, where they can replace the enlarger darkroom. After scanning in a negative or transparency, such printers are capable of outputting from any film format to any size of photographic print (up to 48 inches wide with the Lambda service). Tip: before sending a Photoshop for transparency output, check with the bureau for any specific compatibility problems. I know of at least one instance where the embedding of an ICC profile can trip up some film writers to not read the image data.

The Fujix Pictrography printers are capable of producing a true photographic print finish. A single pass exposure (as opposed to the three or four passes involved with dye-sublimation) is made with a thermal laser diode onto silver halide donor paper, followed by a thermal development transfer to the receiving print. This, Fuji claim, has all the permanence of a conventional color photograph. Admirers of the New York-based photographer Raymond Meier, may be interested to know that he uses his Pictrography machine to supply editorial clients with Pictrographs as finished artwork. Fashion photographers in particular like using Pictrograph outputs, maybe because of the current popularity of supplying C-type prints made from color negatives. I myself own a 3000 Pictrograph printer and can vouch for the benefits of superb color and speed of print output at under two minutes. The latest 4000 machine prints at two resolutions: 267 or 400 dpi in sizes ranging from A6 to A3. The results are very crisp and the smooth glossy surface will cause no problem when scanned from again and the only chemical solution required is purified water! My only gripe is that Fuji have yet to produce a driver interface sophisticated enough to recognize ICC color space profiles although canned profiles may soon become available for the Pictrograph printers (check the Fuji web sites for the latest information). US and European machines have different specifications, but if you can get a custom

ICC profile built for your machine you will see a dramatic improvement in the quality of color output produced. Use the Photoshop 6.0 Image > Mode > Convert to Profile command and convert from your current RGB space to that of the Fuji Pictrograph profile prior to printing.

CMYK output

If the fast print time, A3 output size and price tag sound appealing then the Pictrograph might be an affordable proposition for a small studio business. However, this is still essentially an RGB printer and it has the potential to reproduce colors beyond the restrictive gamut of CMYK. Pictrographs are beautiful as portfolio prints or final art proofs, but do not help when communicating with a printer who has the job of making CMYK separations from a supplied digital RGB file or matching an image supplied as a CMYK. What they want you to supply ideally is a proof printed using CMYK inks showing near enough how you see the colors being reproduced.

Fine art printing

Inkjet printers use CMYK liquid inks which are finely sprayed onto the paper surface at a typical resolution of 1440 dpi. The best of these has to be the Scitex Iris inkjet where the paper is mounted on a drum which revolves at high speed and the print head passes across the surface in a linear fashion (like a drum scanner in reverse). Iris prints made on the standard paper are ideal as repro proofs, but that's not all. There are no limitations to the type of paper which can be used. You can load up paper stock to match that used on the print job. I know of an advertising photographer who owns his own Iris printer and keeps a wide range of paper stocks, so he can proof to any surface required. The very best results are obtained on archival fine art paper – I was quite stunned by the beauty of the first prints I saw produced this way. Iris proofing on art paper has taken off in the US as a medium for exhibiting and selling art photography – whether manipulated or not. In the UK renowned photographer printers such as Max Ferguson have switched from the darkroom to an all-digital setup, supplying clients with Iris art prints. The standard Iris service is comparable in price to other forms of proofing. The inks used are sensitive to sunlight and not guaranteed to last more than a few years. UV protected inks are available for archival printing, but the colors are quite different to the normal inks. Switching from one ink to the other requires flushing out the system and calibrating the printer again. Bureaux will offer one type of service or the other: standard or fine art output, but not both unless running at least two machines.

Inkjet CMYK output

Inkjets are probably the most popular type of CMYK proofing device among photographers. In the print industry, Cromalins still have the edge – the aforementioned Iris system is a leading product in the bureau end of the market. The two principle manufacturers of desktop proofing inkjets are Epson and Hewlett Packard. These budget-priced printers are cheap to buy and the quality of print output is outstanding. Most of the lower-end models are able to produce a photo-realistic print on to an increasingly wide range of paper stocks.

The inkjet printers work by spraying very fine droplets of ink as the head travels back and forth across the receiving paper. For the most part, the different tonal densities are created by varying the number of individual, evenly sized droplets and dithering their distribution. Hence the illusion of a lighter tone is represented using sparsely scattered ink dots. The later Epson printers are able to produce variable sized droplets. The Epson Photo Stylus models use six color inks and these are capable of producing an even smoother continuous tone output. The six color inkjets use additional light cyan and light magenta inks to render the paler color tones (yellow is light enough already). The print output is still standard CMYK, but looks smoother because you have less obtrusive dot dithering in the highlight regions. The print times are also slower than the non-Photo Stylus models.

Inkjet media

If you regularly produce lots of prints, then you'll soon spend many times the cost of the printer buying in ink and paper supplies. The ColorSync color matching system will only work when the correct manufacturer's ink is used (and to some extent the media too). This does lock you into always buying their branded inks, but there is more flexibility in the choice of papers, many of which will match the specifications of Epson glossy paper and glossy film. It has to be said that the canned Epson profiles are good, but they are not that brilliant and do tend to produce slightly darker results than expected. It is possible to contact private vendors who will be able to produce a custom profile for your printer (see Chapter Four, Figure 4.9).

Thicker papers require extra head clearance – there should be a lever on your printer where the head height can be adjusted. You can print on to a variety of papers including fine art papers within certain thickness limitations. At this stage the automated color management using the standard Epson profile will fall down and you will probably have to manually adjust the colors, but the results can look very impressive and it is well worth experimenting to see what can be achieved.

Figure 5.1 The main Epson Print dialog window. Here you need to select the media type to be used. Some third-party glossy papers will work best with the Glossy Film media setting. Normally you will print from RGB and therefore choose the RGB Color setting and you need to check Printer Color Management.

Figure 5.2 Click on the More Settings button in the main dialog to see this dialog window. Select the ColorSync™ radio button and make sure the Profile is set to EPSON standard. The rendering intent should be Perceptual. The media type will already appear as selected. Choose the desired print resolution. Here I have selected SuperFine – 1440 dpi, selected Error diffusion dithering and Super MicroWeave printing. When you OK this option, you are returned to the main dialog (Figure 5.1). Click on the Save Settings button if you would like to save and name this setting for future use.

Figure 5.3 The Epson Page Setup dialog.

Poster inkjet plotters are also capable of printing up to A0 size. These outputs are suitable for all commercial purposes – printing either Photoshop files or vector-based artwork. The latest inks are more colorfast and can be guaranteed to last longer than was the case before. Even so, the prints produced are only intended for economical short-term sales display on a gloss or matt paper surface.

The ideal inkjet

Promises of photo-realistic quality have inevitably led some purchasers of desktop inkjets to make direct comparisons with normal photographic printing. Why can't we have true photographic quality prints that last for ever as well? Why not indeed. And while we are about it, wouldn't it be nice if one could buy beer which doubled as a slimming aid and hangover cure? In all seriousness, I think we have to be a little more realistic in our expectations and ignore some of the hype surrounding what constitutes photo-realistic output. I would prefer the description 'near photographic quality', because I genuinely believe the quality of output from an inkjet can be good enough for exhibition or use in a professional portfolio. With the basic Photo Stylus printers costing around $200–$300 to buy and the unit print costs, including ink and media, costing around $1 each per A4, that's still a pretty good deal!

If it is your intention to sell photographic prints, your customers will naturally enough expect the prints you sell to match the longevity of a traditional print. Inkjet printers are primarily proofing devices. They are designed to produce an accurate color proof quickly and cheaply. If you require archival quality results, there are now third-party

inks made by Lysonic which are compatible with certain Epson desktop inkjets. These inks are customized to resist fading when exposed to ambient daylight for a long time. The catch is that these are not especially designed as color matching inks, so the settings used will probably have to be different and you may not be able to reproduce the full color range of a normal inkjet output. Prompted by the success of third-party ink supplier Lysonic, Epson have now responded by bringing out a new range of printers, inks and papers to offer archival quality color. The other answer to this problem is quite simple: if your clients expect real photographs then use a Pictrograph printer. I know the hardware is more expensive to buy, but it is still a lot cheaper than equipping a mini-lab, which after all is the benchmark standard you are trying to emulate. Lysonic also manufacture grayscale ink cartridges for desktop inkjet printers. These will print overlaying inks of varying gray lightness in place of the usual CMYK inks. The end result is a rich-toned fine art print output with smooth blacks which can be output on a variety of paper surfaces.

Color proofing for press output

If you are looking for a fail-safe method of supplying digital files for repro, then you will want to obtain all the relevant information about the press. If the printer is cooperative, they will be able to supply you with a proofing standard ICC profile or printing inks and other specifications for the press. Enter these in the Edit > Color Settings > Working Space > CMYK > Custom CMYK dialog, as described in Chapter Four. Convert your RGB file to CMYK and save it as a TIFF or EPS file and supply this with a targeted CMYK print proof which shows the printer how the enclosed file should be expected to print within the gamut of the specific CMYK print process. You could also supply an RGB file tagged with an ICC profile, as well as the proof. This will work if it is understood beforehand and accepted that the recipient will be carrying out the conversion to CMYK and using the CMYK proof as a guide. If you send RGB files to printers, be careful to label RGB folders as such and make every effort to avoid any potential confusion down the line. Even a layered Photoshop format file is now placeable in an Adobe InDesign™ layout, flattening on-the-fly, with the ability to recall the layered original for editing.

The Epson print dialog box has an advanced section where you can instruct the printer to use ColorSync color management. You must also describe here which media type you are using to get the correctly balanced output. For the very best quality, choose the highest print resolution and the best dithering settings. In the example shown in Figure 5.2, I selected printing at 1440 dpi on photo quality glossy paper, using MicroWeave diffusion dithering. At the highest quality setting it will take longer to produce a print of course. Although these are CMYK printers, they work best when

fed RGB data. The Epson driver will process the RGB data and carry out its own conversion to the CMYK space of the printer. Good results are obtained when printing directly from Photoshop RGB files, especially if you are working in a larger prepress RGB space like Adobe RGB (1998). Inkjets are therefore good for portfolio work and short-term exhibitions. If a folio print fades, then all you have to do is make a replacement print. The inkjet technology is most ideal for producing excellent quality CMYK output destined to be used as either an 'aim' print or contract proof by the printer. The term 'aim' print most justly describes the appropriateness of a standard Epson inkjet output, when used as a guide for the printer who is determining how to reproduce your image using CMYK inks. The term contract proof is used to describe the same type of thing, except it refers to a more precise form of CMYK proof, one that has been reproduced by an approved proofing device. These include the Rainbow and Kodak dye-sub printers, the Epson 5000 inkjet (with RIP) and prepress bureau service proofs like the Dupont Cromalin™ and 3M Matchprint.

When you supply a CMYK proof you are aiming to show the printer how you envisage the picture should look in print. Because a proof has to be produced using CMYK inks or dyes, you are working within the same color gamut constraints as the halftone CMYK process and therefore the printer now has a realistic indication of what they should be able to achieve. The contract proofing devices benefit from having industry-wide recognition. It is safer to supply a digital file together with a proof which has such a seal of approval. The printer receiving it knows that the colors reproduced on the proof originated from a contract device and were printed from the attached file. His or her job is to match the proof, knowing that the colors in the proof are achievable on the press.

Photoshop print controls

There are three Print dialogs in Photoshop: Print Options (new to Photoshop 6.0); Page Setup; and Print. Print Options is the one we will look at first as the Print and Page Setup dialogs can both be accessed from here. These dialogs will vary depending on which printer device you have selected in the Mac Chooser (Figures 5.1–5.3 show the Epson Stylus Print and Page Setups). On a PC, choose File > Print and click on the Setup button to select the print driver. Use The Page Setup to establish the paper size, page orientation and the percentage scaling of the print output.

Print Options previews how the Photoshop document will print in relation to the page size. When the Center Image box is deselected, you can position the image anywhere you like, by dragging the preview with the cursor. Or, you can position and resize within the specified media chosen, using the boxes at the top. You cannot resize the actual number of pixels via the Print Options. Any changes you make to the dimensions or scaling will be constrained to the proportions of the image.

In the Output options below that, click on the Background... button to print with a background color other than paper white. For example, when sending the output to a film writer, choose black as the background color. Click on the Border button to set the width for a black border. On the right, you can select whether or not to print the following: Calibration Bars, which will print an 11-step grayscale wedge on the left and a smooth gray ramp on the right. In the case of CMYK separations, tint bars will be printed for each plate color. The registration marks will help a printer align the separate plates. The crop marks indicate where to trim the image (the Bleed button option lets you set how much to indent these crop marks). Checking the Caption box will print any text that was entered in the File > File Info box Caption field. Check Labels to print the file name.

Figure 5.4 The Print Preview command will open the above Print Options dialog. You can use this interface to accurately position the image on a page and alter the scale at which the Photoshop image will be printed. Under the Show More Options, you can add print information such as calibration bars, captions and crop marks. Or, you can select Color Management in order to configure the Source and Print spaces.

If a selection is active before you select Print Options and Print Selected Area is checked, the selected area only will be printed.

Soft Proofing

When you carry out a color mode conversion or a Convert to Profile command, the color data is converted to the destination/device color space. When the file is in this new space, Photoshop will continue to color manage the image. If you are converting an RGB master to the working CMYK space, Photoshop will simulate the CMYK print output appearance on the monitor after the file has been converted to CMYK. This is known as 'soft proofing'. A real proof is a hard copy print produced by a contract standard proof printer – soft proofing is therefore a term which is applied to using the monitor as a proofing device. The monitor will never be as accurate when it comes to showing how every CMYK color will reproduce, but it is usually close enough for carrying out all the preparation work, before reaching the stage where a final contract proof is demanded.

If you want to preview the outcome of a color mode conversion, you do not have to convert the color data. Instead, Photoshop is able to calculate a screen preview only, while keeping the color data in its original space. The new Photoshop 6.0 color management system therefore enables you to simulate any CMYK or RGB print output (i.e. Pictrograph or a film writer) without having to carry out a mode conversion first.

If you are editing an RGB master and go to the View > Proof Setup menu and select Working CMYK (which is the default setting), you can preview how the colors will look if you convert from RGB to the working CMYK color space. If you choose the Custom... option you can select any profile space you want from the pop-up list. Name and save the custom proof setting as a '.psf' file in the System\Application Support\Adobe\Color\Proofing folder (Mac), or the Program Files\Common Files\Adobe\Color\Proofing folder (PC). This saved proof setting will then be appended to the bottom of the list in Proof Setup. When a proof setting is selected in the Proof Setup, you can preview the colors in this space by choosing View > Proof Colors. Command/Ctrl-Y is the keyboard shortcut and this will toggle the preview on and off, making it very easy for you to switch from normal to proof viewing mode. The document window title bar will also display the name of the proofing space after the color mode: RGB/*Working CMYK*.

Each new window view can preview a different proofing setup. You can create several new window views of the same document and use the monitor screen to compare the results of outputting to various types of press output. The Proof Setup is not just limited to CMYK output. You can use the Proof Setup to preview how a prepress grayscale file will appear on a Macintosh or Windows RGB monitor.

Simulate Paper White and Ink Black

Checking these options will modify the final conversion of the preview made from the Proof Setup space to the monitor, so that you can more accurately soft proof how a file might actually reproduce after it has been converted to CMYK and printed. In more detail, when you select Proof Colors, Photoshop takes the current screen preview only, and converts it on-the-fly to the destination color space selected in the Proof Setup. The data is then converted back to the RGB monitor space to form a preview using the relative colorimetric rendering intent and with black point compensation switched on. In the custom Proof Setup dialog, Simulate: Black Ink will disable the black point compensation and simulate on screen the actual black density of the printing press. Simulate: Paper White will use an absolute colorimetric rendering to convert the proof color space data to the monitor space, simulating the paper white and black ink colors. Simulate: Paper White and Ink Black will take into account the limitations of the black ink reproduction and how bright the paper white will really be.

Adobe PressReady™

The Adobe PressReady™ program was released at the end of 1999. PressReady™ provides the means to get the color output from selected desktop inkjet printers to closely match the color output from a targeted press. For example, the program will work with the Epson Stylus 800, 1520 and 3000 and 5000 printers. Using PressReady™, you will be able to specify the exact type of CMYK output you wish the printer to reproduce. If your print specifications are for four-color printing on a newspaper stock, you can make the inkjet proof represent the expected output. This way, you can supply a proof to the printer which more accurately depicts how the image should realistically print. Figure 5.7 shows you the PressReady™ Color Management extra Print Options.

PostScript printing

When your computer is instructed to print a document, graphic or photograph, the data has to be converted into a digital language which the printer can understand. RGB image files can successfully be output on the Macintosh using Apple's proprietary Quickdraw – the same language that describes how documents appear on the monitor screen. To print out a page that combines text and images together, Quickdraw will only print the way the data appears on the screen. If you print from a page layout program, it reproduces the screen image only. The text will be nice and crisp and TIFF images will print fine, but placed EPS images will print using the pixelated preview. PostScript is a page description language developed by Adobe. When proof-

Figure 5.5 Adobe PressReady™
Page Setup dialog.

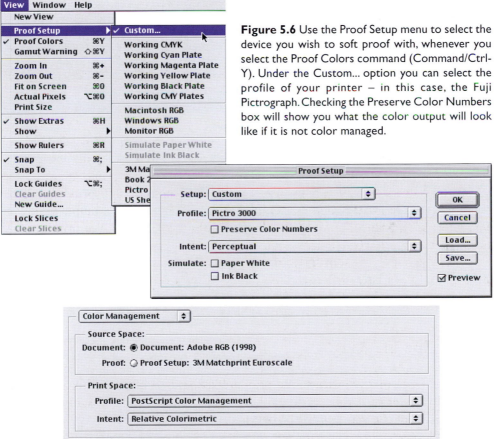

Figure 5.6 Use the Proof Setup menu to select the device you wish to soft proof with, whenever you select the Proof Colors command (Command/Ctrl-Y). Under the Custom... option you can select the profile of your printer – in this case, the Fuji Pictrograph. Checking the Preserve Color Numbers box will show you what the color output will look like if it is not color managed.

Figure 5.7 Under Print Options: Show More Options (see Figure 5.4) select Color Management. Select 'Document' to print direct from the document color space. Select 'Proof Setup' to print using Proof Setup as the source color space. This will enable you to simulate the proof setup space colors in the print output. Select Printer Color Management or PostScript Color Management to have the printer convert the source color to the printer's color space.

Figure 5.8 To set up Adobe PressReady™, go to the Control Panels and choose Adobe Print Color. Enter the RGB space your RGB files are always in (check the Color Settings: Working Spaces: RGB) and the target CMYK space you wish to simulate on your inkjet printer. PressReady™ will enable you to reproduce a CMYK proof output from your RGB master which matches any specified press setting.

Figure 5.9 Select the PressReady™ driver for your inkjet printer and choose File > Print (PC users will be taken to the PressReady™ Properties dialog). Above is the Mac version dialog where you can enter the print output settings. If the image to be printed is in RGB mode, the Source Space should be Document: *RGB space set in Adobe Print Color.*

ing a page layout, the image and text data in the layout are processed separately by a RIP (either on the same machine or a remote computer) and once the data has been fully read and processed it is sent as an integrated pixel map (raster) file to print in one smooth operation. This process is known as Raster Image Processing (RIP). For example, you'll notice many proofing printers come supplied with PostScript (level 2 or later). Normally a prepared CMYK image is embedded in the PostScript file of a page layout program and then converted in the RIP. The RIP takes the PostScript

information and creates the pixelmap line of dots for each separation to be output to film or plate. The Photoshop image data is likely to be in either TIFF or encapsulated PostScript (EPS) form in the file created by the page layout program and it is this which is passed along with the original vector images and fonts to be rasterized. Printing speed is dependent on the type of print driver software the printer uses and the amount of RAM memory installed in the server machine. Too little memory and either the document will take ages to process or won't print at all.

There are many desktop PostScript printers to choose from for less than $10 000 – which one you should go for depends on the type of color work you do. Laser printers are useful to graphic designers where the low cost of consumables such as paper and toners is a major consideration. A setup including a laser printer and dedicated RIP server is ideal for low cost proofing and short run color laser printing. I am thinking here of the Efi Fiery RIP server linked to a color laser printer such as a Canon copier or the recent QMS MagiColor 330GX. The Epson 5000 inkjet system can be purchased with a dedicated RIP which costs roughly three times the price of the printer. Even so, this is probably the best value professional CMYK contract proofer available for proofing A3 page layouts. It outputs to the Dupont Cromalin™ approved standard.

Quantity printing

When faced with a large print order, it is not so easy to attain the levels of discount normally associated with large run color photographic printing. One option might be to have a color transparency output made and use this as the master to print from in the normal way. Alternatively there is the Sienna printing process supplied by the photographic company Marrutt, which can produce low cost C-type prints in large quantities and at a reasonable cost. The aforementioned laser light writers such as the Lambda process are always going to be that bit more expensive. Beyond that, one should look at repro type solutions. The technologies to watch are computer to plate (CTP) or direct digital printing: Chromapress, Xericon and Indigo. These are geared for fast, repro quality printing from page layout documents, containing images and text. They make short print runs an economic possibility.

Stormy waters

Let us pause here for a moment to reflect on how the print production process operates and put the value of color proofing in some sort of context. The digital imaging and four-color halftone printing processes could not be further apart. Halftone printing has been around a lot longer than computers or Photoshop and although the

technology has been refined and to some extent automated, it is still essentially a mechanical process and one that is vulnerable to many variables such as the age of the machine, temperature and humidity to name just a few of the intervening factors.

Color management plays an important role in ensuring that all the prepress activity hangs together as smoothly as possible. For this reason, the profiling of RGB devices as described in the preceding chapter is very important. In today's rapidly changing industry, a digital file may take a very convoluted trip through the world of prepress. The aim of Photoshop ICC color management is to maintain consistency through this part of the process. In an 'all digital' environment this is eminently doable. But once a digital file has been separated and converted to make the plates, it is down to the printer who is running the press to successfully complete the process.

All we can do is to prepare that file as best we can to match the printer's specifications. Thereafter anything can happen and it is in the hands of an experienced print operator to regulate the press and maintain consistent color. This is achieved not through digital curve correction but manual tweaking of the press. This is why you hear people say that your goal should be the standard of a CMYK proof. You cannot profile or target the press itself any more than I can predict which is going to be the quickest route to drive across town tomorrow. As useful as it may be to fine tune a system such as the calibration of your monitor and by doing so maintain consistency from user to user, the reality is that the repro press environment contains so many extra variables. To use a sailing analogy, it is like perfecting the conditions for calm lake sailing and feeling mighty proud of yourself, while ignoring the fact that your boat is soon about to be sailed on a rough sea and the most important thing to steer the vessel with then will be a good map and compass.

Color management (even non-ICC profiled color management) is controllable and should be maintained within the digital domain, but once you leave that digital world and enter the press room, the operation takes a completely new direction. Fretting over how a proof print may have faded 0.3% in the last month is kind of out of balance to the bigger picture. The printer may be satisfied to keep the whole print job to within a 5% tolerance, although many manage to keep within even tighter tolerances. Imagine, for example, a large volume magazine print run. A printer may use up paper stocks from 17 different sources and make 'on-the-fly changes' to the press to accommodate for changing dot gain and other shifts which may occur during the run. The proof is like the printer's map and compass.

The point I am trying to make is that successful repro is as much dependent on the printer exerting his or her skills as it is reliant on the supplier of the digital file getting their side of the job right. Good communication can be achieved through the use of an accepted color proof standard. It is a mistake to think that one can accu-

rately profile the final press output. The best we can hope to achieve is to maintain as accurate an RGB workflow as is possible and to this end, accurate profiling is very important. Once a file has been accurately proofed to a CMYK proofer that is the best we can do – after that it is off to the stormy, choppy waters of repro!

Storing digital files

Which is the best removable drive media for archiving and transporting your digital files? Magneto Optical disks are highly rated for their reliability and because they are cheap to buy. Iomega ZIP drives have in recent times become more popular though and many computers (like the G3 and G4 Macs) come with a ZIP drive as standard where once there used to be a floppy. The older Syquest 44 Mb and 88 Mb media are now defunct as the drives have long been discontinued. Of all the other types of removable media on the market, one should find that any busy bureau will make a point of trying to cater for all needs, but don't bank on it. Always check before bringing a job in that your disk or tape can be read.

The one standard that is universal is CD-ROM. Every computer is sold with a CD-ROM player these days. The CD drives which can read and record to CDR discs are not that expensive to buy and the media costs have tumbled to ridiculously low prices. The only problem with a CD is that if it gets damaged you lose everything and that might be a hefty chunk of valuable data. Make an extra backup copy of important data and archive this separately – this is always a sensible precaution. New on the market are re-recordable CD media and also DVD, which will compact even more data on a single disc. Jaz disk systems are the ZIP disk's big brother, store either 1 Gb or 2 Gb of data and the read/write access times are comparable to a standard internal hard disk. Jaz is useful for handling large amounts of data quickly as a temporary storage medium before archiving to CD or tape.

I had a client who recently complained that his removable disk system was not storing his images properly – they would reopen, but with signs of file corruption having occurred. The fault lay not in the drive but the unwisely long chain of SCSI cables.

Image database management

A seasoned travel photographer once tried to calculate how many rolls of 35 mm film he had shot in his lifetime. If you placed each strip of film end to end, how far would they reach? A trip across the capital city maybe? However much film professionals get through, archiving and storing all those negatives and slides is still quite a task. Film, as I said in the first chapter, is such an efficient method of capturing

image information that it will take a radical development in digital technology before it is ever completely superseded. If I get a commission to shoot for an advertising agency, PR company or magazine, I mostly photograph with either a 35 mm or 120 roll film camera and the pictures taken have been reproduced at anything from a thumbnail sized image on an editorial page up to a film poster in Leicester Square, covering a five storey building. The compactness and versatility of film are a tough benchmark for digital cameras to beat. Archiving film may be time consuming, but archiving digital files is going to be just as, if not more, costly timewise. If done properly though, it will save time and you'll reap the rewards in the future.

From your own experience you will appreciate the importance of keeping track of all your office work files by saving things to their correct folders just as you would keep everything tidy inside the filing cabinet. The task is made slightly easier on the computer in as much as it is possible to contain all your word processing documents on the one drive (and a single backup drive). Digital files are by comparison too large to store on a single disk and need to be archived on many separate disks or tapes. One disk looks pretty much like another and without diligent marking and storing, fast forward a year or so and it will take you forever trying to trace a particular picture. I only have to look at my collection of video tapes to appreciate the wisdom of indexing – I know there are movie masterpieces in there somewhere, but am damned if I can find them when I want to.

The Apple Macintosh operating system features alias making (know as shortcuts on Windows). From any file or application an alias can be created and stored in a separate location. The alias is a tiny sized file – double-clicking the alias will launch the program it was created in and open the original. If that original is stored on a drive not currently loaded, a dialog box appears informing you by name which disk to load (good idea to number your disks). My first image archive relied on this method. I kept an alias of each image file in a single folder on the main computer hard disk. I referred to the icon which helped me locate the exact disk the image was stored on.

That's fine, but if you would like a more sophisticated archival retrieval system then consider a software utility such as Image AXS or Kodak's Shoebox. A good image cataloging program will do more than provide a contact sheet of images, which are obviously better than icon previews, but also allow indexing with field entries to aid searching. Basically these are database programs designed for efficient image retrieval.

You can of course append your own image information within the Photoshop program itself. The File > File Info... dialog box provides a comprehensive list of options for annotating an image to meet with the NAA/IPTC standard, as used in the newspaper industry.

Bureau checklist

To avoid delays and disappointment, make sure you have everything fully prepared before you send that disk. Some bureaux supply their customers with guidelines, others assume you know enough about digital imaging to understand the basic requirements. First, be specific about the media you intend to supply. Asking a bureau if they take Magneto Optical disks is not precise enough, they may only be equipped to accept 128 Mb 3.5 inch disks but not 230 Mb 3.5 inch disks or larger 1.3 gigabyte and 2.6 gigabyte disks. Identify the disk and jewel case with your name and telephone number and don't forget to clearly identify which file on the disk is to be output. Maybe scale the window so only that folder is visible when the window is opened and label it 'Output folder'. Certain types of removable media are renowned for their instability or sensitivity to strong magnetic fields. In fact no digital medium is ever 100% foolproof. Be sure to have a backup copy of the file stored separately, so in case of disk failure another copy can be supplied. Neither is ISDN file transfer completely reliable, but at least one can ring to confirm everything has been transmitted successfully.

The preferred image file format is usually a TIFF, uncompressed and saved using Mac byte order. If the bureau is running PC or UNIX systems, they may request you save using PC byte order (which can also be read by Macs), but this is less likely these days. It is even remotely possible that a bureau may be running a machine with version 2.0 of Photoshop. A layered Photoshop image created in version 3.0 or later will be unreadable unless you left the 'Maximize Backwards Compatibility' option checked in the Save preferences. I suggest you normally switch this option off, because it wastes time and disk space when saving a Photoshop file. It is best to stick with the TIFF format for simplicity's sake. Bureaux also prefer you to remove any masking channels and paths from the final output file. Removing unwanted alpha channels from a TIFF will economize on the stored file size. Only leave paths when saving a clipping path with an EPS or TIFF file.

What output size and resolution should the image be? Check first the required or suggested resolution for the print process and adjust the image dimensions to match this setting and always make allowance for the extra bleed dimensions (which is usually 3 mm along each edge) when a photograph is to fill the page. There are limits as to how much one can 'interpolate up' a digital image. Apply unsharp masking as necessary – Photo CD files always need some sharpening, high quality drum scans or digitally captured images may only need to be sharpened locally to selected areas like the eyes. Preparing a file for repro is another matter. A lot of sharpness gets lost in the subsequent repro process and therefore a little more unsharp masking than looks correct on the monitor screen will be the right amount to use.

Use the correct color mode – either RGB or CMYK. Some service providers, like those outfits who produce the Iris art prints, may use their own color conversion hardware to work from your RGB files. Lastly, consider how you are going to calibrate the image on your monitor to the print. Guidelines on this are provided at the beginning of Chapter Four. If the bureau making the print also supplied the scan you can safely assume that by maintaining a 'closed loop', so long as you do not alter the color balance, the output color balance will match that of the original. If you substantially change the colors, then maybe include a small scaled down version off the edge of the main picture as a reference sample. Trim away or mask out later.

Image protection

Anyone who fully understands the implications of images being sold and transferred in digital form will appreciate the increased risks posed by piracy and copyright infringement. The music industry has for a long time battled against pirates duplicating original disks, stealing music and video sales. Digital music recordings on CD made this problem even more difficult to control when it became possible to replicate the original flawlessly. The issue of piracy is not new to photographers and image makers, but the current scale of exposure to this risk is. It includes not just us Photoshop geeks who are going to be affected, but includes anyone who has their work published or is interested in the picture library market.

To combat this problem, the first line of defence had been to limit the usefulness of images disseminated electronically by (a) making them too small in size to be of use other than viewing on a screen and (b) including a visible watermark which both identified the copyright owner and made it very difficult to steal and not worth the bother of retouching out. The combination of this two pronged attack is certainly effective but has not been widely adopted. The World Wide Web contains millions of screen sized images few of which are protected to this level. The argument goes that these pictures are so small and degraded due to heavy JPEG compression, what possible good are they for print publishing? One could get a better pirated copy by scanning an image from a magazine on a cheap flatbed scanner. Shopping is now replacing sex as the main focus of interest on the Internet, so screen sized web images therefore do now have an important commercial value in their own right. Furthermore, the future success of digital imaging and marketing will be linked to the ability to transmit image data. The technology already exists for us to send large image files across the world at speeds faster than ISDN. Once implemented, people will want to send ever larger files by telecommunications. The issue of security will then be of the utmost importance.

In recognition of this market need, software solutions are being developed to provide better data protection and security, providing suppliers of electronic data with the means to warn, identify and trace the usage of their intellectual property. From a user's point of view, the requirements are to produce an invisible 'fingerprint' or encrypted code, which does not spoil the appearance of the image but can be read by the detection software. The code must be robust enough to work at all usage sizes – screen size to high resolution. They must withstand resizing, image adjustments and cropping. A warning message should be displayed whenever an image is opened up alerting the viewer to the fact that this picture is the property of the artist and a readable code embedded from which to trace the artist and negotiate a purchase.

Two companies have produced such encryption/detection systems – SureSign by Signum Technology and Digimarc by the Digimarc Corporation. Both work as plug-ins for Photoshop. They will detect any encrypted images you open in Photoshop and display a copyright detection symbol in the status bar alongside the file name. The Digimarc plug-in has been included free since Photoshop 4.0. To use Digimarc to encrypt your own work, you have to pay an annual usage fee to Digimarc to register your individual ID (check to see if free trial period offers are in operation). Anyone wishing to trace you as the author, using the Photoshop Digimarc reader plug-in, will contact their web site, input the code and from there read off your name and contact number. Here is the main difference between the two systems – the Digimarc code is unique to each author/subscriber while SureSign provide a unique author code plus transaction number. In my opinion, the latter is a more adaptable system. Anyone contacting me with regard to image usage can quote the transaction number which would relate to a specific image. As for pricing methods, with Digimarc the software is free but you have to pay an annual fee to register your code. At the time of writing, SureSign also sell the software with an annual fee.

Both systems work effectively on digital originals (you can compare them for yourself, a Signum Technology demo is available on the CD-ROM). There is no guarantee that a fingerprint will remain intact when scanned from a halftone printed image, yet Signum report that one client was able to detect the SureSign code from a scanned newspaper page! These programs herald an important step forward for the secure distribution of copyright protected data. The future will see many improvements and new possibilities. Digital images will one day be sent for appraisal sealed in an image degrading 'digilope'. The quality will be good enough to judge if the shot is right or not, but unsuitable for publication. To access the image in its full glory, the client would contact the supplier for a unique code. This code would represent a single transaction indicating who had bought the licence and what specific usage rights had been bought. Now if by chance the customer buying the picture were dishonest and passed the opened version on to someone else or used the picture for extra unnegotiated usages, a discovered infringement would always be traceable to the origi-

nal purchaser. Schemes such as these will help enforce responsible business practice and discourage piracy. There is even an opportunity for people buying pictures to make themselves some extra money. If a client reseals the digilope and passes the image around to other interested buyers and if as a result they buy the image from you again, you can trace the first purchaser or purchasers and offer a commission as a thank you incentive.

The detection business is very important if fingerprint type encryption is to become trusted as a valuable method of copyright protection. Detection software will also help people searching for a particular image, whether encrypted or not. New Mexico Software are talking of a search engine which, for want of a better description, has 'eyes' and can catalog every image it comes across on the Internet. Don't ask me how it will do this, but the theory is that you can show an image to the search engine and ask it to find others that match – just as you would conduct a normal word search. This can be used as another method of controlling piracy – identifying duplicate images on the web and also helping picture researchers locate a specific type of picture. Show it a picture of an elephant drinking from a watering hole and it will suggest a list of web pages featuring pictures that match this criteria. For some reason various international police authorities are interested in acquiring this tool. New Mexico and Signum Technologies recently joined forces with C E Heath and Beazley, a Lloyd's insurance syndicate, who are providing an insurance cover plan to enforce copyright protection and recover damages where ownership can be proved using the encryption detecting software.

Chapter Six

The Work Space

Before moving on to the practical Photoshop techniques, let's first look at the Photoshop interface. The tools and palette layouts have undergone another major refit. Adobe have aimed to unify the interfaces and keyboard key commands of all their graphics software applications. If you switch between using current versions of Photoshop, Illustrator and InDesign, the interface and keyboard commands will remain fairly consistent. For example, the zoom tool shortcut in all these programs is Command/Ctrl+Spacebar. Apart from a few necessary deviations, the transition between all Adobe graphics programs is fairly seamless. The Photoshop 6.0 interface has undergone some significant changes. Those familiar with previous versions of the program will want to pay particular attention to things like the new Options bar and how some of the older, lesser-used tools have been shifted around to make way for the newer tools. There are always new keyboard shortcuts to learn and these are all summarized later on in Chapter Twelve. Overall, the period of adjustment to using the program should be a smooth one. The following pages give an account of the basic Photoshop working area and introduce you to the new tools. Use this chapter as a reference as you work through the remainder of the book.

Photoshop preferences

Photoshop preferences are located in the Edit menu. Changing the preference settings here will customize the various Photoshop functions and update the *preference file* which is stored along with other program settings in the system level Preferences folder (Mac) or Registry folder (PC). Deleting or removing this file will make Photoshop reset all its preferences. A new preference file is generated each time you exit Photoshop.

Open the preferences dialog – Edit > Preferences > General (Command/Ctrl-K). I would leave the Color Picker set to Adobe – this is the picker referred to throughout this book (unless you have a strong attachment to the system Color Picker). Leave the interpolation option set to Bicubic. If you need to override this setting then you can do so in the Image > Image Size dialog. Unchecking the Export Clipboard box saves time when exiting Photoshop to launch another program. Unless you are wanting to paste clipboard contents to another program, then leave it off. Check the Keyboard Zoom Resizes Windows, if you want the image window to shrink to fit whenever you use a keyboard zoom shortcut like Command/Ctrl-minus or Command/Ctrl-plus. If you are going to be jumping between Photoshop and ImageReady, then you may want to check the Auto-update open documents option. Otherwise, Photoshop will remind you anyway when you jump applications. You can check the Beep When Done box, if you want Photoshop to signal a sound alert when tasks are complete. The Dynamic Color Sliders option ensures that the colors change in the Color palette as you drag the sliders – keep this selected. If you would like Photoshop to always remember the last used palette layout, check the Save Palette Locations box (the Reset Palette Locations to Default option is now located under the Window menu). The Reset All Warning Dialogs will reset things like the profile mismatch warning messages. These dialogs contain a Don't Warn Me Again checkbox – if you had accidentally pressed the reset button, these warning dialogs can be restored. Reset All Tools will reset the tool behavior. The Show Font Names in English option is of more significant for non-English language users, who will see instead an option for displaying font names in the native language of their localized version of Photoshop (the same applies for the Show Asian Text Options box). The Use Shift Key for Tool Switch answers the needs of users who wish to disable the Shift key modifier for switching tools in the Tools palette with repeated keyboard strokes. See Figure 6.26 for more information about the redo key preference options.

Figure 6.1 The General preferences dialog.

Saving files

Do you need image previews? I would assume the answer is yes. In the normal course of your work, it is very useful to have picture document icons and thumbnail previews in the Open dialog boxes when searching for a file. There are times though when you don't. Web graphic files should be uploaded as small as possible without a thumbnail or platform specific header information. I usually upload files to my server in a raw binary format, which strips out all this and other Mac resource information anyway. For general cross-platform access you can choose to save a Windows and Macintosh thumbnail with your file. Appending a file with a file extension is handy for keeping tabs on which format a document was saved in. It is also very necessary when saving JPEG and GIF web graphics which need to be recognized in an HTML page. If you are exporting for the web, you probably want to check the Use Lower Case box for appending files. The new Photoshop 6.0 layer features will not be recognized in earlier versions of Photoshop. The Maximize Backwards Compatibility in Photoshop Format option will always include a flattened version of the image in a saved Photoshop file. A safe solution is to now keep this checked. If a Photoshop 6.0 file contains a layer element which is unrecognizable in Photoshop 5.5 or earlier, this will trigger opening the flattened version instead. However, it will lead to slower saves and bigger files. If you deselect this option, you can save your layered Photoshop 6.0 files in the TIFF 7 format instead and a flattened version will always be saved (providing the Enable advanced TIFF save options is checked). TIFF 7 enables compatibility with older versions of Photoshop. Or, set the Saving File preference to 'Ask When Saving'. This allows you to switch some of these options on or off according to your specific needs. The Recent file list refers to the number of image document locations remembered in the Photoshop 6.0 File > Open Recent submenu.

Figure 6.2 The Preferences dialog boxes for Saving Files.

Display & Cursors

The display Color Channels in Color option is a somewhat redundant feature as this does not really help you to visualize the channels any better. If anything it is a distraction, so it is best left unchecked. The Use Diffusion Dither option is a legacy from the days when people were maybe trying to run Photoshop on an underpowered system with an 8-bit color monitor display (256 colors). The Use Diffusion Dither option approximates the in-between colors to produce a smoother looking if not completely accurate color display. It is important to realize that the screen drawing code for Photoshop 6.0 has been revised. This means that the screen display you see is more accurate, but may appear slower than before when performing global image adjustments. The Use Pixel Doubling option will temporarily convert the image window preview to display a quarter as many pixels while you are making an image adjustment with, say, Levels or Curves. Pixel Doubling will greatly improve screen refresh times. The Painting cursor displays an outline of the brush shape at its actual size in relation to the image magnification. This is the default setting, although you could choose the cursor to display with a precise cross-hair or with the standard tool icon. The latter cursor display happens to be the default setting under Other Cursors. This is fine when starting to learn Photoshop but for precision work I suggest changing the Other Cursors setting to Precise. Depending on how you configure the Display & Cursor options, the Caps lock key will toggle the cursor display. When the standard paint cursor is selected, the caps lock will toggle between standard and precise. When the precise or brush size paint cursor option is selected, the Caps lock will toggle between precise and brush size. When standard cursor mode is selected for all other cursors, the Caps lock key will toggle between the standard and precise cursor.

Figure 6.3 The Preferences dialog for Display & Cursors.

Transparency & Gamut

The transparency settings simply modify the transparency display in layers – if you view a layer on its own, with the background layer icon switched off, the transparent areas of a layer are displayed with a checkerboard pattern. Edit the display preferences here if you so wish. The Gamut display comes into effect when working in RGB or Lab mode and you choose View > Gamut Warning. Colors that fall outside the default work space gamut are displayed as a solid color which is set here.

Figure 6.4 The transparency display settings are editable. You have a choice of transparency display settings: none, small, medium or large grid pattern as well as a choice of different grid colors. Should you so desire to customize the interface.

Figure 6.5 Ruler units can be set in pixels, inches, cm, points, picas or as a percentage. The percentage setting is ideal for recording an Actions which you wish to proportionally apply at any image size.

Units & Rulers/Guides & Grid

These preferences control the display settings for these two features. Ruler units can be changed via the Info palette sub-menu or by Control/right mouse-clicking a ruler to open the contextual menu. Use of Guides & Grid is discussed in the following section on Photoshop Windows.

Figure 6.6 Adjust here the settings governing the appearance of the Guides & Grid. There are a choice of line styles available and you can customize the grid appearance to suit whatever sized files you normally work with.

Figure 6.7 Specify the Plug-in folder to use (which may be shared with another application). Up to four scratch disks are supported by Photoshop 6.0.

Plug-ins and Scratch Disk/Memory & Image Cache

The Plug-ins folder will automatically be recognized by Photoshop 6.0 so long as it resides in the same application folder. You can, however, choose an additional plug-ins folder which may reside in another application folder so they can in effect be shared between applications. Click the Browse... button to locate the additional folder. Choose the primary and spill-over scratch disks. The primary scratch disk should ideally be one that is separate to the disk running Photoshop and the system and be kept free of other data. The primary scratch disk choice will only take effect after you restart Photoshop. If you hold down the Command/Ctrl + Option/Alt keys at the beginning of the startup cycle, you can choose the location of the additional Plug-ins folder first then hold down the same key combination again and then choose the scratch disks. Up to four scratch disks can be specified. Holding down Command/Ctrl+Option/Alt+Shift during startup will delete the current Photoshop preferences.

Figure 6.8 The 4 setting is best for most Photoshop work. Leave this as the default. Use a lower setting of 2 or 3 if you are editing small images only. Use a higher setting of 5 or more if you are always editing large, i.e. 50 Mb + RGB, files. This will speed up the screen redraws. Deselect the Use cache for histograms as this will give you more accurate histograms at any screen magnification (see Chapter Eight).

The image cache settings affect the speed of screen redraws. When working with high-resolution images, Photoshop uses a pyramid type structure of lower resolution versions in a 1/4, 1/16, 1/64 progression, to update the screen display when compositing or making layer or Image adjustments. For instance, you may sometimes notice how a layered Photoshop image on screen is not completely accurate at anything other than the 100% magnification – this is the image cache at work, it is speeding up the display preview at the expense of accuracy. The settings can be between 1 and 8. A higher setting provides faster screen redraw, sacrificing the quality of the preview (note

that the number of cache levels chosen here will affect the structure of a 'Save Image Pyramid' TIFF 7 file). Windows memory management is different from Macintosh. Memory allocation is set as a percentage of the total RAM available. The default used by Photoshop is 75%. If more applications are required to run simultaneously, the percentage can be lowered, although this will degrade Photoshop's potential performance on your system. You thought the Web was slow? Underpowered computers will spend a lot of time in wristwatch or egg timer land whilst waiting for commands to execute. The Progress bar on a Macintosh features a Cancel button. Hitting the 'Esc' key or Command/Ctrl-period (.) will also cancel an operation.

Image window

The document window has extra information displayed in the two boxes located in the bottom left corner of the image window (Mac) or at the bottom of the screen (PC). The left-most displays the zoom scaling percentage, showing the current zoom factor. You can type in a new percentage of any value you like from 0.2% to 1600% up to two decimal places and hit Return. Next to this is the Preview box. Holding down the mouse over the Preview box displays a preview showing a placement of the image on the currently selected paper size. The preview reflects the image dimensions at the current resolution set. This can be checked by holding down the Option/Alt key whilst holding down the mouse – the display shows the dimensions and image resolution. Command/Ctrl – mousing down shows the image tiling information. The Preview box displays updated file information. The display preferences can be changed by mousing down over the arrow next to the box:

Preview box options

Hold down the Command/Ctrl key to display the tiling.

Hold down the Option/Alt key to display the file size and resolution information.

Mouse down to display a scaled preview of the size the image will print with the current page setup.

Image scale

Information box

Figure 6.9 The window layout of a Photoshop document as it appears on the Macintosh.

Document Sizes displays the current document size. The first figure is the file size of a flattened version of the image. The second, the size if saved including all the layers.

Document Profile is new to Photoshop 6.0 and displays the current profile assigned to an open document.

Scratch Sizes – the first figure displays the amount of RAM memory used. The second figure shows the total RAM memory after the system and application overhead available to Photoshop. The latter figure remains constant and only changes if you quit Photoshop and reconfigure the memory partition. During a Photoshop session, the first figure will increase dramatically when performing certain operations that consume a large amount of RAM/Scratch Disk memory.

Efficiency summarizes the current performance capability of Photoshop. Basically it provides a simplified report on the amount of Scratch Disk usage. Low percentages warn that it may be advisable to purge the clipboard or undo memory (Edit > Purge > Clipboard/Undo).

Timing times Photoshop operations. It records the time taken to filter an image or the accumulated timing of a series of brush strokes. Every time you change tools or execute a new operation, the timer resets itself.

Tool Selection displays the name of the tool you currently have selected. This is a useful aide-mémoire for users who like to work with most of the palettes hidden.

Title bar proxy icons (Macintosh)

Macintosh users will see a proxy image icon in the title bar. This is dimmed when the document is in an unsaved state. Control-drag the proxy to relocate a saved image.

Opening a second window

You can create a second window view of the image you are working on by choosing View > New View. The image is duplicated in another window. You can have one window with the image at a Fit to Screen view and the other zoomed in close-up on a detailed area. Any changes you make can be viewed simultaneously in both windows. In Photoshop 6.0 you can use multiple window views to soft proof the image in different color spaces. On the Windows system you can choose Window > Cascade to arrange the display of image document windows cascading down from the upper left corner of the screen. Window > Tile will display the image windows edge to edge.

Figure 6.10 To open a second window view of a Photoshop document, choose View > New View. Changes applied to the close-up view are automatically updated in the full frame view. New view document windows can usefully be used to display the same image with different color proof setups applied, so you can preview an RGB image in a different CMYK color space in each new view window.

Rulers, Guides & Grid

The Grid provides you with a means for aligning image elements to the horizontal and vertical axis (go to the View menu and choose Show Grid). To alter the grid spacing, go to the General preferences and select Guides & Grid. To see a practical example of using Guides in a project that involves a PageMaker layout created partly in Photoshop, see the tutorial at the end of Chapter Eleven about preparing a flyer design for Ocean Images, swapping between PageMaker and Photoshop. Guides can flexibly be positioned anywhere in the image area and be used for the precise positioning and alignment of image elements. Guides can be added at any time, providing the Rulers are displayed (View > Show Rulers). To add a new guide, mouse down and drag out a new guide from the ruler bar. Release the mouse to drop the guideline in place. If you are not happy with the positioning, select the move tool and drag the guide into the exact required position.

'Snap to' behavior

The Snap option in the View menu will toggle snap to behavior with Guides, the Grid, Slices, Document bounds and Layer bounds. The shortcut for toggling snap to behavior is Command-semicolon (;). When the Snap to is active, objects will snap to one or more of the above when you reposition them and the crop tool will automatically snap to the document edge. Choose View > Snap to, to switch off this default

Figure 6.11 These windows show the Grid (back) & Guides. To display the Grid, chose View > Show > Grid. To position a Guide, choose View > Show Rulers and drag from either the horizontal or vertical ruler. Hold down the Shift key as you drag to make the guide snap to a ruler tick mark (providing View > Snap is checked). Command/Ctrl-H will toggle hiding/showing Extras like the Grid & Guides. Hold down the Option/Alt key to switch dragging a horizontal guide to dragging it as a vertical (and vice versa).

behavior. It is also the case that when snap is active, and new guides are added with the Shift key held down, the guide will snap to the nearest indentation on the ruler. Objects on layers will snap to position when placed within close proximity of a guide edge. The reverse is also true: when dragging a guide, it will snap to the edge of an object on a layer at the point where the opacity is greater than 50%. Furthermore you can Lock Guides and Clear Guides. If the ruler units need changing, double-click anywhere on a ruler to call up the Ruler Units preferences dialog box. If the rulers are visible but the guides are hidden, dragging out a new guide will make the others reappear. You can even position a guide using New Guide... Enter the exact measurement coordinate for the horizontal or vertical axis in the dialog box.

The Photoshop palettes

The Tools palette and palettes can be shunted around the screen like any other window. Mouse down on the title bar and drag to a new position. Apart from History and Actions, the palettes are grouped together in threes in the default layout. Where palettes are grouped, they are like folders in a filing cabinet. Click on a tab to bring a palette to the front of the group. Double-clicking on any of the tabs collapses the palette. If an uncollapsed palette is positioned on the bottom of the screen display, the palette collapses downwards. Change the height of a palette by dragging the size box at the bottom. To return to the default size, click the zoom box at the top (Macintosh) or click the minimize/maximize box (Windows). One click will resize, a second click collapses the palette. There is no reason why you can't modify the palette layout to

suit your needs. If you have a second monitor display, you can arrange for all the palettes to be displayed nestled on the second screen, leaving the main monitor clear to display the whole image. Palettes can be moved about between palette groups or isolated. Choose any palette and drag the tab away from the palette window – a separate palette is formed. Drag from one palette window to another. When palettes are closed or not visible on the monitor, go to the Window menu – this controls the display of all palette windows. If at any time you wish to restore the palette positions, go to the Window menu and select Reset Palette Locations.

Palette Docking

Photoshop 6.0 palettes can be arranged on screen the traditional way or they can be docked together as shown right. If you have a limited sized screen this is a convenient way of arranging the palettes and it also makes it easier to expand and shrink the height of individual palettes such as the History palette, without covering up the Layers palette, for example.

To set up palette docking, first separate all your palettes and position one palette (like Color) immediately below another (the Navigator/Info/Character & Paragraph set) and slowly drag the tab of the lower palette up to meet the bottom edge of the one above. As the palettes dock, you will see the bottom edge of the upper palette change to a double bar. Release and the two palettes are joined. Drag the Swatches and Style palette across to rejoin the Color palette. Repeat by separating the History and Actions palette and doing the same with the History palette, dragging the tab up to the base of the Color palette set.

When the cursor is positioned over the palette divider, you will see the icon change to a double arrow, indicating that you can adjust the relative height between two sets of palettes (where allowable). If you drag on the lower height adjustment/grow tab in any palette, you can adjust the overall height of the docked palette grouping.

Figure 6.12 The Photoshop 6.0 palettes shown with vertical docking.

Navigator

The Navigator is usually grouped with the Info, Character and Paragraph palettes. The Navigator offers an easy and direct method of scrolling and zooming in and out of the image window. The palette window contains a small preview of the whole image and enables you to scroll very fast, with a minimum of mouse movement by dragging the colored rectangle. This colored rectangle indicates the current view as seen in relation to the whole image (other rectangle colors can be selected via the palette fly-out menu options). To operate the zoom, hold down the Command/Ctrl key and drag the mouse to define an area to zoom to. Alternatively, with the slider control at the bottom, you can quickly zoom in and out or click on the 'little mountain' or 'big mountain' icons to adjust the magnification in increments. You can also type in a specific zoom percentage in the bottom left corner up to two decimal places and hit Return or Enter to set the new zoom percentage. It is also possible to resize the palette as shown in the illustration here, by dragging the bottom of the palette window out – this will provide you with a bigger preview.

Info

This palette reports information relating to the position of the cursor in the image window, namely: pixel color values and coordinate positions. When you drag with a tool, the coordinates update and in the case of crop, marquee, line and zoom tools, report back the size of a dragging movement. The sub-menu leads to Palette Options... Here you can change the preferences for the ruler units and color readouts. The default color display shows pixel values for the current selected color mode plus the CMYK equivalents. When working in RGB, illegal colors which fall outside the current CMYK workspace gamut are expressed with an exclamation mark against the CMYK value.

| File | Edit | Image | Layer | Select | Filter | View | Window | Help | 3:44 pm | Adobe® Photoshop® 6.0 |

Shield cropped area Color: ■ Opacity: 75% □ Perspective Cropped Area: ● Delete ○ Hide ✓ ✗ Character Paragraph

Tool Options bar

The Options bar replaces the old Options palette. When you first install Photoshop, the Options bar will appear at the top of the screen, snapped to the main menu. This is a very convenient location for the tool options, and you will soon appreciate the ease with which you can make changes to the options with minimal mouse navigation movement. The Options bar can be unhooked, by dragging the gripper bar (on the left edge) away from the top of the screen. The Options bar contains a 'palette well' docking area to the right, which will be visible whenever the Options bar is docked at the top or bottom of the screen and your monitor pixel display is at least 832 × 624 pixels (although ideally you will want a larger pixel display to see this properly). Palettes can be docked here by dragging a palette tab into the Options bar palette well. Palettes docked this way are made visible by clicking on the palette tab. One advantage of this arrangement is that you can use the Shift+Tab key shortcut to toggle hiding the palette stack only, keeping just the Tools palette and Options bar visible. The individual Options bar settings for each tool are shown throughout the rest of this chapter. To reset a tool or all tools, mouse down on the tool icon on the left. The 'tick' and 'cross' icons are there to make it simpler for users to know how to exit a tool which is in a modal state.

Character

The Character palette is where you can exercise full control over the font character attributes: point size, leading, tracking, baseline shift and text color. Basically, the Character palette provides you with a level of character control which is comparable to InDesign's text handling (when the type tool is selected, click on the 'palettes' button to open this and the next palette). To find out more about type, check the information about the type tool in Chapter Fifteen.

Paragraph

Photoshop will let you place multiple lines of text. The Paragraph palette is where you can exercise control over the paragraph text alignment and justification. The indentation controls enable you to indent the whole paragraph left and right, or just indent the first line of text.

Figure 6.13 Mouse down on the arrow next to the brush shape icon in the Options bar to call up the brushes list. Mouse down on the brush icon to call up the brush properties dialog and mouse down on the end arrow to adjust the pressure sensitive stylus options.

Any Photoshop image can be made into a custom brush. Create a new document, draw the shape and texture of the brush you want and choose Edit > Define Brush. Name it and it will become appended to the current Brushes set.

Brushes

The standard brushes range from a single pixel, hard-edged brush, to a 300 pixel-wide soft-edged brush, plus a number of creative textured brushes. To select a new brush, mouse down on the downward pointing arrow, next to the brush shape icon in the Options bar (you can do this when any painting type tool is selected in the Tools palette). You can add a new brush by clicking in the blank area at the end of the brush icon list. This opens up the New Brush dialog where you can define the brush shape characteristics. Click OK to append the current list. Brush attributes can be adjusted at any time, by clicking on the brush shape icon, which will open the brush editor shown in Figure 6.13. The upper size brush limit is 999×999 pixels; Hardness, this determines whether there is any softening to the edge of the brush; Spacing – the default is 25%, higher spacing creates a stepped effect in the brush strokes. Angle and Roundness can be adjusted by dragging the cursor around in the preview box or entering numeric values in the boxes. The bottom right preview shows the shape of the final brush. Control/right mouse-click will open the contextual menu in which you can change the painting blend mode or open the Edit Brush dialog. Control/right mouse-click+Shift-clicking will call up the contextual brushes palette in the document window any time a painting tool is selected. If you Control/right mouse-click+Shift-drag instead of clicking, the palette will disappear after you select a brush and release the keys. Use the square bracket keys on the keyboard, to make the brush larger or smaller. Use the square bracket+Shift keys to adjust the hardness of the brush on-the-fly.

Styles

Styles are layer effect presets. New custom layer effect combinations can be saved as Styles, where they are represented in the palette by a square button icon, which will visually indicate the outcome of applying the style. Styles can incorporate the new Pattern and Gradient fill layer effects.

Swatches

Click on a swatch in the Swatches palette to select as the foreground color. To add a new color, click in the empty area at the bottom. This will provide you the option to name the new color being added. Option/Alt-click to erase an existing swatch. New sets of color swatches can be appended or made to replace the current set via the palette sub-menu.

Color

Use this palette to set the foreground and background colors by dragging the color sliders, clicking inside the color slider or in the color field below. Several color modes for the sliders are available from the sub-menu including HTML, hexadecimal web colors. Out-of-gamut CMYK colors are flagged by a warning symbol in the palette box. Black and white swatches now appear at the far right of the color field.

Preset Manager

Use the Preset Manager to manage all your presets from within the one dialog. The Preset Manager keeps track of: brushes, swatches, gradients, styles, patterns, layer effect contours and custom Shapes. Figure 6.14 shows how you can use the Preset Manager to replace a current set of brushes. You can either append or replace an existing set and if the current set is saved, then you can easily reload it again. The Preset Manager will directly locate the relevant preset files from the Presets folder, within the Photoshop folder. The Preset Manager display can be customized. This is particularly helpful if you wish to display the thumbnails of the gradients, as shown in Figure 6.15. N.B. if you double-click any Photoshop setting which is outside of the Photoshop folder, it will automatically load the program and append to the relevant preset group.

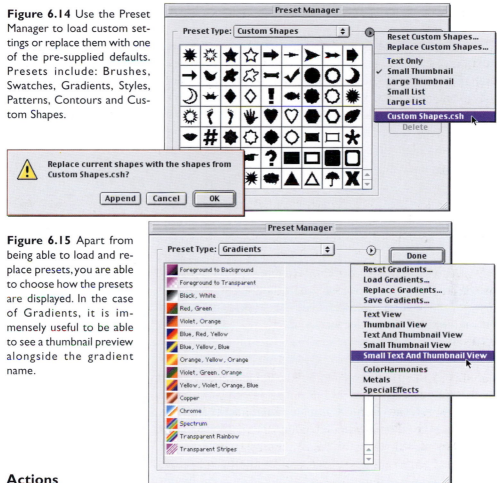

Figure 6.14 Use the Preset Manager to load custom settings or replace them with one of the pre-supplied defaults. Presets include: Brushes, Swatches, Gradients, Styles, Patterns, Contours and Custom Shapes.

Figure 6.15 Apart from being able to load and replace presets, you are able to choose how the presets are displayed. In the case of Gradients, it is immensely useful to be able to see a thumbnail preview alongside the gradient name.

Actions

Actions are recordable Photoshop scripts. Photoshop 6.0 installs a default set of actions (which are shown opposite). As you can see from the descriptions, these will perform automated tasks such as adding a vignette or creating a wood frame edge effect. If you go to the palette flyout menu and select Load Actions... you will be taken to the Photoshop 6.0/Presets/Photoshop Actions folder. Here you will find many more sets of actions to add to your Actions palette. To run an Action, you will mostly need to have a document already open in Photoshop and then you simply press the Play button to commence replay. You can record your own custom actions as well. Chapter Twelve explains these in more detail and lists many other useful Photoshop shortcuts.

History

Photoshop has the ability to remember previous stages of a document during a Photoshop session by recording a set number of states in the History palette. These can be anywhere between 1 and 100, although the more histories you record the more memory Photoshop will need to save all of these. You can click on an earlier history state to revert to that particular stage of the edit, or you can paint in from history, using the history brush. For more information, see the later section on History, page 146.

Layers

Newcomers often have difficulty understanding the difference between layers and channels. Photoshop layers are akin to layers of acetate overlaying the background layer. Each layer can contain an image element, be that a duplicate of the background image, a copied selection from another layer, another Photoshop document which has been dragged across using the move tool or Photoshop text. Adjustment layers are image adjustment instructions in a layer form. Layers can be grouped together in sets (note you can now go beyond the 99 layers limit in a single document). You can apply masking to layer contents with either a pixel layer mask or a layer clipping path. Layers can blend with those underneath in seventeen different modes. Layer effects/styles can be used to add effects such as drop shadows, gradient/pattern fills or glows to a text or image layer. Custom styles can be loaded from and saved to the Styles palette. You will find some of the sub-menu options for layers are duplicated in the Layer main menu. See Chapter Eleven for more information about layers and montage techniques.

Open fly-out menu

Blending mode and Opacity

Linked text layer

Layer with linked layer mask and layer clipping path

Active layer

Eye icon

Layer mask New layer Delete layer/mask

Layer style New set Adjustment layer

Channels

A Photoshop grayscale mode image is comprised of a single 8-bit channel of image information, with 256 levels (except when in 16-bit per channel mode). RGB images are comprised of three channels: Channel 1-Red, Channel 2-Green and Channel 3-Blue (RGB); CMYK images, four channels: Channel 1-Cyan, Channel 2-Magenta, Channel 3-Yellow and Channel 4-blacK. The Photoshop channels palette displays the color channels in this order, with a composite channel (Channel ~) listed at the top. Use the Command/Ctrl key+the channel number (or tilde key in the case of the composite channel) as a keyboard shortcut for viewing channels individually. When saving a selection (Select > Save Selection), this action either generates a new alpha channel or overwrites an existing one. New channels can also be added by clicking the Add channel button at the bottom of the Channels palette (up to 24 channels including the color channels are allowed). For specialist types of printing, alpha channels can be used to store print color information like varnish overlays or fifth/sixth color printing of special inks. Photoshop has a spot channel feature enabling spot color channels to have a color specified and be previewed on screen in color (see Chapter Fifteen). You can use the Channels palette sub-menu or the buttons at the bottom of the Channels palette to delete, duplicate or create a new channel.

Load selection Save selection

New channel Delete channel

Composite channel — RGB
Red channel — Red
Green channel — Green
Blue channel — Blue
Layer mask channel — Layer 1 Mask
Alpha/mask channel — Alpha 1

Paths

A vector path is a mathematically described outline which, unlike a pixel-based mask channel, is resolution-independent and infinitely editable. Paths can be imported from a vector drawing program such as Adobe Illustrator™, or they can be created within Photoshop using the pen path or shape tools. A freshly drawn path is displayed as a Work Path in the palette window. Work Paths should be saved (drag down to the New Path button or double-click the path image icon) if you don't wish the current work path to be overwritten. A path can be used in the following ways: to convert to a selection; apply as a layer clipping path or save as a clipping path in an Encapsulated PostScript (EPS) or TIFF file.

The Tools palette

The Tools palette contains fifty separate tools and their icons give a clue as to each tool's function. The individual tool options are located in the Options bar (Window > Show Options) and double-clicking any tool will automatically display the Options bar if this happens to be hidden for some reason. Figure 6.16 shows the Tools palette layout. You will notice that each tool or set of tools has a keyboard shortcut associated with it (this is displayed when you mouse down to reveal the nested tools or

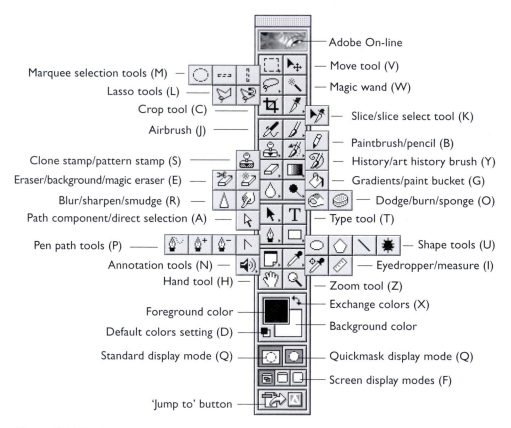

Figure 6.16 The Tools palette with keyboard shortcuts shown in brackets.

hover with the cursor to reveal the tool tip info). For example, pressing 'C' on the keyboard will activate the crop tool. Within the basic Tools palette are extra tools (designated by the small triangle at the bottom of the icon). These become visible when you mouse down on the tool palette icon. Where more than one tool shares the same keyboard shortcut, you can cycle through these other tools by holding down the Shift key as you press the letter key. If you prefer to restore the old behavior whereby repeated pressing of the key would cycle the tool selection, go to the Edit menu, select Preferences > General and deselect the Use Shift Key for Tool Switch option. Personally, I prefer to use the shift modifier. You can also Option/Alt-click the tool icon in the Tools palette to cycle through the grouped tools.

If selecting a particular tool turns out to be an illegal command, you will see a 'prohibit' warning sign appear. For example, if you tried to paint on an image in 48-bit color a prohibit sign would appear instead of the brush icon. Clicking in the image document window will call up a dialog explaining the exact reason why you cannot access or use a particular feature. If you click at the very top of the Tools palette, this will now open the Adobe On-line... dialog (also available in the File menu). Any late-breaking information plus access to on-line help and professional tips are all easily accessible within Photoshop.

Selection tools

In Photoshop, the usual editing conventions apply: pixels can be cut, copied and pasted just as you would do with text in a word processing document. Mistakes can be undone with the Edit > Undo command or by selecting a previous history state in the History palette. Selection tools are used to define a specific area of the image which you wish to modify separately, float as a layer or copy and paste. The use of the selection tools in Photoshop is therefore like highlighting text in a word processor program.

The marquee options include rectangular, elliptical or single row/single column selection tools. The lasso tool is used to draw freehand selection outlines and has two other modes – the polygon lasso tool, which can draw both straight line *and* freehand selections and the magnetic lasso tool. The magic wand tool selects pixels on the basis of their color values. If you have a picture of a red London bus (yes, there are still a few left in London) click on the bus with the magic wand tool and 'hey presto' the red color is selected! That's what most people expect the magic wand tool to do;

I The magic wand tool can be used to create a selection of pixels which are similar in color to the point where you clicked. So, clicking in the blue sky area will select all the blue pixels surrounding the click point. Because the Contiguous option is switched on, the selection is limited to neighboring pixels only.

2 If you were to deselect the Contiguous option in the Options bar, the magic wand tool will then select blue pixels of similar tonal value from everywhere in the image. This has now selected the blue sky areas on the other side of the cloud.

3 If you have most of the desired pixels selected, the Select > Grow command will expand the wand selection according to the tolerance value configured in the magic wand Options bar.

Figure 6.17 The Options bar has four modes of operation for each of the selection tools: Normal; Add to Selection; Subtract from Selection; and Intersect Selection. You can also achieve these same operating modes by using the modifier keys.

Add to Selection Subtract from Selection
New Intersect Selection

in reality it does not perform that reliable a job. I find it works all right on low resolution images (such as those prepared for screen-sized viewing). You can adjust the magic wand tolerance setting so that it will select fewer or more pixels, based on how similar they are in color to the pixels you are clicking on. The tolerance setting governs the sensitivity of the magic wand selection. When you click on an area in the image, Photoshop selects all the adjacent pixels whose numeric color values are within the specified tolerance either side of the pixel value. If the pixels clicked on have a mean value of 120 and the tolerance setting is set at the default of 32, Photoshop will select pixels with a color value between 88 and 152. You can use the smoothing options in the Select menu to tidy up a magic wand selection. If you are going to create complex selections this way then really you are often better off choosing the Select > Color Range option. This selection command provides all the power of the magic wand tool, but has much more control.

I rarely ever use the magic wand when defining critical outlines, but do find it quite useful when I want to make a rough selection area based on color. In short, don't dismiss the wand completely but don't place too much faith either in its capabilities for professional mask making. There are better ways of going about doing this, as shall be explained later in the book.

Modifier keys

Macintosh and Windows keyboards have slightly different key arrangements, hence the double sets of instructions throughout the book reminding you that the Command key on the Macintosh is equivalent to the Control (Ctrl) key on a Windows keyboard (because Windows PC computers don't have a Command key) and the Macintosh Option key is equivalent to the Alt key in Windows. In fact, on the Macintosh compatible keyboards I use, the Option key is labelled as Alt. Macintoshes do have a Control key too. On the Mac its function is to access contextual menus (more of which later). Windows users will find their equivalent is to click with the right mouse button. Finally, the Shift key operates the same on both Mac and PC.

These keys are 'modifier' keys, because they modify tool behavior. Modifier keys do other things too – hold down the Option/Alt key and click on the marquee tool in the Tools palette. Notice that the tool displayed cycles through the options available. Drag down from the system or Apple menu to select About Photoshop... The splash screen reopens and after about 5 seconds the text starts to scroll telling you lots of stuff about the Adobe team who wrote the program etc. Hold down the Option/Alt key and the text scrolls faster. If you hold down the Command/Ctrl key and choose About Photoshop... you will get to see the *Venus in Furs* beta test version of the splash screen. If you want to see another Easter egg, go to the Layers palette, hold

down the Option/Alt key and choose Palette Options from the palette sub-menu. For the most part, modifier keys are used in conjunction with the selection tools and as you get more proficient you should be able to reach to the appropriate key instinctively without your eyes having to leave the screen.

Figure 6.18 The modifier keys on a Macintosh keyboard and their Windows PC equivalents.

The Shift and Option/Alt keys affect the shape and drawing behavior of the marquee tools: holding down the Shift key when drawing a marquee selection constrains the selection to a square or circle; holding down the Option/Alt key when drawing a marquee selection centers the selection around the point where you clicked on the image.

Holding down the Shift+Option/Alt keys when drawing a marquee selection constrains the selection to a square or circle and centers the selection around the point where you first clicked. Here is another useful tip: after drawing the selection, do not release the mouse button yet – hold down the Spacebar. This allows you to reposition the placement of the selection. Release the Spacebar and you can continue to modify the shape as before.

After the first stage of drawing a selection, whether by marquee, lasso, magic wand or a selection has been loaded from a saved alpha channel with subsequent selection tool adjustments, the modifying keys now behave differently.

Holding down the Shift key as you drag with the marquee or lasso tool adds to the selection. Holding down the Shift key and clicking with the magic wand tool also adds to the existing selection.

Holding down the Option/Alt key as you drag with the marquee or lasso tool subtracts from the selection. Holding down the Option/Alt key and clicking with the magic wand tool also subtracts from the existing selection.

A combination of holding down the Shift+Option/Alt keys together whilst dragging with a selection tool (or clicking with the magic wand) creates an intersection of the two selections.

To summarize: The Shift key adds to a selection. The Option/Alt key subtracts from a selection and the Shift+Option/Alt keys intersect a selection. To find out more about practical techniques requiring you to modify selection contents, refer to Chapter Eleven on montage techniques.

Lasso: freehand/polygon/magnetic

The lasso tool behavior is more or less identical to that of the marquee selection tools – the same modifier key rules apply. To use the standard lasso tool, just drag around the area to be selected holding down the mouse as you draw. When you release the mouse, the selection joins up from the last point drawn with the starting point.

In polygon mode, you can click to start the selection, release the mouse and position the cursor to draw a straight line, click to draw another line and so on. To revert temporarily to freehand operation, hold down the Option/Alt key and drag with the mouse. Release the Option/Alt key and the tool reverts to polygon mode. To complete the polygon lasso tool selection position the cursor directly above the starting point (a small circle icon appears next to the cursor) and click.

The magnetic lasso and the magnetic pen tool both use the same code and they are therefore basically the same in operation, except one draws a selection and the other a pen path. The magnetic lasso has a sensing area (set in the Options bar). When you brush along an image edge, where an outline is detectable, the magnetic lasso intelligently prepares to create a selection edge. You continue to brush along the edges until the outline is complete and then you close the selection.

This innovation is bound to appeal to beginners and anyone who has problems learning to draw paths with the pen tool. I reckon on this being quite a powerful Photoshop feature and should not be dismissed lightly as an 'idiot's pen tool'. Used in conjunction with a graphics tablet, you can broaden or narrow the area of focus by varying

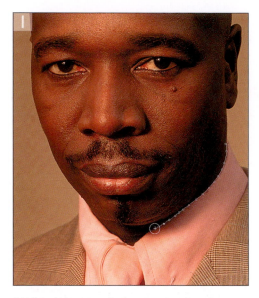

1 Where there is a high contrast edge, the magnetic lasso has little problem following the suggested path roughly drawn by dragging along the shirt collar. Fastening points are automatically added along the path. The center cross-hair hotspot will help guide you when locating the edge.

2 The size of the magic lasso selection area can be enlarged by lessening the pressure if using a graphic tablet input device. This makes drawing an outline much quicker. For precise edge definition, add more pressure to narrow down the tool's field of view.

3 In a situation like this there is quite a lot of room for latitude. As you draw the tool away from the edge, it does not add another point until it senses a continuation of the edge. You can watch the tool laying down a path like a magnet sticking to an edge. To scroll the screen as you work, hold down the Spacebar – this temporarily accesses the hand tool without disturbing the operational flow of the selection tool.

the stylus pressure. Without such a tablet, you have basic mouse plus keyboard control, using the bracket keys ([and]) to determine the size of the tool focus area. The only way to truly evaluate the performance of the magnetic tools is to take them for a spin and learn how to use them in combination with the relevant keyboard keys. In operation, the magnetic lasso and magnetic pen tool operate alike: the magnetic lasso draws a pseudo path, laying down fastening points along the way – the distance apart of the points can be set in the Options bar as a frequency value, whilst the edge contrast specifies the minimum contrast of an edge before the tool is attracted. As you brush along an edge, an outline follows the edge of greatest contrast within the brush width area and sticks to it like a magnet.

4&5 If you veer too far off course, reverse the path of the tool and hit the delete key to erase the previous point (there are no limits to this type of undo). To complete the selection, hit the Enter key or double-click. The end points will join up and if there is a gap, attempt to follow and continue the image outline.

I The magnetic tools in Photoshop, operate by analyzing the composite image to determine where the edges of an object lie. The difficulty is that the edges are not always as clear to Photoshop as they seem to be to us.

2 One answer is to sometimes add a temporary, contrast increasing adjustment layer to the image. So, add a new curves adjustment layer and make the curve an 'S' shape. Now the outline appears much clearer and the magnetic tools have no trouble seeing the edges. When the magnetic selection or path is complete, discard the adjustment layer.

Photograph: Peter Hince.

To reverse a magnetic outline, drag back over the outline so far drawn. Where you meet a fastening point, you can either proceed forward from that position or hit the delete key to reverse your tracks even further to the fastening point before that and so on... You can manually add fastening points by clicking with the mouse.

Whilst defining an outline, a combination of mousing down with the Option/Alt key changes the tool back to the regular lasso to manually draw round an edge. Holding down the Option/Alt with the mouse up changes the tool to the polygon lasso (or freeform pen tool if using the magnetic pen). Other selection modifier key behavior comes into play before you start to drag with the tool – hold down the Shift key then drag to add to an existing selection. You don't have to keep the mouse pressed down as is necessary with the lasso. When using the magnetic lasso, you can just click, drag and only click again when you wish to lay down a fastening point.

To complete a selection, click on the start point. Double-click or hit Enter to close with a line determined by the magnetic tool. Photoshop will intelligently follow the line you are currently on and close the loop wherever there is good edge contrast for the tool to follow. Option/Alt+double-click closes the path with a straight line segment.

⊞ Move tool

The move tool can now be more accurately described as a move/transform/alignment tool. The transform mode is apparent whenever the Show Bounding Box is checked (initially a dotted bounding box appears around the object). When you mouse down on a bounding box handles, the Options bar display will change to reveal the numeric transform controls (no longer a menu item). This transform feature is only active when the move tool itself is selected and not when you use the Command/Ctrl key shortcut.

When two or more layers are linked, you can click on the align and distribute buttons in the Options bar as an alternative to navigating via the Layer > Align Linked and Distribute Linked menus (see Chapter Fifteen for more about the align and distribute commands). The move tool is also activated whenever you hold down the Command/Ctrl key. The exceptions to this are when the slice or slice select tools are selected (the Command/Ctrl key toggles between the two), or when the hand, pen tool or path selection tools are active. The Option/Alt key modifies move tool behavior. Holding down the Option/Alt key plus the Command/Ctrl (move tool shortcut) as you drag a selection makes a copy of the selection.

You use the move tool to:

- Drag and drop layers and selections from one image window to another.
- Move selections or whole images from Photoshop to another application.
- Move selection contents or layer contents within a layer.
- Copy and move a selection (hold down Option/Alt key).
- Apply a Transform to a layer.
- Align and/or distribute two or more layers.

When one of the selection tools is selected, dragging within a selection does not move the selection contents, but moves the selection outline only. When the move tool is selected, dragging will move the layer or selection contents (the cursor does not have to be centered on the object or selection, it can be anywhere in the image window). When the Auto Select Layer is switched on, the move tool will auto-select the uppermost layer containing the most opaque image data below the cursor. This is a useful mode for the move tool with certain layered images. If you have the move tool selected in the Tools palette and the Auto Select Layer option is unchecked, holding down the Command/Ctrl key temporarily inverts the state of the move tool to Auto Select Layer mode. Where many layers overlap, the use of the Ctrl/right mouse-click to access the contextual layer menu is the more precise (if slower) method of selecting a layer from within the document window.

⌗ Crop tool

The crop tool has been nicely enhanced in version 6.0 to include colored shading of the outer crop area. This provides a useful visual clue when making a crop. Figure 6.19 shows the Options bar in 'crop active' mode, where the default shade is a black color set to a 75% opacity. This color can easily be changed by clicking on the color swatch in the Options bar and choosing a new color from the picker. In my opinion, the standard color and opacity will enable you to adequately preview the crop with most images. Only if a sequence of images you are working on have very dark back-ground will you perhaps benefit from changing the color to something like a 'ruby lith' red or another lighter color. The Delete button will delete layered image data outside of the crop boundary. The Hide button will crop the image, but only hide the layer data which is outside the crop boundary (also referred to as big data). The hidden layer data will be preserved. When one or more layer's contents extend be-yond the canvas boundary, the Image > Reveal All command can be used to enlarge the canvas size to show the hidden 'big data'.

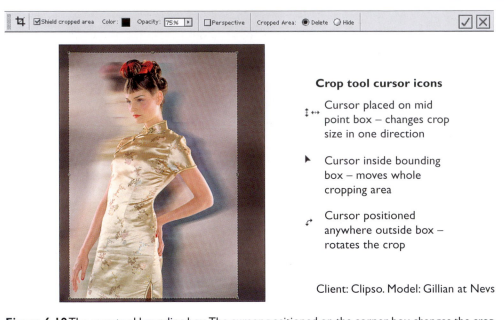

Crop tool cursor icons

‡↔ Cursor placed on mid point box – changes crop size in one direction

▶ Cursor inside bounding box – moves whole cropping area

↻ Cursor positioned anywhere outside box – rotates the crop

Client: Clipso. Model: Gillian at Nevs

Figure 6.19 The crop tool bounding box. The cursor positioned on the corner box changes the crop dimensions both horizontally and diagonally. The center point can be repositioned to set the central axis of rotation.

Figure 6.20 In this example the Image > Trim... command is used to crop the image based on transparency. Photoshop crops all four edges, removing transparent contents only.

You use the Enter key to OK the crop and the Escape (esc) key to cancel and exit from cropping. On Macintosh and PC keyboards, these keys should be diagonally positioned, with the 'esc' key at the top left and Enter key at bottom right. Drag the crop tool across the image to marquee the estimated crop. Refine the position of the crop by directly dragging one of the eight crop handles. The crop tool will snap to the edge of the document if View > Snap to > Document bounds is checked. To avoid this, go to the View menu and uncheck the specific 'document bounds' or general

snap to behavior. Photoshop 5.x users take note: in Photoshop 6.0, if you hold down the Command/Ctrl key as you drag one of the corner handles, this will not disable the snap to behavior, but take you into the perspective cropping mode. For more about perspective cropping, see Chapter Eight.

Constrain the proportions of the crop by holding down the Shift key as you drag. You can reposition the crop without altering the crop size by dragging within the crop area. To rotate the angle of the crop, move the cursor anywhere just slightly outside the crop window. The crop bounding box has a movable center point. When you place the cursor and drag above the center point the central axis of rotation can be repositioned. The Image > Trim... command is also new in Photoshop 6.0. The Trim command can be used to crop an image based on pixel color values. Figure 6.20 shows an example of how trimming can crop an image based on transparency.

Figure 6.21 Images can be sliced up in Photoshop 6.0 using the slice tool. You can optimize individual slices inside the Photoshop Save for Web dialog (ImageReady slices will also be recognized in Photoshop). Choose Layer > 'New Layer Based Slice' to create slices based on Photoshop layers. This will update the slices when layer effects like Drop Shadows are added or adjusted.

| Style: | Normal | ⬍ | Width: | Height: | ☑ Show Slice Numbers | Line Color: | Light Blue | ⬍ |

Slicing tools

Following Photoshop 5.5's incorporation of ImageReady 2.0 as part of the Photoshop package, you will find several of the ImageReady tools are now added to the Photoshop 6.0 Tools palette, and among these are the slicing tools. Slices are used to divide an image up into rectangular sections which will instruct ImageReady as to how to cut up a single image into many smaller blocks. You can specify in ImageReady how each individual slice will be optimized, what file format it will be saved in and what compression shall be utilized. You use the slice tool to manually define a user-slice. As you create user-slices, Photoshop automatically generates auto-slices to divide up the other areas as can be see in Figure 6.21. You can use the slice select tool (toggle with the Command/Ctrl key) to go back and edit the size of each slice afterwards.

The paint tools

Situated below the selection and move tools are the tools for painting and pixel modification. The common options available to these tools are those of different blending modes and opacity settings. If you don't have a pressure sensitive tablet and have to rely on a mouse, you can set the opacity or intensity of the tool action from 1 to 100%. Opacities can also be set from the keyboard: 1=10%, 9=90% and 0=100% (and with double digit accuracy if typed quickly, i.e. 03; 27). If you do have a graphic tablet as your input device (which is always highly recommended) the stylus pressure sensitivity options will become active in Photoshop. These offer fine control over tool behavior (see the Brush dynamics box under the right-most tool icon in the Options bar). The Fade options under Brush dynamics are not stylus-dependent. The number of fade steps entered will allow you to 'fade out' a brush stroke. The Photoshop paint tools are more than adequate for painting and retouching work. Combine the basic tool functions with different blending modes, brush shapes, fade last brush stroke and other options (such as Wet Edges for the paintbrush tool) and Photoshop becomes a sophisticated artist's painting program. For example, you can design your own custom brush shapes or load other custom brush sets via the brushes section of the Preset Manager. The only problem as I see it is the lack of an intuitive interface for this type of work. You need to spend some time familiarizing yourself with all the variables to really feel at home like an artist with his or her favorite paint tools. Metacreation's Painter program is regarded as one of the best bit-mapped paint programs because it provides a very wide range of brushes and the interface is well thought out for the needs of digital paint artists. Here though is a run down of the main Photoshop paint tools.

Airbrush

Mimics the effect of a real airbrush, producing a spray of paint. As you click with the mouse or press down with the stylus, the airbrush paint will continue to spread out if you stop moving the cursor, just as in real life.

Paintbrush

The standard paint tool for retouching work. This can be used with a range of brush sizes from a single hard edged pixel up to the largest soft edged brush (999 pixels). The Wet Edge painting mode builds extra density around the edges of the brush stroke. This imitates a natural paintbrush effect.

Pencil

The pencil produces hard edged, anti-aliased, pencil-like drawing lines. The pencil tool is a fast response sketching tool. The 'Auto Erase' option converts the tool from painting with the foreground to the background color. The Auto Erase feature can also be accessed by holding down the Option/Alt key.

Clone stamp/Pattern stamp

An essential tool for retouching work such as spotting (discussed later in Chapter Ten) and general repair of images. The clone stamp tool is used to sample pixels from one part of the image to paint in another. Keep the Aligned box checked, hold down the Option/Alt key and click where you want to sample from. Release the key

and click in the area you want to clone to. This action defines a relationship between sample and painting positions. Once set, any subsequent clicking or dragging will allow you to apply the clone stamp, always using the same coordinates relationship. The sample point can also be from a separate image. This is useful for combining elements or textures from other pictures. The clone stamp normally samples from a single layer only. The Use All Layers option permits the clone sample to be taken from merged layer pixel information. The pattern stamp tool allows you to select a pattern in the Options bar and paint using the pattern as your source.

History brushes

Before History made its first appearance in Photoshop 5.0, there were few ways you could restore a previous image state. The History amalgamates some of the old work-arounds into a single Photoshop feature. It replaces the use of the snapshot and very cleverly makes use of the image tiling to limit any unnecessary drain on memory usage. One can look at the History as a multiple undo feature in which you can reverse through up to 99 image states, but in actual fact History is a far more sophisticated and powerful tool than just that. Painting from history saves you from tedious work-arounds like having to duplicate a portion of the image to another layer, re-touching this layer and merging back down to the underlying layer again.

The History palette displays the sequence of Photoshop states as you progress through a Photoshop session (as shown in Figure 6.22). To reverse to a previous state, you can either click on it or drag the arrow slider back up the list. The number of histories allowed can be set in the History palette pop-up menu. When the maximum number of history states has been reached, the earliest history state at the top of the list is discarded. If you reduce the number of history states allowed, any subsequent action will also cause the earlier history states to be discarded.

History brush and Snapshot

To create a snapshot, click on the Snapshot button at the bottom of the palette. Snapshots are stored above the divider – this records the image in its current state and prevents this version of the image from being overwritten for as long as the document is open and being edited. The default operating mode stores a snapshot of the opening image state. You can choose not to store an opening image this way if you prefer and take more snapshots at any time to add to the list. This feature is useful if you have an image state which you wish to temporarily store and not lose as you

progress through further image changes. There is no constraint on only having a single snapshot stored at a time. In the History palette options you can check to automatically generate a new snapshot each time you save. This can be useful, but be aware that it may cause Photoshop's memory usage to increase significantly. Alternatively, you can click the duplicate image button to create a duplicate image state and then save this duplicate file.

Figure 6.22 Click on the New Snapshot button at the bottom of the History palette – this will record a snapshot of the history at this stage. If you Option/Alt-click the button, there are now three options: Full Document, which stores all layers intact; Merged Layers, which stores a composite; and Current Layer, which stores just the currently active layer. The adjacent New Document button will duplicate the active image in its current history state.

To use the history brush, go to the History palette and click on the space just to the left of the history state you wish to paint from – you will see a history brush icon appear against it. You can then paint information in from a previous history state (or from one of the snapshots) to the active state. The History brush lets you selectively paint back in the previously held image information as desired. That is a simple way of looking at the history brush, but it is actually more versatile than that. The alternative spotting technique in Chapter Ten shows how the history feature can be used to avoid the need for duplicating layers. The history feature does not really take on the role of a repeat Edit > Undo command and nor should it. There are several actions which will remain only undoable with the undo command, like intermediate changes when setting shadow and highlights in the levels dialog. Furthermore there are things which can be undone with Edit > Undo that have nothing to do with the history. If you delete an action or delete a history, these are only recoverable using Edit > Undo. So although the history feature is described as a multiple undo, it is important not to confuse history with the role of the undo command. The undo command is toggled and this is because the majority of Photoshop users like to switch quickly back and forth to see a before and after version of the image. The current combination of undo commands and history has been carefully planned to provide the most flexible and logical approach – history is not just as an 'oh I messed up. Let's go back a few stages' feature, which is the way programs like Adobe Illustrator work, it is a tool designed to ease the workflow and allow you more creative options in Photoshop.

History stages	Scratch disk
Open file	61.2
Levels adjustment layer	138.9
Curves adjustment layer	139.9
Rubber stamp	158.3
Rubber stamp	159.1
Rubber stamp	160.1
Rectangular marquee	139.7
Feather 100 pixels	149.9
Inverse selection	162.6
Levels adjustment layer	175.3
Flatten image	233.5
Unsharp mask filter	291.7
Close	

Figure 6.23 The accompanying table shows how the scratch disk memory will fluctuate during a typical Photoshop session. The opened image was 38.7 Mb in size and 250 Mb of memory was allocated to Photoshop. Notice how minor local changes to the image do not increase the amount of memory used compared with the global changes. The history states are recorded in the History palette. The active history state is indicated by the pointer icon (circled in blue above).

History and memory usage

Conventional wisdom suggested that any multiple undo feature would require vast amounts of memory to be tied up storing all the previous image states. Testing Photoshop history will tell you this is not necessarily so. It is true that a combination of global Photoshop actions will cause the memory usage to soar, but localized changes will not. You can observe this for yourself – set the image window bottom left corner status display to show Scratch Disk usage and monitor the readout over a number of stages. The right hand value is the total amount of scratch disk memory currently available – this will remain constant, watch the left hand figure only. Every Photoshop image is made up of tiled sections. When a large image is in the process of redrawing you see these tiles rendering across the screen. With history, Photoshop memorizes changes to the image at the tile level. If a brush stroke takes place across two image tiles, only the changes taking place in those tiles are updated and therefore the larger the image the more economical the memory usage will be. When a global change takes place such as a filter effect, the whole of the image area is updated and memory usage will rise accordingly. A savvy Photoshop user will want to customize the history feature to record a reasonable number of histories, while at the same time being

Figure 6.24 This picture shows the underlying tiled structure of a Photoshop image when it is being edited. In this example we have a width of four tiles and a height of three tiles. This is the clue to how history works as economically as possible. The history only stores in Photoshop memory the minimum amount of data necessary at each step. So if only one or two tile areas are altered by a Photoshop action, only the data change for those tiles is recorded.

aware of the need to change this setting if the history usage is likely to place too heavy a burden on the scratch disk memory. The example in Figure 6.23 demonstrates that successive histories need not consume an escalating amount of memory. After the first adjustment layer, successive adjustment layers have little impact on the memory usage (only the screen preview is being changed). Clone stamp tool cloning and brush work affect changes in small tiled sections. Only the flatten image and unsharp mask filter which are applied at the end add a noticeable amount to the scratch disk usage. The Purge History command in the Edit > Purge menu provides a useful method of keeping the amount of scratch disk memory used under control. If the picture you are working with is exceptionally large, then having more than one undo can be both wasteful and unnecessary, so you should perhaps consider restricting the number of recordable history states. On the other hand, if multiple history undos are well within your physical system limits, then make the most of it. Clearly it is a matter of judging each case on its merits. After all, History is not just there as a mistake correcting tool, it has great potential for mixing composites from previous image states.

Non-linear history

Non-linear history enables you to branch off in different directions and recombine effects without the need for duplicating separate layers. Non-linear history is not an easy concept to grasp. The best way to think about non-linear history is to imagine each history state having more than one 'linear' progression, allowing the user to branch off in different directions instead of as a single chain of events in Photoshop. Figure 6.25 shows more clearly the concept of non-linear history and how now in

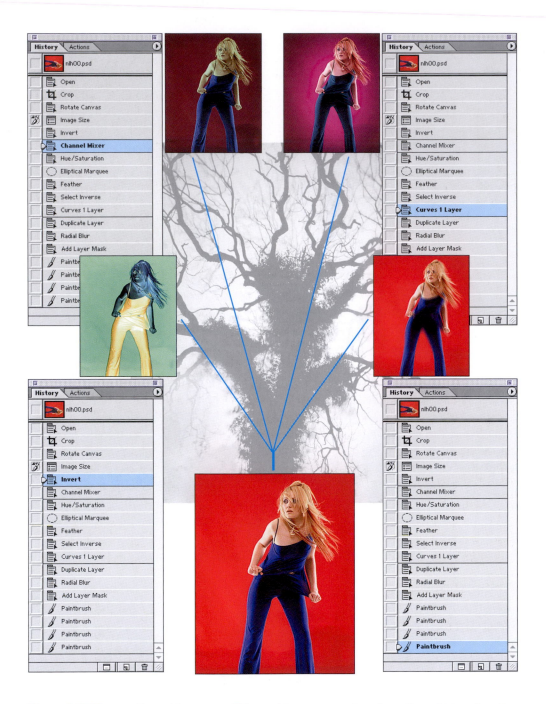

Figure 6.25 The non-linear history tree. This graphic representation of non-linear history in action shows an image at four different stages in the History palette all of which branch off from one common ancestor. If you examine the History palette carefully, you will observe how the non-linear history branches appear separated in the palette by a divider line. Client: Schwarzkopf. Model: Louise Ann.

Photoshop you can take an image down several different routes, whilst working on the same file in a single Photoshop session. Snapshots of history branches can be taken and painted in with other history branches without the need to save and duplicate files. Non-linear history requires a little more thinking on your part in order to monitor and recall image states, but ultimately makes for more efficient use of the available memory. To see some practical examples of how to use this and other history features in a Photoshop retouching session, refer to Chapter Eleven on montage techniques.

Key combination	Action
Command-Z (Toggles Undo/Redo)	
Command-Z	Undo/Redo command
Command+Option-Z	Step back through history states
Command+Shift-Z	Step forward through history states
Command+Shift-Z	
Command-Z	Step back through history states
Command+Shift-Z	Step forward through history states
Command-Y	
Command-Z	Step back through history states
Command-Y	Step forward through history states

Figure 6.26 This is a summary of the outcome of the permutations of the three types of undo settings available in the Edit > Preferences > General options. The toggle undo/redo setting is the default. Command+Shift-Z and Command-Y are identical: they allow you to disable the toggle undo function.

Art history brush

The art history brush was in introduced in version 5.5. I have to confess that this is not the most essential Photoshop tool that was ever invented and am at a loss to know how exactly I might wish to use it. Nevertheless, with art history you use the art history brush to sample from a history state, but the brush strokes have some unusual and abstract characteristics which smudge the pixels with sampling from the selected history state. The brush characteristics are defined in the Art History Options bar. Fidelity determines how close in color the paint strokes are to the original color. The larger the Area setting, the larger the area covered by and more numerous the paint strokes.

1 To explore the potential of the art history brush, I took the backlit flower image and applied a Brush Stroke > Ink Outlines filter. I then clicked to the left of the unfiltered history state, to set this as the history source. The art history brush is located next to the history brush in the Tools palette. With it you can paint from history with impressionistic type brush strokes.

2 The most significant factor will be the brush stroke type – in this particular example I mostly used 'Dab' and set the blending mode to Lighten only. The brush shape will have an impact too, so I varied the choice of brushes, using several of the bristle type brushes (see Photoshop brushes, earlier in this chapter).

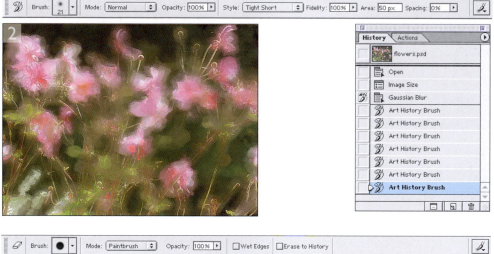

Eraser/background eraser/magic eraser

The eraser removes pixels from an image, replacing them with the current background color. There are four brush modes: paintbrush, airbrush, pencil and block. If you check the Erase to History box, the eraser behaves like the history brush. Holding down Option/Alt as you paint also erases to the currently selected History. The Wet Edges option is available when erasing in paintbrush mode. Note that some graphic tablet devices like the Wacom™ series operate in eraser mode when you flip the stylus upside down. This is recognized in Photoshop without having to select the eraser tool.

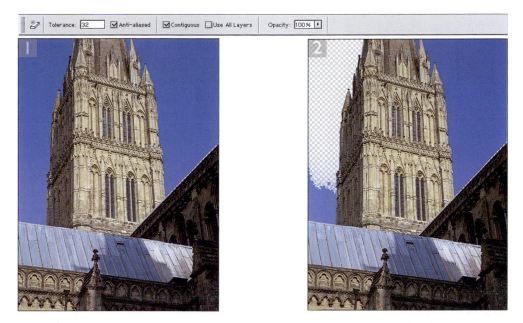

1 The magic eraser tool operates like a combination of the magic wand followed by a delete command. For this reason it is sometimes best to duplicate a layer first before you do any erasing. Remember, you can always use the history feature as a means to restore any mistakenly erased pixels.

2 In this first example, I clicked with the magic eraser on the sky area about half way up to the left of the spire. The magic eraser options were set to Contiguous. This meant that only neighboring pixels which fell within the specified tolerance (32) would be selected by the magic eraser and deleted.

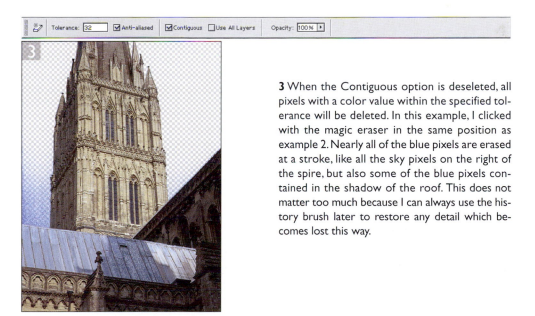

3 When the Contiguous option is deselected, all pixels with a color value within the specified tolerance will be deleted. In this example, I clicked with the magic eraser in the same position as example 2. Nearly all of the blue pixels are erased at a stroke, like all the sky pixels on the right of the spire, but also some of the blue pixels contained in the shadow of the roof. This does not matter too much because I can always use the history brush later to restore any detail which becomes lost this way.

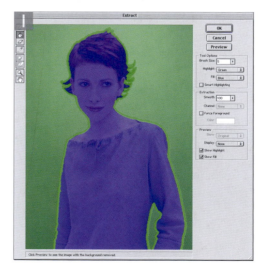

4 The background eraser tool provides more precise control. Here the tool is set to erase sampling 'Once' and in Find Edges mode. This means that when I click and drag, all pixels within a specified tolerance (or pressure applied by the stylus) of the pixel value where I first clicked will be erased by the tool. The background eraser will also erase the background sample color from the edge pixels – this will help remove the color contamination as you erase. The Find Edges mode preserves the edge sharpness better.

To summarize the other erasing tools: the background eraser erases pixels on a layer to transparent based on the pixel color sampled, while the magic eraser works like the paint bucket tool in reverse – erasing neighboring or 'similar' pixels, based on the pixel color value where you click. The magic wand and paint bucket tools also have the 'Contiguous' mode of selection, available as a switchable option in the Options bar. Switching this on or off allows you to make a selection based either on neighboring pixels only falling within the specified tolerance or all pixels in the image of a similar value.

The Extract command

1 The Photoshop Extract command is a sophisticated, automated masking tool and can be compared directly to competing plug-in products. The Extract command is an integral part of the program and works well in combination with the background eraser which can remove any portions of the image that the Extract command fails to erase. You first define the edge of an object, roughly painting along the edge with the highlighter tool (Smart Highlighting makes this task easier now) and mistakes can be undone using Command/Ctrl-Z. Where the object to be extracted has a solid, well-defined interior, you can fill the inside areas using the fill tool.

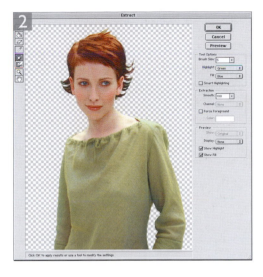

2 When you click on the Preview button, Photoshop calculates and previews the resulting mask in the dialog window. Inside the dialog window interface, you can edit the mask edges with the highlighter, eraser and fill tools or adjust the smoothness to remove any pixel artifacts. You can also tidy up the extraction in the preview, using the new clean-up tools. Test with the Preview as many times as you wish before proceeding to apply the chosen settings and erase the areas outside the object to transparency.

For more on how to use the new eraser tools and the Extract command, see Chapter Eleven on montage techniques.

Client: YU salon. Model: Kate Broe at M&P.

Gradients

The gradient tool can be used to draw linear, radial, angular reflected or diamond gradients. Go to the Options bar and click on the gradient ramp (top left) to select a gradient option such as Foreground to Background color, or click on the small arrow to the right to open the gradient list. When you drag with the gradient tool inside the image window, a gradient fill is created between those two points. Hold down the Shift key to constrain the gradient angle to a horizontal/vertical or 45 degree angle. Check the Reverse box to reverse the gradient fill colors before you drag. The Dither checkbox should be kept on – this will add a subtle noise, ensuring there is less risk of any banding appearing in the gradient fill. When the Transparency box is checked, the transparency masks in gradients are recognized. A number of preset gradients are readily available when you first open the gradient list from the Options bar. You can also easily edit and create your own gradient pattern and any alterations you make to an existing preset gradient will not overwrite that preset. See the accompanying tutorial showing how to create and customize a gradient.

Gradients can also be applied as a fill layer in Photoshop 6.0. Go to the Layers palette, click on the adjustment layer button and select Gradient Layer. This action will add a gradient that fills the whole layer and add a layer mask. This feature is like any other type of adjustment layer in that it allows you to edit the gradient fill. You can alter the precise angle or gradient type etc. at any time.

1 To create a custom gradient, click on the gradient ramp in the Gradient Options bar and choose Edit... to open the accompanying Edit dialog box. (Clicking on the side arrow will call up the gradient list – shown here in Small Text view mode).

2 Click on the lower left-most stop to select it and then double-click it or click once on the color box – this will open the Color Picker. Choose a new color for the start of the gradient. Here I picked a bright blue.

3 If I click above the bar, I can add a new transparency stop. Notice how the lower part of the dialog changes so that I can alter the opacity of the gradient at this 'stop' point to, say, 50%. I can position this transparency stop anywhere along the gradient scale and also adjust the diamond-shaped midpoints accordingly.

4 I can then add another transparency stop, but this time restore the opacity to 100% and curtail the extent of the transparency fade to the right of this point. I added another color stop below and this time made the color purple. When the gradient editing is complete all I have to do is rename the gradient in the space above and click on the New button. The new gradient will be saved and added to the current gradient set.

Noise gradients

I It is important to note that the Noise Gradient Editor is separate to the Solid Gradient Editor and any settings made in the Solid Gradient Editor will have no bearing on the appearance of the noise gradient. When you select Gradient Type: Noise, the smooth gradient ramp will be replaced by a random noise ramp. Clicking on the Randomize button will present you with many interesting new random gradient options to choose from.

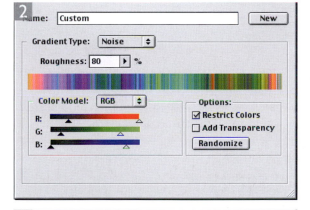

2 Increase the amount Roughness to make the noise gradient more spiky. The color sliders below edit the color content. In RGB mode, the red right-hand slider controls the amount of red content, while the left-hand slider controls the complimentary, cyan content and so on... Check the Saturate Colors box to boost color richness.

3 The Noise Gradient Editor is a very versatile tool, and it is well worth experimenting with the roughness slider – lower percentage settings can produce some very subtle effects.

More about gradients is covered in the Preset Manager section of this chapter, page 128 and Chapter Fourteen on coloring effects and the use of gradient fill and gradient map fill layers.

| | Fill: | Pattern | ⇕ | Pattern: | ▾ | Mode: | Normal | ⇕ | Opacity: | 100% | ▸ | Tolerance: | 32 | ☑ Anti-aliased | ☑ Contiguous | ☐ All Layers |

Paint bucket

In some ways this tool is in effect nothing more than 'make a magic wand selection based on the Tolerance setting in the Options bar and fill the selection with the current foreground color or predefined pattern'. In this mode of operation, there is none of the flexibility associated with making a magic wand or Color Range selection and modifying it before filling. I had never found a good use for this tool until it was pointed out that you could use the paint bucket to quickly fill the inside areas of a mask or quickmask outline. The Contiguous option is also available for the paint bucket (see description for the magic wand). But the paint bucket can also be used for filling with a pattern as well as with a solid color. Choose the Pattern mode from the Options bar and select the pattern type.

| | Brush: | ● | ▾ | Mode: | Normal | ⇕ | Pressure: | 50% | ▸ | ☐ Use All Layers | | ✎ |

Focus: blur/sharpen/smudge

If your aim is to soften an image edge, do not use the smudge tool, but rather the blur option from the focus tool options. In blur mode, the blur tool is just like painting with one of the blurring filters. I use it a lot to soften portions of image outlines after compositing or locally modifying alpha channel masks. I recommend you use the converse option – sharpen – sparingly. Excessive tool sharpening creates nasty image artifacts. The results are too crude for my liking, it is much better to make a feather edged selection of the area to be sharpened and apply the unsharp mask filter instead. While either the blur or sharpen tool are selected, you can temporarily switch between one tool and the other, by holding down the Option/Alt modifier key.

| | Brush: | ● | ▾ | Mode: | Normal | ⇕ | Pressure: | 50% | ▸ | ☐ Use All Layers | ☐ Finger Painting | | ✎ |

The smudge tool selects the color of the pixels where you first click and smears pixels in whichever direction you drag the brush. For best results I recommend using a pressure sensitive graphics tablet. The Finger Painting option uses the current foreground color for the start of the smudge. It is best to think of this as an artist's tool like a palette knife used in oil painting.

Toning tool options	
Dodge tool	**Function**
Option+Shift+W	Set Dodge to Shadows
Option+Shift+V	Set Dodge to Midtones
Option+Shift+Z	Set Dodge to Highlights
Option/Alt key	Toggle to Burn tool
Burn tool	**Function**
Option+Shift+W	Set Burn to Shadows
Option+Shift+X	Set Burn to Midtones
Option+Shift+Z	Set Burn to Highlights
Option/Alt key	Toggle to Dodge tool
Sponge tool	**Function**
Option+Shift+J	Set Sponge to Desaturate
Option+Shift+A	Set Sponge to Saturate

Figure 6.27 The toning tool shortcut options.

Toning: dodge/burn/sponge

Dodging and burning should be familiar concepts. Photoshop provides a nice element of control over the tool effect: you can choose to apply the toning effect selectively to either the Highlights, Midtones or Shadows. Thus if you want to darken or burn the shadow portion of an image without affecting the adjacent highlights, choosing the burn tool in Shadows mode will enable you to do this. As an alternative to the clone stamp tool, the dodge tool is excellent for removing wrinkles and facial lines without altering the underlying texture if applied in very low percentages. The third option is the sponge tool which has two modes: Saturate increases the color saturation, Desaturate lowers the color saturation. The handy shortcuts listed in Figure 6.27 permit quick access to the tonal range application settings. As with the blur and sharpen tool, holding down the Option/Alt modifier key will temporarily switch between the dodge and burn tools.

Pen and path drawing

Photoshop provides a suite of vector path drawing tools. These work in the same way as those found in programs like Illustrator and Freehand. For detailed instructions on drawing paths and working with the pen tool, refer to Chapter Eleven on montage techniques. The magnetic pen tool behavior (now a freeform pen tool option) is more or less identical to the magnetic lasso. The freeform pen is like the same tool in Illustrator – a free drawing pen tool, which operates like the lasso.

Type tool

The type tool now for the first time allows direct on-canvas text editing. This is a major step forward in the way Photoshop handles type. There are two ways you can use the type tool: either click in the image window and begin typing – this will add a single line of text – or you can click and drag to define a box within which you can add flowing lines of text. Click on the Palettes button in the Options bar to bring the Character and Paragraph palettes (briefly mentioned at the beginning of this chapter) to the front of the palette set. These provide full typographic control of the text entered.

Because the type is in vector art form, it remains fully editable. You can highlight type in the window, to reset the type at any time. (Tip: choose View > Hide Extras to hide highlighting.) You can change the fonts, apply different colors to all the text or just single characters, or enter new text. Layer effects/styles can be applied to both type layers and image layers. Layer effects automate the process of adding grouped layers to provide effects such as drop shadows. Although you can create advanced text effects with plug-ins like Vector Effects from Metacreations, there are so many more text effects which can only be achieved in Photoshop. Layer effects now offer a phenomenal variety of text effects and for the first time in Photoshop 6.0, you can now distort text using the Warp Text commands, which are available from the Options bar.

This is a book about Photoshop and photography. A rich variety of text effects can be achieved in Photoshop and many designers who work in print and multimedia often use the program for this very purpose. There are plenty of other Photoshop books devoted mainly to the needs of graphic designers, but contain little information about image manipulation. I am going to concentrate on the needs of image makers first here – you will therefore find only a limited amount of information on the type tools in Chapter Fifteen.

Line and shape tools

The line tool now shares its position with the new shape tools which are another crossover from ImageReady. Single pixel or wider lines can be drawn with the line tool. To constrain the drawing angle in 45 degree increments, hold down the Shift key (this applies to all the painting tools as well). Arrow heads can be added to the line either at the start or finish of the line. Click the Shape... button in line tool Options to customize the appearance of the arrowhead proportions. You see, the potential to create shapes has been in Photoshop all along. What Photoshop now does is to unleash that potential and let us create filled shapes which can be in the form of a filled layer with a layer clipping path, a solid fill, or a path outline. You can define polygon shapes and also import custom shapes from EPS graphics, such as a regularly used company logo, and store these as presets using the Preset Manager if you wish.

| ☐ | Author: [Martin Evening] | Font: [AGaramond ⬍] | Size: [Medium ⬍] | Color: ☐ | [Clear All] |

Annotation tools

Photoshop now enables you to add either text or sound notes to a file. Annotated documents can be saved in the Photoshop, PDF or TIFF formats. To annotate an open document, select the text note tool and click inside the image window. A note icon is placed together with an open text window. Enter text inside the window – for example, this can be a short description of the retouching which needs to be carried out on this part of the picture. After completing the text entry, close the text window. The text note will remain as a small icon floating above the actual image. Although viewable in Photoshop, these notes will not be visible when you actually come to print the image. If you save a copy of an image as a PDF and send this to a client, they will be able to open it in Acrobat, add notes in Acrobat and export a Notes file for you to import back into the original Photoshop image. To delete a note or delete all notes, Control/right mouse-click on a note icon. The contextual menu will offer you the choice of deleting that note or all notes in the current document. If you want to append a sound note to a file, check in your System Control Panels that the computer's built-in microphone is selected as the incoming sound source. When you click in the window with the sound note tool a small sound recording dialog appears. Press the record button and record your spoken instructions. When finished, press Stop. The sound message will be stored in the document when saved in the above file formats.

| ✎ | Sample Size: [3 by 3 Average ⬍] |

Eyedropper/color sampler

The eyedropper samples pixel color values from any open image window and makes that the foreground color. The sample area can be set to Point, 3×3 Average, 5×5 Average. I prefer the last two options. This is because a single pixel color value may not be truly representative. You might quite easily be clicking on a 'noisy' pixel or some other pixel artifact. A 3×3 average, 5×5 average sample area will usually provide a better indication of the color value of the pixels in the area you are click-ing. If you hold down the Option/Alt key, the sample becomes the background color (when working with any of the following tools: airbrush, brush, pencil, type, line, gradient or bucket – holding down the Option/Alt key creates a new foreground color). The sampler tool provides persistent pixel value readouts in the Info palette from up to four points in the image. The sample point readouts will remain visible all the time in the Info palette. The sample points themselves are visible whenever the color sampler tool is selected. The great value of the color sampler tool is having the

ability to monitor pixel color values at fixed points in an image. To see what I mean, take a look at the tutorial in Chapter Eight, which demonstrates how the combination of placing color samplers and precise curves point positioning means that you now have even more fine color control with valuable numeric feedback in Photoshop. Sample points can be deleted by dragging them outside the image window, Option/ Alt-clicking on them, or clicking on the Clear button in the Tool Options bar.

Measure

The measure tool provides an easy means of measuring distances and angles. To draw a measuring line, open the Info palette and click and drag with the measure tool in the image window. The measure tool also has a protractor mode – after drawing a measuring line, Option/Alt-click on one of the end points and drag out a second measuring line. As you drag this out, the angle measurements are updated in the Info palette. The measure tool will only remain visible whenever the tool is selected, or you can hide it with the View > Hide Extras command. The measure tool can be updated at any time by clicking and dragging any of the end points. As with other tools the measure tool can be made to snap to grid or guides.

Navigation tools – hand and zoom

To navigate around an image, select the hand tool and drag to scroll. To zoom in on an image, either click with the zoom tool to magnify, or drag with the zoom tool, marqueeing the area to magnify. This combines a zoom and scrolling function. In normal mode, a plus icon appears inside the magnifying glass icon. To zoom out, hold down the Option/Alt key and click (the plus sign is replaced with a minus sign). A useful shortcut well worth memorizing is that at any time, holding down the Spacebar accesses the hand tool. Holding down the Spacebar+Command/Ctrl key calls up the zoom tool. Holding down the Spacebar+Option/Alt calls up the zoom tool in zoom out mode. An image can be viewed anywhere between 0.2% and 1600%. Another zoom shortcut is Command/Ctrl-plus (Command-click the '=' key) to zoom in and Command/Ctrl-minus (next to '=') to zoom out. The hand and zoom tools also have another navigational function. Double-click the hand tool to make the image fit to screen. Double-click the zoom tool to magnify the image to 100%. There are buttons on the Options bar which perform similar zoom commands: Fit On Screen; Actual Pixels; Print Size. Navigation can also be controlled from the Navigator palette, the View menu and the lower left box of the image window. Checking the Resize Windows to Fit box will cause the Photoshop document windows to always resize to

accommodate resizing, but within the constraints of the free screen area space. The Ignore Palettes check box will tell Photoshop to ignore this constraint and resize the windows behind the palettes.

Foreground/background colors

As mentioned earlier when discussing use of the eyedropper tool, the default setting is with black as the foreground color and white as the background. To reset the default colors, either click on the black/white foreground/background mini icon or simply click 'D'. Next to the main icon is a switch symbol. Clicking on this exchanges the colors, so the foreground becomes the background. The alternative shortcut is to click 'X'.

Figure 6.28 The Photoshop Color Picker. The color field appears the way it does here because Gamut Warning is checked in the View menu and the alert beside the newly selected foreground color tells you it is out of gamut. If you check on the cube icon below, this will make the selected color jump to the nearest HTML web safe color. Check the Only Web Colors box to see this restricted palette only.

Selection mode/Quick mask

The left icon is the standard for Selection mode display. The right icon converts a selection to display as a semitransparent colored 'Quick mask'. Double-click either icon to change the default overlay mask color. Hit 'Q' to toggle between each.

Screen display

The standard mode displays images in the familiar separate windows. More than one document can be opened at a time and it is easy to select individual images by clicking on their windows. The middle display option changes the background display to an even medium gray color and centers the image in the window with none of the distracting system window border. All remaining open documents are hidden from view (but can be accessed via the Window menu). Full Screen mode displays the image against a black background and hides the menu bar. The Tools palette and other palettes can be hidden too by pressing the Tab key. To show all the palettes, press the Tab key again. To toggle between these three viewing modes, press the 'F' key. You can also use Tab+Control/right mouse-click to cycle through each open image window, however the associated screen display is set. Here is another tip: if you are fond of working in Full Screen mode with a totally black border, but miss not having access to the menu bar, in the two full screen modes you can toggle the display of the menu bar with the Shift-F keyboard command. When you are in the middle full-screen viewing mode you can replace the gray colored pasteboard by selecting a new color in the Color Picker and Shift-clicking with the paint bucket tool in the pasteboard area. Warning: this action cannot be undone with Command/Ctrl-Z!

Jump to button

Image Ready™ 3.0 is a stand-alone application, which is installed with Photoshop 6.0. Clicking on the 'Jump to' icon will switch you from Photoshop to ImageReady™ and vice versa, without having to exit from the current program (although you will need to save first). The file will always continue to remain open in the previous program and you can select different programs to jump to from the File > Jump to menu. Upon installation, applicable application aliases are installed in the Photoshop 6.0 > Helpers > Jump to Graphics Editor folder, i.e. Adobe Illustrator™ from Photoshop or HTML editing programs like Adobe GoLive™ from ImageReady™. If the other program is not currently open, the Jump to button will launch it.

Summary

The tools and palettes mentioned here will be cropping up again over the following chapters. So if you don't fully understand yet what everything does, hopefully the later tutorials will help reinforce the message. As an aid to familiarizing yourself with the Photoshop tools and Palette functions, help dialog boxes pop up after a few seconds whenever you leave a cursor hovering over any one of the Photoshop buttons or tool icons. A brief description is included in the box and tools have their keyboard shortcuts written in brackets.

Chapter Seven

File Formats

Photoshop supports an incredibly wide range of image file formats and can handle almost anything you care to throw at it – all the tools are there to open incoming files. Choosing which format to output your images to can be narrowed down to a handful of professionally recognized formats. Where and when you use these is explained in this chapter. Many of the features described in this chapter cater for the needs of designers working in screen-based publishing, i.e. multimedia and web page design and were first introduced in Photoshop 5.5. Until now, the options available in Photoshop were beginning to look rather limiting. Since the decision to package ImageReady™ with Photoshop, this means that you now have the power to edit image graphics for screen use. You can switch back and forth between Photoshop 6.0 and ImageReady™ 3.0 to produce optimized, sliced images, animated GIFs and even rollover buttons complete with Javascript code. This modular approach means that many Adobe graphics programs are able to integrate with each other. The emphasis is on flexibility. Screen-based publishing is a rapidly growing sector of the publishing industry and it is predicted that the percentage of designers operating in cross-media publishing, i.e. screen and print, will soon overtake those working in print design only.

While an image is open, it can be manipulated using any of the Photoshop features, some of which like layers and adjustment layers can only be recognized by a few of the formats in Photoshop. For example, if you open up an EPS file, you can add layers in Photoshop, but if you want to save the file as an EPS still by doing a File > Save As... this will call up the Save dialog shown in Figure 7.1. This alerts you to the fact that if you click Save now, not all the components in the image (i.e. the layers) will be fully saved. This is because while you can save the file as an EPS, the EPS

format does not support layers and the document will therefore be saved in a flattened state. If I were to select the native Photoshop file format and check the Layers box, then it will become possible for me to now save this version of the image in the native Photoshop format *and* preserve the layer features. Only the Photoshop 6.0, PDF and TIFF 7 formats support saving all the new Photoshop features such as layer clipping paths and gradient map adjustment layers. Saving in the native Photoshop format is the speedier option (a layered TIFF 7 save can be very slow) and the file size is usually always more compact, except when you save a layered Photoshop file with the Maximize Backward Compatibility checked in the preferences. The Photoshop, PDF and TIFF 7 formats all support 'big data'. This means that data on a layer that may extend beyond the confines of the canvas boundary will be preserved. A summary of format features can be found in Figure 7.18 at the end of this chapter.

Figure 7.1 The Navigation Services Save dialog box.

Common file formats

TIFF (Tagged Image File Format)

This is the most universally recognized, industry-standard image format. If you are distributing a file for output as a print or transparency, or for someone else to continue editing your master file, you will usually be safest supplying it as a TIFF. Labs and output bureaux generally request that you save your output image as a TIFF, as this can be read by most other imaging computer systems. TIFFs support alpha chan-

nels and paths, although bureaux receiving TIFF files for direct output will request that a picture file is flattened and saved with all alpha channels removed. An uncompressed TIFF is about the same size as shown in the Image Size dialog box. The TIFF 7 format in Photoshop 6.0 has several compression options. LZW (which appears in the Save dialog box) is a lossless compression option. Data is compacted and the file size reduced without any image detail being lost. Saving and opening will take longer when LZW is utilized, so some bureaux will request that you do not use it. ZIP is another lossless compression encoding which like LZW is most effective where you have images that contain large areas of a single color. JPEG compression is a lossy compression method and is described more fully later. TIFF 7 has the benefit of being able to support transparency and saving all of the Photoshop 6.0 features, but only when the Enable advanced TIFF save options is checked in the Saving files preferences. The byte order is chosen to match the computer system platform the file is being read on. Most software programs these days are aware of the difference, so the byte order selected is now less relevant. The two main formats used for publishing work are TIFF and EPS. Of the two, TIFF is the more flexible format, but this does not necessarily imply it is better. The PDF file format is also gaining popularity for DTP work. TIFF files can readily be placed in QuarkXPress, PageMaker, InDesign and any other DTP or word processing document. The TIFF format is more open though and unlike the EPS format, you can make adjustments within the DTP program as to the way a TIFF image will print.

Figure 7.2 The advanced TIFF save options are switched off by default. This means that the TIFF save dialog will normally be the same as that in Photoshop 5.x. However, when the advanced TIFF save options are enabled in preferences you will see the new TIFF 7 dialog, which allows you to save layered TIFFs and utilize JPEG or ZIP compression methods.

The TIFF 7 Save Image Pyramid option will save a pyramid structure of scaled-down versions of the full-resolution image. TIFF 7 pyramid-savvy DTP applications will be able to display a good quality TIFF preview, but without having to load the whole file.

EPS

EPS (Encapsulated PostScript) files are the preferred format for placing large color separated files within a page layout document. An EPS file contains a low resolution preview to display the image on screen while the image data written in the PostScript language is used by a printer to build the output on a PostScript device. The image

data is 'encapsulated' which means it cannot be altered outside of the program that created it (such as Photoshop). The downside of using EPS is that all the PostScript image data must be processed by the RIP every time you make an output, even if only a smaller amount of data is required to produce a proof – EPS files can take longer to process than a TIFF. However, the EPS format structure means you get an almost instantaneous rendering of the image preview when editing a DTP document on the screen. The saving options include:

Preview display: This is a low resolution preview for viewing in the page layout. The choice is between None, a 1-bit/8-bit TIFF preview which is supported on both platforms, or a 1-bit /8-bit/JPEG Macintosh preview. I recommend the 8-bit preview mode or JPEG Macintosh preview if working on the Mac.

Encoding: The choice is between ASCII or Binary encoding. ASCII is the more generic and suited to Windows platforms only, but generates larger sized files. Binary files are half the size and faster to process. JPEG coding produces the smallest sized, compressed files. Use JPEG only if you are sending the job to a Level 3 PostScript printer. Bear in mind that image quality will become significantly de-graded whenever you select a lower quality JPEG compression setting.

Include Halftone Screen and Include Transfer Functions: For certain subjects, images will print better if you are able to override the default screen used on a print job. Transfer functions are similar to making Curves image adjustments. Check these boxes if you want information entered to override the default printer settings. They do not alter the screen appearance of the image and are adjusted to accommodate dot gain output. The screen and transfer functions are defined in Photoshop. If printing the same file to two different printers, you may wish to save one file for the final print job as it is and save another version for the proof printer specifying the use of preset transfer functions to compensate for the different printing characteristics.

PostScript Color Management: This will enable PostScript Level 2 devices or higher to be able to read embedded profiles in Grayscale, RGB or Lab files saved from Photoshop 6.0. I believe it is better to handle the color management inside Photoshop only.

If any vector data is present in the document this can be interpreted such that the vector information will be rasterized in the EPS file. As usual, clipping paths can be saved in an EPS file – a clipping path will act as an outline mask when the EPS file is placed into a page layout program. If you have a work path saved in the paths palette it can be specified to be used as the clipping path from within Photoshop.

DCS

QuarkXPress also uses a version of the EPS format known as DCS (Desktop Color Separations). The DCS 1.0 format generates five separate files: one preview composite and four-color separation files. The benefits to be gained from managing files this way are less necessary these days. The DCS 2.0 format is a self-contained file containing the preview and separations. Crucially, DCS 2.0 supports more than four color channels, i.e. spot colors and HiFi color.

Figure 7.3 The DCS 2.0 Format options dialog box.

Photoshop PDF

The PDF (Portable Document Format) is an electronic publishing format which is primarily used for the distribution of document layouts, although it is fast gaining acceptance for prepress work and is the principal format for Adobe Acrobat™ and Adobe Illustrator™ 9.0. Every time you install an Adobe software product, the latest version of Adobe Acrobat Reader will always be available to install on your hard disk. This freeware program is available for both Macs and PCs and readily available to install from consumer magazine CDs or to download from Adobe's web site. CD Presentations, like the Adobe Photoshop Tutorial CD, use the Acrobat PDF format to display electronically published documents. Adobe Acrobat can reproduce pages designed in Adobe InDesign™ or Adobe Illustrator™ to be viewed as self-contained documents. Best of all, Acrobat documents are small in size and can be printed at high resolution. The beauty of the PDF is its independence of computer operating system and the fonts installed on the client's computer. I can create a document in PageMaker and export as an Acrobat PDF using the Acrobat Distiller program (Distiller is included in the full version of Acrobat and PageMaker). Anyone with the Acrobat Reader program can then open my document and see the layout just as I constructed it with the pictures plus text in the fonts I used. The Photoshop PDF format (see Figure 7.4) can save *all* Photoshop 6.0 features, with either JPEG or lossless ZIP compression and is backwards compatible in as much as it will save a flattened composite for viewing within non-Photoshop 6.0 programs.

Importing multi-page PDF files

The Photoshop parser plug-ins enable any Adobe Illustrator, EPS or single/multi-page PDF file to be imported. Complete PDF documents can now be rasterized and batch processed to be saved as Photoshop image document files. The Import feature enables you to extract all or individual image/vector graphic files contained in a PDF document as separate image files (see Figures 7.4 and 7.5).

Figure 7.4 The PDF Options save dialog.

Figure 7.5 If you attempt to open an Acrobat document from within Photoshop, the Generic PDF parser dialog will appear, providing a preview of individual pages contained in the document. This will be followed by a Rasterize Generic PDF dialog. If you choose File > PDF Image Import, you can extract all or individual images from a self-contained PDF document.

PICT

PICT is primarily a Macintosh file format which while it can be read by PC versions of Photoshop, it is not a format for DTP work, although it has some uses in multimedia development applications such as Macromedia Director. The PICT format utilizes lossless Run Length Encoding compression – areas of contiguous colors (i.e. subjects against plain color backgrounds) compress more efficiently without any image degradation, although files can be compressed using various levels of JPEG compression. I would add though that there is nothing about PICT which the native Photoshop file format cannot do better and there are also some pixel size limitations with the PICT format.

JPEG

The most dramatic way of compressing image files is to use JPEG (Joint Photographic Experts Group) compression. For example, an 18 Mb, 10" × 8" file at 300 ppi resolution can be reduced in size to around 1 Mb without causing too much degradation to the image. JPEG uses what is known as a 'lossy' compression method. The heavier the compression, the more the image becomes irreversibly degraded. If you open a JPEG file and examine the structure of the image at 200%, you will see what I mean – the picture contains a discernible checkered pattern of 8 × 8 pixel squares, which when using the heaviest JPEG setting will easily be visible at 100% viewing. Compression is more effective if the image contains soft tonal gradations. Detailed images do not compress so efficiently and the JPEG artifacts will be more apparent.

Once an image has been JPEGed, it is not a good idea to compress it a second time because this will compound the damage done to the image structure. Having said that, providing the image pixel size remains identical, the destruction caused by successive overwriting is slight (except in those areas of the picture which have been altered). This, of course, is not a good practice to follow. The idea with JPEG is that

Figure 7.6 Two JPEG images: both have the same pixel resolution and both have been saved using the same JPEG quality setting. Yet the cloud image will compress to just 21 kilobytes, while the windows image is almost three times bigger at 59 kilobytes. This is because of all the extra detail contained in the street picture. The more contrasting sharp lines there are, the larger the file size will be after compression. For this reason it is best not to apply too much unsharp masking to an image before you save it as a JPEG. If necessary, you can deliberately apply blur to a background in Photoshop to remove distracting detail and thereby reduce the JPEG size.

Figure 7.7 The JPEG Options save dialog box. Baseline Standard is the most universally understood JPEG format option and one which most web browsers will be able to recognize. Baseline Optimized will often yield a slightly more compressed sized file than the standard JPEG format and most (but not all) web browsers are able to correctly read this. The Progressive option creates a JPEG file which will download in an interlaced fashion, the same way as GIF files can be encoded to do so.

JPEG Options

Matte: None

OK
Cancel
☑ Preview

Image Options
Quality: 6 Medium
small file large file

Format Options
● Baseline ("Standard")
○ Baseline Optimized
○ Progressive
Scans: 3

Size
~63.97K / 11.3s @ 56.6Kbps

Name	Date Modified	Size	Kind
clipso.eps	Today, 11:14 am	882 K	Adobe® Photoshop® 6.0 document
clipso.tif	Today, 11:13 am	599 K	Adobe® Photoshop® 6.0 document
clipso.psd	Today, 11:13 am	273 K	Adobe® Photoshop® 6.0 document
clipso.pct	Today, 11:14 am	270 K	Adobe® Photoshop® 6.0 document
clipso.png-24	Today, 11:40 am	165 K	Adobe® Photoshop® 6.0 document
clipso.jpg (100%)	Today, 11:51 am	70 K	Adobe® Photoshop® 6.0 document
clipso.gif (89a)	Today, 11:19 am	42 K	Adobe® Photoshop® 6.0 document
clipso.jpg (50%)	Today, 11:52 am	18 K	Adobe® Photoshop® 6.0 document
clipso.jpg (10%)	Today, 11:52 am	7 K	Adobe® Photoshop® 6.0 document

comparison — 9 items, 22.5 MB available

Figure 7.8 Here we have one image, but saved nine different ways and each method producing a different file size. The opened image measures 500 × 400 pixels and the true file size is exactly 586 kilobytes. The native Photoshop format is usually the most efficient format to save in. Large areas of contiguous color such as the white background are recorded using a method of compression, which does not degrade the image quality. The PICT format utilizes the same 'run length encoding' compression method, while the uncompressed TIFF and EPS formats doggedly record every pixel value and are therefore larger in size.

Client: Clipso. Model: Bianca at Nevs.

173

you can reduce an image one time only to occupy a much smaller space than the original file and do this for faster electronic distribution, or saving a large file to a restricted disk space. A shortage of disk space is not something that need concern us much these days, but it can be useful if you simply must compress something to fit on a removable disk. Some purists will argue that where professional quality counts, JPEG compression should never be used under any circumstances. If JPEG file compression is used with EPS or TIFF files, this can cause problems when sending a file to some older PostScript devices, so that is one good reason for not using it. Assuming JPEG compression does not cause this problem, image degradation at the higher quality compression settings is barely noticeable. This will be true when the image is viewed on the screen in close-up, never mind when it is seen as a printed output. Wildlife photographer Steve Bloom once showed me two Pictrograph prints. One of these was a 24 Mb uncompressed original and the other a 2 Mb JPEG version. Could I or any other imaging expert tell which was which? Answer: no.

File formats for the Web

Saving with JPEG compression is how web designers are able to make continuous tone photographic images small enough to download quickly over the Internet. Image quality is less of an issue here when the main object is to reduce the download times. When a high compression number setting is used, less compression will take place and the higher the image quality will be. Photoshop compresses images on a scale of 0–12 with 0 applying the highest compression and being the most lossy of all. The previous compression scale of 1–10 now roughly equates to the newer scale range of 2–12. When you save as a JPEG, the image appearance will change to display a preview of how the compressed JPEG will look when it is reopened and the JPEG Options dialog box will indicate the compressed file size in kilobytes and provide an estimated modem download time.

This improvement alone is tremendously helpful. Before, you would have to make a guess as to which was the most appropriate compression setting to use. To confirm if this was the case or not, you would then have to switch to the Finder and check the file info for the saved JPEG. If the file needed further compression, you would return to the original master and save again with a lower JPEG setting. There is no quality problem when repeating JPEG saves this way – for as long as the image is open in Photoshop, all data is held in Photoshop memory. Only the version saved on the disk is successively degraded.

As you can see in Figure 7.8, the JPEG compression is most effective, but this is achieved at the expense of throwing away some of the image data. JPEG is therefore known as a 'lossy' format. At the highest quality setting (100%), the image will be

barely degraded though. The JPEG file size is now just 70 kilobytes, or 12% of its original size at this highest setting. Using the medium quality setting (50%) the size is reduced further to just 18 kilobytes. This is probably about the right amount of compression to use for a web page display. The lower (10%) setting will squeeze 586 kilobytes down to under 7K, but at this level the picture will appear extremely 'mushy' and is best avoided.

Other file formats for the Internet

As far as publishing images on the Web are concerned, only one thing matters and that is keeping the total file size of your pages small. In nearly every circumstance JPEG is the most effective way of achieving file reduction for continuous tone images. Graphics that contain fewer and distinct blocks of color should be saved using the GIF format. Occasionally one comes across a photograph to be prepared for a web page that would save more efficiently as a GIF (see Figure 7.9) and vice versa – there are some graphics which will benefit from being saved as a JPEG (see Figure 7.10). Photoshop 6.0 includes expanded saving options, allowing you to save a copy from any type of image state, choosing whether to include an ICC profile or not in your JPEG file. Some web servers are case sensitive and will not recognize capitalized file names. Go to Edit menu and select Preferences > Saving Files and make sure the Use Lower Case Extensions box is checked.

GIF

The GIF (Graphics Interchange Format) format is normally used for publishing graphic type images such as logos. To prepare an image as a GIF, the color mode must be Indexed Color. This is an 8-bit color display mode where specific colors are 'indexed' to each of the 256 or fewer numeric values. So you select a palette of indexed colors which are saved with the file and then choose save as Compuserve GIF or export to the GIF89a format (File > Export > Gif89a). The file is then ready to be placed in a web page and viewed by web browsers on all computer platforms. That is the basic concept of how GIFs are produced. Photoshop contains special features to help web designers improve the quality of their GIF outputs, such as the ability to preview Indexed mode colors whilst in the Index Color mode change dialog box and an option to keep matching colors non-dithered. This feature will help you improve the appearance of GIF images and reduce the risks of banding or posterization. When Preview is switched on, it may take a while for the display to reflect the image mode changes unless you are working on an image resized for the screen, which you should be anyway. You will find that when designing graphic images to be converted to a GIF, those with horizontal detail compress better than those with vertical detail.

Figure 7.10 Exception to the rule 2: The Index page graphic for the Association of Photographers web site would normally have been saved as a GIF (at around 20 kilobytes). The problem here was that the subtle gray tones looked terrible when dithered to the 216 color Web Palette. I therefore saved as a JPEG retaining the subtlety, making the size now 30 kilobytes, still keeping the total page size within a tolerable limit.

Figure 7.9 Exception to the rule 1: This high contrast landscape image contains very few tones. As a 350 pixel tall JPEG the smallest I could make it was around 33 kilobytes. Not bad, but as a six color GIF it only occupied 18 kilobytes and with little comparative loss in quality.

Save for Web

The Save for Web option is found in the File menu. This comprehensive dialog interface gives you absolute control over how any image can be optimized for Web use when choosing either JPEG, GIF, PNG-8 or PNG-24 formats. The preview display options include: Original, Optimized, 2-up and 4-up views. Figure 7.11 shows the dialog window in 4-up mode display. In this example you can preview the original version plus three variants with different levels of JPEG compression applied. In the annotation area below each preview, you are able to make comparative judgements as to which level of compression will give the best payoff between image quality and file size, and also determine how long it will take to download at a specific modem speed. The modem speed options can be set in the Preview menu to display download times for a 14.4K, 28.8K or 56.6K modem. The Preview menu is also where you can set the gamma compensation – to preview how the web output image will

Save for Web tools
Preview display options
Preview menu
Optimize settings
Optimize menu
Output settings

Zoom level
Color information
Browser preview button
Select browser menu
Modify JPEG quality

Figure 7.11 The Save for Web interface. Click on the button next to the Quality setting to open the Modify Quality Setting dialog. Use an alpha channel to zone optimize the JPEG compression range.

Client: Alta Moda. Model: Melody at Storm.

Figure 7.12 Under the Optimize menu you can choose Optimize To File Size and specify the optimum number of kilobytes you want the file to compress to.

display on either a Macintosh display, a PC Windows display or with Photoshop compensation. The Select Browser menu is where you can select which web browser to use when you wish to preview a document that has been optimized, in the actual browser program (see Figure 7.14).

Photoshop provides improved JPEG formatting choices including Progressive JPEG. The Netscape 4.0 and Internet Explorer 4.5–5.5 browsers support this format enhancement, whereby JPEGs can download progressively the way interlaced GIFs do. The optimized format (see check box below the Optimize menu) will provide more efficient compression, but again is not generally compatible with any but the more recent web browsers. The quality setting can be set as Low, Medium, High, Maximum or it can be set more precisely as a value between 1 and 100%. The Blur control will allow you to soften an oversharpened original and obtain further file compression when using the JPEG format.

There are a couple of new added features in the Photoshop 6.0 version of the Save for Web dialog which are worth pointing out. You can set zone optimized levels of compression based on an alpha channel stored in the master document. An example of this is shown in Figure 7.11. Next to the Quality setting (in the JPEG mode Save for Web dialog) is a small selection mask icon. Click on this icon to open the Modify Quality Setting dialog. Here you can adjust the sliders to establish the JPEG range of compression from the total mask to no mask areas and vary the softness of this transition. In the Figure 7.11 example, the area of important detail is located in the area defined by the mask. I can apply less compression in this portion of the picture, smoothly falling off to higher compression in the outer areas. In the Save for Web GIF format mode (which is discussed next), an alpha channel can be used to zone optimize the color reduction and modify the dither settings. The Save for Web Save dialog lets you save as: HTML and Images, Images only, or HTML only. The output settings allow you to determine the various characteristics of the Save for Web output files such as: the default naming structure of the image files and slices; the HTML coding layout; and whether you wish to save a background file to an HTML page output (see Figure 7.13). Figure 7.14 shows an example of a temporary document window generated with the HTML code generated by Save for Web along with the HTML code in the format specified in the output settings.

Figure 7.13 The HTML section of the Optimize Settings found in the Save for Web dialog. Other menu options include Background, Saving, and Slices. Click on the Generate CSS button to create cascading style sheets based on the current image slicing.

Figure 7.14 When a browser window preview is selected (see Figure 7.11), the chosen browser program is launched and a temporary page will be created, like the one illustrated opposite. This will allow you to preview the Photoshop image file as it will appear on the final web page. This is especially useful for checking if the RGB editing space used will be recognized differently by the browser. If you are relying on embedded ICC profiles to regulate the color appearance on screen, you can check to see if the profile is indeed being recognized by the selected web browser program.

Figure 7.15 This close-up view of the JPEG saved at the 10% quality setting clearly reveals the underlying 8×8 pixel mosaic structure, which is how the JPEG compression method breaks down the continuous tone pixel image into large compressed blocks. At the higher quality settings you will have to look very hard to even notice any change to the image. Successively overwriting a JPEG will degrade the image even further. However, if no cropping or image size change takes place, the degradation will only be slight. As a general rule always re-JPEG an image from the uncompressed master file.

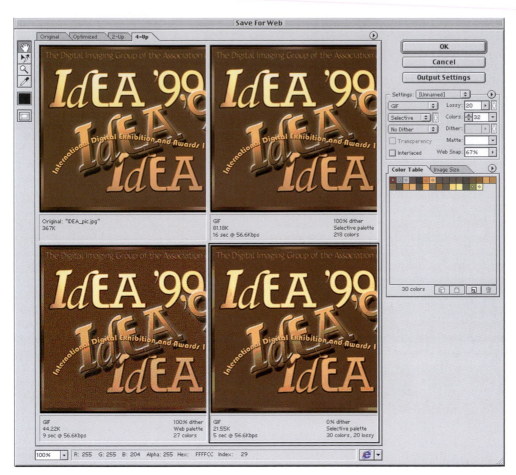

Figure 7.16 The Save for Web interface operating on a GIF file. Design: Rod Wynne-Powell.

Figure 7.17 The color table with Color palette fly-out menu shown.

A: Snaps selected colors to web palette.

B: Locks selected colors to prohibit being dropped.

C: Adds eyedropper color to the palette.

D: Deletes selected colors.

The Image Size options are fairly similar to those found in the Image > Image Size dialog box. You can simply enter a new percentage to scale the image to and check what impact this will have on the file size (this will change the file size in all the optimized windows). Another option is to select Optimize To File Size from the Optimize menu (see Figure 7.12). Use this to target the optimized file to match a specific kilobyte file size output.

The GIF Save for Web options are also very extensive. You have the same control over the image size scale and can preview how the resulting GIF will appear on other operating systems and browsers – the remaining options all deal with the compression and color table settings that are specific to the GIF format. The choice of color reduction algorithms are there to allow you to select the most suitable 256 maximum color palette to save the GIF in. This includes the 8-bit palettes for the Macintosh and Windows systems. These are fine for platform specific work, but such GIF files may display differently on the other system's palette. The Web palette contains the 216 colors common to both platforms and is therefore a good choice for web publishing if viewers are limited to looking at the image on an 8-bit color monitor display. The Perceptual setting produces a customized table with colors to which the eye is more sensitive. The default Selective setting is similar to the Perceptual table, but more orientated to the selection of web safe colors – this is perhaps the best compromise solution to opt for now as even the most basic PC setup sold these days is well able to display 24-bit color. The Adaptive table palette samples the colors which most commonly recur in the image. In an image with a limited color range, this type of palette can produce the smoothest representation with a limited number of colors, but is less ideal for web publishing.

The Lossy option allows you to reduce the GIF file size by introducing file compression. This can be helpful if you have an overlarge GIF, but too much compression will noticeably degrade the image until it looks like a badly tuned TV screen. The diffusion dithering algorithm is effective at creating the impression of greater color depth and reducing image banding. The Dither slider allows you to control the amount of diffusion dithering. The Pattern and Noise options have no dither control. If the image to be saved has a transparent background, the Transparency option can be kept checked in order to preserve the image transparency in the saved GIF. If there is no transparency in the image yet, then you can select the color to matte with using the eyedropper tool and clicking inside the image preview area. The color chosen will appear selected in the color table.

The Web Snap slider will let you modify the color table by selecting those colors that are close to being 'browser safe' and making them snap to these precise color values. The slider determines the amount of tolerance and you can see the composition of the color table being transformed as you make an adjustment. The Interlace option will add slightly to the file size, but is worth selecting – the image will appear to download progressively in slices.

File format	RGB	CMYK	Indexed Color	Grayscale	Layers	Alpha Channels	Paths	ICC	Annotations
Adobe Photoshop	•	•	•	•	•	•	•	•	•
Adobe Photoshop 2.0	•	•	•	•		• (Mac)	•	•	
FlashPix	•			•			• (Mac)		
GIF89a (Export)			•						
JPEG	•	•		•			• (Mac)	•	
Photoshop EPS	•	•		•			•	•	
Photoshop DCS 1.0		•					•	•	
Photoshop DCS 2.0	•	•		•		•	•	•	
Photoshop PDF	•	•	•	•	•	•	•	•	•
PICT	•		•	•			• (Mac)	•	
PNG-8			•	•		•	• (Mac)		
PNG-24	•			•		•	• (Mac)		
Scitex CT	•	•		•			• (Mac)		
TIFF 7	•	•	•	•	•	•	•	•	

Figure 7.18 File format saving options showing which Photoshop features can be saved in the listed formats. Those indicated with a red dot are savable on the Mac OS only.

PNG (Portable Network Graphics)

This is a newish format for the display and distribution of RGB color files on-line. PNG (pronounced 'ping') features improved image compression and enables alpha mask channels to be saved with the image for creating transparency. Other advantages over JPEG and GIF are higher color bit depths, supporting up to 32-bit images and limited built-in gamma correction recognition, so you can view an image at the gamma setting intended for your monitor. Newer versions of Netscape Navigator and Microsoft Internet Explorer web browsers will support the PNG format (Microsoft Internet Explorer 5.0 for Mac and PC does).

FlashPix

The FlashPix format was jointly developed and backed by Eastman Kodak, Live Picture, Microsoft and Hewlett-Packard. It is based on the Live Picture IVUE pyramid structure format. High resolution images are viewed by a browser connected to a modem. To view the full sized image on the screen, a screen resolution preview only is downloaded. If you zoom in to a small section, just the detail information in that area of the picture is downloaded to the browser. The viewer can inspect an image at full view and select any area in close-up quickly without at any time having to download the entire image. Note that the FlashPix format plug-in must be installed using the Custom rather than the Easy Install option. Microsoft® OLE is required to run FlashPix – check the Microsoft® OLE 2.08 checkbox.

When saving in the FlashPix format there are options for compression (with a choice of strengths) or no compression. As a FlashPix image is opened in Photoshop, a choice of image resolutions is offered – this is similar to the choice of Image PAC resolutions you get with Photo CD.

IVUE

The IVUE format (on which FlashPix is based) is used by the Live Picture program for display and image processing in Live Picture. Files are converted from Photo CD or a TIFF file to the IVUE pyramid structure format using Live Picture software before they can be opened in Live Picture. Photoshop and Live Picture complement each other and for that reason you can import IVUE files into Photoshop, for further modification. The IVUE Import plug-in (which comes with Live Picture) must first be installed in the Photoshop plug-ins folder.

Future of electronic publishing

Digital imaging was first regarded as a modern, faster alternative solution to the conventional repro and photographic retouching process. Much attention has been focused on the narrowing gap between high-end and desktop machine capabilities with the prediction that in the future we will be handling ever larger file sizes. One can argue the opposite though – that the growth of multimedia, screen-based publishing (including the Internet) does not require large file sizes. Most images you see on screen are reduced versions from much bigger files, but as more work is commissioned for direct use in multimedia only, there will be less need to capture or work at a resolution higher than whatever is needed to fill a screen display.

Chapter Eight

Basic Image Adjustments

The aim of this chapter is to introduce everything you need to know about opening up a picture and carrying out basic image corrections. That is all most people ever want to know, but one can become distracted and confused by the many image controls available in Photoshop. The procedures outlined here show some of the methods used to prepare my own images. Of course, all the image adjustment commands are useful in one way or another – not even the simple Brightness/Contrast command should be regarded as totally redundant. What I have done here is provide a guide to the image corrections which professionals would use. I suggest these techniques provide the greatest scope for correcting and fine tuning your images and are a good solid base on which to build your retouching skills.

Cropping

Open a file as you would any document, choosing File > Open... If scanning the image, make sure the scanner software and Import plug-in filters are installed correctly, then choose File > Import > (select scanner module). Select the crop tool from the tools palette and drag to define the area to be cropped. To zoom in on the image as you make the crop, you will want to use the zoom tool shortcut: Command/Ctrl+Spacebar and marquee drag area to magnify. To zoom out, here is a handy tip: use Command/Ctrl+0, which is the shortcut for View > Fit To Window. Then zoom back in again to magnify another corner of the image to adjust the crop handles.

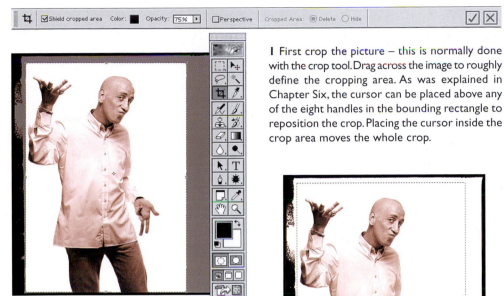

1 First crop the picture – this is normally done with the crop tool. Drag across the image to roughly define the cropping area. As was explained in Chapter Six, the cursor can be placed above any of the eight handles in the bounding rectangle to reposition the crop. Placing the cursor inside the crop area moves the whole crop.

2 You can also crop with the rectangular marquee tool. Define a selection and choose Image > Crop. The constraining options available in the marquee options include Constrain Aspect Ratio and Fixed Size. Irregular selections are now recognized.

3 You can enter the target image dimensions and resolution in the above crop options boxes. Type in the numeric values and measurement units. To match the dimensions and resolution of an existing picture, make the target image active and click Front Image (this automatically sets the fixed target size to match the image size). Activate the other image and apply the crop tool. The image will be cropped to match the resolution and size of the former image.

4 If the cursor is dragged outside the crop area with the crop tool, mousing down and dragging rotates the crop. You do this to realign an image which has been scanned slightly at an angle. Should there not be enough canvas size available, Photoshop will add the current Background color as extra canvas (or transparency if not a Background layer) after cropping. The crop bounding box center point (see image 1) can be repositioned to alter the central axis of rotation.

Orientation and canvas

Use the Image > Rotate controls to orientate your image the correct way up. If you alter the canvas size, the image pixels remain unaltered and only the surrounding dimensions are added to. The Image > Canvas size lets you enlarge the image canvas area, extending in whichever direction is set in the dialog box. The added area to the Background layer will be filled with the current background color. This is useful if you want to extend the image dimensions in order to place new elements. Since version 5.0 of Photoshop it has been possible to add to the canvas area without having to use the Image > Canvas Size command, just resize the crop boundaries beyond the document bounds and into the pasteboard area.

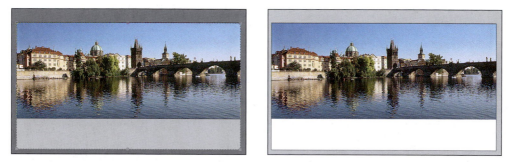

Figure 8.1 The crop tool as canvas size tool – drag any one of the bounding box handles outside of the image and into the pasteboard area. Double-click inside the bounding box area or hit Enter to add to the canvas size, filling with the background color.

Precise image rotation

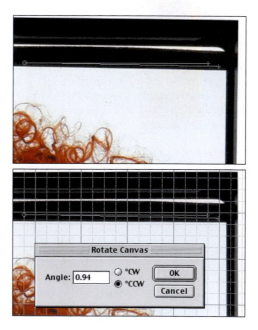

1 When a scanned original is opened up in Photoshop, you may discover that the scanned photograph is not perfectly aligned. Although the crop tool will allow you to both crop and rotate at the same time, there is another, more accurate way of correcting the alignment. Select the measure tool and drag along what should be a straight edge in the photo.

2 After doing this, go to the Image menu and select Rotate Canvas > Arbitrary... You will find that the angle you have just measured is already entered in the Angle box. Choose to rotate either clockwise or counterclockwise and you should find that the canvas has now been accurately rotated. This can easily be confirmed by choosing View > Show > Grid.

Perspective cropping

With Photoshop 6.0's crop tool you can crop and change the perspective in one action. This is perfect if you have a photograph of a building or other object in which you wish to remove the converging verticals or 'keystone' effect.

It has been possible of course to choose Select > All and apply an Edit > Free Transform. You can drag the bounding box handles and correct the perspective that way. The problem with using this method though is that you can only judge the accuracy of your transform with a pixelated proxy image as your guide and you have to guess where to drag the corner handles in order to straighten the image. With perspective cropping, it is much easier to accurately position the corner handles on top of the full-resolution preview and then apply the crop. If the crop is not immediately accepted, hit the Cancel button and try repositioning the center point to snap to the center of the new crop. Edge snapping can be disabled in the View > Snap to sub-menu.

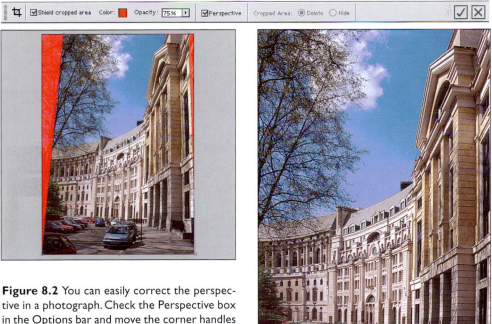

Figure 8.2 You can easily correct the perspective in a photograph. Check the Perspective box in the Options bar and move the corner handles independently. In the example shown here, I altered the crop opacity color to red – this makes it easier to see the crop. The bounding box handles can be hidden if you choose View > Hide Extras. Using this method, you will find it much easier to zoom in and gauge the alignment of the crop edges against the converging verticals in the photograph.

Image analysis

You have opened an image, cropped it and rotated it as necessary. The next stage will be to apply a tonal correction. First you will want to take a look at the image histogram. This graphical representation of the digital image's tonal makeup can inform you of any problems relating to the quality of the scan which you will want to address now by doing a rescan, before you proceed any further. The Image > Histogram dialog contains a lot of extra information which while useful for making a detailed analysis, provides more information than we really need to concern ourselves with right now.

We are going to start by looking at how to make basic Levels adjustments. Open up any image and choose Image > Adjust > Levels. The Levels dialog contains its own histogram and typical examples of these are shown below in Figure 8.3. The upper two examples in Figure 8.3 would suggest that an unacceptable amount of detail is being lost in either the highlights or the shadows. The comblike structure of the lower left example is not ideal, but an inevitable consequence of heavy tonal

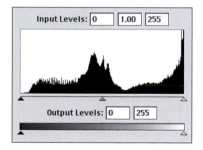

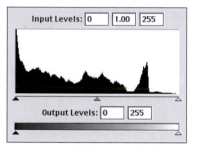

If the levels are bunched up towards the right, this is a sign of highlight clipping.

If the levels are bunched up towards the left this is a sign of shadow clipping.

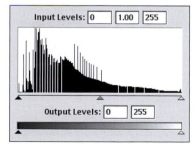

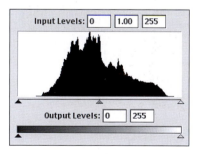

A histogram with a comblike appearance indicates that either the image has already been heavily manipulated or an insufficient number of levels were captured in the original scan.

This histogram shows that the image contains a full range of tones, without any shadow or highlight clipping evident and no gaps between the levels.

Figure 8.3 Examples of histogram displays you might come across in the Photoshop Levels dialog.

manipulation. It is generally more acceptable to lose tonal separation in the shadow areas than it is in the highlights. After a Photoshop digital file has been converted to a halftone separation and printed, you would be lucky to be able to detect more than 50 levels of tonal separation from any single ink plate. So the loss of a few levels at the completed edit stage does not necessarily imply that you have too little digital tonal information from which to reproduce a full-tonal range image in print. If you were starting out with a scan which had a histogram that looked like a broken hair comb and intended to carry out further tonal corrections, then clearly you do run the risk of posterization appearing when the picture is printed.

Levels adjustments

The object of tonal correction is to maximize the tonal range of the digital file for its intended output. Your output could be a web page or a transparency, but most likely it will be the printed page and this will eventually involve a halftone separation being made from the digital file. Halftone printing has its limitations but a basic Levels tonal correction made in Photoshop will enhance the image's printed appearance. Figure 8.4 shows an evenly spread histogram in the Levels dialog and no clipping of the shadows or highlights. However, the printing process does not

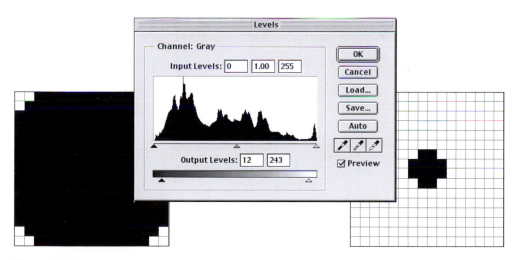

Figure 8.4 The Levels dialog. This shows the histogram for a grayscale image, with the shadows on the left and the highlights on the right. The shadow point Output level is set to 12. This is equivalent to a 95% dot on the press and typically any higher value percentage will clog up to solid black (see Figure 8.5). So setting the shadow point below 12 may cause the shadows to be clipped. The highlight point is set to level 243. This is equivalent to a 5% dot at which point the halftone dot produced by the imagesetter will on the press just be capable of applying ink to the page. Any higher level value will produce a smaller dot but the smaller dot will not register any ink on the page – it will appear as pure white.

translate a full range of tones in a digital image going from level 0–255 as a perfectly reproduceable range of tones in print. Figures 8.4 and 8.5 explain some of the reasons for this. If the destination is print, you want the shadow point to begin not at zero, but a little above that, otherwise the shadow tones will clog up on the press. And if keeping the highlight detail is important then you want the brightest highlights to fall slightly short of the brightest levels value of 255.

Levels is where you should start learning how to apply tonal corrections. Forget Brightness and Contrast and Color Balance for now – these are not professional tools. Anything you can do in Levels you can also do in Curves, and then some. But to begin with we shall look at Levels in more depth.

Figure 8.5 Dot gain is a phenomenon which occurs at the printing stage after the halftone plates have been made. A Photoshop level of 24 is equivalent to a 9% ink dot. An imagesetter would plot this on the film that goes to make the plate as shown left. When the printing press reproduces a halftone ink dot on the page from the plate, the dot will swell in size and hence appears slightly darker. Dot gain will therefore make the 95% shadow halftone dot plotted in Figure 8.3 appear as a solid black.

Figure 8.6 In the case of a high key image such as this, it is important to retain highlight detail. Some highlights we can afford to let them burn out to white, and indeed this helps to create the impression of a full tonal range of contrast. In crucial areas where the detail matters such as the white jacket and the blonde hair, it is necessary to make sure that the levels are not too high and within the limits of what the press can reproduce. To use an example which is based on the press referred to in Figure 8.4, any level higher than 243 will reproduce as a dot which is too small for any ink to adhere to the page. The Info palette is an essential tool for checking these numeric values.

Client: West Row. Model: Bianca at Nevs.

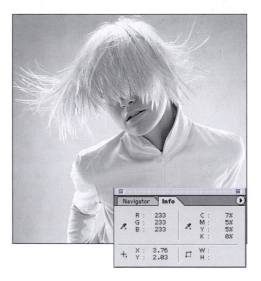

Specular highlights

I The guidelines for setting the shadow and high-
light points will help you choose the optimum
settings for retaining the shadow and highlight
detail and work within the constraints of the
printing press. At the same time it can also lead
to a dull print output if you do not make full use
of the tonal range. There are times when you
will want to make use of rich blacks and bright
paper whites to reproduce a full contrast image.
The subject shown here contains highlights which
have no detail. If we assign these 'specular' high-
lights a white point of 243, and the shadow point
12, the printed result will look needlessly dull.

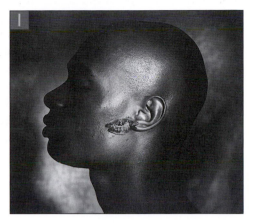

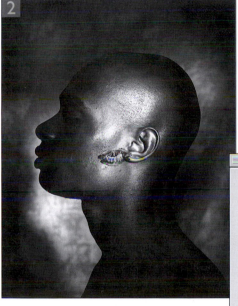

2 The brightest portions of the image are the
shiny skin reflections and we can safely let these
areas burn out to white, because they do contain
image detail. Assign the brightest area in the
highlights (where there is detail) as the white
point and let the specular highlights print to paper
white. The adjusted version benefits from a wider
tonal scale making full use of the press and at
the same retains important highlight detail where
it matters.

Use the Levels dialog to set the input shadow and highlight points, plus the overall
brightness of the picture by adjusting the middle, input 'gamma' slider. Either adjust
the shadow and highlight sliders in the Levels dialog box so that they just clip the
ends of the histogram bars or you can pick specific target shadow and highlight
image pixels and assign a new pixel value.

The first adjustment method is quick and easy to perform. If you want to reset the settings in any of the Image adjustment dialog boxes, hold down the Option/Alt key – the Cancel button changes to Reset. The Auto button speeds up the process of tonal adjustment, but is really a bit too basic for professional use. It is important to get the adjustments right from the start and this need not take too long to accomplish. The second, more precise method involves assigning specific parts of the image to represent the shadow and the highlight points. The process takes a little longer, but is a more precise way of setting the tonal range, producing neutral shadows, highlights and midtone values. Repro and color experts rely mainly on the numerical pixel values as a guide to judging color balance. Before making the tonal adjustment, go to the Eyedropper options and set the Sample Size to 3 × 3 Average.

1 The Levels dialog box displays the tonal range as a histogram. The tonal range of a scanned image usually needs to be expanded. This is done by dragging the highlight and the shadow Input sliders to just inside the histogram limits. When the Preview box is checked these tonal changes can be seen taking place in the image window area only.

2 A better method of deciding where to set the Input sliders is to hold down the Option/Alt key as you drag the slider. While the Option/Alt key is held down the whole screen is displayed in 'threshold' mode. The shadow and highlight limits are easily discernible. Note that this method differs slightly from earlier versions of Photoshop, in that you do not need to turn the Preview box off and that the threshold mode method works with both Mac and PC systems.

3 Now adjust the gamma slider – this affects the overall brightness of the image. If you prefer, you can enter numeric values for the Input Levels in the boxes above the histogram display. To apply the adjustment to the image, click OK.

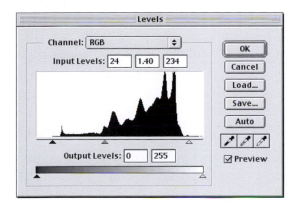

4 The Output sliders determine the output tonal range limits. For example, you can set the shadow and highlight inputs to clip the endpoints and then depending on the need of the press, as described in Figure 8.3, bring in the output sliders to match. You can also use these sliders to soften the contrast of a picture. To create a faded background image, slide the shadow output slider across to the right.

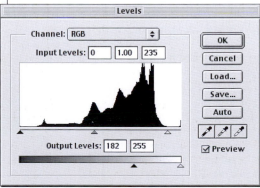

193

Assigning shadow and highlight points

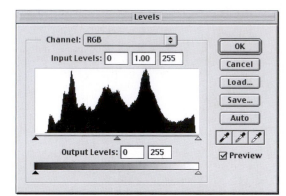

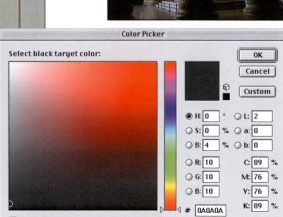

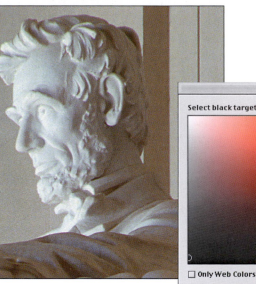

I Double-click the highlight eyedropper icon in the dialog box and set the highlight target value to match that of the press. A brightness setting of 96% as shown here is OK for most printing situations. Study the image. Look for the shadow and highlight points – the previously described Threshold mode technique is a good way of finding out where these are. Zoom in on the image and click on the area you want to assign as the highlight target point. This should be a subject highlight, not a specular highlight such as a reflection or glare.

2 Now set the shadow point. Double-click the shadow eyedropper icon and set a brightness setting of 4% in the text box as the target brightness. After that, with the shadow eyedropper still selected, zoom in on the image to identify and click on the darkest shadow point (use the Threshold mode again to help identify). The gamma slider can be adjusted the same way as in the last example to adjust the relative image brightness.

Figure 8.7 The Info palette can be used to read color information which helps determine whether the colors are neutral or not regardless of any monitor inaccuracies. Even RGB values equal a neutral gray tone.

Unsharp masking

The only sharpening filter you really need is the Unsharp Mask (Filter > Sharpen > Unsharp Mask). I know this sounds like a contradiction in terms, because how can unsharpening make a picture sharper? The term in fact relates to the reprographic film process whereby a light, soft unsharp negative version of the image was sandwiched next to the original positive during exposure. This technique was used to increase the edge sharpness on the resulting plate. The Photoshop Unsharp Mask (USM) filter reproduces the effect digitally and you have a lot of control over the amount of sharpening and the manner in which it is to be applied. Sharpen and Sharpen More are preset filters which sharpen edges but feature none of the flexibility associated with USM.

Do all pictures need to be sharpened and could they not have been scanned sharper in the first place? Wherever possible, use an unsharpened original as your master and apply any sharpening as necessary in Photoshop at the end of the editing session. Much depends on the capture device, scanner or scanner settings – most scans will benefit from a little USM and Photo CD images in particular will always require sharpening. The Kodak Photo CD system relies on the softness of the scanned image to enable the Image PAC files to compress more easily on to the CD disc and produce equally good quality results at any of the chosen resolutions. So although it may not *always* be required, it can sometimes be necessary to apply some level of unsharp masking to get an image looking sharp on the monitor. While unsharp masking may make a picture look sharper and better for that, this apparent sharpening is

achieved at the expense of introducing artifacts into the image which will permanently degrade the picture and possibly emphasize any noise present. Furthermore, if you sharpen the image before carrying out color adjustments and any retouching, the sharpening artifacts can become even more noticeable afterwards.

Sharpening for repro

A printed result will not exactly match what you see on the screen. The process of converting a digital image to halftone plates inevitably incurs a loss of sharpness along the way. For this reason it is always necessary to 'sharpen for repro', beyond getting the image to look sharp enough on the screen. Such unsharp masking must be done at the end of a Photoshop session and after conversion to CMYK. It therefore makes sense to keep a master version which you can reseparate from as requested and always apply the final unsharp masking on a copy version. Unsharp masking artifacts will create darker and lighter pixels. This can affect the tonal range, so it is best not to set the final levels till after applying USM. Figure 8.8 reproduces three versions of an image: raw Photo CD scan; sharpened for display on the screen; and sharpened for repro output.

Amount

The amount setting controls the intensity of the sharpening applied. The higher the percentage (up to 500%) the greater the sharpening effect will be. The correct amount to apply will vary depending on the state of the image and the type of press output. Generally speaking, I would typically apply an amount between 120% and 200%. Experience will help you make the right judgement on screen as to what the correct amount to use should be. Try setting the amount value really high to begin with. See which Radius and Threshold settings work best at the high setting with the image and then reduce the amount down to an appropriate level.

Radius

While amount controls the level or intensity of unsharp masking, the Radius and Threshold settings affect the distribution of the sharpening effect. The Radius setting controls the width of the sharpening effect and the setting you should choose will depend very much on the subject matter and the size of your output. The recommended setting is usually between 1 and 2. As the Radius setting is increased you will notice how the edges are emphasized more when using a wider radius. Figure 8.9 demonstrates the impact increasing the Radius can have on the edge sharpness, while all the other settings remain constant.

Figure 8.8 The left-most version shows a raw Photo CD scan converted to CMYK and reproduced without using any USM. The middle version has been partially sharpened only to appear sharp on the monitor. The version on the right has been converted to CMYK and additional USM applied to appear correct when printed in this book.

Photograph: Peter Hince.

Figure 8.9 When presented with an image or portion of an image that needs 'bringing into focus', a higher Radius setting will help create the illusion of better definition. The above pictures are all sharpened with an amount of 150% and Threshold setting of 1. From left to right: No sharpening, Radius 1, Radius 2.

Threshold

The Threshold setting controls which pixels will be sharpened based on how much the pixels to be sharpened deviate in brightness from their neighbors. Higher Threshold settings apply the filter only to neighboring pixels which are markedly different in tonal brightness, i.e. edge outlines. At lower settings more or all pixels are sharpened including areas of smooth continuous tone. If the Threshold setting is 4, and two

neighboring pixels have values of 100 and 115, then they will be sharpened, because their tonal difference is greater than 4. If one pixel has a value of 100 and the other 103, they will be left unsharpened because the pixel difference is less than 4. Raising the Threshold setting will enable you to sharpen edge contrast, but without sharpening any scanner noise or film grain which is visible. Scans made from 35 mm film originals may benefit from being sharpened with a higher Threshold setting than would need to be applied to a 120 film scan.

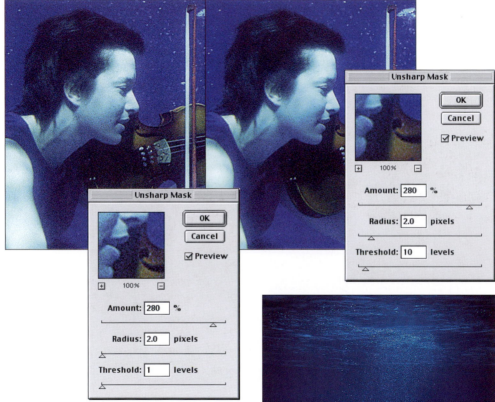

Figure 8.10 This photograph taken of musicians underwater was shot through a very scratched plastic porthole. As a result of these environmental conditions, the picture was already quite soft in appearance and therefore needed a lot of extra sharpening. But the problem with doing that is that at a low threshold setting, the high Amount and Radius also emphasized the film grain. Increasing the Threshold to 10 solved the problem. The photograph was made to appear sharper but without sharpening too much of the film grain.

Photograph by Eric Richmond.

Selective sharpening

Anti-aliased text and other graphic artwork is fine left as it is and will not benefit from being sharpened. Photoshop 6.0 vector objects are on separate layers anyway and will be processed separately by a PostScript RIP when rendered in print. If you do render any of the shape or type layers, try to keep them on their separate layers. Only sharpen the bitmapped image data.

The unsharp masking controls will enable you to globally correct most pictures and prepare them ready for print output. There are times though when you will find it beneficial to selectively apply the sharpening in a way that will reduce the problems of unwanted artifacts becoming too noticeable. For example, the blue channel is often the one which contains the most noise. Go to the channels palette and Shift select the red and green channels only, while selecting the composite channel eye icon.

Figure 8.11 The high amount of sharpening in the Figure 8.10 example produced chromatic artifacts around the backlit bubbles. If this happens, apply an Edit > Fade command and change the blending mode to Luminosity. This has the same effect as converting an image to Lab mode and sharpening the luminosity channel only (but quicker).

Chapter Nine

Color Adjustments

The image adjustment controls discussed in the preceding chapter take care of the regular image enhancements. So now we shall get to grips with the fine tuning aspects of the Photoshop image adjustment controls, not to mention some of the fun things which can be done while playing around with color. The Curves, Color Balance and Variations image adjustments allow you to exercise control over what happens to the color in either the shadows, highlights or midtones. Yet there are times when you want to narrow down the adjustments further and just work on a particular range of colors only, without affecting the overall color balance. It is also important to stress here that the color data in an image can easily become lost through repeated image adjustments. It is a bit like trying to carry a round of drinks from the bar – the less steady your hand, the more drink that gets spilt. The glasses will only get emptier, never fuller. Pixel color information is gradually lost through successive adjustments as pixel values are rounded off, although a Levels followed by a normal Curves adjustment hardly harms the image at all.

Hue/Saturation

First we will start with the Hue/Saturation command. The dialog controls are based around the HSB (Hue, Saturation, Brightness) color model, which is basically an intuitive form of the Lab color model. When you select the Hue/Saturation image adjustment you can alter these components of the image globally or selectively apply an adjustment to a narrow range of colors. The two color spectrum ramps at the bottom of the Hue/Saturation dialog box provide a visual clue as to how the colors are being mapped from one color to another. The hue values are based on a 360

degree spectrum. Red is positioned in the middle at 0 degrees. All other colors are assigned numeric values in relation to this, so cyan (the complementary color of red) can be found at either minus 180 or +180 degrees. Adjusting the hue slider only will alter the way color in the image will be mapped to a new color value. Figure 9.1 shows extreme examples of how the colors in a normal color image will be mapped by a Hue adjustment only. As the hue slider is moved you will notice the color mapping outcome is represented by the position of the color spectrum on the lower color ramp. Saturation adjustments are easy enough to understand. A plus value will boost saturation, a negative value will reduce the saturation. Outside the Master edit mode,

Figure 9.1 Examples of extreme 'hue only' adjustments using the Hue/Saturation image adjustment.

1 In the following example, we have a composite image where gold body paint makeup was applied to the skin, but the film recorded the gold a much redder color than was desired.

Michael Smiley – Edinburgh Fringe poster.

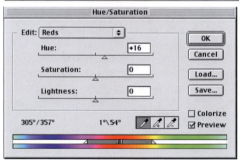

2 In the Hue/Saturation dialog box, you will notice an Edit pull-down menu at the top, which contains a list of the subtractive and additive primary colors. These narrow the color control to these color ranges only. So, by selecting Reds from this Edit menu, we can enhance or subdue the saturation of the red color component of the image and shift the red colors so that they become more yellow and less magenta.

3 After that, click on Yellows and similarly tweak the settings – this time to adjust the yellow component only and in this case enhance the color saturation.

1 In the default mode, changes made will affect the image globally. As you adjust the Hue slider, the upper color ramp always remains as it is and you will see the lower color ramp shift accordingly.

2 If you click on the Colorize button, the default setting is a primary red color (180 degrees) at 25% Saturation and 0% Lightness. Notice that the pop-up menu is dimmed and that the lower color ramp reflects the color value as defined above.

3 The pop-up menu is used to specify a narrow range of colors. This feature was to be found in the old style Hue/Saturation dialog box. The difference is that now you can be more specific as to which colors are to be altered. Here you see the magenta range of colors have been selected from the menu. The dark narrow strip in the middle of the sliders represents the chosen color to modify and the lighter gray spaces represent the threshold drop-off either side of the color selection.

4 Now watch what happens when the Hue, Saturation and Lightness sliders are adjusted and extra colors moving towards the red end of the spectrum are shift added with the eyedropper. See how the lower color ramp colors reflect the cast introduced to the shot.

you can choose from one of six preset color ranges with which to narrow the focus of the Hue/Saturation adjustment. Once in any of these specific color ranges, a new color value can be sampled from the image window, around which to center a Hue/ Saturation adjustment. Shift-click in the image area to add to the color selection and Option/Alt-click to subtract colors (see page 202).

When the Colorize option is switched on, the hue component of the image is replaced with red (hue value 0 degrees), lightness remains the same at 0% and saturation is 25%. Some people recommend this as a method of obtaining a colored monochrome image. Yes it works, but frankly I would suggest you follow some of the steps outlined later in Chapter Thirteen on black and white effects.

Color balancing with Levels

While the Levels dialog box is open, you can at the same time correct color casts by adjusting the gamma in the individual color channels. Where you see the pop-up menu next to the channel at the top, mouse down and choose an individual color channel to edit. Increasing the gamma in the Green channel will make an image appear more green (RGB mode). In CMYK mode, increasing the gamma setting in the *Magenta* channel will make the image go more green. To neutralize midtones, in the Levels or Curves dialog box, select the gray eyedropper and click on an area in the image that should be a neutral gray. The levels will automatically adjust the gamma setting in each color channel to remove the cast. Levels may be adequate enough to carry out basic image corrections, but does not provide you with much control beyond reassigning the highlights, shadows and midpoint color values. The best tool to use for color correction is Curves. This is because you can change the color balance and contrast with a degree of precision that is not available with the Levels, Color Balance and Variations image adjustments.

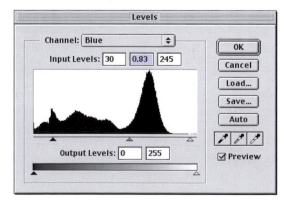

Figure 9.2 Individual color channel Levels adjustments can be applied to adjust the color balance.

Variations

Figure 9.3 The Variations dialog displays color balance variations based on the color wheel model (shown right). Here you see the additive primaries, red, green, and blue, and the subtractive primaries, cyan, magenta, and yellow, placed in their complementary positions on the color wheel. Red is the opposite of cyan; green is the opposite of magenta, and blue, the opposite of yellow. Use these basic rules to gain understanding of how to correct for a color imbalance. For instance, clicking on the red preview will cause the red variant to shift to the center and readjust the surround previews accordingly. Clicking on the cyan preview will restore the central preview to its original color balance.

Note the other controls available in the Variations interface. You can modify the color of the shadows, highlights or midtones separately. In this respect, Variations is just like the Color Balance adjustment, but you also have built in the saturation adjustment and a lighter or darker option. And you can save or load a previous Variations adjustment setting. Variations may be a crude color correcting tool, but it is nonetheless a useful means with which to learn color theory.

Auto Contrast

The Auto Contrast image adjustment is a refined version of the Auto Levels adjustment. When Auto Contrast is applied, the levels of the image are expanded to produce a full tonal range and in most cases without inadvertently upsetting the color balance. This adjustment will clip the black and the white pixels by 0.5%, ensuring that representative pixel values are chosen.

Color Balance

The Color Balance is a sort of blind curves adjustment command. The interface controls may look intuitive enough, but it is not really the most useful tool for balancing and correcting color. If you are able to follow the later tutorials which show how to use curves adjustments to correct color accurately, then you might as well disregard Color Balance. Although I do sometimes use Color Balance to tone black and white photographs.

Variations

The Variations adjustment offers a more impressive and easy to use dialog box. It is identical to Color Balance in that you can choose to make an image more green or more cyan in the shadows, midtones or highlights plus you can select from the darker, lighter and more/less saturated options. The increments of adjustment can be fine or coarse and warnings of channel clipping are displayed in the preview boxes. Variations is not bad as a starting tool for beginners, because it combines a wide range of basic image adjustment tools in a single interface and an out-of-gamut warning is given when the safe limits of an adjustment have been reached.

Curves adjustments

Any adjustment which can be done in Levels can also be done using Curves. The Curves interface is less intuitive, but it is also much more powerful because you not only set the shadows and highlights, but have accurate control of the overall contrast as well as in the individual color channels. Figure 9.4 shows the Curves dialog (you can toggle enlarging the dialog view by clicking the zoom button in the top right corner). The linear curve line represents the tonal range from 0 in the bottom left corner to 255 levels top right. The vertical axis represents the input values and the horizontal axis, the output values. So, if you move the shadow or highlight points only, this is equivalent to adjusting the input and output sliders in Levels. In Figure 9.4, the highlight input point has been moved in several levels.

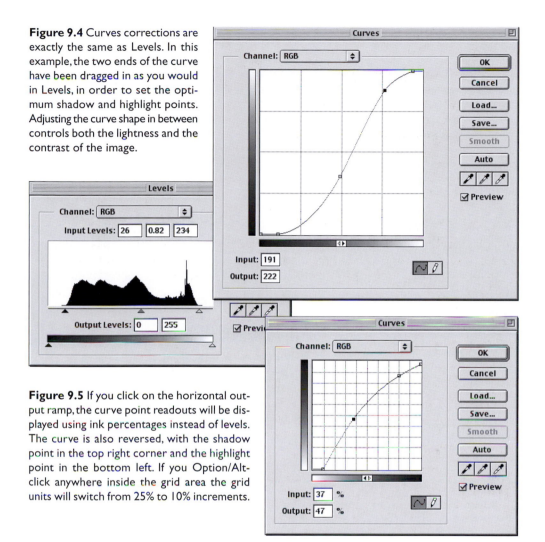

Figure 9.4 Curves corrections are exactly the same as Levels. In this example, the two ends of the curve have been dragged in as you would in Levels, in order to set the optimum shadow and highlight points. Adjusting the curve shape in between controls both the lightness and the contrast of the image.

Figure 9.5 If you click on the horizontal output ramp, the curve point readouts will be displayed using ink percentages instead of levels. The curve is also reversed, with the shadow point in the top right corner and the highlight point in the bottom left. If you Option/Alt-click anywhere inside the grid area the grid units will switch from 25% to 10% increments.

The following example shows how simple it is to use Curves to correct an RGB image where we wish to make the shadows lighter but without lightening the overall photograph. With Curves, you can target a specific range of tones and remap the pixel values to make them lighter or darker or increase the contrast in that tonal area only. To use a musical analogy, you could say that choosing curves over levels is like playing with a fretless guitar instead of a fretted instrument. Various examples of curves use are featured throughout this book. For example, Chapter Fourteen shows how coloring effects can be achieved through curves adjustments. The default RGB units are measured in brightness levels from 0–255. CMYK curves are by default displayed differently (click on the horizontal output ramp to toggle between displaying with levels or ink percentage readouts). This alternate mode (see Figure 9.5) is designed for repro users who primarily prefer to see the output values expressed as ink percentages.

1 The photograph shown here lacks detail in the shadows. The information is there but in its current state the hair will print too dark. We don't want to lighten all of the photograph, otherwise the mood in the original picture will become lost. Choose Image > Adjust > Curves. The dialog box contains a line on a graph on which you can remap the image tones. Identify which portion of the curve needs adjustment by mousing down in the image area (such as on the darker areas of the hair) and watch where the circle appears on the curve.

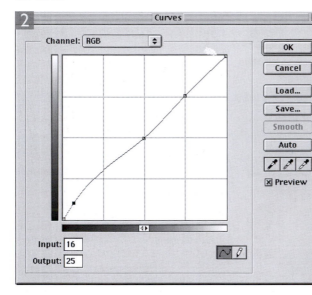

2 Click on the curve line to anchor both the midpoint and the highlights. Now refer back to stage one which helped you determine where to add a point on the shadow end of the curve, click on the curve and drag upwards to lighten. The line bends to form a smooth curve and the shadows are made lighter. Precise positioning of the curve anchor points is achieved by using either the keyboard arrow keys or entering numeric values in the Input and Output boxes below.

3 In this corrected version the midtone and highlight tone values remain unaltered, while the shadow detail has been lifted. You can always use Curves in this way to exert fine control over the lightening or darkening at precise points on the tonal scale.

Client: Schwarzkopf Ltd. Model: Maria at M&P.

The next example shows how you adjust the curve to both improve image contrast and correct the color balance at the same time. If the monitor has been correctly calibrated, this can be judged by eye on the screen.

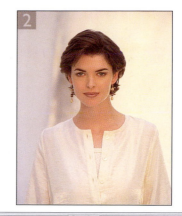

I The highlight and shadow points have been set to expand the tonal range, but the photograph looks too flat plus it also has a slightly warm cast.

2 Apply a Curves correction. Change the channel selection from RGB to Blue. Drag the cursor over the image areas which look like they need color correction. Note the position of the circle which appears along the curve as you do this. Select this point on the curve and raise it slightly as shown. This will begin to remove the yellow cast, making the image midtones appear more blue.

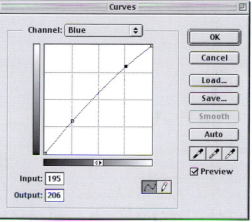

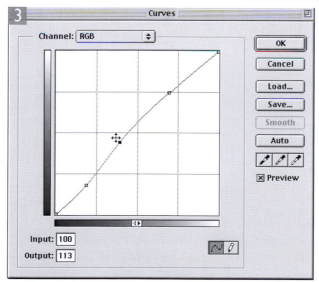

3 Return to RGB mode and add control points to the curve at the shadow and highlight ends. Drag these points to form an 'S' shape like the one shown here. Drawing an 'S' shape the other way round achieves the opposite effect and softens the contrast. If you are not happy about the position of a curve point, it is very easy to move it around and change the shape. When a control point is selected, to select the next point, use Command/Ctrl+Option/Alt+Tab. To select the previous control point, use Command/Ctrl+Option/Alt+Shift+Tab. To get rid of a point altogether, drag it to the outer edge of the graph or Command/Ctrl-click on the point in the grid.

Client: Schwarzkopf Ltd. Model: Erin at Models One.

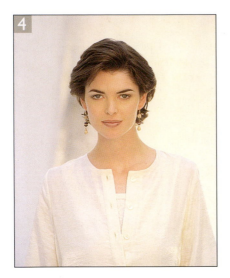

4 As with Levels, selecting individual channels from the pop-up channels menu in the Curves dialog enables you to selectively alter color values at any position along the tonal curve. This implies that you can not only correct color imbalances but also introduce color casts or even create cross-processed effects such as is demonstrated later on in Chapter Fourteen.

There is also a more precise way of correcting the color balance. If you exploit the fine tuning capabilities built into the Curves dialog and combine this with the use of the color sampler tool, you can correct with absolute precision. Repro professionals will often rely more on the numeric readouts to judge the color in a digital image. The follow-on tutorial, featuring the white boot, is a good example of where the Info palette readout can be used to determine the neutrality of the image tones and is the ultimate guarantee of perfect color correction. If you match up the RGB values so that red = green = blue, the resulting color is always a neutral gray. Remember, this is not the case with CMYK color (see Chapter Four on color management).

I When you have a white object photographed against a white background, any color cast will always be very noticeable. First of all select the color sampler tool and click on the image in up to four places to locate the persistent color readouts at different places on the boot.

2 Follow the Levels adjustment procedure as outlined in the previous chapter (Assigning shadow and highlight points, page 194) to add a Levels adjustment layer and expand the tonal range and neutralize the shadows and highlights as much as possible. This already improves the picture and removes most of the cyan cast.

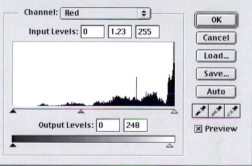

To add a new color value as a point on the curve, Command/Ctrl-click in the document window and to add extra points, Shift+Command/Ctrl-click. To select multiple points, shift click them in the Curves grid – move one and they all move in unison. To deselect all the points, use Command/Ctrl-D. When a single point is selected you can select the next point using Command/Ctrl+Tab and the previous point by using Command/Ctrl+Shift+Tab. An image like this white boot might be used as a cutout against a white background. Not even the best reprographic press can reproduce the faint highlight tones between 247 and 255 on the tonal scale. If you set the whitest white to 255, the first tone to register as a highlight ink dot on the page will be at around 249 or less. Anything above will be clipped and burnt out. Where a border of a white object fades to a white cutout, this subtle detail is not going to print. I usually set the highlight to a maximum white of 247 or 249 as shown in the earlier Levels tutorial and the shadows to a value of 10 as anything darker will print as a solid black.

3 The color sample points can be repositioned as necessary by dragging on them with the color sampler (you can access the tool while in an image adjustment dialog, by holding down the Shift key). Add a Curves adjustment layer and adjust each color channel curve as necessary. The first RGB readout figure in the Info palette tells you exactly where to position the point on the curve (see the Input numeric box). Now either manually drag the point or use the keyboard arrows (Shift+arrow key moves the control points in multiples of 10) to balance the output value to match those of the other two channels. Just like Robinson Crusoe's table, what you adjust at one point on the curve will affect the shape and consequently the color in another part. This is why it is advisable to monitor the color values across the range of tones from light to dark. Remember that you can shift select image sampled colors to add points to the curve.

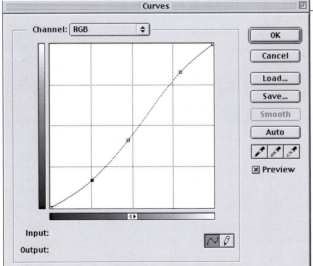

Photograph: Davis Cairns.
Client: Red or Dead Ltd.

As a final word on Curves, click on the Arbitrary Map option to change the Curves adjustment mode. You can sketch away with the pencil cursor anywhere in the graph to map any shape of curve you could imagine. The results are likely to be quite repulsive, but if you click on the smooth button once, twice or more, you will see that the curve become less jagged and the tonal transitions in the picture are made more gentle. An example of Arbitrary Map mode curves adjustments is found in Chapter Thirteen on black and white effects.

Replace Color

Hue/Saturation crops up again in the Replace Color command, which is really like a combination of the Select > Color Range and Hue/Saturation command combined in one. With Replace Color, you can select a color or range of colors, adjust the fuzziness of your selection and apply the Hue/Saturation adjustments to those selected pixels only. Alas, the selection made this way is not savable. For critical situations you will want to make a Color Range type selection first and while the selection is active, choose New Adjustment Layer... > Hue/Saturation from the Layers palette. This two-step process is probably the more flexible approach.

I This is the before image. Using the Replace Color adjustment command we can quickly take the image information in the purple backdrop and alter the Hue, Saturation and Lightness values. This image adjustment command is not available as an adjustment layer, because the single command is a combined two-stage process which involves making a pixel selection.

2 Choose Image > Adjust > Replace Color. To make the selection, first click with the eyedropper either on the image or in the dialog box mask preview window. Click again with the 'add eyedropper' icon to add to the selection. Click with the 'minus eyedropper' to remove colors. Use the Fuzziness control slider to determine how much tolerance you want to apply to the selection area (see magic wand tool). Now change the Hue/Saturation values. As you can see here, the biggest change took place with the Hue, making the background go green instead of purple. Small saturation and lightness adjustments were also necessary.

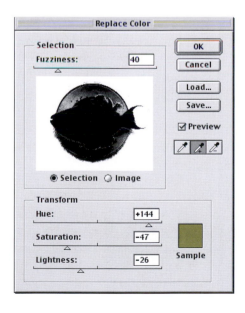

3 After performing the Replace Color operation, there was a little spill-over on to the blue plate. All you have to do is erase the offending areas — you can use the history brush to do this, then make a circular selection with the elliptical marquee tool. The marquee actions can be modified when you hold down the Option/Alt key to draw out from the center and constrained to a circle when you hold down the Shift key at the same time. If at any time you also hold down the Spacebar, you can drag to reposition the selection. If you release the Spacebar (but have still held down the Option/Alt+Shift keys), you can carry on expanding or contracting the selection. Now feather the selection and select the Open image state as the History source and restore the original unaltered image.

Color Range

The Color Range option is like a super magic wand tool which resides in the Select menu. It seems appropriate at this point to highlight an extra feature in the dialog pull-down menu: you can use the Color Range command to make a selection based on out-of-gamut colors. This means you can use Color Range to make a selection of all those 'illegal' RGB colors outside the CMYK gamut and apply corrections to these pixels only. This task is made easier if you feather the selection slightly and hide the selection edges (View > Hide Edges). Then choose View > Gamut Warning. Adjustments can be made using the Selective Color or Hue/Saturation commands as before. Local areas may also be corrected with the sponge tool set to Desaturate.

Figure 9.6 The Color Range selection tool.

Adjustment layers

Adjustment layers and the Image > Adjust commands are identical in purpose. Adjustment layers offer the facility to apply multiple image adjustments and/or fills to an image, but let these changes remain 'dynamic' (the gradient, color and pattern fill dynamic layers are discussed later). That is to say, an adjustment layer is an image adjustment which can be revised at any time. The adjustment layers provide deferred pixel processing in Photoshop. Used in conjunction with History they give Photoshop a three-dimensional work space of not just multiple, but limitless, undos. One drawback to adjustment layers is the way they may slow down the monitor display. This slowness is not a RAM memory issue, but to do with the extra calculations that are required to redraw the pixels on the screen. The slowdown is just like having lots of extra complicated layers in an Adobe Illustrator™ document which have to be rendered again every time you scroll or resize the image window. Adjustments are savable in the native, TIFF 7 and PDF formats. Note that the threshold preview mode is now enabled in the Levels adjustment layer dialog. Adjustment layers and their close cousins, the Gradient Overlay Color Overlay and Pattern Overlay fill layers, can also be masked by an alpha channel, a converted selection or a clipping path. Here is a tip you might like to try: create a adjustment layer, any will do, change the blending mode and observe how the image can be made to interact with itself.

Multiple adjustment layers

You can have more than one adjustment layer saved in a document, with each producing a separate image adjustment. In this respect, adjustment layers are very useful because combinations of adjustments can be previewed to see how they will affect a single layer or the whole image before you apply them. You can have several adjustment layers in a file and choose to readjust the settings as many times as you want, but the pixel values are only adjusted once as you merge the adjustment layers down. This means there is less risk of image degradation being caused by cumulative image adjustments. In any single image one could have saved a series of image adjustment color variations to a folder and be able then to reload these from within an adjustment layer dialog. This makes it easy to demonstrate alternative color changes to a client. The adjustment layers can be changed quickly and they will only occupy a few kilobytes of disk space. Whichever way you look at it, that is a huge saving in time and storage. Many of the workflows described in this book take advantage of how adjustment layers allow you to make accumulated image adjustments and apply them as a single image adjustment when you flatten all the layers. As shown in the accompanying example, it is possible to make multiple adjustments without compromising the image quality.

1 You can match the effect of using a graduated filter over the camera lens in Photoshop with a Levels adjustment layer. Create a new adjustment layer. Choose Levels and darken the image by moving the Levels gamma slider to the right. Next, add a mask to the adjustment layer. When an adjustment layer is active, painting with the paintbrush or filling anywhere in the image area with black will add an opaque mask which removes the adjustment.

2 Set the foreground/background colors to their defaults (as shown in the Tools palette). Activate the Levels adjustment layer, select the linear gradient tool and drag from the bottom up to the middle of the picture, a gradient is drawn which masks the lower portion of the image. This action restores the original levels in the now masked areas. The masking can be undone at any time by painting or filling with the white background color. Different blending modes can be used with an adjustment layer. For example, a Multiply blend will make the levels adjustment darker.

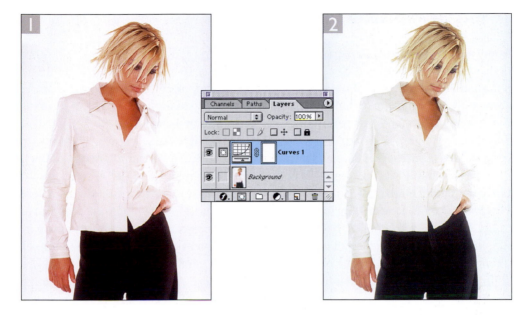

1 This is the before image in 24-bit RGB color mode without any image alteration, showing the colors as they appeared on the scan.

2 A Curves adjustment layer was added. This corrected the warm cast. The Curves adjustment can be readjusted at any time.

3 Now a lot more adjustment layers have been added. The Channel Mixer effect added a cyan cast, which I chose to fade off to the center by adding a layer mask to the layer. At this stage the background layer retains all the original pixel information. When the layers are flattened, a single, combined image adjustment will take place.

Client: Schwarzkopf Ltd. Model: Emma at Boss.

16 bits per channel support

Many scanners are able to capture high-bit data. Imported files which contain more than 8 bits per channel will be opened in Photoshop in 16 bit-per channel mode. 16 bit per channel support will allow color adjustments, cropping, rotating and use of the clone tool. In Photoshop 6.0, this list has been extended to include Lab color, Canvas Size adjustments and the following filters: Gaussian Blur; Add Noise; Dust & Scratches; Median; Unsharp Mask; Solarize; and High Pass. Figure 9.7 shows a comparison of histogram displays between and 8-bit to 16-bit per channel and back to 8-bit and an all 8-bit per channel operation. You may not feel the need to use 16 bits per channel all the time for every job, but I would say that for critical jobs where you don't want to lose an ounce of detail, the short-term file size increase may prove to be worth this extra delay. Testing has shown that extreme color adjustments carried out in a 16-bit per channel image after conversion back to 8-bit retained more of the image detail present in the original, whereas the 'all 8-bit route' image would be slightly degraded. More obvious benefits from the use of 16-bit per channel image adjustment can be seen when applying Curves adjustments containing strong kinks in the curve or use of the curves arbitrary map function. Multiple adjustment layers also do less damage to the pixel information because the combined adjustment is then a single operation. True, but for ultra-critical color adjustment and color conversions, I would recommend converting the image data to 16 bits per channel. This has the effect of doubling the file size, but need only be a temporary first step for getting the intitial levels set right.

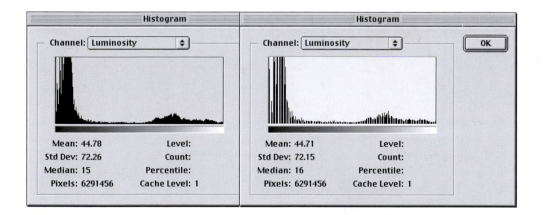

Figure 9.7 The left column is color manipulation carried out in 16 bits per channel and converted back to 8-bit and the right column where 8 bits per channel were used throughout.

Selective Color

The Selective Color command is the ultimate, precision color control tool. It allows you to selectively fine tune the color balance in the additive and subtractive primaries, blacks, neutrals and whites. In that respect the controls are fairly similar to the Hue/Saturation command, except here you can adjust the cyan, magenta, yellow and black component of the chosen color range. The Selective Color command is therefore a tool for correcting CMYK color, but you can also use it to prepare an RGB file before converting it to CMYK. The color control available with Selective Color is a bit like adjusting the sound on a music system with a sophisticated graphics equalizer. Subtle or quite strong changes can be made with ease to the desired band of color tones. The Selective Color command is therefore another alternative to the Hue/Saturation adjustment for getting RGB colors to fit the CMYK color space. In the accompanying tutorial, I show how the gamut warning can help you pinpoint the illegal out-of-gamut colors in RGB. You may want to consider carrying out such adjustments using two window views: one with the normal RGB version and the other with gamut warning and the Working CMYK proofing switched on in the View menu.

As a final note on the above technique – there is bound to be a noticeable color shift and more than just the blue colors will benefit from adjustment. Since the initial blue did not exist in CMYK it had to be converted to something else. What that something else is, well that's the art of preparing images for four-color printing. The trick is to convert the existing colors in a way that the color values obviously change but the final perception looks right to the eye. Blue skies are a good example – bright deep blues do not convert well to CMYK, as deep blue will fall outside the CMYK gamut, but adjusting the Selective Color values of, for example, the blue, cyan and black will produce another type of blue using a different combination of inks other than the default conversion that does work convincingly to the eye. Where the color matching is critical, Selective Color may help to correct an imbalance and improve the output color, provided the output color to be targeted is within the CMYK gamut. When this is not so, special printing techniques must be adopted – adding an extra printing plate using a custom color, for example.

Returning now to this last tutorial, you may like to explore other refinements to the technique. For instance the CMYK Preview window could also have the Gamut Warning switched on too. As corrections are made using Selective Color, you can see whether the colors are changing to your satisfaction and falling inside the CMYK gamut.

1 Not an easy one to show this, because we are starting with an 'RGB' image that is printed in CMYK. But imagine the situation – you are looking at an RGB scan which is fine on screen, but not all the colors fall within the CMYK gamut. The Photoshop Image > Mode conversion will automatically compensate and translate the out-of-gamut RGB colors to their nearest CMYK equivalent. If there are only a few out-of-gamut RGB colors to start with, there will be little change to the image appearance after converting.

2 To check if this is the case, you can select View > Proof Setup to Working CMYK (highlight the option to switch on; highlight again to switch off) and choose View > Gamut Warning. The latter will display out-of-gamut RGB colors with a predefined solid color (set in preferences as neutral gray by default). If the gamut warning shows any out-of-gamut pixels, use the Image > Adjust commands to compensate and bring them within the CMYK gamut. Here I used the Image > Adjust > Selective Color command to selectively shift the magenta and yellow percentages of the blue component color.

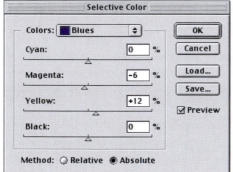

3 The result of the previous image adjustment is a picture where the 'illegal' RGB colors have been adjusted so that when the conversion takes place all the RGB colors have a direct CMYK equivalent. You can just as easily use the Hue/Saturation command to do this job. I used Selective Color because it is a fine-tuning color adjustment tool and one based around the destination CMYK color model. A relative percentage change will proportionally add or subtract from the current value. So if the cyan value is currently 40% adding a Relative 10% will equal 44%. Adding an Absolute 10% will make the new value 50%.

Chapter Ten

Repairing an Image

Most photogaphers will be interested in the potential of Photoshop as a tool for retouching pictures more than anything else. So we'll start with cloning and then go on to examine other creative techniques which can be used to clean up and repair damaged photographs. Cloning is a popular retouching technique and once mastered, most people will use the clone stamp all the time to repair their images, but there are other retouching techniques which will serve you better in certain situations.

Basic cloning methods

The simple tricks are always the best and the clone stamp tool never fails to impress clients. The clone stamp tool is used to clone parts of an image. All that is required is some basic keyboard/mouse coordination. When the clone stamp tool is selected, you first select an area to sample from, hold down the Option/Alt key and click. Then release the Option/Alt key and click or mouse down with the mouse to paint over the area you want to clone to. When the Aligned box is checked, the area sampled retains the same angle and distance in relation to where you paint with the clone stamp tool. When the Aligned option is deselected, the sampled point always remains fixed. This latter mode is ideally used when the area to sample from is very small, as you can keep a tight control over the area you are sampling from. The Aligned mode is the most appropriate option to select for everyday spotting of scans. Select the Use All Layers option to sample from merged layers. As with all the other brush tools, you can change brush size, shape and opacity to suit your needs. While you may find it useful working with different combinations of these settings with the

painting tools, the same does not apply to the clone stamp tool. Typically you want to stick to using the fine to medium-sized brushes (just as you would always choose a fine paintbrush for spotting bromide prints). If the brush has too soft an edge, this can also present problems. I mostly always leave the opacity set to 100%. Cloning at less than full opacity usually leads to telltale evidence of cloning. Where the film grain in the photograph is visible, this can lead to a faint overlapping grain structure, making the retouched area look slightly blurred or misregistered. When smoothing out skin tone shadows or blemishes, I will occasionally switch to an opacity of 50%

1 The Options bar which displays the clone stamp options is normally always snapped to the top or bottom of the screen. The two basic modes of operation are Aligned and Non-aligned. The 'Aligned' box is normally checked by default. The Non-aligned mode allows you to set the source sample point and repeat cloning, always commencing from that exact same source wherever you paint in the image window. The tool opacity should be left at 100%. Sometimes painting at a lower opacity will work, but the best way to disguise your cloning is to use the clone stamp at 100%.

2 This example shows the source image area identified by a surrounding yellow rectangle. All the other clones (which are marked with cyan rectangles), were repeated from the same source starting point using the clone stamp in Non-aligned mode.

3 In Aligned mode, Photoshop will always maintain the relationship (the alignment) between the sample and painting points. Normally, the clone stamp tool will only act on the active layer contents. When the Use All Layers box is checked, Photoshop will sample data from all the layers which are currently visible, as if they were a single flattened layer.

or less. Retouching light soft detailed areas means I can get away with this. Otherwise stick to 100%. Lines and wrinkles can be removed effectively with the dodge tool or with the brush tool set to Lighten mode. Areas of smooth tone transition demand you be really careful when cloning. You may not even be aware of the tonal gradation present, but make sure the area you sample from is of the exact same hue, lightness and saturation or else the brushwork will stand out a mile. For this reason, I have included alternative repairing techniques to handle such situations.

Figure 10.1 If I want to, I can sample the sky from one image window and copy it using the clone stamp to another separate image. Option/Alt-click with the clone stamp in the source image, select the other image window and click to establish a cloning relationship between the source and destination images.

Spotting used to be such a laborious and tricky process. I am reminded of an old story about a commercial photographer who rather than use a scalpel knife to remove a black speck in the sky, would paint in a couple of wings and turn it into a seagull. Thankfully with Photoshop anyone can learn to quickly spot a picture now.

Figure 10.2 Gradient banding is a common problem in Photoshop. Banding can occur whenever you apply a heavy blur filtration. It can also sometimes appear on gradient fills. The gradient options include a dither mode and this will help somewhat. However, the best way to hide banding is to apply a small amount of noise, using the Noise > Add Noise filter. The Gaussian option will produce a more irregular distribution of noise.

The example here shows a noticeably banded gradient with and without the noise being added. The noise filter is well worth remembering any time you wish to hide banding or make Photoshop paintwork appear to merge better with the grain of the scanned original.

Retouching a color negative

Not until Photoshop 4.0 introduced adjustment layers was it possible to retouch a masked color negative and output again as such. In the example shown opposite, the client wanted the color negative original to be scanned as a positive, so that it could be output again to film as a color negative. This color negative scan can be displayed on the screen as a positive image by the introduction of an extra layer and three adjustment layers, one to neutralize the mask, one to invert the image and the others to expand the levels and increase the color saturation. You can then spot and retouch the active background layer without actually altering the color or masking of the color negative original.

The following example uses a color negative photograph of Luton Town Hall, taken by David Whiting, which was digitized as a negative to include the orange color mask and output to film as a color negative again. This is a refined version of a technique which was devised by Rod Wynne-Powell of Solutions Photographic.

I The scanned negative requires some retouching prior to being output as a negative again. It would be hard to retouch the negative as it is because the colors are inverted with an orange colored mask and the tonal range is too narrow for us to see properly what is going on. The following steps are intended for viewing a positive version of the image. The added layers can be discarded later.

2 The first stage is to counterbalance the orange mask – sample from the rebate using the eyedropper tool set to a 3 x 3 pixel sample radius (go to the eyedropper tool options). Make a new layer, fill with the sample color (Option/Alt+Delete) and invert: Image > Adjust > Invert. Now change the opacity to 50% and the blending mode to Color. As you can see, this neutralizes the orange mask.

3 Next add an adjustment layer to convert the image to a positive. Go to the Layers palette submenu, select New Adjustment Layer and choose Invert. This operation inverts the tonal values exactly, converting the negative image into a pale positive.

4 To boost the contrast, make a second adjustment layer. Select Levels and in the Levels dialog box, click on the Auto Levels button. Finally add a Hue/Saturation adjustment layer and bring up the saturation a little more. We now have an approximate image preview of the negative as a positive. To carry out any spotting or retouching, the base layer must be active. Any further changes made to the image pixels should be carried out on the negative only. When you are satisfied with your retouching, discard the adjustment layers and output to transparency. Provided you are operating within a closed loop with the bureau who supplied the scan, the output will near enough exactly match the original.

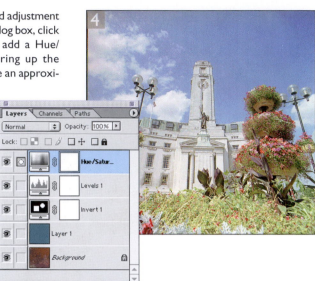

Alternative spotting technique using the history brush

This method has evolved from a technique which was first described by Russell Brown, Senior Creative Director of the Adobe Photoshop team. The Remove Dust and Scratches filter can be used to remove image defects and is found in the Filter > Noise sub-menu. If this filter is applied globally to the whole image, you will always end up with a soft-looking result. You are actually only meant to apply this filter selectively to the damaged areas of the photograph in Photoshop. The technique shown here has the advantage of applying the filtered information precisely to fill in the dirty areas without the risk of destroying the tonal values in the rest of the picture.

1 There are a number of hair and scratch marks visible in this picture. Most are on the backdrop and a few are on the subject. This spotting technique makes good use of the history brush facility. Check the history settings in the palette fly-out menu. In this example, Non-linear history has been allowed.

Photograph: Peter Hince.

2 Apply Filter > Noise > Remove Dust & Scratches to the image. Check the preview and adjust the Amount setting so that most of the marks appear to be removed in the filter preview and then apply the filter to the whole image.

3 Afterwards, activate the previous unfiltered image state in the History palette, but set the history brush to paint from the filtered version. Go to the tool options bar and change the history brush blending mode to Darken. When you paint over the light scratch and dust marks, the history brush will darken only those pixels which are lighter than sampled history state.

4 So, to use the history brush for spotting, change the tool blending mode from Normal to either Lighten or Darken. If you are removing light spots, use Darken mode. If you are removing dark spots, use Lighten.

Cloning selections

Cloning with the clone stamp tool is an acquired skill and to hide your cloning effectively, you need to keep changing the source point you are sampling from. If you don't, you may find parallel herringbone patterns betray signs of your retouching. The clone stamp tool always clones from the previous image state. It does not resample the 'clone added' image areas. It is not practical to reconstruct large areas of an image simply with the clone stamp tool. The previous techniques are suitable for most spotting treatments, but where there are larger areas to repair, another method of cloning is required. The next example shows how to replace an area to be repaired with a cloned selection from another part of the same image.

1 In the following steps I shall demonstrate how to clone the windows in the building on the right. If I were to use the clone stamp tool to sample and copy the windows, then the perspective of the cloned windows would not match correctly. So instead, I will make a selection of some of the windows in order to copy them as a new layer and then position this copied layer to match the correct perspective.

2 First make a rough selection of the area we are going to copy from. Select the polygonal lasso tool and set the Feather to 3 pixels. Click with the polygonal lasso tool around the outside of the upper windows to make a selection as shown.

3 Now that we have a feathered selection of the windows, go to the Layer menu and choose Layer > New > Via Copy. Or you can use the keyboard shortcut Command/Ctrl-J. The copied selection will appear as a separate layer in the Layers palette. Select the move tool and drag the new layer down to where we wish to add the new windows.

4 As was predicted, the cloned windows do not match the perspective of the rest of the building after they have been copied and repositioned. Select the Edit > Free Transform command. A bounding box will appear around the layer 1 contents. Hold down the Command/Ctrl+Shift keys and drag the middle left handle upwards. Repeat with the middle right handle. This modifier key combination will constrain the transform to a shear type transformation. Then drag either the top or bottom middle handle to compensate for any vertical stretching. The illustration on the right shows how the layer 1 preview looked after the perspective correcting transformation had been applied. Hit Enter to apply the transform.

Restoring a faded image

Here is a common problem – how do you restore a photograph which has unevenly faded? The answer is to make an image adjustment to darken the photograph and then selectively remove this image adjustment to restore the areas which were not faded. The technique shown here uses adjustment layers, which provide a quick and easy way of allowing you to selectively apply an image adjustment.

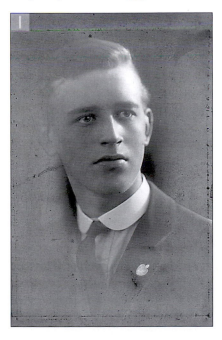

1 With the image to be restored open and the Layers palette visible on the screen, click on the Create New Adjustment Layer button at the bottom of the palette and select Levels from the pop-up menu.

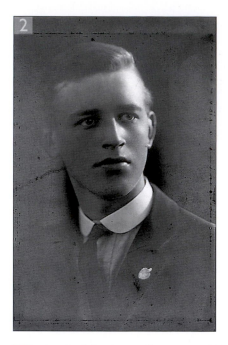

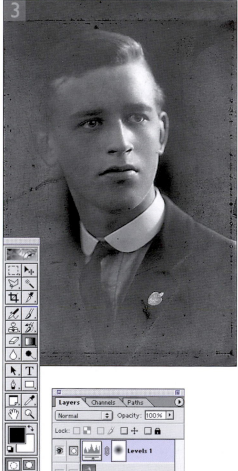

2 The Levels dialog box will now open. We will want to darken the image with this levels adjustment layer, so drag the gamma Input slider to the right. The amount of darkening is not critical. Remember that adjustment layers do not permanently affect the image until after you flatten the image or merge down the adjustment layer.

3 When the adjustment layer is selected, painting anywhere in the image area is just like painting on a layer mask linked to an image layer. To restore the lightness at the center of the photograph, drag with the gradient tool in radial gradient mode from the center outwards, using the default foreground/background colors, and the gradient options set to the foreground to background gradient option.

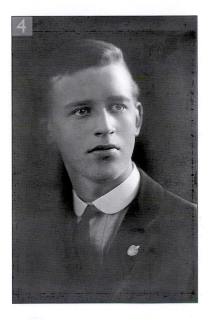

4 Readjust the Levels adjustment layer again in order to balance the fade (double-clicking the adjustment layer will reopen the Levels dialog box). You can also add to the radial gradient fill by selectively painting on the adjustment layer mask with a low opacity brush. For this final version, I changed the layer blending mode from Normal to Multiply and reduced the blend opacity slightly. This action darkened the outer edges while keeping the same lightness in the center of the photograph.

Keyboard shortcuts

You will notice in this chapter that I introduced a few keyboard shortcuts for the menu and Tools palette commands. Newcomers to Photoshop will no doubt prefer sticking to the longer routine of selecting tools by clicking on them in the Tools palette and navigating through the menus and sub-menus. After a month or so, try to absorb the keyboard shortcuts, learning a few at a time.

Here are a few examples of the essential keyboard shortcuts: rather than keep switching between the current tool and the move tool, it is much easier to temporarily access it by holding down the Command/Ctrl key (except when the pen or hand tool is selected), then instead of using the mouse, you can also control movement via the keyboard arrow keys, nudging the layer or selection in 1 pixel (10 pixels with the Shift key also held down) increments. A series of nudges count as a single Photoshop step in History and can easily be undone with a single undo or step back in History.

Hold down the Spacebar to temporarily access the hand tool and hold down Command/Ctrl+Spacebar to zoom (magnify). To zoom out, hold down the Option/Alt+Spacebar keys. If the hand tool is already selected, then holding down either the Command/Ctrl or Option/Alt keys will have the same effect. Double-clicking the zoom tool will set the view to actual pixel size (100%) as does the keyboard combination of Command/Ctrl+Option/Alt-0. Double-clicking the hand tool will set the view to the fullest screen size within the constraints of the visible palettes. The alternative keyboard shortcut is Command/Ctrl-0.

These are both very useful time saving features and it is also worth mentioning that these actions are governed by whether the palette and Tools palette windows are currently displayed or not. Pressing the Tab key will toggle hiding and displaying the Tools palette and all palettes (except when a palette settings box is selected). The Shift+Tab keys will keep the Tools palette in view and toggle hiding/displaying the palettes only. When the palettes are not displayed the image window will resize to fill more of the screen area. This can make quite a big difference if you are using a smaller sized monitor. These and other shortcuts are all listed in menu and palette order in Chapter Twelve.

Time now to explore more ways of digitally retouching your pictures and making repairs to an image. Some of these techniques will demand a reasonable level of drawing skill and ideally you should be using a pressure-sensitive graphic drawing tablet as your input device rather than a mouse. Mistakes can easily be made – in other words, before proceeding, always remind yourself: 'now would be a good time to save a backup version to revert to.'

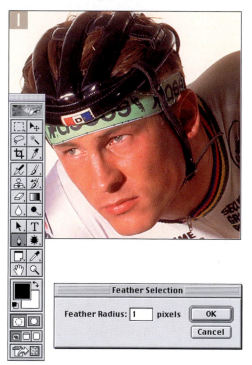

1 Here is the problem – remove the thick black lettering and convincingly replace the removed areas so that they match the green fabric texture. Commence by drawing a path to define the outline of the head band or, if you prefer, use the freehand lasso tool.

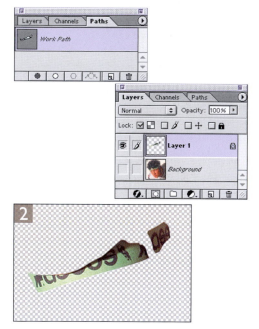

2 Having drawn a closed path, convert it to a selection (drag the work path to the palette Make Selection button). Feather the selection by 1 pixel (Select > Feather) and float as a new layer (Command/Ctrl-J). Check the Lock transparency box in the Layers palette. This is important *if* you want the following retouching to be constrained to within the non-transparent areas.

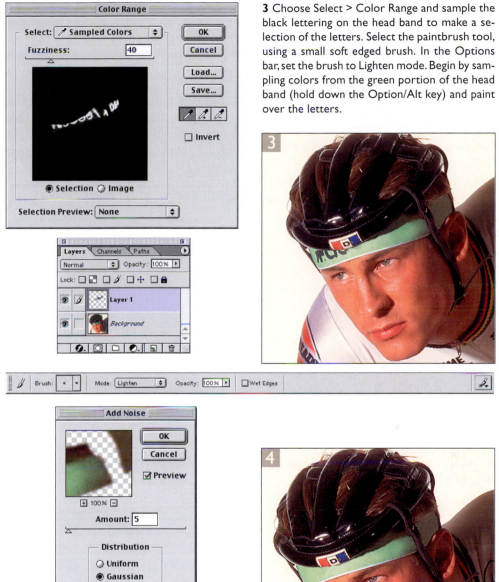

3 Choose Select > Color Range and sample the black lettering on the head band to make a selection of the letters. Select the paintbrush tool, using a small soft edged brush. In the Options bar, set the brush to Lighten mode. Begin by sampling colors from the green portion of the head band (hold down the Option/Alt key) and paint over the letters.

4 Keep resampling different shades of green to achieve realistic tonal gradation. With the selection still active, add some grain to the retouched areas: choose Filter > Noise > Add Noise. Select 'Gaussian Noise' and experiment with an Amount setting of 5. Now blend the retouched head band layer with the background layer.

I have included here a mixture of Photoshop retouching techniques which would be useful for photographers and have selected some Photoshop retouching tasks which demand a special approach, like how to retouch areas where there is not enough information to clone from. The good old clone stamp tool serves us well when repairing an image provided there are enough pixels available for us to sample from. If not, you have no choice but to paint the information in using the paint brush tool. Unless you are careful, these brush strokes may not look like they are part of the original photograph (excessive cloning, especially at low opacities creates the same type of mushy result). The reason such brushwork tends to stand out is because the underlying film grain texture is missing. This can easily be remedied by introducing the Add Noise filter selectively to the 'painted' pixels. The steps in the accompanying tutorial show how the black lettering was removed from the cyclist's head band.

Brush blending modes

In the previous tutorial, the brush blending mode was changed to Lighten and it is good practice to remember always to reset these blend mode options back to Normal. A number of the painting and editing tools are able to operate in a variety of blending modes which are identical to those you come across in layers and channel operations. In this instance, Lighten mode was chosen in preference to Normal because I wanted to selectively paint over the black areas whilst minimally affecting the existing green. Just try getting your head round the total of 133 different tool blending mode combinations or rather don't, as it is unlikely you will ever want to use them all. For example, will you ever want to use the clone stamp tool in Difference mode? To narrow down this list, I reckon the following modes are probably the most useful: Screen, Multiply, Lighten, Darken and Color combined with the brush, airbrush, blur and gradient tools.

I photograph and clean up a lot of hair and beauty type photographs and sometimes get requested to tidy up the hair color where perhaps the roots are showing. I will first marquee the area and float it to a new layer so that if I don't like the result I can ditch the new layer. I sample a color from the area with the right hair color, then set the brush to Color mode and paint over the roots. When painting in Color mode, the lightness values which define the hair texture and shape are unaffected – only the color values are replaced. The saturation values remain unaffected, so it may be necessary to run over the area to be colored beforehand, desaturating the area and then coloring it in. Painting in Color mode has many uses. Artists who use Photoshop to colorize scanned line art drawings will regularly use the Color and other blending modes as they work. Painting using the Color blending mode is also ideal for hand coloring a black and white photograph.

Retouching with the paintbrush

I regularly retouch fashion and beauty photographs using Photoshop. But sometimes the retouching can be very obvious, especially when the eyes are unnaturally lightened to paper white. Successful retouching is dependent on skilled brush work and knowing when and where to hold back on the level of retouching so that the natural features of the subject are preserved. For the sort of retouching I normally do, which usually means retouching skin tones, the paintbrush tool is indispensable. Photoshop layers and their blending modes play an essential part in making it possible to produce subtle blends between the retoucher's brush and the underlying photographic image. The following steps will show you how to do all of the above and how to add film grain selectively to your painted layers.

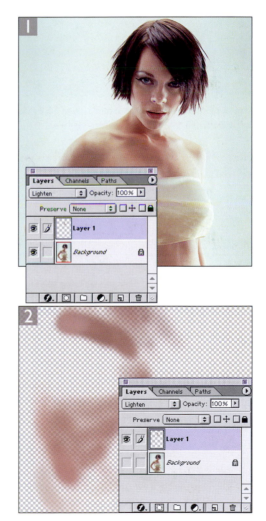

1 To clean up the face, add a new image layer, set the blending mode to Lighten and select the paintbrush tool. A pressure-sensitive tablet is essential for such retouching work – make sure that under the Brush Dynamics options, the Opacity is set to Stylus. Sample skin tone colors from the face and start to paint in Layer 1 using light strokes. Because the layer is in Lighten mode, the painting will only affect those pixels which are darker than the sampled color. Keep resampling new flesh tone colors as you work in a new area. To do this, hold down the Option/Alt key to temporarily convert the paintbrush to the eyedropper tool. Change the brush size as required, using the square bracket keys ([&]) and gradually smooth out any skin blemishes or unwanted shadows.

2 If the background layer visibility is switched off, then it is possible to see the retouching brush strokes that have been applied to the face much more clearly. Remember, the painting made on this 'Lighten' layer only affects the pixels which are of the same lightness or darker than the Layer 1 pixel color value. If the Layer 1 was set to Darken blending mode, only those pixels which are lighter than the sampled paint color would be affected. You could of course apply the retouching directly to the Background layer by painting with the paintbrush in Lighten or Darken blend mode, but this method is more flexible.

3 If a lot of paintbrush retouching is added on this layer, there is a danger that the completed retouching may make the skin take on an almost 'plastic' appearance. That might be the desired effect but if you wish to avoid this, go to the Layers palette and reduce the Layer 1 opacity setting. I personally prefer to take the Layer 1 percentage down to around 75% opacity, although often I will take the opacity even lower. I reckon it is always a good idea to restore some of the original shadows and skin texture.

4 Paintbrush work can also make a photograph look obviously retouched as the painted areas do not actually match the grain texture of the rest of the picture. Option/Alt-click the New Layer button at the bottom of the Layers palette to create a new layer via the dialog. Set the Layer blending mode to Overlay and check the Fill with Overlay Neutral Color (50% Gray) box. A 50% gray color in Overlay mode will not affect the layers below. However, if you apply the Add Noise filter, the variations in pixel values either side of 50% gray *will* modify the pixels in the underlying layers.

5 With the addition of a noise layer, it is possible to apply a noise texture to the brush strokes only and make this proportionate to the opacity of the pixels in Layer 1. Hold down the Option key and click the dividing line between Layer 1 and Layer 2 – this action creates a Clipping group. The opacity of Layer 1 will now mask the overlaying Layer 2.

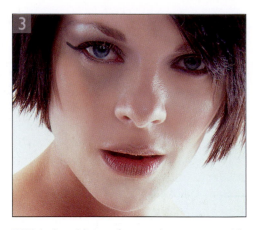

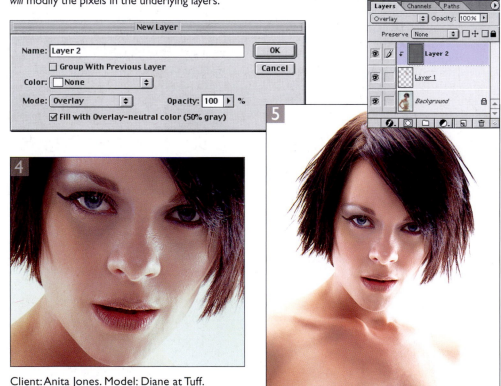

Client: Anita Jones. Model: Diane at Tuff.

Softening the focus

If you wish to soften the focus, the best way to go about this is to apply a Gaussian blur filtration and follow this with a Fade command (the Fade command will also fade an image adjustment or a paint stroke) in order to restore some of the sharpness contained in the unfiltered image state. As is shown below, you can change the fade blend mode to achieve interesting variations with which you can simulate favorite camera and darkroom printing techniques. If you prefer, duplicate the background layer, apply a Gaussian blur and selectively remove the blurred layer using a layer mask.

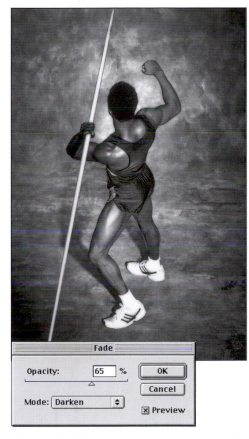

Figure 10.3 With the javelin thrower example, I applied a Gaussian blur filter and followed this with Edit > Fade Gaussian Blur and changed the mode to Darken. This action will simulate diffusion darkroom printing. With the forest scene I applied a similar amount of blur and faded using Lighten mode. This produced a soft focus lens effect.

Removing a fogged film cast

1 In this tutorial I shall demonstrate how to build a restored version of this Downtown Atlanta scene and make use of the image information which has survived. When the damage to a photographic original is as severe as this, there are limits as to how much one can perfectly retouch such a picture. The end result can never be absolutely perfect, but it is at least possible to do enough to salvage something which would otherwise be unusable. With a little care you can mend photographs which you once thought were beyond all hope.

2 With an example such as this, the most logical thing to do is start by analyzing the individual color channels. We will want to make use of whatever tonal information is still preserved in the individual color channels and blend these into the damaged portions of the photograph. Go to the Channels palette and click on each of the color channels in turn to see the extent of the damage. The red channel is clearly the worst, the green channel is only slightly affected, while the blue channel, although unaffected, is very noisy. This suggests that we should make use the information existing in the relatively unharmed green channel to build up the tonal information which is missing mainly in the red channel.

3 Begin by highlighting the green channel in the Channels palette, and Select All (Command/Ctrl-A). Copy the channel contents (Command/Ctrl-C) and then add a new layer above the background and paste the green channel from the clipboard (Command/Ctrl-V). Next, set the layer blending mode to Darken. These few steps will immediately make a significant improvement to the appearance of the photograph.

4 With the Layer 1 active, choose Hue/Saturation from the Image > Adjust menu. Check the Colorize box and set the Hue value to 180. This will colorize Layer 1 with cyan, which is the opposite of red. When seen on its own, Layer 1 should now look like the example shown here.

5 So far, Layer 1 contains the pasted green channel, which has been colorized cyan and the blending mode has been changed to Darken. The exposure is a bit uneven though. It looks a little darker on the fogged, right-hand side. Option/Alt-click the Create new adjustment layer button in the Layers palette. This will create a new adjustment layer, but show the New Layer options dialog where you can check the box which says Group With Previous Layer. This will make a clipping group of the subsequent levels adjustment with Layer 1.

6 Raise the Gamma (middle slider) value to 1.06 and click OK. When that is done, add a narrow linear gradient mask to the adjustment layer as shown opposite. The original image is located on the CD-ROM, so if you are following this technique and wish to match the mask I created here, set the ruler units to percent and choose Show Rulers from the View menu. Select the linear gradient tool and set the gradient tool options to 'Foreground to Background'. Zoom in on the image so that you can drag the gradient tool in the image window from the 62% to the 64% positions on the horizontal axis and hold down the Shift key as you do so.

7 I also wanted to target more precisely the way Layer 1 removed the red cast. To do this, double-click Layer 1 to call up the Layer Style options dialog, select the Red channel from the pop-up menu and adjust the Underlying blend settings as shown in the dialog box. This will successfully even out the exposure difference, leaving us with a result that looks something like the image on the left.

8 Command/Ctrl-click the masked Levels adjustment layer to load the mask as a selection and then Command/Ctrl-click the New Layer button in the Layers palette to create a new adjustment layer – select Hue/Saturation. Apply the settings shown here.

9 Note how the adjustment layer will be automatically masked with the loaded selection from the previous adjustment layer. The fogging is almost gone now. Next, add a Curves adjustment layer. This should finally tweak the colors of the fogged portion of the image to make them match those of the good half. Again, Command/Ctrl-click the previous adjustment layer mask and choose Curves from the adjustment layer menu. I used a curves adjustment to tweak the color balance (the Curves preset used is also contained on the CD-ROM). Figure 9 gives you an indication of how the photograph will appear after the curves adjustment has been applied.

240

10 The final touching up will have to be done manually as it requires the use of the paintbrush tool. Add an empty new image layer and set the blending mode to Color. Begin by zooming in on the sky portion and sample the sky colors using the eyedropper tool. Paint over any remaining reddish streaks with the paintbrush tool, parallel to where you sampled the color from. Here is a useful tip: with the paintbrush selected, hold down the Option/Alt key to temporarily convert the paintbrush to the eyedropper tool. Repeat below on the bollard and the buildings – sampling colors and painting over the streaks. Try also adding a global Hue/Saturation adjustment to boost the overall color saturation by around 10%. What you end up with may not be the best quality digital scan ever, but it does go to show that you can recover an almost usable image from something which first appeared to be a complete disaster.

Tool applications and characteristics

Some Photoshop tools are more suitable for retouching work than are others. The blur tool is very useful for localized blurring – use it to soften edges that appear unnaturally sharp. Exercise caution when using its neighbor, the sharpen tool. In my experience the sharpen tool has a tendency to produce unpleasant artifacts. If you wish to apply localized sharpening, try selecting an area with the lasso tool, feather the edge by 5 pixels or so and apply an unsharp mask to this selected area. If you have a selection saved, this can be converted to a path (load the selection, go to the Paths palette and choose Make Work Path). You can use paths as a guideline for stroking with Photoshop tools. For example, the blur tool can be used to selectively soften an edge. So, if you want to soften the outline of an image element and have a matching selection saved, convert this to a path, select the blur tool and choose Stroke (Sub) Path from the Paths palette. And, of course, in the History palette you can always selectively paint back in the non-blurred image state data using the history brush.

The smudge tool is a paint smearing tool. It is important to recognize the difference between this and the blur tool which is best suited for merging pixels. The smudge tool is more of a painting tool, either used for blending in a foreground color or 'finger painting', smearing pixels across an image. Smudge strokes look odd on a photographic image unless you are trying to recreate the effect of Instant Polaroid™

smearing. A better smudge tool is the super putty plug-in which is part of the Pen tools suite freely distributed by Wacom. Some retouchers like to use the smudge tool to refine mask channels, working in Quickmask mode, and the smudge tool set to Finger Painting to drag out mask pixels to follow the outline of hair strands, for example. I tend to stick with the brush tool nearly all the time, making use of the different pressure sensitivity options (available only if you have a pressure-sensitive graphic tablet device installed). Among the brush dynamics options you can choose Opacity: Size. Low stylus pressure produces fine faint brush strokes; heavy pressure produces thicker and darker brush strokes. Or you can select both options to apply simultaneously.

Rescuing shadow detail

Sometimes no amount of Curves contortion can successfully lift up the shadow tones without causing the rest of the image to become degraded. Curves adjustments must be done carefully. The curve shape should be smooth, otherwise gentle tonal transitions will become lost and may appear posterized. There are similarities here with the problems faced when trying to get the best full tone print from a contrasty negative. The invention of multigrade black and white paper was a godsend to photographic printers who were then able to print using a combination of paper grades with one or more enlarger exposures. If you have ever printed in the darkroom yourself, you'll know what I mean. If not, don't worry – all you need to know is that the Photoshop method I am about to describe can achieve the same end results in black and white or color. The following tutorial is a method which exploits the adjustment layers feature in Photoshop.

Shadow tones can appear compressed or lost for a variety of reasons. It may not be the image but the monitor display which is at fault, so check the monitor has been properly calibrated and that the viewing conditions are not too bright and consequently flaring the screen. You should also realize that monitors are not able to represent a full range of tones displayed in evenly balanced steps. All monitors compensate for their limited dynamic range by applying a small amount of tonal compression in the highlights and more tonal compression in the shadow areas. If there really is a problem with the shadow detail, the true way to find out is to check the histogram and rely on that for guidance. If there are a bunched-up group of bars at the left of the histogram – then yes, you have compressed shadow tones. Knowing a little about the picture's history helps. I once had to correct some transparency scans where the film had been underexposed and push processed by at least two stops. The image was contrasty, yet there was information in the shadows which could be dug out. Or maybe you can see from the original photograph that the lighting was not quite good enough to capture all the shadow detail. You will be amazed how much information is contained in a high quality scan and therefore retrievable.

1 Create a luminance mask based on the composite channel. Command/Ctrl-click the RGB (~) channel in the Channels palette. Then click on the Save selection as channel button to convert the selection into an alpha channel.

2 Choose Image > Adjust > Invert to invert the alpha 1 channel. Apply some Gaussian blur to soften the alpha 1 'luminance mask' (you may want to add a little gaussian noise if you see any banding) and then apply a curves adjustment to lighten the shadow areas and darken the midtone/highlights.

Gaussian Blur

Radius: 6.0 pixels

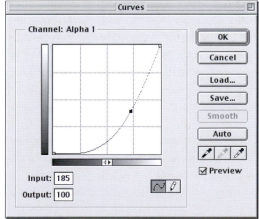

Curves

Channel: Alpha 1

Input: 185
Output: 100

3 Load the modified Alpha 1 channel as a selection and click on the Add adjustment layer button in the Layers palette and choose Curves. This action will open the Curves dialog and add a Layer mask to the new adjustment layer based on the selection. Now apply a curves adjustment to mainly lighten the shadows. The layer mask will selectively apply any adjustment you make to the darker areas of the photograph only.

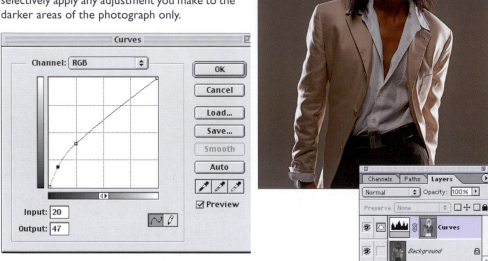

Client: Anita Jones. Model: Sze Kei at Rage.

Scanning halftone images

When a halftone printed image is scanned and brought into Photoshop, you will quite often notice that a moiré pattern is introduced as a result of the scanning process. The severity of the moiré depends on a number of factors such as the coarseness of the printed screen, the scanning resolution used and most importantly, the angle which the original page was scanned at. Rotating the page by 15 degrees can make a big difference and it is easy enough to rotate the page back into alignment once captured in Photoshop, by using the crop tool. Try also scanning at the higher resolutions and work downwards in gradual increments to find the optimal resolution. The viewing scale on the monitor can also appear to compound the problem of any moiré present, so inspect at either 100%, 50% or 25% etc.

The bigger question though is the legality of copying pictures from a publication. Fine if it is your own work, but do make sure that permission of the copyright holder is always sought. Be warned that steps are being taken to inhibit infringement of copyright. First of all, images can be invisibly encrypted using either the SureSign or Digimarc systems which are available as third-party plug-ins for Photoshop (the

Digimarc plug-in is included with Photoshop 6.0). Photoshop always displays the copyright symbol © in the status window at the bottom of the document window whenever it discovers that a Digimarc watermark has been invisibly embedded in the file. You won't always be aware that a published picture has this tagging embedded. The process of removing the moiré plus smoothing away the halftone dots may actually enhance the encrypted signature instead of destroying it. It has to be said that at the smaller file sizes used to publish on the Internet, the robustness of any fingerprint is much weaker. See also Chapter Five for more information about image protection.

1 Start with as large a scan as possible with the intention of reducing the image size later. The moiré pattern is mostly found in the green and blue channels, there is a slight amount in the red channel. To minimize image degradation, apply just a small amount of Gaussian blur or Noise > Median to the red channel.

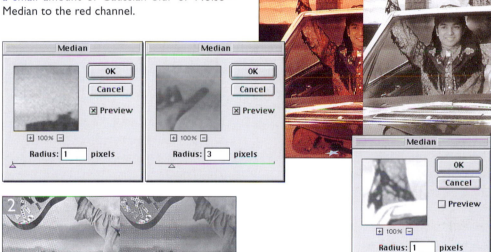

2 The green and blue channels require more softening. Work on each channel individually and apply the Median filter (Filter > Noise > Median). Use a small Median Radius value. If you cannot remove all traces of the moiré, try applying a Gaussian blur first followed by the Median filter.

3 Any remaining traces of moiré should disappear after reducing the file size. Finally apply unsharp masking to restore some of the lost sharpness.

Moiré patterns can be eliminated by softening the image detail in the worst affected channels followed by a resharpening. You can soften an image using the Gaussian blur, Median Noise filter or a combination of the two. Some scanner software programs have their own descreening filters. These may or may not do a good job. The advantage of the method outlined here is that with a manual correction, you only soften as much detail as is absolutely necessary.

Dodge and burn

The dodge and burn tools are certainly very handy, but they are not really suitable for use as the Photoshop equivalent of the darkroom printing methods. The tutorial featured earlier in this chapter showed you how to restore a faded photograph by using a combination of adjustment layers and a soft radial mask. So, to dodge or burn a large area of a picture, you are better off making a heavily feathered selection and applying a Levels or Curves image adjustment – the results will be a lot smoother. The dodge and burn tools are better suited for modifying small areas of a picture only and mostly using light opacity brush strokes. The great thing about these two tools is that they can be targeted to act on just the Highlights, Midtones or Shadows only. My only criticism or warning is that these tools cannot always modify the hue, saturation and brightness values together in a convincing manner. This is not a huge problem, just something to watch out for. If you try to dodge an area of a picture too much, you might discover it removes too much of the saturation as well, so use them carefully. The other difficulty Photoshop users face is the slowness of the large brushes, although this is not a fault of the program, rather a limitation of the desktop computers used to run Photoshop. The associated sponge tool is great for tweaking color saturation. Again be careful when applying the sponge tool in Saturate mode, not to allow clipping or artifacts to appear. Use the sponge in Desaturate mode to correct for oversaturated areas, to smooth color transitions or to reduce the saturation of out-of-gamut colors.

When you first discover the clone stamp tool, it is natural to think that it should be used for all blemish removals. Not so, cloning out facial wrinkles and such like can also be removed with the dodge tool set to Midtones and applied with a smallish soft edged brush at low opacity (1–2%). After gently brushing with the dodge tool, you will notice how the lines start to disappear. As was demonstrated earlier, I also like to paint color in using the brush tool set to Lighten mode. Keep in mind the ability to restrict the application of the dodge and burn tools and its usefulness will become apparent in all sorts of situations. To improve the definition of hair silhouetted against a light background, you can use a small low opacity brush burn tool set to Shadows to build up the fine hair detail without darkening the background.

Chapter Eleven

Montage Techniques

onfusion often arises when trying to understand the relationship between alpha channels, masks, Quick mask mode and selections. Let me help ease the learning curve by saying they are interrelated and essentially all part of the same thing. That is to say, a selection can be viewed as a Quick mask or saved as an alpha channel (also referred to as a mask channel). An alpha channel can be converted to make a selection, which in turn can be viewed in Quick mask mode. Also discussed later in this chapter is the use of image layer masks and layer clipping paths and how to draw paths with the pen tool and convert these to selections.

Selections and channels

So when you read somewhere about masks, mask channels, image layer mask channels, alpha channels, Quick masks and saved selections, the writer is basically describing the same thing: either an active, semipermanent or permanently saved selection. We will begin with defining a selection. There are several tools you can use to do this – the marquee, lasso, magic wand and Select > Color Range. The marquee comes in four flavors: rectangular, oval, single pixel horizontal row and vertical column. The lasso has three modes – one for freehand, another for polygon (point by point) drawing and a magnetic lasso tool. When you use a selection tool to define an area within an image (see Figure 11.1), you will notice that a selection is defined by a border of marching ants. Selections are only temporary. If you make a selection and accidentally click outside the selected area with the selection tool, it will disappear – although you can restore the selection with Edit > Undo (Command/Ctrl-Z).

During a typical Photoshop session, I will draw basic selections to define areas of the image where I want to carry out image adjustments and afterwards deselect them. If you end up spending any length of time preparing a selection then you will usually want to save the selection as an alpha channel (also referred to as a mask channel). To do this, choose Save Selection from the Select menu. The dialog box will ask if you want to save as a new selection. Doing so creates a brand new alpha channel. If you check the Channels palette, you will notice the selection appears there labeled as an alpha channel (#4 in RGB mode, #5 if in CMYK mode). To reactivate this saved selection, choose 'Load Selection' from the Select menu and select the appropriate channel number from the sub-menu.

You don't have to use the selection tools at all. You can also create a new alpha channel by clicking on the Make New Channel button at the bottom of the Channels palette and fill the empty new channel with a gradient or paint in the alpha channel with a painting tool using the default white or black colors. This new channel can then be converted into a selection. In between masks and selections we have what is known as a Quick mask. To see how a selection looks as a mask, switch to Quick mask mode (click on the right-hand icon third up from the bottom in the tools palette). Now you see the selection areas as a transparent colored overlay mask. If the mask color is too similar to the subject image, double-click the Quick mask icon, click on the Color box in the opened dialog and choose a different color with the Color Picker. In Quick mask

mode (or when working directly on the alpha channel) you can use any combination of Photoshop paint tools, Image adjust commands or filters to modify the alpha channel content.

To revert from a Quick mask to a selection, click the selection icon in the tools palette (a quick tip is to press 'Q' to toggle between the two modes). To reload a selection from the saved mask channel, go Select > Load Selection. Command/Ctrl-clicking a channel is the other shortcut for loading selection and by extension, combining Option/Alt+Command/Ctrl-channel # (where # equals the channel number) does the same thing. Alternatively you can also drag the channel icon down to the Make Selection button in the Channels palette.

Figure 11.1 The right half of the image shows a feathered selection (feathering is discussed later in this chapter) and the left half the Quick mask mode equivalent display.

Summary of channels and selections

Selections

In marching ants mode, a selection is active and available for use. All image modifications made will be effective within the selected area only. Selections are temporary and can be deselected by clicking outside the selection area with a selection tool or choose Select > Deselect (Command/Ctrl-D).

Quick mask mode

A semipermanent selection, whereby you can view a selection as a transparent colored mask overlay. To switch to Quick mask mode from a selection, click on the Quick mask icon in the tools palette or use the keyboard shortcut 'Q' to toggle between selection and Quick mask mode. Quick mask modifications can be carried out using any of the fill or paint tools.

Alpha channels

A selection can be stored as a saved selection, converting it to become a new alpha channel (Select > Save Selection). A selection can be reactivated by loading a selection from the saved channel (Select > Load Selection). Alpha channels, like color channels, contain 256 shades of gray, 8-bit information. An anti-aliased selection, or one that has been modified in Quick mask mode with the fill and paint tools, will contain graduated tonal information. An active alpha channel (click on the channel in the Channels palette to make it active) can be manipulated any way you want in Photoshop. A saved channel can be viewed as a colored transparent mask, overlaying the composite channel image, identical in appearance to a Quick mask. To view this way, highlight the chosen mask channel to select it and click on the eye icon of the composite channel (Command/Ctrl-~).

Work paths

A work path can be created in Photoshop using the pen tool in work path mode. A path is (among other things) an alternative method for defining an image outline. A work path (closed or not) can be converted to a foreground fill, stroke or a selection. For example, in the Paths palette, drag the path icon down to one of the buttons such as the Make Selection button. An active selection can be saved as a path – choose Make Path from the Paths palette sub-menu. Saving a selection as a path occupies just a

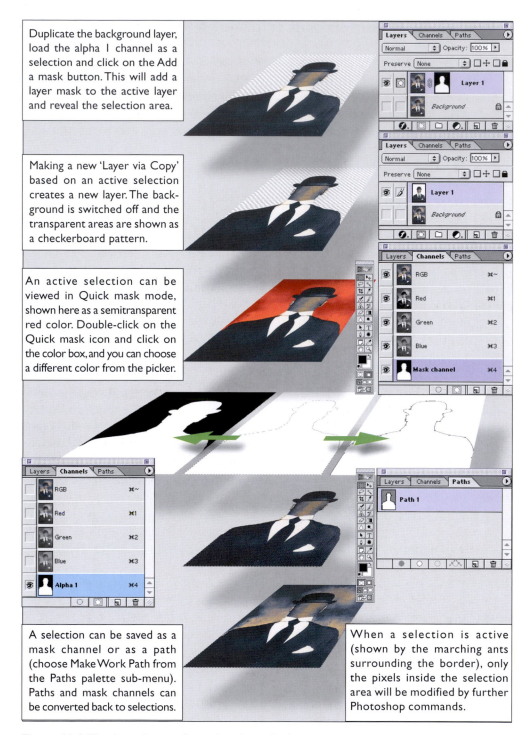

Duplicate the background layer, load the alpha 1 channel as a selection and click on the Add a mask button. This will add a layer mask to the active layer and reveal the selection area.

Making a new 'Layer via Copy' based on an active selection creates a new layer. The background is switched off and the transparent areas are shown as a checkerboard pattern.

An active selection can be viewed in Quick mask mode, shown here as a semitransparent red color. Double-click on the Quick mask icon and click on the color box, and you can choose a different color from the picker.

A selection can be saved as a mask channel or as a path (choose Make Work Path from the Paths palette sub-menu). Paths and mask channels can be converted back to selections.

When a selection is active (shown by the marching ants surrounding the border), only the pixels inside the selection area will be modified by further Photoshop commands.

Figure 11.2 The above diagram shows the relationship between selections, channels, paths and layers.

few kilobytes of file space. This is only more economical than saving as an alpha channel if you are saving in the TIFF format. Paths cannot save graduated tone selections though. A saved path can only generate a non-anti-aliased, anti-aliased or feathered selection, but we'll come to that later on in the chapter. A work path can be used to define a layer clipping path (which will mask a layer's contents) or it can be used in Create Shape Layer mode to add a filled layer which is auto masked as you define a path outline.

Modifying selections

As was mentioned in Chapter Six, to modify the content of a selection you need to learn how to coordinate the use of the modifier keys with the dragging of the mouse as you define a selection. To add to a selection with a selection tool, hold down the Shift key as you drag. To subtract from a selection with a selection tool, hold down the Option/Alt key as you drag. To intersect a selection with a selection tool, hold down the Shift+Option/Alt keys as you drag. Placing the cursor inside the selection and dragging moves the selection boundary position, but not the selection contents. The magic wand is a selection tool too – click with the wand, holding down the appropriate key(s) to add or subtract from a selection.

To expand or shrink a selection, choose Select > Modify > Expand/Contract. Select the number of pixels to modify by up to a maximum of 100 pixels. From the same menu the other options include Border and Smooth. To see how this works, make a selection and choose Select > Modify > Border. Enter various pixel amounts and inspect the results by switching from selection to Quick mask mode. I think the border modification feature is rather crude as it is and can be improved by applying feathering or saving the selection as a channel and filtering with Gaussian blur. An example of a border modification is featured in the Extract tutorial on page 288.

Smoothing and enlarging a selection

Selections made on the basis of color values, i.e. when you use the magic wand or Color Range method, under close inspection are rarely complete. The Smooth option in the Select > Modify sub-menu addresses this by averaging out the pixels selected or not selected to the level of tolerance you set in the dialog box.

The Grow and Similar options enlarge the selection using the same criteria as with the magic wand tool, regardless of whether the original selection was created with the wand or not. To determine the range of color levels to expand the selection by, enter a tolerance value in the Options palette. A higher tolerance value means a greater range of color levels will be included in the enlarged selection.

The Select > Grow option expands the selection, adding contiguous pixels, i.e. those immediately surrounding the original selection of the same color values within the specified tolerance. The Select > Similar option selects more pixels from anywhere in the image of the same color values within the specified tolerance.

Anti-aliasing and feathering

All selections and converted selections are by default anti-aliased. A bitmapped image consists of a grid of square pixels. Without anti-aliasing, a diagonal line would be represented by a sawtooth of jagged pixels. Photoshop gets round this problem by anti-aliasing the edges – filling the gaps with in-between tonal values. All non-vertical/horizontal sharp edges are rendered smoother by this process. Therefore anti-aliasing is chosen by default. There are only a few occasions when you may wish to turn it off. Sometimes you have an 8-bit image which resembles a 1-bit data file (say an alpha channel after you have applied the Threshold command) which needs to be anti-aliased. If it is just a small portion that requires correction, use the blur tool to lightly soften the edge, otherwise follow the technique below.

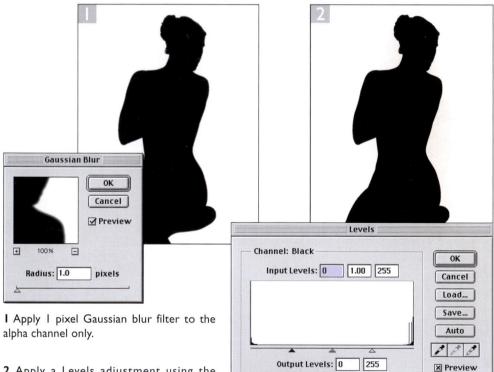

1 Apply 1 pixel Gaussian blur filter to the alpha channel only.

2 Apply a Levels adjustment using the following settings: set the shadow point to 65, the gamma setting to 1.0 and highlight point at 190.

I The objective here is to make a simple soft edged selection based on tonal values and change the color of the background slightly. Use the magic wand tool to make a selection of the backdrop. A tolerance setting of 25 was used.

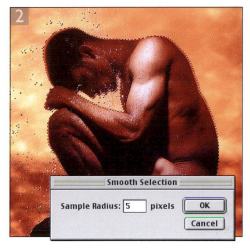

2 Enlarge the selection locally by choosing Select > Grow. Note that the amount of growth is governed by the tolerance values linked to the magic wand tool options. The magic wand tool may not select all the desired backdrop pixels. Choose Select > Modify > Smooth, entering a Radius value of between 1 and 16. The selection is now a lot smoother. Smooth works like this: if the Radius chosen was 5, Photoshop will examine all pixels with an 11 x 11 pixel block around each pixel. If more than half are selected, any stray pixels will be selected as well. If less than half are selected, any stray pixels will be deselected.

3 With the selection satisfactorily complete, hide the selection edges (View > Hide Extras) and open the Hue/Saturation dialog box. Adjust the Hue and Saturation sliders to color the selected area.

Photograph by Eric Richmond.

Anti-aliasing sorts out the problem of jagged edges. Selections usually need to be softened more than this. It is obvious when a photograph has been retouched or montaged, when the edges of a picture element are too sharply defined – the result looks unnatural. The secret of good compositing lies in keeping the edges of your picture elements soft. Study a scanned image in close-up and even the sharpest of images display smooth tonal gradation across the image edges.

To soften a selection edge, go to the Select menu, choose Feather and enter the pixel radius value to feather by. A value between 1.0 or 2.0 is enough to dampen the sharpness of a selection outline, but you can select a much higher radius. For example, if you want to create a custom vignette effect, use the lasso tool to define the outline, feather the selection heavily (50–100 pixels or more depending on file size), invert the selection and apply a Levels or Curves adjustment. This will enable you to lighten or darken the outside edges with a smooth vignette. See Figure 11.1 for an example of a feathered selection seen in marching ant and Quick mask mode.

Layers

Layers are very different to channels. As the name might suggest, they are like image layers on acetate overlaying the base background image – remember all those Walt Disney cartoon animations built up of multilayered celluloid elements? Figure 11.2 shows an example of a layered image. You can now add as many new layers as you like to a document up to a new limit of 8000. Every time you drag and drop the contents from one document window into another using the move tool, it becomes a new layer in the destination document. New empty layers can be created by clicking the New Layer button in the Layers palette. A new layer can also be made based on a selection. Choose Layer > New via copy (Command/Ctrl-J). This will 'float' the selection contents, duplicating them to become a new layer in register with the image below. Layers are individually controllable image elements. In any multilayered document, you can selectively choose which layers are to be viewed (by selecting and deselecting the eye icons), link layers together in groups, arrange groups of layers into layer sets, merge linked layers or merge just those which are visible. Layers are easily discarded – just drag the layer icon to the Layers palette delete button. To duplicate a layer, drag the layer icon to the New Layer button.

Masking layers

Of course, you can edit the contents of a layer with the eraser tool or by a process of selection followed by delete. These are logical enough methods, but such editing is only reversible via the history. There are now two ways of masking a layer in

Photoshop 6.0. Portions of the layer image can be removed by adding either a layer mask or a layer clipping path to the individual layer, which will hide the layer contents. Layer masks are defined using a pixel-based mask while layer clipping paths are defined using path outlines. Either method (or both) can be used to mask out unwanted areas in a layer, and do so without permanently erasing the layer contents. By using a layer mask to hide rather than erase unwanted image areas, there is provision to go back and change the mask at a later date. Or if you make a mistake when editing the layer mask, it is easy to correct mistakes – you are not limited to a single level of undo.

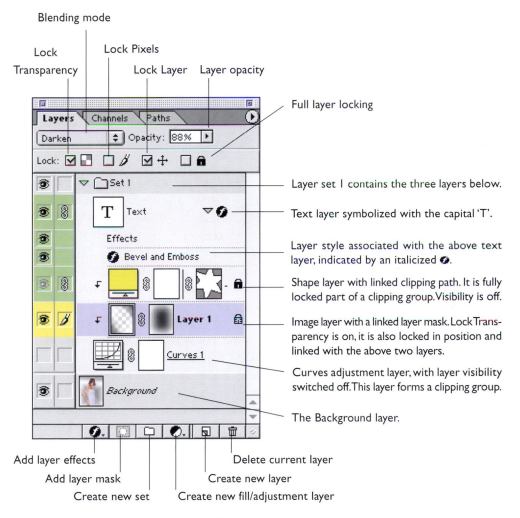

Figure 11.3 This is an overview of the Photoshop 6.0 Layers palette. Note how the layers which belong to a set are colored a light gray in the layer stack and also indented. Photoshop 6.0 allows you to label layers with different colors. The type and layer effect/style features are discussed in greater detail in Chapter Fifteen.

Blending modes

Photoshop layers can be blended with those layers underneath by using any of the seventeen different blending modes available. It helps if you understand and can anticipate the effect an alteration in the blending mode will have upon the final image. The next few pages provide visual examples and a brief description of each of the blending modes in Photoshop. These blending modes are also available as mode options for the painting and fill tools.

Normal

This is the default mode. Changing opacity simply fades the intensity of overlaying pixels by averaging the color pixels of the blend layer with the values of the composite pixels below (Opacity set to 80%).

Dissolve

Combines the blend layer with the base using a randomized pattern of pixels. At 100% opacity, the blend layer is unaltered. As opacity is reduced, the diffusion becomes more apparent (Opacity set to 80%).

Multiply

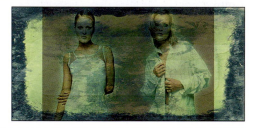

Multiplies the base by the blend pixel values, always producing a darker color, except where the blend color is white. The effect is similar to viewing two transparency slides sandwiched together on a lightbox.

Screen

Multiplies the inverse of the blend and base pixel values together, always making a lighter color, except where the blend color is black. The effect is similar to printing with two negatives sandwiched together in the enlarger.

Overlay

This plus the following two blend modes, Soft Light and Hard Light, should be grouped together as variations on the theme of projecting one image on top of another. The Overlay blending mode is usually the most effective, superimposing the blend image on the base (multiplying or screening the colors depending on the base color) whilst preserving the highlights and shadows of the base color.

Soft Light

Darkens or lightens the colors depending on the base color. Soft Light produces a more gentle effect than the Overlay mode.

Hard Light

Multiplies or screens the colors depending on the base color. Hard Light produces a more pronounced effect than the Overlay mode.

Color Dodge

Brightens the image using the blend color. The brighter the color, the more pronounced the effect. Blending with black has no effect (Opacity set to 80%).

Color Burn

Darkens the image using the blend color. The darker the color, the more pronounced the effect. Blending with white has no effect.

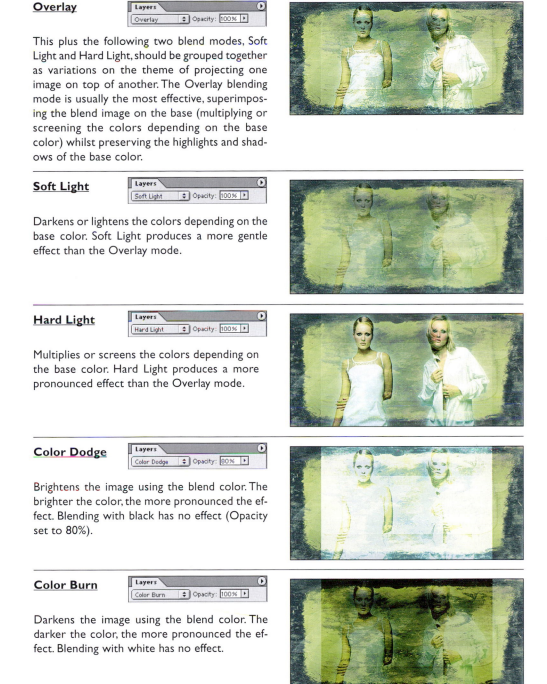

Darken

Looks at the base and blending colors and color is only applied if the blend color is darker than the base color.

Lighten

Looks at the base and blending colors and color is only applied if the blend color is lighter than the base color.

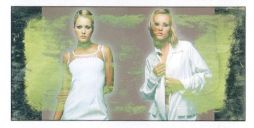

Difference

Subtracts either the base color from the blending color or the blending color from the base, depending on whichever has the highest brightness value. In visual terms, a 100% white blend value will invert (i.e. turn negative) the base layer completely, a black value will have no effect and values in between will partially invert the base layer. Duplicating a background layer and applying Difference at 100% will produce a black image. Dramatic changes can be gained by experimenting with different opacities. An analytical application of Difference is to do a pin register sandwich of two near identical images to detect any image changes – such as a comparison of RGB color spaces, for example.

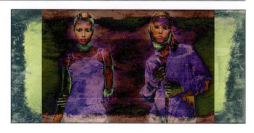

Exclusion

A slightly muted variant of the Difference blending mode. Blending with pure white will invert the base image.

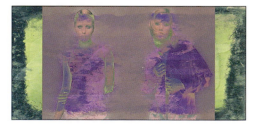

Hue

Preserves the luminance and saturation of the base image, replacing with the hue of the blending pixels.

Saturation

Preserves the luminance and hue of the base image replacing with the saturation of the blending pixels.

Color

Preserves the luminance values of the base image replacing the hue and saturation values of the blending pixels. Color mode is particularly suited for hand coloring photographs.

Luminosity

Preserves the hue and saturation of the base image while applying the luminance of the blending pixels.

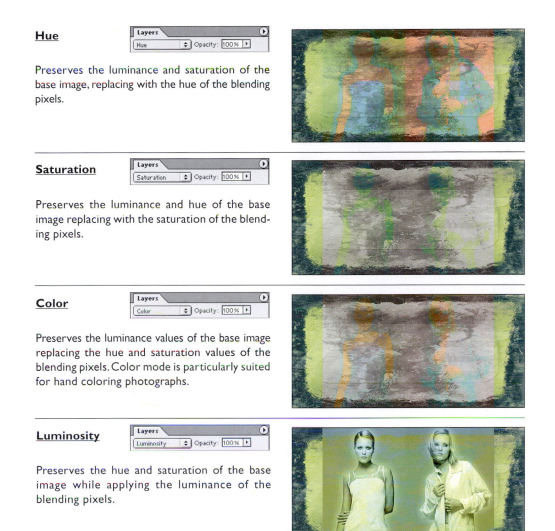

Adding an empty image layer mask

It is fairly common to want to create either an empty or completely obscuring layer mask on a layer, then to paint in or paint out the detail to be shown or hidden using the fill and paint tools. To add a layer mask to a layer with all the layer remaining visible, click the Layer Mask button in the Layers palette. Alternatively, choose Layer > Add Layer Mask > Reveal All. To add a layer mask to a layer with all the layer hidden, Option /Alt-click the Layer Mask button in the Layers palette. Alternatively, choose Layer > Add Layer Mask > Hide All.

Adding an image layer mask based on a selection

To add a layer mask based on a selection, highlight a layer, make the selection active and click on the Add Layer Mask button at the bottom of the Layer menu. Or, choose Layer > Add Layer Mask > Reveal Selection. To add a layer mask to a layer with the area within the selection hidden, choose Layer > Add Layer Mask > Hide Selection. Or, Option/Alt-click the Layer Mask button in the Layers palette. Choosing 'Add Layer Mask > Reveal Selection' was how I created the top layer in Figure 11.2. A layer mask is active when a thin black border appears around the layer mask icon and the Brush icon in the Layers palette changes to a circle surrounded by gray (▣).

Viewing an image layer mask in Mask or Rubylith mode

Normally the layer mask is hidden from view and the result of editing the mask is seen directly in the layer image. The small Layer Mask icon shows you roughly how the mask looks. You can if you wish view the mask as a full screen image:

Option/Alt-click the Layer Mask icon to view the layer mask as a full mask. Option/ Alt+Shift-click to display the layer mask as a transparent overlay (rubylith). Both these actions can be toggled.

Applying and removing image layer masks

When work is complete there are several ways to remove a layer mask.

From the Layer menu, choose Layer > Remove Layer Mask. A dialog box asks do you want to Discard, Cancel the operation or Apply the layer mask? Select either option and click OK.

1 To separate an object like this tree from the background, you need to create a alpha channel mask of the tree outline and use this as a layer mask to hide the unwanted areas.

2 This shows the completed alpha channel mask. A pixel-based mask is more suitable for this type of masking as the subject contains soft detailed edges (the following masking technique makes use of a layer clipping path in which the subject to be masked contains smooth geometric edges).

3 Duplicate the Background layer and keep this layer active. Switch of the eye icon for the original Background layer and load the alpha mask channel as a selection. Click on the Add layer mask button in the Layers palette. This will use the active selection to form a layer mask with the selected areas hiding the layer contents.

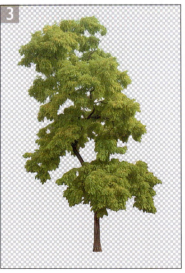

With the mask icon for the layer selected in the Layers palette, click on the palette delete button or drag the active layer mask icon to the delete button. The same dialog box appears asking do you want to Discard, Cancel the operation, or Apply the layer mask? To temporarily disable a layer mask, choose Layer > Disable Layer Mask. To reverse this, choose Layer > Enable Layer Mask. Another shortcut is to Shift-click the Layer Mask icon to disable, click again to enable. When a layer mask is disabled the icon is overlaid with a red cross. Control/right mouse click the mask icon to open the full list of contextual menu options for applying, discarding or disabling a layer mask.

Layer clipping paths

A layer clipping path is just like an image layer mask, except the masking is described using a vector path. A layer clipping path can be edited using the pen path tools or the shape geometry tools. Because a layer clipping path is vector based, it is resolution-independent and can be transformed or scaled to any size without a loss in image quality. To add a clipping path from an existing work path, go to the Paths palette, make a work path there active and choose Layer > Add Clipping Path > Current Path.

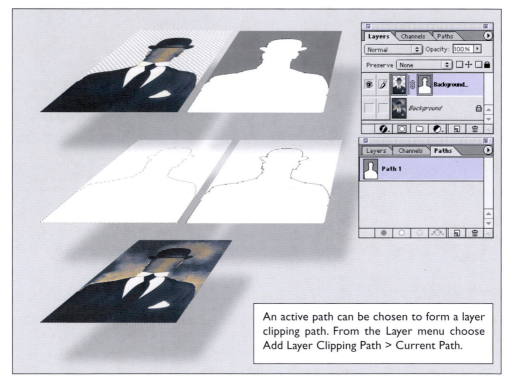

An active path can be chosen to form a layer clipping path. From the Layer menu choose Add Layer Clipping Path > Current Path.

Figure 11.4 The above diagram shows the relationship between paths and layer clipping paths.

1 To make an outline of the leather top in this photograph, draw a pen path first. Make the work path active. Click on the New adjustment layer button in the Layers palette and select Hue/Saturation. This will add an adjustment layer with a linked layer clipping path. You can choose Layer > Change Layer Content to switch between alternative types of adjustment/fill layers using the layer clipping path.

2 I can make a Hue/Saturation adjustment and apply this to the top only. To edit a layer clipping path, use the pen tools to revise the path edges.

Client: Anita Jones. Model: Amanda at Nevs.

You will notice that a layer clipping path icon is represented by a path outline. The gray fill represents the hidden areas. This visual clue will become important when you wish to make a hole in the layer and need to draw an additional path in subtract mode, which is placed inside the first and subtracts from it. An example of this scenario is shown later in the Spirit of St Louis tutorial.

Working with multiple layers

Layers have become such an essential Photoshop feature for doing complex montage work. It was not always so – in the early days of digital imaging, even high-end workstations were limited to working with just one layer at a time. When working with more than one layer you can choose to link layers together by creating links in the Layers palette. To do this, click in the column space between the eye icon and the layer name – you will see a link icon appear. When two or more layers are linked, movement or transform operations will be applied to the linked layers as if they were one, but they still remain as separate layers, retaining their individual opacity and blending modes. To unlink a layer, click on the link icon to switch it off.

Layer masks and layer clipping paths are by default linked to the layer content. If you move a masked layer, the mask moves with it, as long as no selection is active – then any movement or transformation of the layer content will be carried out independently of the associated mask. Switch off the link between layer mask/clipping path and the layer, then the two become unlinked. Any further movements or transformations can now be applied to the layer or the layer mask/clipping layer separately. You can tell if the layer or the layer mask/clipping layer are selected – a thin black border surrounds the layer or layer mask icon. Photoshop's adjustment layers act just like real layers. If, for example, you need an image to interact with itself (i.e. apply a Multiply blend), rather than make a copy layer as before, create an adjustment layer (any type will do) and apply the required blending mode, this will save you consuming precious extra RAM memory.

Layer set management

Layers can now be organized more efficiently in sets. This brings several advantages: because multilayered documents can be grouped together inside the Layers palette in nested folders or 'sets', the Layers palette stack can be made less cluttered and groups of layers in a complex document can therefore be organized more logically. Layers grouped in a set can be hidden or made visible/invisible by clicking on the Layer set eye icon. It is possible to adjust the opacity and blending mode of a set as if it were a single layer, while the layers inside the set itself can contain subsets of layers with individually set opacities and blend modes or adjustment layers. You can also add a layer mask or clipping layer to a layer set and use this to edit the layer set visibility as you would with an individual layer. To reposition a layer, click on the layer and drag it up or down the layer stack. To move a layer into a set, drag it to the set icon or into the open set list. Dragging a layer down and to the left of the icon of the last layer in a set and releasing will move the layer out of the set. To drag the last layer in a set out of that set, drag it across to the left and release.

Layer sets

1 A total of forty-six layers were used in the construction of this image. When a Photoshop document ends up with this many layers, the layer stack can become extremely unwieldy. It is now possible to organize layers within layer sets. All the layers which relate to the yellow butterfly fish are grouped together in a single layer set folder. I was able to group them by shift-clicking on the fish in the document window using the move tool in Auto Select mode. This linked each layer I clicked on. Then I chose New Set From Linked... from the Layers palette menu.

2 The visibility of all layers in a set can be switched on or off and the opacity of the layer set group can be adjusted as if all the layers were a merged layer. Double-clicking a layer set will call up the Layer Set Properties dialog. Here you can select a label color and rename the set.

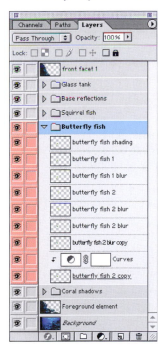

Photograph: Peter Hince. Client: Araldite. Agency: Warman & Bannister.

1 The four letter layers here are grouped together in a set. Layer A is using the Multiply blending mode; B is using Overlay; C is using Difference; and D is using the Screen blending mode. The blending mode of the set these layers are contained in is 'Pass Through'. This means that the layers in the set blend with the layers below the same as they would if they were in a normal layer stack.

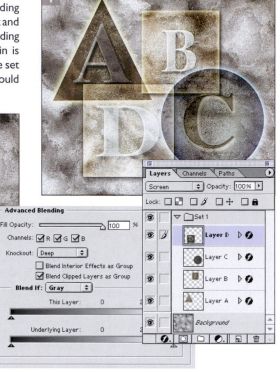

2 If I select Layer D and double-click the layer to open the Layer Style dialog, I can alter the advanced blending options. The Knockout option allows you to 'punch through' the layers. A 'Deep' knockout will make Layer D punch through the three layers below it, straight down to the background layer. Layer D now appears as it would if resting directly above the background layer. A 'Shallow' Knockout will punch through to just above the layer or layer set immediately below.

3 The default layer set blend mode is Pass Through. If you change the layer set blending mode to anything else, then the layers within the set will continue to blend with each other as before, but will not interact with the layers underneath as they did in Pass Through mode. When the layer set blend mode is Normal, the set's layers appear as they would if you switched off the visibility of the background layer.

Advanced blending options

Layer sets allow you to group a number of layers together such that the layers contained within a set are in effect like a single layer. In Pass Through blending mode the layer blending passes through the set and the interaction is no different than if the individual layers were in a normal layer stack. However, when you select any other blending mode, this is equivalent to what would happen if you chose to merge all the layers in the current set and made them become a single layer.

Among the Advance Blending modes, the Knockout blending options enable you to force a layer to punch through some or all of the layers underneath it. A Shallow knockout will punch through to the bottom of the layer set. A Deep knockout will punch through to just above the Background layer. Layer styles are normally applied independent of the layer blending mode. When you check the Blend Interior Effects box, such effects will take on the blending characteristics of the selected layer. Try opening the image opposite from the CD-ROM and observe the Blend Interior Effects options using Layer C which is using the Difference blending mode. The result is the same as if you had 'fixed' the interior layer effect in normal mode and then changed the blend mode to Difference.

Color coding

Figure 11.5 Layers can now be color coded via the Layer Properties (Option/Alt+double-click Layer).

Layer locking

Layers and their contents can be locked in a number of ways. The Lock Transparency option is identical to the old Preserve Transparency checkbox. When Lock Transparency is switched on, any painting you do to that layer will only affect the opaque portion of the layer and where the image is semitransparent, will retain that level of transparency. The Lock Image Pixels option will lock both pixels and the transparent areas. If you attempt to paint on a layer locked this way, you will see a prohibit warning sign.

Lock Image will lock the Layer position only. This means that while you can continue to edit a layer's pixel contents, you are not able to accidentally 'knock' the layer position with the move tool or apply a transform command. You can select combinations of Lock Transparency; Lock Image Pixels; and Lock Image, but you can also check the Lock All box for those situations where you wish to lock everything absolutely.

1 This shows the Layers palette with a new image layer (Layer 1) above the Background layer. Lock Transparent Pixels will prevent you from accidentally painting in transparent areas of a layer.

2 Lock Image Pixels will preserve transparency and prevent you from accidentally painting on any part of the image layer, yet allow movement of the layer.

3 Lock Layer Position will prevent the layer from being moved, while you can continue to edit the layer pixels.

4 Checking the Locking All box will lock the layer absolutely. The layer will be locked in position, the contents cannot be edited, nor can the opacity or blend modes be altered, but the layer can be moved up or down the layer stack.

Transform commands

You have a choice of options in the Image menu to rotate or flip an image. You use these commands to reorientate a document where, for example, the photograph was perhaps scanned upside down. The Edit > Transform commands are applied to a layer or grouped layers only, whereas the Image menu commands rotate or flip the whole canvas. Select a layer or make a selection and choose either Edit > Transform or Edit > Free Transform (or check Show Bounding Box in the move tool Options bar). Rotating, flipping, scaling, skew and perspective controls can be applied either singly or combined in one process. All these commands are to be found under the Edit > Transform menu and also under the contextual menus (Ctrl/right mouse-click). The Free Transform options permit you to

apply any number of tweaking adjustments before applying the actual transform. A low resolution preview quickly shows you the changed image shape. At any time you can use the Undo command (Command/Ctrl-Z) to revert to the last defined transform preview setting.

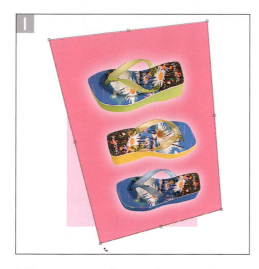

1 You can rotate, skew or distort an image in one go using the Edit > Free Transform command. The following steps show you some of the modifier key commands to use to constrain a free transform adjustment.

2 Place the cursor outside the bounding border and drag in any direction to rotate the image. Holding down the Shift key as you drag constrains the rotation in 15 degree increments.

3 Hold down the Command/Ctrl key as you click any of the handles of the bounding border to perform a free distortion.

4 If you want to constrain the distortion symmetrically around the center of the image, hold down the Option/Alt key as you drag a handle.

5 To skew an image, hold down the Command/ Ctrl+Shift key and drag one of the side handles.

Photograph by Davis Cairns. Client: Red or Dead.

6 To carry out a perspective distortion, hold down the Command/Ctrl+Option/Alt+Shift keys together and drag a corner handle. When you are happy with the new shape, press Enter to carry out the transform. Press ESC to cancel. The transform uses the default interpolation method selected in Preferences to calculate the new image shape.

Numeric Transforms

When you select any of the transform commands from the Edit menu or check Show Bounding Box in the move tool options, the Options bar will display the numeric transform commands shown below. The numeric transform options enable you to accurately define any transformation as well as choose where to position the centering reference point position. For example, a common use of the Numeric Transform is to change the percentage scale of a selection or layer. Enter the scale percentages in the Width and Height boxes. If the Constrain Proportions link icon is switched off, you can set the width and height independently.

Repeat Transform

After applying a transform to the image data, you can instruct Photoshop to repeat that transform again. The shortcut is Shift+Command/Ctrl-T. The image transform will take place again on whatever layer is selected and regardless of other steps occurring inbetween. Therefore you can apply the transform to the same layer again or transform another existing layer.

Transforming selections and paths

You can also apply transforms to Photoshop selections and paths. Make a selection and choose Transform Selection from the Select menu (if you choose Edit > Transform, you will transform the selection contents). Transform Selection is just like the Edit > Free Transform command – you can use the same modifier key combinations to scale, rotate and distort the selection outline. Or you can use Ctrl/right mouse-click to call up the contextual menu of transform options. With Transform Selection, you can modify a selection shape effortlessly. Selections are memorized in Photoshop beyond a single undo. Choose Select > Reselect to bring back the last used selection.

Whenever the pen tool is selected the Edit menu will always be in path/point transform mode. This means that whenever the pen tool is selected, you can only transform a completed path or a group of selected path points (the path does not have to be closed). You will not be able to execute a transform on an image layer until another tool is selected.

Drawing paths with the pen tool

Unless you have had previous experience working with a vector-based drawing program like Freehand or Adobe Illustrator, the concept of drawing with paths will be unfamiliar. It is difficult at first to get the hang of, but I promise you it is well worth mastering the art of drawing with the pen tool. Hard as it may seem at first, it is like riding a bike, once learned, never forgotten. Paths are useful in several ways: either applying a stroke with one of the paint tools, for saving as a clipping path, or defining a complex selection shape, which can be converted to a selection or applied as a layer clipping path to mask a layer.

Figure 11.6 Our eyes have no trouble seeing the edge of this blouse. But a selection tool such as the magic wand will only see closely related pixel color values, and any attempt to define the edge using the magic wand will always be disappointing. This is a classic example of where the pen tool in Photoshop wins over masking tools that require a high contrast edge in order to make an accurate selection.

Because it is difficult to master the art of drawing with the pen tool, many people are inclined to give up on paths and persevere with other mask methods. Figure 11.7 shows an example of a photograph where is would be hard to define a smooth edge boundary other than by drawing a path outline. Historically, Photoshop began as a program which was used by its customers to edit relatively small sized image files. The Apple computers in those days could only be expanded in a limited fashion and always at great cost. Consequently, Photoshop was in practice a veritable tortoise compared with the high-end systems then used to retouch large digital files. The Photoshop selection tools like the lasso and magic wand were suited to operating efficiently with small sized files, which was all the program was likely to deal with back then. In a typical design studio, most of the images handled were less than 10 Mb in size. Today Photoshop is able to handle files ten times that size with ease on a top of the range desktop computer. The pen tool is the professional's selection tool, so if you are planning to work on large sized files, you will mostly find it quicker to draw a path and convert this to a selection rather than relying on the selection and paint tools alone. The magic wand may do a grand job on tutorial sized images, but is not a method that translates well to working on bigger files. The magnetic tools fall half way between. They are cleverly designed to automate the selection process, but there is usually no alternative available but to manually define the outline with a path.

Guidelines for drawing pen paths

We shall start with the task of following the simple contours illustrated in Figure 11.7. You will find a copy of this image in a layered Photoshop format on the CD-ROM. This Photoshop file contains saved path outlines of each of the shapes. The background layer contains the basic image and above it there is another layer of the same image but with the pen path outlines and all the points and handles showing. Make this layer visible and fade the opacity if necessary so that you can follow the handle positions when trying to match drawing the path yourself. Start at kindergarten level with the letter 'd'. If you mastered drawing with the polygon lasso tool, you will have no problem doing this. Click on the corner points one after another until you reach the point where you started to draw the path. As you approach this point with the cursor you will notice a small circle appear next to the cursor which indicates you are now able to click (or drag) to close the path.

Actually this is better than drawing with the polygon lasso, because you can now zoom in if required and precisely reposition each and every point. As before, hold down the Command/Ctrl key to switch to the pointer and drag any point to realign it precisely. After closing the path, hit Command/Ctrl-Enter (not Enter on its own any more) to convert the path to a selection.

Figure 11.7 The path tutorial file which can be found on the CD-ROM.

If you now try to follow the 'h', this will allow you to concentrate on the art of drawing curved segments. Observe that the beginning of any curved segment starts by dragging the handle outward from the direction of the intended curve. To understand the reasoning behind this, imagine you are trying to define a circle by drawing a square perimeter. To continue a curved segment, click and hold the mouse down while you drag to complete the shape of the end of the last curve segment and predict the initial curve angle of the next segment. This assumes the next curve will be a smooth continuation of the last. Whenever there is a sharp change in direction you need to make a corner point. Convert the curved segment by holding down the Option/Alt key and clicking. Click to place another point. This will create another straight segment as before in the 'd' example.

Hold down the Command/Ctrl key to temporarily access the direct selection tool which can be used to reposition points. When you click a point or segment with this tool, the handles are displayed. Adjust these to refine the curve shape. The 'v' shape will help you further practice making curved segments and corner points. A corner point should be placed whenever you intend the next segment to break with the angle of the previous segment. In the niches of the 'v' symbol, hold down the Option/Alt key and drag to define the predictor handle for the next curve shape.

Pen tool in action

This tutorial shows you how to use the pen tool to draw a closed path outline around a portion of the shoe pictured here, how to duplicate a path and go back and readjust the path outline shape. To show the results clearly, the images here are printed as viewed on the monitor, working at a 200% scale view. Because path outlines can be hard to reproduce in print, I have added a thin blue stroke to make them a little more visible. By the way, it is essential to work with at least a 32 000 color display in order to see the path outlines clearly.

I Select the pen tool and check that in the pen tool Options you have the Rubber Band option checked. This will make it easier for you to see the path segments taking shape as you move and drag with the mouse. Click on the image to create a starting point for your path. As you click, hold down the mouse and drag away from the point. You are now dragging a handle which will act as a predictor for the beginning arc of the curved segment you will create after placing the second point in the path.

2 If you simply click to create the second point, the path will have all the curvature at the starting point and flatten off towards the second point. To follow the line of the shoe strap, click and drag the mouse following the flow of the image curve shape. You will now notice that there are two equidistant handles in line with each other leading off from the second path point. You have just completed drawing a curved segment.

3 Now add a corner point at the apex. Hold down the Option/Alt key and click with the mouse whilst continuing to drag the handle upward and outward to the right. The Option/Alt key action defines it as a corner point and the dragging concludes the curvature of the segment just drawn.

4 After making a corner point, hold down the Option/Alt key again and drag the handle out downwards to the right, to begin drawing a series of curved segments.

5 Drawing a straight segment is the easy part. End the curved segment by Option/Alt clicking the last point and simply click to draw a straight or series of straight lines.

6 Continue to draw the shape of the path as before. When you reach the end of the path and place the cursor on top of the original starting point a tiny circle appears to the bottom right of the pen tool icon. Clicking now will complete the path and create a closed path. Drag the mouse as you complete this operation to adjust the final curve shape.

These are the basic techniques for drawing straight line and curved segment paths. Try practicing with the supplied tutorial image to get the hang of using the pen tool. Your first attempts probably won't be spot on. Don't worry too much, the following tutorial shows you how to refine the path outline.

1 Activate the work path in the Paths palette. As with selections, a work path is only temporary. If you activate the path icon and draw a new path, it is added to the work path. If you don't activate the work path, the original is lost and a new work path created. Double-click the work path or drag the icon down to the Make New Path icon. Photoshop renames it Path 1. It will now be savable as part of the image just like an alpha channel.

2 Select the direct selection tool from the tools palette (or hold down the Command/Ctrl key with the pen tool selected) to select one or more points on a path. Marquee points to select them and click on any of the selected points or segments and drag to reposition them. The path points all move in relation to each other.

3 Reposition the points and redraw the curved segment by Option/Alt dragging the handles until the curves more neatly follow the contours of the ribbon. Points can be added or deleted using the add point or delete point tools, but also when the pen tool is selected clicking on a segment or clicking on an existing point is a very convenient and easy to remember shortcut.

Montages

No matter how much one attempts to fake reality in Photoshop, there are always going to be limitations as to how natural an image can look when assembled as a composite in Photoshop. It certainly helps if the elements to be combined all meet the right criteria. Providing that the perspective of the individual elements is the same and the lighting conditions are near enough right, half the battle will already be won. If you don't have these attributes there to begin with in the elements to be assembled, it will be virtually impossible to produce a convincing composite. Another thing to remember is that pixel sharp edges rarely exist in a photographic image. Smooth, soft edges always look more convincing.

Now to put the previous discussion on drawing a path with the pen tool in context. The first montage technique demonstrated here shows you how to prepare a silhouette based on a cutout made entirely with the pen tool. A pen path is the most sensible solution to use here because the object to be cut out has a smooth 'geometric' outline and the background behind the aircraft is very 'busy' and it would be almost impossible to separate the aircraft from the scenery behind using any other method. This technique also shows a use of layer clipping path masks in Photoshop 6.0.

The Spirit of St Louis, flown by Charles Lindbergh, made the world's first solo transatlantic flight from the US to Paris in 1927 and I photographed this historic aircraft inside the Washington DC National Air and Space Museum, Smithsonian Institution. The daylight coming in from the skylight above enabled me to composite the aircraft against a separately shot sky background which produced a realistic looking photographic comp.

1 Here are the two images: the sky background and the museum interior shot of the Spirit of St Louis. Roughly resize the St Louis image before positioning it as a layer above the sky. From the Tools palette, select the move tool and drag the whole image across to the sky image window. The aircraft can also be scaled as a layer using the Transform > Scale or Free Transform commands.

2 We need to isolate the aircraft from its surroundings. Because the subject has such a detailed background, there are no automatic ways of doing this in Photoshop, so in this instance, drawing a path is the only solution. Magnify the image to view on screen at 200% and draw a path with the pen tool around the aircraft's edges.

When the pen tool is selected, you can access all the other family of pen path modifying tools using just the Command/Ctrl and Option/Alt keys. Holding down the Command/Ctrl key temporarily changes the pen tool to the direct selection tool. Holding down the Option/Alt key temporarily changes it to the convert point tool. Clicking on a path adds a new point and clicking on an existing point deletes it. To make a hole in a work path, inside of the outer edge, click on the Exclude overlapping areas mode button in the pen tool Options bar.

Spirit of St Louis: Pioneers of Flight Gallery.
Reproduced courtesy of:
National Air and Space Museum, Smithsonian Institution.

3 When the path is complete, make sure the airplane layer and path are both active. Go to the Layer menu and choose: Add Layer Clipping Path > Current Path. This will add a clipping path to the airplane layer based on the active work path. The clipping path mask will appear linked alongside the aircraft layer.

4 At this stage it is possible to reposition the aircraft again if you wish, because the clipping path is linked to the layer image contents. Under close inspection, the aircraft appears to have been reasonably well isolated by the path. However, where this is not the case, you can edit the layer clipping path outline using the usual pen path editing tools. If I group select several of the path points around the wheel and move them, you can see how the background is still visible and will now show through.

5 Once you are happy with the clipping path, choose Layer > Rasterize > Layer Clipping Path. This will convert the layer clipping path into an image layer mask.

6 Activate the image layer mask. Go to the Filter menu and select Other > Minimum and choose a 1 pixel radius. This step will effectively 'choke' the mask, making it shrink to fit around the edge of your masked object. If you like, fade the last filter slightly using the Edit > Fade... command. Next try applying a 1 pixel radius Gaussian Blur and follow this with an Edit > Fade... of 50% or higher. Now apply a levels adjustment to the mask. Choose Image > Adjust > Levels, but keep the shadow point set where it is and adjust the gamma and highlight sliders only. The gamma adjustment will need to be quite extreme. In effect what has been done over these past few steps, is to shrink the mask slightly, soften the edge and now use the Levels adjustment to fine tune the choke on the mask.

7 If the mask is mostly OK and only a couple of areas need adjustment, then still follow all the above steps, but revert in the History palette back to the history state before you began adjusting the mask (you might want to ensure Allow Non-Linear History is switched on in the History palette options). Then click on the history brush icon for the very last state and select the history brush from the tools palette. The image has now fully reverted to the unmodified layer mask state, but wherever you paint with the history brush, you can paint in the modified mask and vary the opacity of the history painting as you do so.

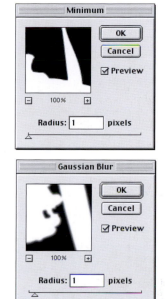

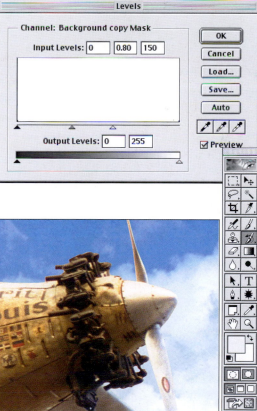

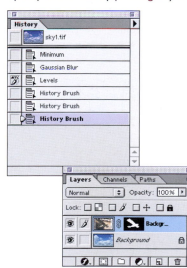

8 By this stage, the Spirit of St Louis should appear successfully cut out from its original museum surroundings. Because an image layer mask has been used to isolate the aircraft, no pixels have actually been erased and the mask can be edited at any time.

9 Select the aircraft layer again and Option/Alt+mouse down on the adjustment layer button in the Layers palette. Choose Curves and in the New Layer dialog box, check Group With Previous Layer. This will ensure that the following color adjustment will affect this layer only. The curves adjustment made the aircraft slightly more blue and therefore blend more realistically with the color balance of the sky.

10 I duplicated the aircraft layer and applied a motion blur to this copied layer. This was placed as shown in the Layers palette and the opacity reduced to 80%. I then prepared a spinning propeller illustration. I dragged this in as a separate layer and transformed it to match the scale of the aircraft. This final tweaking helped create the illusion of the Spirit of St Louis flying through the air. Except, did they have high speed color film to record the transatlantic flight in 1927?

Masking hair

Once you get the hang of using the pen tool and combining its use with layer clipping paths, you will soon discover that this is an effective way of isolating a subject such as in the previous composite where the object you wish to cut out contains smooth, geometric contours.

When you are presented with a subject that contains a complex outline, such as the model's hair in the next photograph, the main question is: how do you go about separating the hair from the background? More to the point, how can you do this convincingly without it looking like an obvious retouch job? The trick here is to make use of the existing color channel contents and to copy the information which is already there in the image and modify it to produce a new mask channel. So instead of attempting to trace every single strand of hair with the pen or paintbrush tool, you can save yourself a lot of time by recycling the information already contained in the color channels and use this to define the finely detailed edges. You will find that the pen tool can then be used to finish off tracing the curves of the model's body.

Whenever I shoot a subject where I intend later to make a cutout, I always ensure that I am shooting against a plain colored background. I find white backgrounds usually provide the best channel contrast. It depends as well on the color of the destination background I am using. If you want later to combine a studio shot against a blue sky, it might well help if you plan to shoot against a sky blue backdrop in the studio.

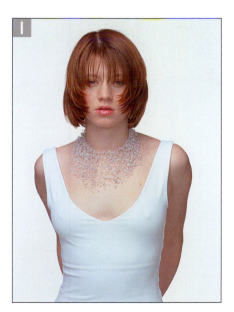

1 In the previous Spirit of St Louis example, the most appropriate method for creating an outline was to draw a path with the pen tool. This was because the subject was a mechanical object with lots of smooth curves and straight lines. Masking the outline of a person is another story though. You can use the pen path tools to draw around the body and shoulders, but what about the individual strands of hair? We can get round this by making use of information already contained in the image and use this as the basis for a new alpha channel mask.

Client: Nigel Alexandre. Model: Cressy at Premier.

2 Let's start by examining the individual color channels. I am only really interested in finding a shortcut for masking the hair at this moment. Select the channels palette. Of the red, green and blue channels, it is the blue channel which contains the most depth and contrast in the hair. Drag the blue channel down to the new channel button at the bottom of the palette. This action will duplicate the channel.

3 Now we should think about increasing the definition of the hair outline in our new 'blue copy' alpha channel. Go to the Image menu and choose Apply Image... Let me explain the settings chosen here: the listed target channel is the one we are looking at – 'Blue Copy'. The source image is the same image document (no other document is open at present) and the source channel to 'apply' with is going to be Blue Copy as well and the Blending mode is set to Multiply. What this means is that the Blue Copy channel is now blending with itself using the Multiply mode. In addition, I checked the Mask box and selected Blue Copy again to use this channel as the mask and checked the Invert box. This means that an inverted Blue Copy channel is also being used as a mask. The shadow areas will be multiplied to become darker, while the highlights will be masked.

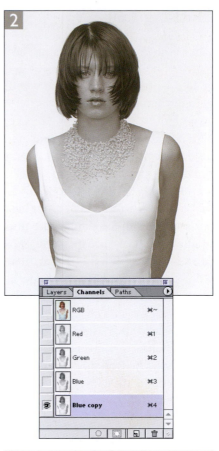

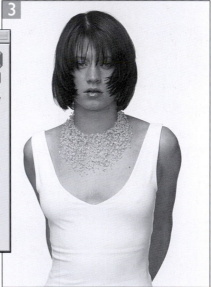

4 After doing this, apply a Curves adjustment as shown here, to add more contrast to the hair outline.

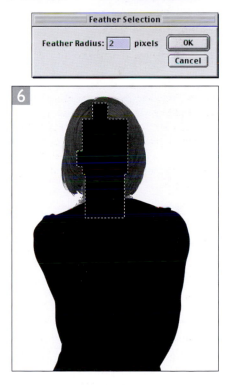

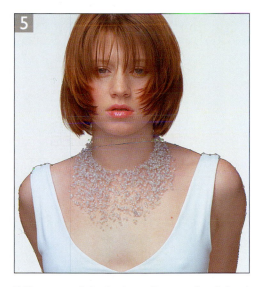

5 The rest of the body outline can be defined using the pen tool, referring to the color composite image.

6 When the work path is complete, hit Command/Ctrl+Return and choose Select > Feather. Enter a pixel amount of 1 or 2. Select the Blue Copy alpha channel again and fill the feathered selection area with Black. Use the rectangular marque tool to draw inside the head and fill the interior of this selection also with black.

One cannot stress enough just how important it is making a good mask when compositing with any image editing program. Once you have prepared a decent mask, the remaining composite work will all fall into place. Retouched photographs will not look right if they feature 'pixel-sharp' edges. Softer masks usually make for a more natural-looking finish. Experiment by softening your masks – a mask derived from a path conversion will be too crisp, even if it is anti-aliased. So, either feather your selections and if you have a layer mask, try applying a little Gaussian blur. You might find it helpful to use the blur tool to locally soften mask edges. Or, you could apply a global Gaussian blur filtration to the whole mask and use the history brush to restore the unblurred version.

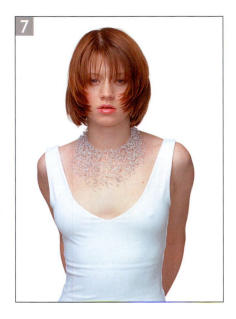

7 Finish off the mask by filling in any gaps using the paintbrush tool. We will now have a completed mask channel. This mask channel can be used for various purposes. For instance, you could make a selection of the background and lighten it to pure white.

8 It is time now to add a new backdrop. Open a new backdrop image, select the move tool and drag the new image window on top of the image we have been working on. The new backdrop will appear in the Layers palette as Layer 1. I changed the layer blending mode to Multiply and chose Edit > Free Transform and scaled the overlaying layer to fit the canvas boundaries.

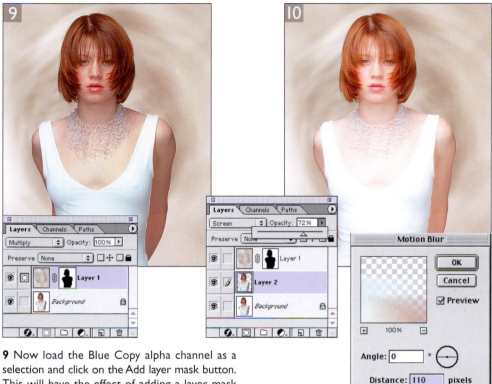

9 Now load the Blue Copy alpha channel as a selection and click on the Add layer mask button. This will have the effect of adding a layer mask which reveals the selected areas. If the mask is working, the end result should be a perfectly masked background. Where the Background layer is white, the Multiply blend mode will blend the same as if the blending mode were set to Normal. Where there are loose stray hairs, the backdrop layer will 'multiply' with the pixel values and should preserve the visibility of every single hair strand.

10 Select the Background layer and reload the Blue Copy channel as a selection. Make a new layer via copy (Command/Ctrl-J) and switch off Lock Transparency. Apply a horizontal Motion blur and set the blending mode to Screen and reduce the layer opacity.

Clipping groups

You can create clipping groups within layers. The lowest layer in a clipping group acts as a layer mask for all the grouped layers above it. To create a clipping group, you can either link layers together and choose Layer > Group Linked, Option/Alt-click the border line between the two layers, or use Command/Ctrl-G to make the selected layer group with the one below. When a layer is grouped, the upper layer(s) becomes indented. All layers in a clipping group assume the opacity and blending mode of the bottom layer. To ungroup the layers, Option/Alt-click between the layers, the layers ungroup and the dotted line becomes solid again. To demonstrate clipping groups in action, I am going to continue the tutorial, showing how to add an adjustment layer to the backdrop layer and make the adjustment apply to the backdrop layer only.

11 I wanted to lighten the backdrop layer in such a way that I could revise any adjustment made. Obviously, an adjustment layer was called for, but I wanted it to affect this specific layer only. By holding down the Option/Alt key as I click the Add adjustment layer button from the Layers palette, this will open the New Layer dialog and allow me to check the Group With Previous Layer box. The new adjustment layer will now be grouped with the layer immediately below. If you forget to do this, you can also Option/Alt-click the dividing line between the two layers. Either action will create a layer clipping group where the upper layer is masked by the one underneath. To emphasize the Layer 2 blurred glowing edge effect, I added a new empty layer to the top of the layer stack and filled this with white. I then Command/Ctrl clicked Layer 2 to load this as a selection and clicked on the Add layer mask button in the Layers palette.

12 And finally, I added a Curves adjustment layer to colorize all the combined layers. I applied a cross-processing type curve. To see the curve settings used, check out the cross-process curves in Chapter Fourteen.

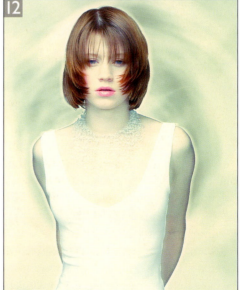

Extract command

The Image > Extract command is able to intelligently isolate an object from its background. While automatic masking can sometimes make light of tedious manual masking, it can rarely ever be 100% successful. However, some of the enhancements added in version 6.0 certainly do make the Extract command a more workable tool now. Before using the command, you may find it helpful first to duplicate the layer which is to be extracted. The active layer will be displayed in the Extract dialog window. You then define the outline of the object using the highlighter brush. This task is made easier in Photoshop 6.0 thanks to the new Smart Highlighting option, which is like a magnetic lasso tool for the Extract command. Smart highlighting will work well on clearly defined edges and can be temporarily disabled by holding down the Command/Ctrl key as you drag. You have to highlight the complete edge of the object first (excluding where the object may meet the edge boundaries) and then fill the interior with the Extract fill tool (clicking again with the fill tool will undo the fill). The eraser tool can be used to erase highlight edges and when using the highlighter tool, you can toggle between highlighter and eraser by holding down the Option/Alt key. When the edges and interior fill are completed, click on Preview button to see a preview of the extraction, or click OK to make an immediate extraction. The edge touchup tool can be used inside the preview window to add definition to weak edges – adding opacity where it sees transparency inside the edge and removing opacity outside of this edge. The cleanup tool will merely erase transparency from the extraction or restore erased transparency when you Option/Alt-drag.

Tool Options The slider control will set the highlight or eraser brush size, or you can enter a numeric value in the box. Choose a color for the Highlight and Fill displays.

Extraction The smoothness can be set anywhere between 0 and 100. If the preview shows an incomplete pixel selection, increasing the smoothness value will help reign in the remaining pixels. Force Foreground is useful where the object interior edge is particularly hard to define and the interior pixels are of a similar color value. Select the eyedropper tool to sample the interior color and check Force Foreground.

Preview The view choices can be switched between the original image and the current extracted versions. The Show option allows you to choose the type of matte background to preview the extraction against. This can be the standard, transparent, Photoshop background pattern, gray, white, black or any other custom color.

Load Highlight – the usage for this is explained in the text.

Figure 11.8 The Extract command dialog box options.

1 In this example, we will use the Extract command to try and isolate the dancer from the background. This is not going to be easy as there is not a great deal of color difference between the subject and the background. First, duplicate the Background layer. This will ensure that as pixels are erased with the Extract command, the original image information is still preserved. Another strategy would be to take a Snapshot of the original image state.

2 Begin by making a rough selection of the outside area using the magic wand and tidy this selection using the Quick mask mode. The selection is not critical – this is just a shortcut which will save drawing an edge highlight later. Back in selection mode, go to the Select menu, choose Modify > Border and enter a value of 6 pixels. Save the border selection as a new alpha channel in the Channels palette and invert this new alpha channel.

3 Choose Image > Extract. The pre-saved Alpha 1 channel can now be loaded as a highlight edge under the Extraction Options. If you think the highlight edge needs adjustment, do so using the highlight and eraser tools – you want the highlight edge to overlap the foreground and background areas. But the highlight edge must form a complete enclosure (you can ignore where the object meets the image boundaries).

4 To automatically fill the interior, select the fill tool and click inside the object area. The interior of the object is now filled and you can click on the Preview button to test the success of the extraction before proceeding to OK.

5 At this stage you can tell if the extraction is going to work well or not. Use the zoom tool to magnify the preview to inspect the edges more closely. To zoom out, hold down the Option/Alt key and click with the zoom tool in the preview. Select the cleanup tool and drag to erase stray pixels from the background and Option/Alt drag to restore opacity where too many pixels have been extracted. You can use the edge cleanup tool to follow edges, adding opacity where it sees transparency inside the edge and removing opacity outside of the edge. Change the brush size to make the brush bigger or smaller as necessary. The preview here shows the object isolated against the transparent grid pattern. However, the preview can be altered to display the object against a white, black, gray or custom color matte background. This will help you to visually determine the success of the extraction.

Photograph by Eric Richmond.

6 If the outline requires further refining, go to the dialog View menu and switch between the extracted preview and the original image. Select the Show Fill and Show Highlight options and edit the highlight edge using the highlighter and eraser tool as before. When complete click OK to process the image.

Complex image blending

1 A photo composite will only look convincing if the elements to be combined together are shot with a matching perspective. The camera position and lens used should be the same in each shot. This is especially true where a wide-angle lens perspective has been used. Julian Calder took these two pictures for a book titled 'Keepers of the Kingdom'. The flag bearer could not make it to the Robert the Bruce statue location, so he had to be shot separately and the two pictures blended together later using Photoshop. They were photographed with a longer than normal focal length lens, so in this instance, any slight perspective difference would be less noticeable. If you are combining library shots with a shallow perspective, you can always blur the background detail as necessary, to make it appear slightly out of focus. This will help add an illusion of photographic depth.

2 To get the shadows and lighting to match, the flag bearer was flipped (Image > Rotate Canvas > Flip Horizontal). Then the flag bearer image was dragged using the move tool across to the Robert the Bruce window, which made the flag bearer become a new separate layer. The positioning does not have to be too precise just yet. The most difficult part of this job is making a convincing silhouette of the flag bearer. When working with high-resolution files, the pen tool provides the most accurate method to define an outline edge. This is especially true here, around the lower part of the tunic where the edges are quite dark and the magnetic lasso or any other type of masking tool would have a tough time trying to differentiate where the edge lies.

3 Sometimes it is better to cheat, or rather make use of information which is already contained in the image. For example, I could see there was enough contrast in the red channel between the flag and the background and was therefore able to use this as the basis for making a mask channel. The red channel was duplicated and the contrast increased using the Curves command. I then carefully filled the flag interior using the paintbrush tool. This screen shot shows two stages of progress – the finished alpha channel mask and the duplicated red channel (shown inverted to stand out more).

4 The alpha channel so far masks the flag only and very importantly, the soft edges are preserved where the flag was fluttering in the wind. As was mentioned earlier, the lower half of the body is less easy to distinguish and this is where the pen path drawn at stage two can now finish the job off. The path is selected and converted to a selection by hitting Command/Ctrl-Enter. I applied a feather of a 2 pixel radius and filled the selection interior with white. The selection can also be inverted in order to tidy up the outside areas by filling with black paintbrush strokes.

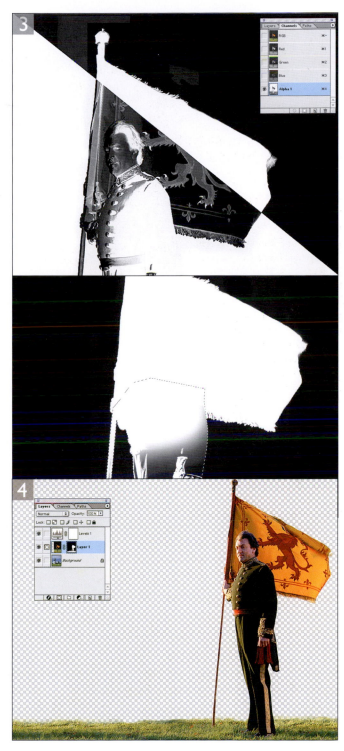

5 When all the mask preparation had been completed, the modified alpha channel was loaded as a selection and converted to a layer mask which would be used to cut out the flag bearer layer from the dark surround.

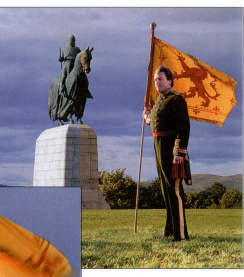

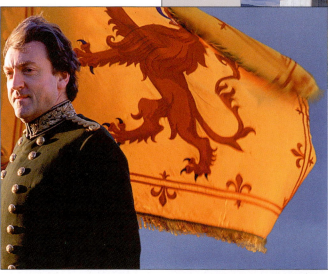

6 Once the client was happy with the finished composition, I found it helped if I merged all the layers, flattened the file and tidied up the image (but I remembered to keep a layered version archived). Where the grass blends from the foreground to the background, I smoothed out some of the rough areas. The client also later wanted the picture to extend as a landscape format, so it was necessary to stretch the left-hand portion of the photograph and carefully clone portions of the sky to hide any distortion.

Removing a matte color

1 If you add a layered image with an anti-aliased edge, some of the edge pixels will still contain some of the original background color. If the original picture has a black background, when the cutout appears pasted as a layer against the new backdrop, some of the black matte pixels will appear as a dark gray around the outline edge.

2 Use the Layer > Matting > Remove Black Matte command to remove all the stray black pixels. Likewise, the Remove White Matte command will remove the white pixels from a cutout which was once against a white background. Where you have colored fringing, the Layer > Matting >Defringe command will replace edge pixels with color from neighboring pixels from just inside the edge.

Client: Pierre Balmain. Model: Louise at Nevs.

Ribblehead Viaduct by Ian McKinnell

The following steps highlight the work of London-based photographer Ian McKinnell. Ian was commissioned by the UK design agency Stocks Austin Sice to illustrate the annual report of a software company called Logica. This was one of a series of five pictures illustrating various aspects of Logica's aspirations and goals, in this case teamwork. Ian worked closely with the art director, Nick Austin, in conceiving the images to illustrate these often abstract ideas. Landscape was one of the themes which ran through the report and after much research the backgrounds were narrowed down to three locations across Britain. It was a very hard week's work – this photograph was taken at Ribblehead Viaduct in the Yorkshire Dales. 'I still remember the look of surprise on the face of the man behind the hire car check-in when I returned what was a brand new Mercedes I had for only six days and that now had over 3 500 miles on the clock!'

The main photograph was taken just after dawn, which involved my assistant and I lugging some very heavy 5×4 equipment over the moors in the dark, accompanied by some very colorful language as one or other of us stepped in things we would rather have not. It was one of a few different shots of the viaduct taken that morning. Had I known when I was there that this was the shot then I would have taken a number of other sheets of film to capture the parts of the landscape obscured by the original columns, but it's always easier to work these things out later when it's too late! Fortunately I did remember to take shots of my assistant, Lorenzo, in a similar position to the model's as a guide to matching the dawn's early light in the studio. In order to control the perspective of the image and to keep the verticals vertical, it was essential to use a 5×4 camera.

I The most difficult part of this job (apart from wandering the moors in the dark) was to match the perspective and lighting of the models to the original image. Using paths, I extended the key perspective lines to establish their vanishing points, creating a box for each of the three columns to be filled by the people and establishing the eye line (i.e. where the centre of the camera lens should be).

2 I then had each of these boxes output on to film to use as a template in the back of my 5x4 camera. Getting the perspective right for the models at the shooting stage was critical, as few changes could be made later without the image appearing false and unnatural. The template boxes ensured that the people were the right shape to fit into the image. Manipulating 3D images convincingly in a 2D software package is very difficult. Careful study of the original viaduct image and the guide shots of my assistant helped form the basis for the lighting setup, the choice of lens and camera position. The models had to stand on boxes to establish the correct eye line and then push hard on the ceiling so that their arms were tensed and looked as if they could be holding up a weight. It was very uncomfortable for them and they could not hold the position for very long! I didn't try to match the color of the original sunlight as it would be easier to make these color changes later in Photoshop.

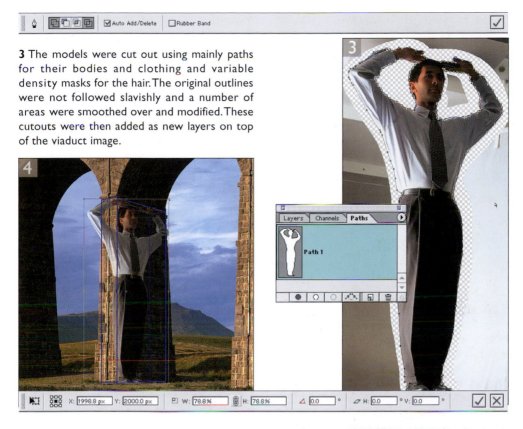

3 The models were cut out using mainly paths for their bodies and clothing and variable density masks for the hair. The original outlines were not followed slavishly and a number of areas were smoothed over and modified. These cutouts were then added as new layers on top of the viaduct image.

4 The exact sizing was carried out by reducing the opacity of the models (so that the original column could be seen through them) and carefully tweaking the exact shapes using the Free Transform. In some instances, a little perspective control had to be introduced, but this was minimal and was done by eye until it looked right. This took many attempts, so I kept the original cutouts handy in case I needed to start over again. To ensure the highest quality in an image, it is best to avoid using the Transform more than once. If I cannot get it right the first time, I will not transform it again, but start from scratch.

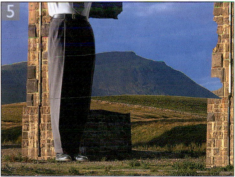

5 When the models were placed in their final positions, work could begin on extending the background to remove the viaduct columns and create the impression of the models appearing to support the bridge. This work was carried out using the clone stamp tool. The clone stamp retouching was carried out on separate layers so that any mistakes could easily be corrected. To control the shape of the mountains in the background, the outline was defined with a path, converted to a selection and feathered by one or two pixels. Using Command/Ctrl+Shift-I, I could swop between the mountains and the sky to build up a convincing edge.

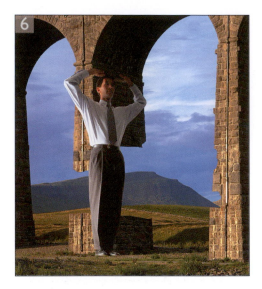

6 The most difficult and time consuming area to fix was the grass around the legs and feet. I try not to keep cloning the same areas of the original images repeatedly. Instead, I try to find areas from elsewhere in the image, then copy and paste it over the area I need to cover and then use a curves adjustment to try and match the color and density of the area underneath. I then erase the areas I don't need. In many cases, adding a little noise over a cloned area can help it look more convincingly part of the photograph. A great advantage of using 5x4 originals is that there is very little grain in the scanned images. With smaller format films it can be very difficult to match the more pronounced grain.

7 One of the touches that (hopefully) makes this image seem more convincing, are the little bits of grass and vegetation which go over the people's shoes. It is little touches like this which help create a sense of scale. This was achieved by copying part of the background image behind the shoes, pasting it into a new layer on top of the shoes and using the eraser tool to remove the areas I didn't want. There is usually more than one way of approaching a problem in Photoshop. For example, I could have achieved the same result by using a layer mask.

8 A lot of work had to be done on the faces and hands of the models to try and get them to look as if they had really had been there and that the viaduct was casting shadows on them. Much of this was done using the paintbrush on a separate layer which is set to the Darken blending mode. Some areas were lightened using curves, with a lot of attention paid to keeping the colors consistent.

Photograph: Ian McKinnell.
Client: Logica. Agency: Stocks Austin Sice.

9 Each person had their own curves adjustment layer for small tweaks to their density and color, using a mask so as not to affect the rest of the image, and another curves adjustment layer over the whole image. I use these adjustment layers so that I can keep changing my mind and try lots of variations without changing the original image until the last minute. The most vital part of building an image such as this is the planning, visualizing the final image in your mind and then working backwards from there.

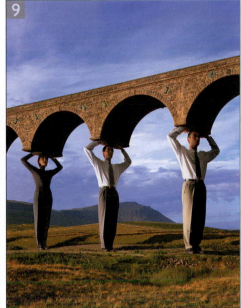

Exporting clipping paths

Not to be confused with layer clipping paths or layer clipping groups, clipping paths are vector paths that can be used to mask the outline of an image when it is exported to be used in a DTP layout program such as Adobe PageMaker™, Adobe InDesign™ or QuarkXPress™. You will remember me saying earlier that a selection can be converted to and from a path? If an image document contains a closed path, when you save it as an EPS format file, there is an option for selecting that path as a clipping path. In Adobe Illustrator™, for example, you can use the saved clipping path as a masking object.

Imagine a catalog brochure shoot with lots of products shot against white ready for cutting out. Still-life photographers normally mask off the areas surrounding the object with black card to prevent unnecessary light flare from softening the image contrast. Whoever is preparing the digital files for export to DTP will produce an outline mask and convert this to a path in Photoshop or simply draw a path from scratch. This is saved with the EPS file and used by the DTP designer to mask the object.

Clipping paths are an effective tool for lots of projects, but not in every case. I had a design job to do for photographer Peter Hince, who asked me to design a brochure showing a collection of his underwater photographs, Ocean Images. I assembled the

twelve black and white pictures in PageMaker. They all had rough edged rebates which Peter wanted preserved. I could have made a path outline of each image and placed these on top of the background image. What I did instead was to prepare the design in PageMaker, scaling the individual images and working out their position. After that I reproduced a similar guideline layout in Photoshop and created a multi-layered image, positioning the individual images and merging them all into one to make a single CMYK, EPS file. The foregoing steps demonstrate how I retained the subtlety of the borders, which may otherwise have become lost.

Another good reason for doing things this way is that it saves on the RIP time for proofing and imposition and reduces the chances of file errors. On the other hand, clients might ask you to alter one of the images after seeing the proof, so save that multilayered Photoshop original for backup!

1 The background layer consists of a water re-flection pattern. All the individual photographs are aligned to Guides, as they will appear in the final design and grouped on the one layer. Before proceeding to the next stage, copy this layer by dragging down to the New Layer button.

2 To demonstrate the following steps, I have worked on a cropped view of the above layout, which shows just a single picture against the water background layer. Switch off the Eye icon for the copy layer and make the original Turtle layer active. We now want to remove the white pixels from the outer edges of the turtle image frame.

Photographs: Peter Hince/Ocean Images.

3 Double-click the layer to open the Layer Options dialog box. Hold down the Option/Alt key to split and drag the highlight sliders for This Layer, as shown here. What this does is to remove the pure white tones from blending with the underlying layers. It also makes some of the inner highlight areas transparent. These will be covered up with the copy layer.

4 Activate the copy layer again and marquee inside the image border. When finished, invert the selection (Select > Invert Selection) and delete or cut the selected area (Edit > Cut). Flatten the image before saving to export to the DTP program, but also save a layered copy of the image in case further adjustments are required.

Chapter Twelve

Shortcuts

Getting to know the basics of Photoshop takes a few months, learning how to become fluent takes a little longer. There are a great many keyboard short-cuts and not all of them are listed in the manual. In this chapter I have grouped together a list of tips and keyboard shortcuts to help expand your knowledge of Photoshop. These are a reminder of some of the suggestions covered elsewhere in the book – use it as a reference for productive and efficient Photoshopping. Learn the keyboard shortcuts a few at a time. Don't try to absorb everything at once.

The key to efficient working is to plan your projects in advance. Rather than dive straight in, think through first about what you want to achieve – either write down or make a mental note of what it is you want to do and work out the best order in which to do everything in. An obvious example would be to avoid preparing your work at high resolution when the final and only use was just a few megabytes. You would want to reduce the file size at the beginning of the Photoshop session rather than at the end in order to save on the computer processing time. Another reason is that there is often more than one way of doing something and a little time spent thinking through things at the beginning will save much in the long run. This is particularly true if working on an underpowered computer or you are pushing your machine to its limits.

Where a project requires experimentation to see which effects work best, it may be wise to start with a low resolution version first. This will enable you to edit quickly without waiting for the dreaded wristwatch or egg timer. Make a note of the settings that looked best and repeat these at higher resolution. This is a particularly handy way of exploring the different blending modes and filters but remember that the filter effects may work slightly differently at higher resolutions and the settings will need to be scaled up.

Instead of making notes you could try recording the steps used as an action. This can then be replayed on subsequent images. Process an image once, recording each step used, stop the recording and play the action on single or batches of images. You will find several Actions already available when you install Photoshop and discover many more which are freely available on the Internet. One such site is Actions X Change maintained by Joe Cheng and can be found at: <www.actionxchange.com>. Another is the Elated site <www.elated.com/toolbox/actionkits/>. Both these sites have ready prepared actions or sets of actions with examples of the types of effects achieved with them for you to freely download for use in Photoshop. To find out more about actions, see the section towards the end of this chapter – working with actions. Macintosh/Windows key equivalents are used everywhere else in this book, but due to lack of space, only the Macintosh keys are listed in the tables. Remember, the PC equivalent for the Command key is Ctrl and the Option key is Alt. To start with, here are the single key shortcuts for accessing tools and commands in the Tools palette:

Toolbox	
A	Direct selection path/path component selection tools
B	Paintbrush/pencil tools
C	Crop tool
D	Reset to default Foreground/Background colors
E	Eraser/background eraser/magic eraser
F	Toggle the three screen display modes
Shift+F (after first F)	Toggle menu bar on/off in two secondary display modes
G	Gradient/paint bucket tools
H	Hand tool
Spacebar	Access hand tool whilst any other tool is active
I	Eyedropper/color sampler/measure tools
J	Airbrush tool
K	Slice/direct slice tools

To cycle through the hidden tools, hold down the Option/Alt key and click again on the tool icon in the Tools palette or hold down Shift and press the key shortcut again. For example, if the eraser tool is currently selected, Option/Alt-click the eraser tool icon or press Shift-E to cycle through the other eraser tools.

Toolbox continued	
L	Lasso/polygonal lasso/magnetic lasso tools
M	Rectangular/elliptical marquee tools
N	Notes/audio annotation tools
O	Dodge/burn/sponge tools
P	Pen/freeform pen path drawing tools
Q	Quick mask mode/selection mode
R	Blur/sharpen/smudge tools
S	Clone stamp/pattern stamp tools
T	Type tool
U	Shape drawing tools: rectangle/rounded rectangle/ellipse/polygon/line/custom
V	Move tool
Command key	Access move tool whilst any tool is active, bar pen tool
Arrow keys	Nudge selection border only, by I pixel
Arrow keys	Whilst move tool selected: nudge selection by I pixel
Shift+Arrow keys	Nudge using 10 pixel increments
W	Magic wand tool
X	Exchange foreground/background colors
Y	History brush/art history brush
Z	Zoom tool
Option-Z	Zoom out tool
Command+Spacebar-click	Zoom in
Option+Spacebar-click	Zoom out

Toolbox continued	
Shift+A	Toggle between direct select/path component selection tools
Shift+B	Toggle between paintbrush and pencil tools
Shift+E	Cycle through eraser tools
Shift+G	Toggle between gradient and paint bucket tools
Shift+I	Cycle through eyedropper tools and measure tool
Shift+K	Toggle between slice and slice select tools
Shift+L	Cycle through lasso tools
Shift+M	Toggle between rectangular and elliptical marquee tools
Shift+N	Toggle between notes and audio annotation tools
Shift+O	Cycle through toning tools
Shift+P	Toggle between pen and freeform pen tools
Shift+R	Cycle through focus and smudge tools
Shift+S	Toggle between clone stamp and pattern stamp tools

Efficient running

Load Photoshop first, allocating as much RAM memory as possible (see Chapter Six) and run Photoshop on its own. There needs to be plenty of free hard disk space available and this must at least exceed the amount of available RAM by a margin of around 15 Mb. Regularly clear the clipboard memory (use the Edit > Purge command).

Keep the minimum number of image files open at any one time. Check the scratch disk size by having the status box at the bottom of the image/application window set to show Scratch Disk memory usage. Once the left-hand value starts to exceed the right, you know that Photoshop is running short of RAM memory and employing the scratch disk as virtual memory. To copy selections and layers between documents, use drag and drop actions with the move tool. This will save on memory usage and preserve any clipboard image at the same time. Save either in the native Photoshop format or as an uncompressed/unlayered TIFF to the hard disk and not to removable media (nor should a removable drive be used as a scratch disk).

File menu	
Keyboard shortcut	**Function**
Command-N	File > New File
Command+Option-N	File > New File using previously selected settings
Command-O	File > Open File
Command-W	File > Close
Command+Shift-W	File > Close All
Command-S	File > Save
Command+Shift-S	File > Save As...
Command+Shift+Option-S	File > Save for Web...
Command+Option-P	File > Print Options
Command+Shift-P	File > Page Setup
Command-P	File > Print File
Command+Shift-M	Jumps to the default Jump to application
Command-Q	File > Quit
F12	File > Revert to last saved version as a new history state
Esc or D	Activate Don't Save after File > Close (System command)
Esc or Command-Period (.)	Cancel or Abort function (System command)

Contextual menus

You will find that a good many shortcuts are available just a mouse-click away. Contextual menus are available throughout Photoshop. On a Macintosh you use Control-click and on the PC use right mouse-click to open a contextual menu in an image document window or a Photoshop palette such as the Layers, Channels or Paths palette. For example, you can Control-click/right mouse-click in the document window to access a list of all the menu options associated with the currently selected tool.

Edit menu	
Keyboard shortcut	**Function**
Command-Z	Edit > Undo last operation
Command+Shift-Z	Edit > Step forward through history
Command+Option-Z	Edit > Step backward through history
Command+Shift-F	Edit > Fade last operation (image adjustment, filter etc.)
Command-X	Edit > Cut
Command-C	Edit > Copy
Command+Shift-C	Edit > Copy Merged
Command-V	Edit > Paste
Command+Shift-V	Edit > Paste Into
Option+Delete/Backspace	Edit > Fill with foreground color
Command+Delete/Backspace	Edit > Fill with background color
Option+Shift+Delete/Backspace	Fill layer with foreground color while preserving transparency
Command+Shift+Delete/Backspace	Fill layer with background color while preserving transparency
Shift+Delete/Backspace	Open Edit > Fill dialog box
Command+Option+Delete/Backspace	Fill from history
Command-T	Edit > Free Transform
Command+Shift-T	Repeat the last applied Transform
Command+Option-T	Free Transform with Duplication
Command+Option+Shift-T	Transform again with Duplication
Command+Shift-K	Edit > Color settings
Command-K	Edit > Preferences > General
Command+Option-K	Edit > Preferences > General (last used dialog box)

Selections

Holding down the Shift key when drawing a marquee selection constrains the selection being drawn to a square or circle.

Holding down the Option/Alt key when drawing a marquee selection centers the selection around the point from where you first dragged.

Holding down the Shift+Option/Alt keys when drawing a marquee selection constrains the selection to a square or circle and centers the selection around the point where you first clicked.

If you hold down the Spacebar at any point, you can reposition the center of the selection. Release the Spacebar and continue to drag using any of the above combination of modifier keys to finish defining the selection.

After drawing a selection and releasing the mouse, hold down the Shift key to add to the selection with the lasso, marquee or magic wand tool.

Hold down the Option/Alt key to subtract from the existing selection with the lasso, marquee or magic wand tool.

Hold down the Shift+Option/Alt key to intersect with the existing selection using the lasso, marquee or magic wand tool.

Filters

If you can't run a filter, it may be that there is not enough free memory available. If memory is running low, purge the clipboard memory or try quitting Photoshop and reloading. To speed up filter preview redraws on the screen, try making a marquee selection first and observe the changes as you adjust the settings. Apply the filter, but then undo the filter (Command/Ctrl-Z) and then deselect the selection and choose Command-F to repeat the last used filter, but this time to the whole image area.

Window display options (PC only)

Choose Window > Cascade to display windows stacked one on top of the other going from top left to bottom right of the screen. Choose Window > Tile to display windows edge to edge.

Image menu	
Keyboard shortcut	**Function**
Command-L	Image > Adjust > Levels
Command+Shift-L	Image > Adjust > Auto Levels
Command+Shift+Option-L	Image > Adjust > Auto Contrast
Command-M	Image > Adjust > Curves
Command-B	Image > Adjust > Color Balance
Command-U	Image > Adjust > Hue/Saturation
Command+Shift-U	Image > Adjust > Desaturate
Command-I	Image > Adjust > Invert Image Color
Command+Shift-F	Edit > Fade Image Adjustment
Option+Image > Duplicate	Holding down the Option key whilst choosing Image > Duplicate bypasses the Duplicate dialog box
Command+Option-X	Image > Extract Command
Command+Shift-X	Image > Liquify Command

The Option/Alt key can be used in combination with any of the above image adjustment commands (just as you can with filters) to open up the relevant dialog box with the last used settings in place. This is a generic Photoshop interface convention. The above fade command will fade filters, image adjustments and all types of brush strokes. It used to be located in the Filter menu, but is now an Edit menu item.

Select menu	
Keyboard shortcut	**Function**
Command - A	Select > Select All
Command - D	Select > Select None
Command + Shift - D	Select > Reselect
Command + Option - D	Select > Feather
Command + Shift - I	Select > Invert Selection

Layer menu	
Keyboard shortcut	**Function**
Command+Shift-N	Layer > New Layer
Command+Option+Shift-N	Layer > New Layer (without dialog box)
Command-G	Layer > Group With Previous Layer
Command+Shift-G	Layer > Ungroup
Command-E	Layer > Merge Down
Command+Option-E	Clone layer contents to the layer directly below
Command-J	Layer > New > Layer Via Copy (float to new layer)
Command+Shift-J	Layer > New > Layer Via Cut
Command+Shift-E	Layer > Merge Visible
Command+]	Arrange > Bring a layer forward in the stack
Command+Shift+]	Arrange > Bring a layer to the top of the stack
Command+[Arrange > Send a layer backward in the stack
Command+Shift+[Arrange > Send a layer to the bottom of the stack

Filter menu	
Keyboard shortcut	**Function**
Command-F	Filter > Apply last filter used (with same settings)
Command+Shift-F	Edit > Fade filter
Command+Option-F	Open dialog with last used filter settings

Moving and cloning selections

To move the border outline only, place the cursor inside the selection border and drag. To move the selection contents, the move tool must be selected. The Command/Ctrl key shortcut saves you from having to select the move tool each time – just hold down the Command/Ctrl key and drag inside the selection. To clone a selection (without making it a layer), hold down the Option/Alt key+Command/Ctrl key and drag.

View menu	
Keyboard shortcut	**Function**
Command-Y	View > Proof Colors
Shift+Command-Y	View > Gamut Warning
Command-plus	View > Zoom in with window resizing
Command+Option-plus	View > Zoom in without resizing window size
Command-minus	View > Zoom out with window resizing
Command+Option-minus	View > Zoom out without resizing window size
Command-zero	View > Fit To Screen
Double-click hand tool	View > Fit To Screen
Option+Command-zero	View > Actual Pixels at 100%
Double-click zoom tool	View > Actual Pixels at 100%
Command-H	View > Show Extras (selections/target path/grid/guides/slices/notes)
Command-R	View > Show/Hide Rulers
Command-;	View > Snap (guides/grid/slices/document bounds)
Command+Option-;	View > Lock Guides
Double-click guide with move tool	Edit Guides & Grid settings: color and increments
Control+Tab	Cycle through open document windows (Mac)

Window menu	
Keyboard shortcut	**Function**
Tab key	Hide/show all palettes
Shift-Tab key	Hide/show all palettes except Tools palette and Options bar

Info and Navigator

Double-click the ruler margins to open the Units & Rulers preferences. You can use the keyboard numbers to set the tool opacity while any paint or fill tool is selected (1 = 10%, 9 = 90%, 0 = 100%). For more precise settings, enter on the keyboard any double number values in quick succession (i.e. 04, 23, 75 etc.). Use the up arrow to increase values in the box by 1% and use the down arrow to decrease values in the box by 1% (hold down the Shift key to decrease or increase by 10%). The Navigator palette provides a swift way of scrolling across an image. The bottom left box in the Navigator palette indicates the current viewing percentage scale. As with the identical box in the document window display, any value can be entered between 0.19% and 1600.00%. To zoom to a specified percentage and keep this box highlighted, hold down the Shift key whilst pressing Enter. Use the Navigator slider control to zoom in and out or mouse down on the left button to zoom out incrementally and the right button to zoom in. The dialog palette preview display indicates by a red rectangle which portion of the image is visible in relation to the whole – the rectangle border color can be altered by going to the palette options. To scroll quickly, drag the rectangle across the Navigator palette screen. Hold down the Command/Ctrl key and marquee within the thumbnail area to specify an area to zoom to. The Navigator palette can also be resized to make the preview window larger.

Navigation	
Keyboard shortcut	**Function**
Page up	Scroll up by one screen
Page down	Scroll down by one screen
Shift+Page up	Scroll up in smaller steps
Shift+Page down	Scroll down in smaller steps
Shift+Page up/Page down	Scroll up or down a single frame of a Filmstrip file
Command+Page up	Scroll left one screen
Command+Page down	Scroll right one screen
Command+Shift+Page up	Scroll left one screen in smaller steps
Command+Shift+Page down	Scroll right one screen in smaller steps
Home key	Display top left corner of image
End key	Display bottom right corner of image

Working with Actions

Photoshop is able to record a script of the operations performed in a Photoshop session and save them as an Action. These Actions can then be replayed on other images and shared with other Photoshop users so that they can repeat this sequence of Photoshop steps on their computer. Actions can save you the bother of laboriously repeating the same steps over and over again on subsequent images. To make things even easier, there is a Batch command in the File > Automate menu. You can use the Batch interface to automatically process any folder of images and have the files either save and overwrite or save to a new folder location, including the batch opening of images from a Kodak Photo CD disc.

Playing an Action

A folder set of prerecorded Actions was added to the Actions palette when you installed Photoshop 6.0. To test them out, have an image open, select an Action from the menu and press the Play button. Photoshop automatically snaps into action, running through the recorded sequence of commands, just like a pianola. If the number of steps in a complex Action exceeds the number of available histories, there will be no way of completely undoing all the commands when the action has completed. As a precaution, either take a snapshot in the History palette or save the document before executing an Action and if you are not happy with the result, fill from the saved snapshot in History or revert to the last saved version. Extra sets of Actions are easily loaded by simply going to the Actions palette menu and highlighting one of the named sets in the list. The Commands.atn set will install a number of useful preset Actions which will assign basic Photoshop actions like Cut and Paste with Function keys. Note that the Adobe Photoshop 6.0 > Presets > Actions folder contains a PDF document illustrating all the preset Action outcomes. If you are sent a Photoshop Action as an Action document (it may be appended with .atn), instead of loading it via the Actions palette, just double-click it to open Photoshop and automatically install it in the Actions Palette.

Recording Actions

First, record your action using a dummy image. Click the New Action button at the bottom of the Actions palette. Name the new Action you are about to record and then press the Record button. You can at this stage also assign a Function key combination which will in future initiate the Action. Now carry out the Photoshop steps you wish to record and when finished, press the Stop button in the Actions palette. Actions will be able to record most Photoshop operations including use of the Paths,

History palette steps, the Lighting Effects filter, Apply Image and most of the tools in Photoshop including the new shape tools. Tools such as the marquee and gradient fills are recorded based on the currently set ruler unit coordinates. Where relative positioning will be required, choose the Percent units in Units & Rulers preferences before you begin recording. Avoid using commands which as yet cannot be recorded with an Action. This is less of a problem now, as since version 5.0 was released, the scriptability of Photoshop has been vastly improved, but certain operations like paintbrush strokes (or any of the other painting tools) cannot be recorded as this goes beyond the scope of what can be scripted.

Watch out for recording commands that rely on the use of named layers or channels (which are present in your dummy file, but will not be recognized when the Action is applied to a new image). Try to make sure that your actions will not always be conditional on starting in one color mode only, or being a certain size. Set the ruler units to Percent if you need the Action to work with different sized images. If you intend recording a complex Action, the best approach is to plan the sequence of Photoshop steps you intend to record carefully in advance. The example overleaf demonstrates how to record a basic Action. A break can be included in an Action. This will initiate a message dialog to appear on screen. This message dialog can include a memo to yourself (or another user replaying the Action), reminding you of what needs to be done at this stage. Actions can be saved as Sets of Actions. If you want to save a single action, duplicate it by Option/Alt dragging to a new Set. If you hold down the Command/Ctrl+Option/Alt keys as you choose Save Actions... this will save the text descriptions only of all the Action steps to the Photoshop Actions folder.

Troubleshooting Actions

Check you have the start image in the correct color mode. Many Actions, such as those which use certain Photoshop filters, are written to operate in RGB color mode only. Color adjustment commands will not work properly if the starting image is in Grayscale or Indexed Color. Some pre-written Actions require the image you start with to fit certain criteria. For instance, text effect Actions will require you to begin with an image that already contains text on a separate layer, ready to process. If you have just recorded an Action and you are having a problem getting it to replay, you can inspect it command by command. Open a test image and expand the Action to display all the items. Hold down the Command/Ctrl key and click on the Play button. This will play the first command only. If there is a problem, double-click the command item in the list to rerecord it. Hold down the Command/Ctrl key again and click on the Play button to continue. To replace this item completely, press Record and perform a new step, then click Stop. This will delete the old step and replace it with the one you have just recorded.

1 The normal procedure when recording an Action is to start with a dummy image, record all your steps and then test the Action to make sure it is running correctly. The Action can easily be edited later where there are gaps or extra steps that need to be included.

2 This Action is designed to instruct Photoshop to add an extra layer fill with a color (any will do, we just need to fill it with pixels in order for the following step to work) and apply a custom gradient fill. Action recordings should be as unambiguous as possible. For example, if you record a step in which a named layer is brought forward in the layer stack, on playback the action will look for a layer with that name. Therefore, use the main Layer menu or Layer key command shortcuts listed in this chapter. Doing so will make your Action more universally recognized.

3 In this Action, a new layer is created and filled with a KPT gradient. The Action requires that a mask channel is present in the starting image to be loaded as a layer mask to reveal the object on the background layer.

Photograph: Davis Cairns. Client: Red or Dead Ltd.

4 When the recording is complete, hit the Stop button in the Actions palette. Expand the Action items to inspect the recording. Just before the filter step, I inserted a 'Stop' with a message reminding me that the next step requires me to select a KPT gradient. The Stop allows the Action to continue playing after pressing Enter.

Figure 12.1 An example of the Batch Action dialog set to apply a prerecorded Action. Select the Action you wish to apply from the pop-up menu at the top. Then choose the source folder containing the images to process. You can either instruct Photoshop to save and close, overwriting the original or select a destination folder where the processed files should be saved to. If you included an Open command in the recorded Action, then don't override this command, although you will want to override the save file operation as the recorded command will probably be to a different destination folder. The file naming options enable you to define the precise naming structure of the batch processed files.

Batch processing Actions

One of the great advantages of Actions is that you have the ability to record an Action and then apply it to a batch of files. The Batch Actions dialog can be accessed via the File > Automate menu. You will need to select a Source folder and if you want to save copy files to a new folder, select a Destination folder as well, although Photoshop 6.0 will also accept all opened files as a source. Figures 12.1 and 12.2 show you how to configure Batch Actions processing.

Figure 12.2 The Batch interface in Photoshop 6.0 features a section where you can specify the file naming rules of files saved from a Batch process. For example, the file document name itself can be made to be capitalised or made all lower case. Likewise, the file extension can be configured the same way. As you can see from the lists opposite, you can have Photoshop name the batch processed files in a great many ways. The example in the File Naming section (see Figure 12.1) indicates how the resulting file name will appear.

Automation plug-ins

This Photoshop feature will allow third-party developers to build plug-ins for Photoshop which will be able to perform complex Photoshop operations. The Photoshop suite of automated plug-ins are described on the following pages. These should be of special interest to everyone, including those who only use Photoshop occasionally and wish to carry out skilled tasks like resizing an image without constantly having to refer to the manual. They can operate like 'wizards'. An on-screen interface will lead you through the various steps or else provide a one-step process which can save you time or be built into a recorded Action.

The Conditional Mode Change... is a good example of how an Automation plug-in can accomplish sometimes a two-step process, quickly in a single stage. You select the mode the active file is in (or choose to check all modes). Fit Image... is a very simple utility which bypasses the Image > Image Size menu item. It is well suited for the preparation of screen-based design work. Enter the pixel dimensions you want the image to fit to by specifying the maximum pixel height or width. With Multi-Page PDF to PSD... you can open multiple pages of a PDF document as individual Photoshop image files. The opening dialog offers a choice of source file, which pages you want to select, what resolution to open to and the location of the folder to save to.

Picture Package

With the Picture Package automated plug-in you can take a single image and make it be repeated using various preset layouts as a single page output. So you can have (as in the Figure 12.3 example) the combination of a 5 x 7, 2 postcard and four smaller sized versions all oriented to fit on a single page layout. There are many preset template combinations available for you to choose from in the dialog layout menu. If you are feeling adventurous, go to the Photoshop 6.0/Presets/Layouts folder. Open the 'Read Me' file and learn how to write the basic code for designing your own custom layouts.

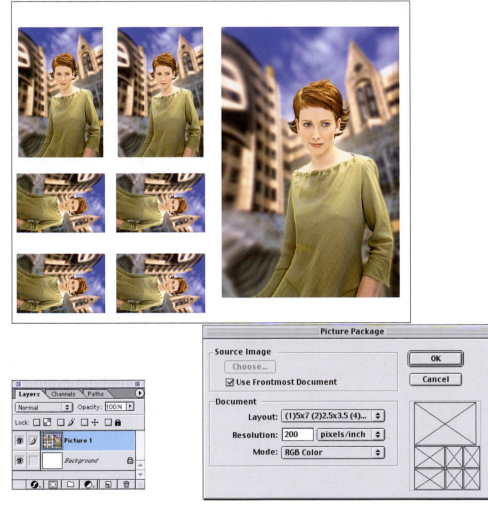

Figure 12.3 The Picture Package dialog box and an example of the resulting print output.

Client: Schwarzkopf Ltd, YU salon. Model: Kate Broe at M&P.

Client: Umberto Giannini.

Figure 12.4 The Contact Sheet II interface and an example of a Contact Sheet II output, using the Filename As Caption option.

Contact Sheet II

In its latest form, the Contact Sheet, now known as Contact Sheet II, is able to take all the images from a chosen folder and construct a contact sheet of these and print the caption name below each picture.

Just choose a source folder and all the images will be opened up and assembled to form a contact sheet page, or pages, if there are more images in the folder than will fit on a single page grid. The Contact Sheet layout and save destination are specified in the opening dialog box. You can choose to use any font for the caption and also now a choice over the caption point size. Another thing to watch out for is the limit on the caption length, as only the first twelve characters will be displayed, so check how you name the files. A nice refinement with Contact Sheet II is it remembers the last used settings rather than always opening with the standard default settings.

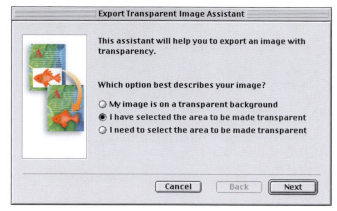

Figure 12.5 Two dialog boxes from Actions plug-ins found in the Help menu. On the left: the Export Transparent Image, which is asking if the image is already on a transparent background or a selection is currently active. On the right: Resize Image where the user can select the ratio of image resolution to screen resolution selected, plus a warning that the image may need to be rescanned if this size is selected.

Export Transparent Image and Resize Image

These last two Automation plug-ins are located in the Help menu. They are very nicely designed and illustrate just what we might come to expect in the future. The Export Transparent Image interface starts by asking you whether the purpose of the final image is for print or on-line use. For example, if you want to make a transparent GIF and there is no selection currently active, it will tell you to cancel and make a selection first. From there on it will duplicate the current image and ask clearly put questions about the intended final output and guide you towards that desired goal. The Resize Image Automation plug-in also has a clearly designed interface and takes the user step by step through the process of sizing an image for reprographic or on-line use (see Figure 12.5).

Web Photo Gallery

This is one of my favorite automated plug-ins. The Web Photo Gallery can process a folder of images and automatically generate the HTML code needed to build a web site complete with thumbnail images, individual gallery pages and navigable link buttons. This Photoshop feature can therefore save you many hours of repetitious work. Imagine you have a set of Photoshop images that need to be forwarded to a client over the Internet. When you build a self-contained web photo gallery in Photoshop, the processed images and HTML pages are output to a destination folder.

You upload this processed folder to your web server and pass the URL link on to the person who needs to see the photographs. In the Figure 12.6 example, I decided to call the destination folder 'guildford' and therefore appended '/guildford/frameset.htm' to the normal web site address as the full URL to follow. If you select either the 'Simple' or 'Table' styles, it will suffice to simply append with '/guildford/'. There is no need to add the 'index.htm'.

Figure 12.6 The Web Photo Gallery. Client: Clippers. Model: Laura Prophet at Premier.

The source must be any folder of RGB images (subsets of folders can be processed too). Ideally convert all these to sRGB color and resize them to the exact viewing size. This is not essential, as the Web Photo Gallery options allow you to precisely scale the gallery images and thumbnails down in size while being processed. There is a choice of four template styles: Simple, Table, Horizontal Frame, and Vertical Frame. Under Options you can enter the banner information and customize the image sizing and layout appearance. If you go to the Gallery Thumbnail options, you can choose whether to use the file name, or the File Info information, or both as the caption. You can now also choose the number of columns and rows of thumbnail images for the Simple and Table style layouts. In the Customize Colors options, you can edit the background, text, banner and active link colors. When all the options are set, these will be remembered the next time you use the Web Photo Gallery. Choose your destination folder and click OK. You can also create your own layout templates. Go to the Photoshop 6.0/Presets/Web Contact Sheet folder and use the folders in there as a guide for designing your own customized HTML templates. Remember, when the output folder is complete, you can further enhance the appearance of your gallery pages by importing them into a separate web site editing program such as Adobe GoLive™.

Creating a Droplet

Figure 12.7 A Photoshop Action can be converted into a mini application, known as a Droplet, which can be saved outside of the Photoshop folder. A Droplet will launch Photoshop and initiate the Action sequence, whenever you drag and drop a file on top of the Droplet icon. You can name a Droplet anything you like. To be PC compatible, add an .exe extension. PC Droplets can be made Mac compatible by dragging them once over to the Photoshop application icon. The options for selecting an action and specifying the file naming structure are identical to those found in the Batch Actions dialog. When finished, click OK to create a new Droplet and choose a location, such as the Desktop to save it to.

320

Brushes	Palette shortcuts
Keyboard shortcut	**Function**
Bracket: [Reduce brush size
Bracket:]	increase brush size
Shift+[Reduce the brush hardness
Shift+]	Increase the brush hardness
Command+Shift-F	Edit > Fade last brush stroke
Caps lock	Display precision crosshair cursor/brush size cursor
Click brush icon in Options bar	Edit the brush shape
Click arrow next to brush icon	Open the Brush presets
Double-click a brush preset	Rename the brush
Click in an empty space	Create a new brush
Option-click on a brush preset	Delete a brush preset
Control+Shift-click with a painting tool	Open the brush presets dialog – hit Enter to dismiss the dialog
Control+Shift-drag with a painting tool	Open the brush presets dialog – the dialog will be dismissed when you release the mouse
Shift key	Having started using the brush, then pressing and holding the shift key will use this brush in a straight line to the next click

Swatches	Palette shortcuts
Keyboard shortcut	**Function**
Click on swatch	Choose swatch as foreground color
Option-click on swatch	Choose swatch as background color
Click in an empty slot	Add the foreground color as a swatch and name it
Shift+Option click in a slot	Add the foreground color as a swatch without naming it
Shift-click swatch color	Replace a swatch with the foreground color
Command-click on swatch	Remove swatch from palette

Color	Palette shortcuts
Keyboard shortcut	**Function**
Shift-click Color bar	Cycle between all the color spectrum options
Control-click Color bar	Specify Color bar to use
Click gamut warning swatch	Select nearest in gamut color

History	Palette shortcuts
Keyboard shortcut	**Function**
Command-Z	Toggle moving back and forward one step (undo/redo)
Command+Option-Z	Move one step back through history
Command+Shift-Z	Move one step forward through history
Click New Snapshot button	Create a new Snapshot
Click New Document button	Create a new document from current image state
Option-click on history state	Duplicate any previous history state

See Figure 6.26 in Chapter Six for more *variable* history shortcut options.

Layers and channels

Extra layers will add to the overall file size and add to the RAM memory usage. When a document contains a lot of layer elements, Photoshop will also take longer to calculate the screen redraw every time you scroll the image or change the viewing magnification. If you anticipate editing very large image files (over 50 Mb RGB) then you should raise the number of Image Cache levels in the General Preferences from four to five, or even higher. Doing this will speed up the screen redraws at lower viewing magnifications.

Adjustment layers may also only occupy a few kilobytes of file space, but when a document contains several adjustment layers, this too can slow down the time it takes to refresh the screen image. There are two things that can be done to remedy this – either temporarily switch off the eye icons on these layers or merge them with the layers below and apply the adjustment permanently.

Layers	Palette shortcuts
Keyboard shortcut	**Function**
Click New Layer button	Create new empty layer
Option-click New Layer button	Create new empty layer, showing New Layer dialog box
Drag layer to New Layer button	Duplicate layer
Click palette Delete button	Delete selected layer (or drag layer to delete button)
Option-click palette Delete button	Delete selected layer (bypassing alert warning)
Option+[Select next layer down
Option+]	Select next layer up
Shift+Option+[Select bottom layer
Shift+Option+]	Select top layer
Double-click layer name	Open Layer Style dialog box
Option+double-click layer name	Open Layer Properties dialog box (e.g. for renaming)
Double-click adjustment layer icon	Edit adjustment layer settings
Double-click adjustment layer name	Edit Layer Style options
Double-click layer style icon	Edit Layer Style options
Keyboard numbers (1=10%, 9=90%, 0=100%)	Set layer opacity whilst a non-painting tool is selected (Enter any double number values in quick succession)
Up arrow	Increase value setting in box by 1%
Down arrow	Decrease value setting in box by 1%
Shift+Up arrow	Increase value setting in box by 10%
Shift+Down arrow	Decrease value setting in box by 10%
Return	Commits edit in pop-up slider in mouse up mode
Escape or Command-period (.)	Exit slider edit in mouse up mode
Click Layer Eye icon	Show or hide layer (toggle)
Option-click Layer Eye icon	View layer on its own/view all layers (toggle)

Layers continued	Palette shortcuts continued
Keyboard shortcut	**Function**
Command-click layer thumbnail	Load layer transparency as a selection
Command+Shift-click layer thumbnail	Add layer transparency to selection
Command+Option-click layer thumbnail	Subtract layer transparency from selection
Command+Option+Shift-click layer thumbnail	Intersect layer transparency with selection
Click Add a Mask button	Create a layer mask with reveal all/reveal selection
Option-click Add a Mask button	Create a layer mask with hide all/hide selection
Option-click layer mask thumbnail	View layer mask as a mask on its own (toggle)
Command-click layer mask icon	Load a layer mask as a selection
Click in Link icon area	Link/unlink a layer to currently selected layer
Click Link layer between the layer mask/clipping layer thumbnail	Lock/unlock the layer and the layer mask/clipping layer
Shift-click layer mask/clipping layer thumbnail	Disable/enable layer mask/clipping layer
Double-click layer mask thumbnail	Open Layer Mask Display Options
Shift+Option-click layer image mask thumbnail	View layer mask as an alpha channel (rubylith)
Option-click the divide line between two layers	Toggle between creating a layer clipping group and ungrouping
/	Switch on/switch off Lock transparent pixels
Option-click layer eye icon	Hide all layers except that one (toggle)
Command+Option+Shift-E	Merge visible layers to selected layer
Option+Merge Down	Merge down and leave a copy of the selected layer
Option+Merge Linked	Merge a copy of linked layers into layer below

The native Photoshop file format is able to save alpha channel content efficiently. A simple silhouette type mask will not add much to the total file size of a Photoshop document. However, this is not the case when you save using the TIFF file format. If you want to save lots of channels, the Photoshop file format will make more economical use of the disk space.

Layer sets can help you manage and organize the layers in a complex document. When layers are grouped in a set, you can quickly change the visibility and blending options for all the layers in the set at a stroke. Without the resources of unlimited processing power and RAM memory, there is sometimes no alternative but to periodi-

Layer sets	Palette shortcuts
Keyboard shortcut	**Function**
Click new layer set button	Create new layer set
Option-click new layer set button	Create new layer set with layer set options dialog
Command+Shift-J	Create new layer set from all linked layers
Command+Shift-J	Create new layer set from selected layer
Click trash icon	Delete selected layer set (with an alert)
Option-click trash icon	Delete selected layer set (without an alert)
Command-E	Merge selected layer set
Command+Shift-]	Move set to top of the stack
Command-]	Move set up, move layer into set that is right above it or move top layer in a set out of the set
Command-[Move set down, move layer into set that is right below it or move bottom layer in a set out of the set
Command+Shift-[Move set to bottom of the stack
Option+Shift-]	Select topmost layer or set
Option-]	Select next layer or set (cycle up)
Option-[Select next layer or set (cycle down)
Option+Shift-[Select bottom layer or set
Option-click eye icon for the set	Toggle show all layers/show just this set

cally merge existing layers before introducing new ones. Save the different layered versions of the image as you progress, before merging and moving on to the next stage. By working this way, you will always be able to revert back to any previous layered version of the image. The layer blending modes and the order in which those layers are arranged in the layer stack are crucial to the overall appearance of the image. If you have a layer in Normal blending mode and the one underneath is in Multiply mode, if you merge these two layers together, the uppermost layer will merge and now blend in Multiply mode as well.

Blending modes	
Keyboard shortcut	**Function**
Shift-plus	Set layer to next blend mode in list
Shift-minus	Set layer to previous blend mode in list
Option+Shift-N	Normal mode
Option+Shift-I	Dissolve mode
Option+Shift-M	Multiply mode
Option+Shift-S	Screen mode
Option+Shift-O	Overlay mode
Option+Shift-F	Soft Light mode
Option+Shift-H	Hard Light mode
Option+Shift-D	Color Dodge mode
Option+Shift-B	Color Burn mode
Option+Shift-K	Darken mode
Option+Shift-G	Lighten mode
Option+Shift-E	Difference mode
Option+Shift-X	Exclusion mode
Option+Shift-U	Hue mode
Option+Shift-T	Saturation
Option+Shift-C	Color
Option+Shift-Y	Luminosity

Channels	Palette shortcuts
Keyboard shortcut	**Function**
Command-click channel	Load channel as a selection
Command+Shift-click channel	Add channel to current selection
Command+Option-click channel	Subtract channel from current selection
Command+Option+Shift-click channel	Intersect channel with current selection
Shift-click channel	Add to or remove from the channels active
Command-1	Activate channel-1, e.g. red or cyan channel and so on
Command-~ (tilde)	Activate composite channel, e.g. RGB or CMYK
Command+Option-1	Load channel 1 as a selection and so on to channel 9
Click New channel button	Create a new channel
Option-click New channel button	Create a new channel whilst opening the Options dialog box
Command-click New channel button	Create a new Spot color channel
Click on Save Selection button	Create a new channel from current selection
Option-click on Save Selection button	Create a new channel from current selection with channel options dialog box
Click Load Selection button	Load active channel as a selection
Shift-click Load Selection button	Add selected channel to current selection
Option-click Load Selection button	Subtract selected channel from current selection
Option+Shift-click Load Selection button	Intersect selected channel with current selection
Click Delete button	Delete selected channel (or drag channel to wastebasket)
Option-click Delete button	Delete selected channel (without alert warning)

Paths	Palette shortcuts
Keyboard shortcut	**Function**
Click New path button	Create a new path
Option-click New path button	Create a new path showing the New Path dialog box
Drag path to New path button	Duplicate path
Click Delete path button	Delete path
Option-click Delete path button	Delete path, bypassing the alert warning
Double-click Path name	Edit the path name
Click Make work path button	Convert a selection to make a work path
Option-click Make work path button	Convert a selection to make a work path via Make Work Path dialog (choose pixel tolerance setting)
Double-click work path icon	Save the work path as a new path
Drag a work path to the New path button	Convert a work path into a new path
Command-click a Path in the palette	Load the path as a selection
Click Load path as a selection button	Convert active closed path to a selection
Option-click Load path as a selection button	Convert active closed path to a selection via Make Selection dialog box
Command+Enter key (selection or path tool active)	Convert active path to a selection
Click Stroke Path button	Stroke perimeter of path with Foreground color
Option-click Stroke Path button	Stroke perimeter of path via the Stroke Path dialog box
Click Fill path button	Fill path with Foreground color
Option-click Fill path button	Fill path via the Fill Path dialog box
Click empty area of Paths palette	Deactivate path

Pen tool

Keyboard shortcut with pen tool selected	Function
Command key	Direct selection tool (whilst key is held down)
Option key	Convert direction tool (whilst key is held down)
Click on anchor point or path	Remove anchor point/add anchor point (toggle)
Shift key	Constrains the path drawing horizontally, vertically and at 45 degrees
Command-click Path	Activate all control points without selecting them
Command+Shift-click	Add to selected path points
Command+Option-click path in image	Select entire path or uppermost sub-path
Command+Option+Shift-drag path	Clone selected path (Shift key constrains movement to 45 degree increments, let go after first dragging)

General

Keyboard shortcut	Function
Command-Period (.)	Cancel or abort an operation
Esc	Cancel operation (Crop/Transform/Save)
Delete key	Remove selected area to reveal transparency (on layer) or background color (on background layer)
Option key	When a painting tool is active, use the Option key to sample in window area to make foreground color
Tab key	Toggle Show/Hide palettes (see Window menu)
Tab key	Jump to next setting in any active dialog box
Option-click Cancel button	Change Cancel button in dialog boxes to Reset

Chapter Thirteen

Black and White Effects

D uplicating black and white darkroom techniques in Photoshop will be of particular interest to photographers. The main problem with digital black and white work is getting a good quality scan from a black and white negative or print. At the beginning of the book in Chapter One, I said that digital capture from a black and white original is a real test of scanner quality. Scanning in a color image records a different range of grayscale tones in each of the three color (RGB) channels. When you change from RGB to Grayscale mode in Photoshop, the tonal values of these three channels are averaged out, usually producing a smooth continuous tone grayscale. The formula for this conversion roughly consists of blending 60% of the green channel, 30% of the red and 10% of the blue. If the original scanned image is a monochromatic negative, there is little or no deviation between the color channels and the averaging-out process emphasizes the deficiencies contained in the weaker channels, although the green channel will probably be the least noisy of the three. The rigidity of this color to mono conversion formula also limits the scope for obtaining the best grayscale conversion from a scanned color original. This is addressed towards the end of the chapter.

An 8-bit grayscale image has a maximum of 256 brightness levels. A decent grayscale image will look all right on the monitor and may even look acceptable in print. A practical consequence of using 8-bit grayscale files is that as many as a third of the tonal shades will get lost during the reproduction process. The fine quality black and white printing you see in some magazines and books is achieved using a duotone or conventional CMYK printing process. Adding two or more printing plates will dramatically increase the range of tones that can be reproduced from a monochrome image.

Duotone mode

You need to start with an image in grayscale mode first before you convert to a duotone: Image > Mode > Duotone. A duotone is made using two printing plates, a tritone has three and a quadtone four. The Ink Color boxes display a Photoshop preview of the ink color with the name of the color (i.e. process color name) appearing in the box to the right. The graph icon to the left is the transfer function box. In here you specify the proportions of ink used to print at the different brightness levels of the grayscale image. The transfer function box opens when you double-click the graph icon. You can change the shape of the curve to represent the proportion of ink used to print in the highlights/midtones/shadows. Normally the inks are ordered with the darkest at the top and the lightest inks at the bottom of the list. There are a number of duotone Presets (plus tritones and quadtones) to be found in the Photoshop Goodies folder. Experiment with these by clicking the Load... button in the duotone dialog box and locating the different preset settings.

Printing duotones

When preparing an image for placing in either InDesign™ or QuarkXPress™, the only file formats (other than Photoshop) to support duotones are EPS and DCS. Remember though that if the ink colors used in the duotone are custom colors, these need to be specified to the printer and this will add to the cost of making the separations if CMYK inks are already being used in the publication. Duotones that are converted to Multichannel mode are converted as spot color channels. Alternatively you can take a duotone image and convert it to CMYK mode in Photoshop. This may well produce a compromise in the color output as you will be limited to using the CMYK gamut of colors.

So, I hear you say, 'in that case why not use the CMYK mode instead of duotone, what difference will an extra plate make between a tritone and CMYK?' Well, a designer's job is to make the best use of his or her skills within an allocated budget. It is common for a color print job to include extra plates beyond the four employed in CMYK. Yes, you can construct many flat colors using a mix of these four inks, but designers have to be wary of misregistration problems. It is all right to specify large headline text in a process color, but not smaller body text. For this reason, designers specify one or more process colors for the accurate printing of colors other than black or a pure cyan, magenta or yellow. A typical custom brochure print job with full color images might require a total of six color plates, whereas a brochure featuring black plus one or two process colors requires fewer printing plates to make sumptuous duotones or tritones. You find designers working within the limitations of black plus two custom inks are still able to pull off some remarkable illusions of full color printing.

Duotone: 159 dk orange 614 (Pantone)

Duotone: 327 aqua (50%) bl1

Duotone: 506 burgundy (75%) bl 3

Tritone: BMC blue 2 (Process)

Normal – Grayscale Mode

Tritone: bl 313 aqua 127 gold (Pantone)

Quadtone: bl 541 513 5773 (Pantone)

Quadtone: Custom (Process)

Quadtone: Extra Warm (Process)

Figure 13.1 Examples of preset duotones (see Goodies folder) applied to a grayscale image. Process color duotones are formed using the standard CMYK process inks. Pantone (or any custom process color ink) duotones can be made from specified color inks other than these process colors.

1 One major difference with Photoshop 6.0 is the way it handles the representation of the color output on the monitor. The grayscale display is foremostly based on the assumption that you want to see a representation on screen of how the grayscale file will print. Go to the Color Settings and select the anticipated dot gain for the print output. This will be the Photoshop grayscale work space all new documents will be created in or be converted to. If you are working on a grayscale image intended for screen-based publishing then go to Window > Proof setup and select the Windows RGB preview.

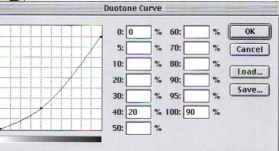

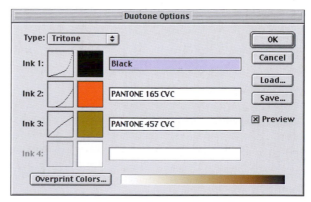

2 With the Preview switched on in Duotone Options, any changes you make to the duotone settings will be immediately reflected in the on-screen image appearance. In this example a custom color tritone was selected – the darkest color is at the top and at present the middle orange graph icon double-clicked and the transform curve is being modified. The transform curve is similar to the image adjustment curves, except a little more restrictive in setting the points. You specify the ink percentage variance at set points along the horizontal axis. The color ramp in the duotone dialog reflects the tonal transformation across an evenly stepped grayscale ramp.

Full color toning

When you select a duotone preset you get to see a preview of the color on the screen and this opens up many possibilities for the creative use of working in duotone mode to simulate all types of print toning effects. I now use Duotone mode much more and will maybe afterwards convert the image to either RGB or CMYK color. The other alternative is to start with the image in RGB or CMYK color mode and desaturate (see the Black and white from color Channel Mixer technique, page 340 for guidance on producing custom grayscale conversions) or convert a grayscale file to RGB color mode and use some of the other techniques demonstrated here which simulate traditional darkroom toning techniques. The simplest way of toning an image is to use the Color Balance adjustment. Normally I am inclined to disregard the Color Balance as a serious color correction tool. But in situations such as this, the simple Color Balance controls are perfectly adequate for the job of coloring a black and white image. The Color Balance controls are intuitive: if you want to colorize the shadows, click on the Shadows radio button and adjust the color settings. Then go to the Highlights and make them a different color and so on. If you apply the color adjustment as an adjustment layer, you can afford to make quite a dramatic color adjustment and then fade the adjustment layer opacity afterwards.

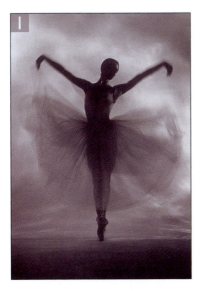

Photograph: Eric Richmond

1 Start with a grayscale image and convert to RGB color mode or take an RGB image and choose Image > Adjust > Desaturate (or use the 'black and white from color' Channel Mixer in monochrome mode method described later on). Then add a Color Balance adjustment layer to colorize the RGB/monochrome image. Choose New Adjustment Layer... from the Layers palette fly-out menu and select Color Balance. Click on Shadows and move the sliders to change the shadow tone color balance.

2 Repeat the same thing with the Midtones and Highlights. Return to the Shadows and readjust if necessary. With an adjustment layer you can return again to alter these Color Balance settings at any time. The Color Balance image adjustment method is ideal for toning monochrome images. To further modify the Color Balance toning, try varying the adjustment layer opacity in the Layers palette.

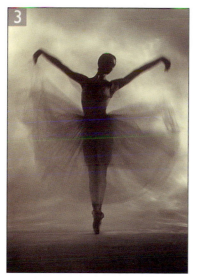

3 Providing the original monochrome image is in RGB or CMYK color mode, the Channel Mixer is another interesting tool that can be used for coloring an image and imitating color toning effects. For more instructions on Channel Mixer use, see the simulating sunset light technique described in Chapter Fourteen.

Split toning

For those who have not come across this printing method, a split tone is a black and white image that has only been partly toned or a mix of toning effects have been applied. For example, a print is placed in a bleach bath to remove all the silver image, then it is thoroughly washed and placed in a bath of toner solution, which replaces the bleached silver with the sepia or other dye image. If the print is only partially bleached, you get an interesting split tone effect in the transition between the base and toned colors. The following steps demonstrate the use of the Layer blending options in conjunction with adjustment layers.

1 The color original is converted to monochrome while remaining in RGB – use Image > Adjust > Desaturate or apply the Channel Mixer in Monochrome mode.

2 Tone the desaturated image using a Color Balance adjustment layer as was described in the previous example. Click on the Midtone and Shadow buttons and move the sliders to adjust the shadow and midtone colors.

3 Add a second adjustment layer. Choose Color Balance again. Now click on the Midtone and Highlight buttons to set the highlight color tones.

4 Go to the Layers palette sub-menu and select Blending Options. Hold down the Option/Alt key and drag one half of the shadow triangle slider as shown here to separate the sliders. The wide spacing of the slider halves produces the gentle tonal transition shown here.

Solarization

Some people dismiss the Photoshop Solarize filter as being too basic and of limited use and I'm inclined to agree. It is much better to generate your own custom solarizations using a Curves image adjustment. The original photographic technique is associated with the artist Man Ray and is achieved by briefly fogging the print paper towards the end of its development. Working in the darkroom, you can get nice effects by selectively solarizing the print image: place the partially developed print under a white light source, dodging the print during second exposure. Needless to say, this is a very hit and miss business. The digital method provides more control, because you can precisely select the level of solarization and the areas of the image to be affected.

1 Start with an image in Grayscale mode. Go to the Layers palette and add a new Curves adjustment layer (you will want to apply the solarization using this layer and later remove parts of it to reveal the unaffected background layer).

2 Select the arbitrary map tool (circled in red) and draw an inverted V. The easiest way to do this is to draw by Shift-clicking which will create straight lines, or use the point curve tool to draw a series of wavy curves.

3 Add a mask to the adjustment layer: activate the layer and start defining the areas of this layer you wish to erase using the lasso tool. Apply a heavy feathering to the selection: Select > Feather and enter a high value. I used 80 pixels, but you could apply a greater or lesser amount, depending on the file size.

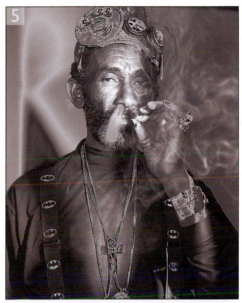

4 Check the success of your feathered selection by switching to Quick mask mode. Don't worry about the mask being absolutely perfect, you can refine the mask in the next stage.

5 Switch back to Selection mode and fill the adjustment layer mask with black. In Layer Mask mode, the default foreground/background colors are black and white: choose Edit > Fill > Foreground Color. Deselect the selection, choose a large brush set to a low opacity and paint in or paint out the unsolarized Background layer.

6 Finally, I merged the layers, converted the image to RGB color mode and colored the picture using the previously described split tone technique.

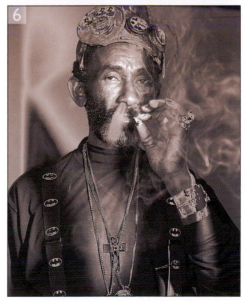

Black and white from color

A black and white image can be obtained from a color original (in CMYK or RGB mode, for example) and converted to Grayscale mode easily enough. In fact as was explained earlier, this may be a better way of obtaining grayscale scans from midrange scanning equipment or Photo CD scans. The distinction between shooting black and white or color is lost on many of the clients I have worked with. How you light and color compose a shot is determined by whether it is intended for color or monochrome. Ideally you would want to shoot one or the other using the most suitable medium for the capture and if that medium is a black and white negative, I recommend nothing less than a high quality professional scan for the job.

If, on the other hand, you want to convert from a color file, you do have the latitude of being able to make creative decisions at the pre-press stage which will simulate the effect of filtering the lens at the time of shooting on black and white film. A straightforward conversion from RGB to Grayscale mode translates all the color

1 This is a typical example of how to use the Channel Mixer in Monochrome mode. When photographers shoot with black and white film, the emulsion is more or less evenly sensitive to all colors of the visual spectrum. If you add a strong colored filter over the camera lens at the time of shooting, that color sensitivity is altered as certain wavelengths of color are blocked out by the filter. The following steps mimic the effect of an orange/red lens filter being used to strengthen the cloud contrast in the sky.

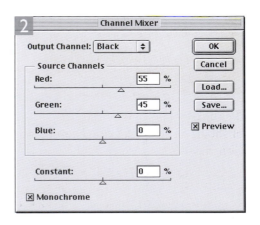

2 Click on the New adjustment layer button in the Layers palette and select Channel Mixer. Check the Monochrome box and adjust the sliders to alter the balance of the color channels used to render the new monochrome version of the original. For the very best results, try to get the percentages in each slider box to add up to 100%. This is not a hard and fast rule – variations other that 100% will just be lighter or darker. Use whichever looks best.

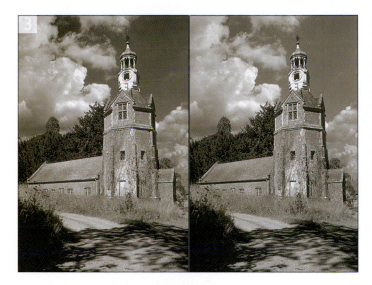

3 The standard conversion to grayscale mixes each color channel using a fixed formula – the resulting monochrome image (on the right) has an acceptable amount of tonal contrast. The Channel Mixer version on the left contains greater contrast between the clouds and the blue sky.

4 Another adjustment layer was added above the final channel mixed version. This time, a Color Balance adjustment layer to create a split tone coloring effect.

data evenly to monochrome. This is what a panchromatic black and white film does or should be doing rather, because there are slight variations in the evenness of emulsion sensitivity to the visual and non-visual color spectrum. It can be argued that these variations give films their own unique, special character. You are also probably familiar with the concept of attaching strong colored filters over the lens to bring out improved tonal contrast in a monochrome image. The same principles apply to converting from color to black and white in Photoshop.

Infrared film simulation

The spectral sensitivity of a photographic film emulsion will extend slightly beyond that of the human visual spectrum. This can sometimes cause problems in color photography when an object radiates light we cannot see, but the film does. This phenomenon, known as metamerism, can affect the way the colors of specific garments can appear the wrong color on the final film. There is also a special infrared sensitive film emulsion you can buy, which is acutely sensitive to infrared radiation. The black and white emulsion is quite grainy. Vegetation reflects a lot of infrared light which we human observers are not aware of. Hence, green foliage will appear very bright and almost iridescent when captured on infrared film.

1 This woodland scene is a prime candidate with which to demonstrate the following infrared technique. As you can see, there are a lot of fresh green leaves in the picture. What follows is an extension of the color to monochrome technique using the Channel Mixer.

2 Essentially, what I am attempting to do here is to take this Channel Mixer technique to extremes. Now if we want the green channel to appear the lightest, because that's where all the green foliage hangs out, then we have got to somehow boost the green channel mix. The maximum setting allowed is 200% which produces a burnt-out 'screened' result. Bearing in mind the 'keep everything adding up close to 100%' rule, I reduced the other two channel percentages, to give them minus values. There was a little cyan coloring in the green, so I reduced the red channel by only 30% and the blue channel was therefore set to minus 70%.

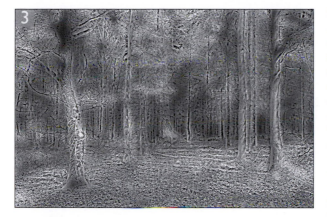

3 So far so good. Now I want to add some glow to the foliage. It is important that the underlying image has remained in RGB (because it is the adjustment layer which is making the monochrome conversion). I went to the channels palette and highlighted the green channel and applied a Gaussian blur filtration to that channel only. The result of the full blur is shown opposite. This isn't the desired result, so I followed that with a Edit > Fade Filter command, reducing the blur to a 26% opacity and Screen blend mode.

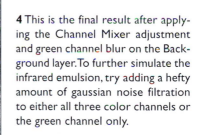

4 This is the final result after applying the Channel Mixer adjustment and green channel blur on the Background layer. To further simulate the infrared emulsion, try adding a hefty amount of gaussian noise filtration to either all three color channels or the green channel only.

Adding a photographic rebate

This final example combines several of the black and white techniques discussed in this chapter. If I want to mimic the effect of a photographic type rebate, like that associated with a Polaroid™ negative emulsion, I will go about this by opening a prepared scan of such a rebate, add this as an image layer and set the blend mode to Multiply. The rebate image must have clear 100% white areas. That way, only the dark areas will show through using the Multiply blending mode.

| Layer | Select | Filter | View | Window | Help |

New
Duplicate Layer...
Delete Layer

Layer Properties...
Layer Style

New Fill Layer
New Adjustment Layer

 Levels...
 Curves...

Change Layer Content
Layer Content Options...
Type
Rasterize

 Color Balance...
 Brightness/Contrast...

New Layer Based Slice

 Hue/Saturation...
 Selective Color...
 Channel Mixer...
 Gradient Map...

Add Layer Mask
Enable Layer Mask

 Invert...
 Threshold...
 Posterize...

Add Layer Clipping Path
Enable Layer Clipping Path

Group with Previous ⌘G
Ungroup ⇧⌘G

In this example we can see how the combination of an image layer and three adjustment layers produce a sepia toned print effect. The background image has remained in RGB throughout. The first adjustment layer is a Channel Mixer adjustment – this layer converts the RGB color image to monochrome, using a custom mix of the RGB channel contents.

The Levels adjustment layer above it darkens the image, but I made a rectangular selection feathered of about 150 pixels and filled with black. Only the inside edges of the image are now affected by this adjustment.

The third layer is a specially prepared image layer made from a Polaroid™ processed shot. This layer is set to Multiply mode which will successfully merge the border rebate to blend with the underlying background image. Lastly, a Curves adjustment layer is added. The red and blue color channel curves were adjusted to alter the color balance.

Client: Tresemme. Model: Stevie at Nevs.

Chapter Fourteen

Coloring Effects

At a recent exhibition of digital photography, a visitor was heard to remark: 'It's all cheating isn't it?' A fair comment I suppose, although one should realize that photographers and printers were manipulating their images (or cheating) in darkrooms long before computers came along. The quest for new photographic styles has always inspired image makers to seek out and develop fresh techniques like processing films in the wrong chemistry.

It's all a matter of using any means at your disposal to achieve your ends, which is why computer manipulation should be seen as just another aspect of the image making process. The following techniques begin by emulating the results achieved with chemicals, but as will be seen, there is ample room for exploration to go further and create many types of color shifted results. Use the basic formula as a springboard for new ideas and variations beyond the scope of a wet darkroom.

Photoshop is especially able to handle wild distortions thanks to extended 16-bit channel support with color adjustments This is now available for a limited range of Photoshop functions, including basic filters. Extreme or repeated color changes compound the data loss in each color channel – you may not necessarily notice this unless you later inspect the color channels individually. A histogram readout will certainly show where gaps in the levels occur. Data gets lost when working at 16-bit too, but crucially when you revert or compress to 8-bit color there is more than enough data to fill in the gaps. Close analysis will show the difference between a series of color adjustments made in 16-bit and 8-bit. An 8-bit image may result in some signs of posterization at certain delicate parts of the image. More usually you will see better preserved image detail in the 16-bit color manipulated image.

Cross-processing

There are two types of cross-processing, both of which gained popularity towards the late eighties. There was the E-6 transparency film processed in C-41 color negative chemicals technique and C-41 film processed in E-6. For the latter effect, you used Kodak VHC film, overexposed by 2 stops and over processed by 1 stop. The highlights became compressed in the yellow and magenta layers, so pure whites appeared pinky orange and shadow tones contained a strong cyan/blue cast. Most of the mid to highlight detail (like skin tones) got compressed or lost. It was a very popular technique with fashion and portrait photographers who were fond of bleaching out skin tones anyway. In fact, Kodak designed this emulsion specifically for wedding photographers. This was in order to cope with the high contrast subject tones of black morning suits and white bridal gowns. The sales of VHC rocketed. Kodak must have assumed the new demand was coming from their traditional wedding market base, so set about improving the VHC emulsion after which VHC did not cross-process so effectively unfortunately. From a technical standpoint, the manipulation of silver images in this unnatural way is destructive. I have had to scan in cross-processed originals and typically there are large missing chunks of data on the histogram. The digital method of manipulating images to such extremes carries its own risks too. It is all too easy to distort the color in such a way that image data slips off the end of the histogram scale and is irrevocably lost. Having said that, the digital method has the added benefit that you can be working on a copy file and so therefore the original data is never completely thrown away. Secondly, you are in precise control of which data is to be discarded, taking the hit or miss element out of the equation.

I have looked at several methods of imitating the cross-processed look in Photoshop and concluded that Curves adjustments are probably the best method with which to demonstrate these particular techniques. Figure 14.1 replicates the C-41 film processed in E-6 effect. Notice the adjustment of the highlight points in the red and blue channels – this creates the creamy white highlight and the curve shape of the lower portions of the red and blue channels produces the cross-curved color cast in the shadows.

The curves in Figure 14.2 show that the tonal range is uncompressed. A contrast increasing curve is introduced to both the red and green channels, while the blue channel has a complimentary shaped contrast-reducing curve – this again creates a cross-curved color cast, as in Figure 14.1. But overall Figure 14.2 produces a more contrasty outcome, similar to the effect of processing E-6 transparency film processed in C-41 color negative chemicals.

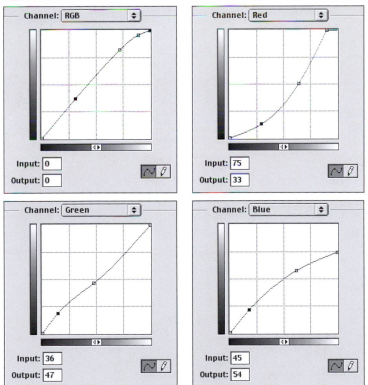

Figure 14.1 The C-41 film processed in E-6 chemicals cross-processing color effect.

Client: West Row, Leeds.

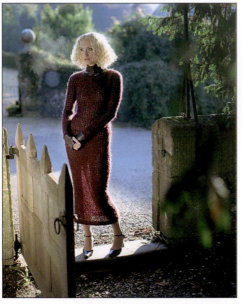
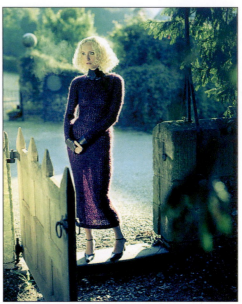

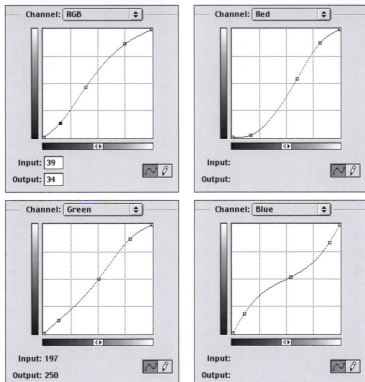

Figure 14.2 The C-41 film processed in E-6 chemicals cross-processing color effect.

Model: Ane Linge. Photograph by Thomas Fahey.

Channel Mixer adjustments

As the Photoshop program develops, so you adapt your way of working. The Channel Mixer can achieve the sort of coloring effects that once could only be done with the Apply Image command. The Channel Mixer is an interesting image adjustment tool, which alters the image by swapping color channel information, sometimes producing quite unique and subtle color adjustments which cannot necessarily be achieved with the other color adjustment tools. Controlling the Channel Mixer is no easy task. The example here shows you how to make a photograph appear to have been taken at sunset and make the scene appear to have richer, golden colors.

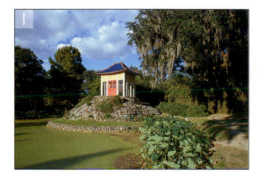

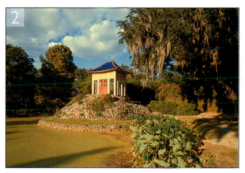

1 This image is correctly color balanced, but it lacks the drama of a golden warm sunlit image. One answer would be to adjust the overall color balance by applying a curves correction. The Channel Mixer, however, offers a radically different approach, it allows you to mix the color channel contents and does so on-the-fly.

2 Examine the Channel Mixer settings shown below. The main color enhancement occurs in the red channel. I boosted the red channel to 125%, mixed in a little of the green channel and subtracted 34% with the blue channel. Very slight adjustments were made to the green and blue channels, but you will notice how the green and blue channel percentages remained anchored close to 100%.

Output Channel: Red		
Source Channels		
Red:	+125	%
Green:	+13	%
Blue:	-34	%
Constant:	+2	%

Output Channel: Green		
Source Channels		
Red:	-2	%
Green:	+102	%
Blue:	0	%
Constant:	0	%

Output Channel: Blue		
Source Channels		
Red:	-6	%
Green:	-6	%
Blue:	+100	%
Constant:	-2	%

Figure 14.3 I used Photoshop cross-processing techniques with variations on copies of the same original image. Some were further adjusted using the Hue/Saturation image adjustments. I also experimented with making a selection based on the model's outline, inverting it and filling the background area with different colors. The individual pictures were assembled on separate layers to make the final composite as shown here.

Figure 14.4 The Channel Mixer on its own is an excellent tool to use for both wild and subtle color control. The Channel Mixer affords just the sort of control you always dreamed of having in the darkroom. It is possible with a little patience to discover a whole host of new color distortions. Any setting you discover can be saved as you progress, to add to your collection of favorite color effects. The four examples shown here are all Channel Mixer variations that were applied to the original image without any Curves adjustments.

Figure 14.5 In the above illustration, four identical RGB images are colored by an overlaying color fill layer set to the 'Color' and 'Hue' blending mode at 50% and 100%.

Model: Clair Rawlings.

Color overlays

An easy way to fade image colors is to add a blending layer consisting of a single color, set to either the Hue or Color blending modes. This produces an effective faded look (see Figure 14.5).

The Color blending mode is grouped with Luminosity, Hue and Saturation. Each of these blending modes operates along a similar principle: an HSB component of the pixel values of the blend layer replace those of the underlying pixels. HSB refers to Hue, Saturation and Brightness (luminosity).

Color mode: The hue and saturation values of the blend layer are combined with the luminosity of the underlying layers. The effect is to colorize the layers below.

Hue mode: Only the hue values of the blend layer are combined with the underlying saturation and luminosity values. The layers beneath are colorized, but the saturation of the base image is retained.

Saturation mode: The saturation values of the blend layer replace those of the underlying layer. A pastel colored overlay layer will cause the underlying layers to become desaturated, but not alter the hue or luminosity values.

Luminosity mode: The brightness values of the blend layer replace those of the underlying, but do not effect the hue and saturation.

Retouching with overlays

Let's look at more ways these and other overlay blending modes can be applied when retouching a photograph. Suppose you have a landscape picture and are looking for a simple method to remove the clouds from the sky. Cloning with the clone stamp tool or cutting and pasting feathered selections could possibly work, but you would have to be very careful to prevent your repairs from showing. For example, how will you manage to clone in the sky around the branches and leaves?

The sky is graduated from dark blue at the top to a lighter blue on the horizon. The easiest way to approach this task is to fill the sky using a gradient set to the Darken blending mode. The foreground and background colors used in the gradient are sampled from the sky image. Darken mode checks the pixel densities in each color channel. If the pixel value is lighter than the blend color it gets replaced with the blend color. In the accompanying example, the clouds (which are lighter than the fill colors) are removed by a linear gradient fill. The trees, which are darker than the fill colors, are left almost completely unaltered. To apply a gradient fill, I clicked the fill layer button at the bottom of the Layers palette and chose Gradient. The Gradient type was Foreground to Background, and I changed the fill layer blending mode to Darken. Before I did this, I loaded the blue channel as a selection. The Blue channel contains the most contrast between the sky and the trees. When a selection is active and you add a new fill or adjustment layer, or you click on the Add layer mask button, a layer mask is automatically added which reveals the selected areas only. As with adjustment layers, fill layers can be adjusted on-the-fly while retaining the layer masking.

I The before picture contains a cloudy sky. Sample colors from the top of the sky and from the horizon to set the foreground and background colors.

2 Load the blue channel as a selection and click on the Create new fill button at the bottom of the Layers palette to add a new gradient fill layer. The Gradient Fill dialog opens. Click OK to add a new layer using the Foreground to Background gradient at the angle shown. Then set the fill layer to Darken blending mode. The pre-loaded selection will have added a layer mask to hide the tree branch outlines.

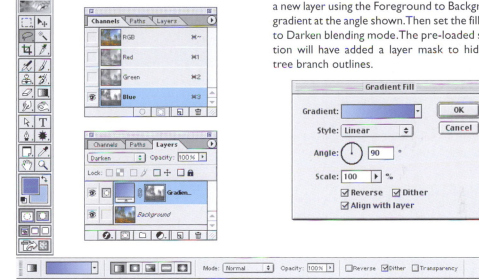

The second example features a view of Piccadilly Circus in London. This is actually a composite image of several views joined together to make a panoramic picture. This layer blending technique is a reverse of the last one. Instead of removing the light colored clouds, the object here is to remove hair and dust marks from the sky area. It is not necessarily that easy to remove marks like these with the clone stamp tool alone. Whenever you come across areas that feature subtle tonal changes, there is an increased chance that any spotting will be easily noticed. In this example, a new layer and a gradient are added – sampling the sky colors, but this time the blending mode is set to Lighten. This will replace only the darker dust marks and hairs with the lighter sky colors of the gradient layer.

1 Another landscape, but this time there are a lot of dust marks on the scan which need to be removed. One can eradicate these by applying the same technique as before, but this time set the gradient tool to Lighten. Lighten mode checks the pixel densities of the color channels and if the pixel value is darker than the blend color it gets replaced with the blend color. Hence the dark scratches and marks are removed in one simple step and without affecting the clouds. This technique works fine on a scene where there are no trees in the sky as there was before.

2 Before close-up view of sky showing the black dust marks which need to be removed. Sample the horizon color with the eyedropper tool. Invert the foreground and background colors (press 'X') and then sample the top of the sky.

3 Create a new layer and drag the gradient tool from the top of the sky down to the horizon. Add a layer mask to the layer. Activate the layer mask. With the gradient tool, fill the mask as shown using the default Foreground/Background colors. Brush out on the layer mask unwanted overlaps and merge the layers.

Gradient Map coloring

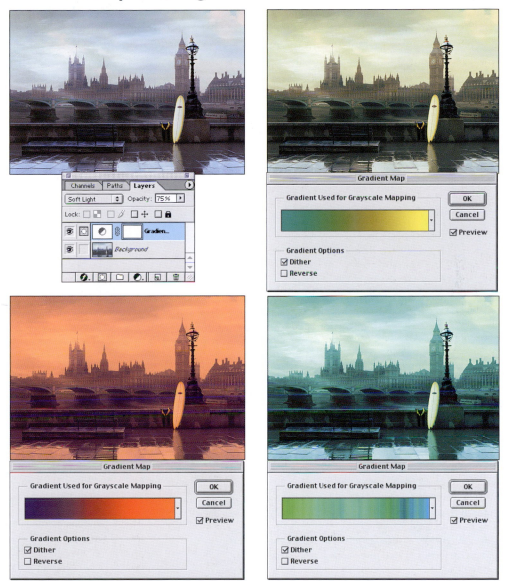

Normal blending mode at 45%.

Overlay blending mode at 40%.

Figure 14.6 The Gradient Map is a new adjustment layer option which has been added to Photoshop 6.0. The above examples show how various types of gradients can be applied to a color image as a Gradient Map and how the original photograph can be radically colored in many different ways. The Noise gradients can look very interesting as well. In most cases, I have discovered that it pays to fine tune the smoothness and shape of the gradient using the gradient edit options and also to experiment with the layer blending modes.

Client: Crescendo Ventures. Agency: Moline Willett.

Hand coloring a black and white photograph

Hand coloring enthusiasts will find that Photoshop makes things a little easier in as much as you can do all the painting work on a separate layer without risk of damaging the original. That was always the problem – one slip of the brush and you might have to start work on the print all over again. To reproduce some types of coloring, you are only as good as your brush skills allow. Photoshop enables you to create mask outlines to restrict the extent of your coloring. The following tutorial by Adam Woolfitt demonstrates the use of some of the selection and color adjustment methods described in previous chapters to create a colored image from a black and white original.

1 The original is an RGB scan from a black and white negative of Mulfra Quoit in Cornwall, UK, which had been shot on Konica Infra Red 120 film. Adam made a soft, feathered selection of the lower part of image and used the Hue/ Saturation command with Colorize clicked on, to color this area green.

2 He then made a selection of the sky and colored this blue, again using Hue/Saturation. The middle-distance areas were selected and separately toned magenta. Adam made several magic wand selections of the stones using different tolerance settings in the Options bar and each time colored the stones a different shade of sepia.

Lastly, Adam duplicated the background layer and applied a Gaussian blur to the background copy and with the Background copy layer selected, took the opacity slider down to 60%. An image layer mask was added to this layer and Adam selectively painted on the layer mask with black to make the blurring less strong in some areas.

Photograph: Adam Woolfitt.

Chapter Fifteen

Layer Effects

This chapter shows you some of the special things you can now do in layers and how these features will be of use to image makers as well as designers working in graphics or web design. Layer effects enable multiple (and reversible) Photoshop layering actions. This is a wonderful tool with which to automate the application of various Photoshop effects like embossing or adding a drop shadow. Layer effects can be used in various ways: applying effects to an image element on a layer; text effects with a type layer; and creating special painting effects where an empty layer can have layer effects active and anything painted in that layer will have the effect applied as you add image data to it.

Layer effects and Styles

In Photoshop you can add various layer effects to any of the following: a type layer; an image layer; or a filled layer masked by either a layer clipping path or a layer mask. The individual layer effects can be accessed via the Layer menu or by clicking on the Add a layer style button at the bottom of the Layers palette. Layer effects can be applied individually or as a combination of effects and these can be saved to become a 'layer Style' and added to the Styles palette presets. Layer effects are fully editable and will follow any edits you make to the type or the contents of a layer. When you add a new effect, the Layer Style dialog will open and allow you to adjust the effect settings. After creating a new layer effect, an italicized 'f' symbol appears in the layer caption area with a layer called 'Effects' and an itemized list of all the effects below. Double-clicking the layer/layer effect name or 'f' symbol, reopens the Layer Style dialog. Drag and drop the 'Effects' layer to copy the effects to another layer.

Drop Shadow

As you can see, there are quite a range of options associated with each layer effect. The Drop Shadow uses the Multiply blending mode to make the shadow with the default color set to black. Now obviously you can change these parameters, so the effect can become something like a drop glow, using any color you want and with varying opacities. Below this is the angle setting, where you can either enter a numeric value or use the rotary control to manually set the shadow angle. The Use Global Angle comes into play when you want to link the angle set here with those used in the Inner Shadow and the Bevel and Emboss layer effects and that of any other Layer Styles layers. If you want to set these angles independently, then deselect this option. Below this are the shadow distance and blur controls – these are self-explanatory. The Intensity setting intensifies the effect in much the same way as if you were to duplicate a real drop shadow layer and have it set to Multiply mode on top of the Multiply mode beneath it.

Inner Shadow

The Inner Shadow controls are more or less identical to the Drop Shadow effect. The only difference being that this applies a shadow within the layered type or object area. The result may appear to be either that of a recessed shadow or will give a convex 3D appearance to the layer object. It all depends on the angle you choose and the size and distance of the shadow. The shadow and glow effects feature a Noise slider. At one level this will reduce the risk of banding, but the noise can also be used to add a grainy texture to your layer style.

Outer Glow

Inner Glow

These both have similar controls. The Outer Glow is very much like the Drop Shadow, but is defaulted to the Screen blending mode, spreading evenly outwards from the center; you could say that the Inner Glow corresponds with the Inner Shadow effect. The glow layer effects can apply either a solid or a gradient-based glow. The Inner Glow contains options for edge and center glows. Used in conjunction with the Inner Shadow, you can achieve a very smooth 3D 'contoured' appearance with the centered Inner Glow setting. Note the Spread and Choke controls which are now available with the shadow and glow effects.

Bevel and Emboss

This adds a highlight and a shadow edge 180 degrees apart from each other. When you adjust the height or angle settings of the light, the two move in sync, creating an illusion of depth. There are many options here – the bevel style can be applied to create an outer bevel, an inner bevel, or pillow emboss. The embossing technique can be 'chisel hard' or 'soft'. There are some interesting Gloss Contour options in the shading section which can produce metallic-looking effects and you can also add a contour separately to the bevel edge and add an 'embossed' pattern texture to the surface.

Satin

This can add a satin type finish to the surface of the layer or type. You will want to adjust the distance and size to suit the pixel area of the layer you are applying the effect to.

Gradient Overlay

The Gradient Overlay will add a gradient fill. Separate opacity and blend modes can be applied to create subtle combinations of coloring. Use Align with layer to center align the gradient to the middle of the layer. The scale option will enlarge or shrink the spread of the gradient.

Pattern Overlay

Select a saved pattern from the presets. The opacity and scale sliders will modify the appearance of the overlay pattern. Use 'Link with Layer' to lock the pattern relative to the layer object.

Color Overlay

This Layer effect will add a color fill overlay to the layer contents. You are able to vary the opacity and change the blending mode.

Stroke

The Stroke effect applies a stroke to the outline of the layer or text with either a color, a gradient or a pattern. The options in this dialog are similar to those in the Edit > Stroke command, except as with all layer effects, the stroke is scalable and will adapt to follow any edits or modifications made to the associated layer.

Creating Styles

Figure 15.1 When you add a new layer effect, the effect will appear in a list below the layer in the Layers palette in the same descending order that the layer effects appear in the Layer Styles dialog. Each effect has its own 'f' effect icon and the effect can be made visible or invisible by toggling the eye icon next to it in the Layers palette. Or, you can hide all of the effects at once by clicking on the eye icon next to 'Effects'. When you have found an effect setting or a combination of settings which you would like to keep, you can save these as a style via the Layer Style dialog. Click on the New Style button and give the style a name and it will be appended in the Styles palette. There are several preset styles that you can load in Photoshop 6.0. The Styles palette shown opposite contains the 'Textures' Styles presets using the Large Thumbnail view setting.

Applying layer styles to image layers

The illustrations overleaf show how you can add layer effects and styles to image layers. Layer effects operate in the same way as adjustment layers do – they create a live preview of the final effect and only when you flatten down the layer are the pixels modified and does the effect become fixed. Layer effects are not scalable in the same way as the image data is. If you resize the image the Layer effect settings will not adapt, they will remain constant. If you go to the Layer menu and choose Layer Style > Scale Effects, you will have the ability to scale the effects up or down in size. The layer effect parameters in Photoshop 6.0 are now large enough to suit high-resolution images. In the Layer Styles dialog you can select or deselect the global angle to be used by all the other layer effects. Although normally the effects work best when the same global angle is used throughout (the global light setting can be established in the Layer > Layer Styles menu). The Create Layers option is also in the Layer Styles menu options. This will deconstruct a layer style into its separate components. You can use this to edit individual layer elements if so desired. Layer effects and styles can be shared with other files or other layers. Go to the Layer Styles sub-menu and choose Copy Layer Style, then select another layer in the same or another image and choose Paste Layer Style from the same sub-menu.

1 Layer effects can be used to add glows and shadows to a type layer but Layer effects can work equally well on pixel image layers too. An EPS logo is first imported into Photoshop using the File > Place command. After resizing, hitting the Return or Enter key will rasterize the vector art as an image layer. A series of Layer effects were applied to the layer to create a new layer style.

2 In more detail, Bevel and Emboss, Inner Glow and Inner Shadow Layer styles were applied to the image layer. The global angle settings were deselected so that the Inner Glow angle was separate to the Bevel and Emboss angle. Note that the angle controls in the Bevel & Emboss dialog contain adjustments for both the lighting angle and the attitude of the light source.

3 If a layer mask is added to the layer you can then mask out portions of the layer contents. The combined layer effects in the layer style will adapt to follow the new contours and update as the layer contents change. When painting in the layer mask, the layer style adapts to follow the mask outline.

Painting effects

Take a look at the illustrations below to see how this can work. The potential is to have three-dimensional painting brushes in Photoshop. For example, if you have an empty layer with the Drop Shadow layer effect applied to it, whenever you paint anywhere in the layer the paint strokes will automatically appear with a drop shadow attached. I quite like the effects which can be achieved using a combination of the Drop Shadow, Bevel and Emboss and Inner Glow layer effects.

Another approach you can use is to add an image texture layer, apply a layer style and then add a layer mask to hide the layer contents. As you paint on the layer mask with white, you will be unhiding the layer contents and applying a layer style at the same time. The example below shows how you can create an effect which is like painting with a viscous fluid, creating a contoured edge as you paint.

1 I used this weathered stone texture for this demonstration, which is really the same as the previous example but in reverse. First add an image layer containing a texture and Option/Alt-click the Add layer mask button to add a layer mask that hides all the layer contents.

2 If you paint on the layer mask with white, you will now reveal the hidden layer contents. If a Style is applied to this layer, the brush strokes will take on the characteristics of the layer style. The individual layer effects can be edited at any time. This doodle example shows just some of the interesting possibilities.

Layer effect contours

The layer effect contours in Photoshop 6.0 will affect the shape of the shadows and glows for the Drop Shadow, Inner Shadow, Outer Glow and Inner Glow layer effects. The examples on these two pages show the results of applying different contours and how this will affect the outcomes of these various layer effects. The Bevel and Emboss and the Satin layer effects are handled slightly differently. In these cases, the contour will affect the surface texture appearance of the layer effect. The Bevel and Emboss dialog refers to this type of contour being a 'Gloss Contour' and you can generate some interesting metallic textures by selecting different gloss contour shapes. The Bevel and Emboss edge itself can be modified with a separate contour (see Bevel and Emboss dialog at the beginning of this chapter).

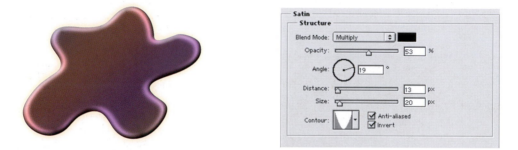

Figure 15.2 A Layer style was applied to a filled shape layer. The silky texture can be attributed to the use of an inverted cone contour being combined with the Satin layer effect.

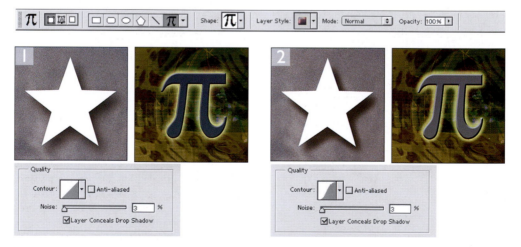

1 The linear contour is the default. In all these examples a Drop Shadow effect was added to the Star shape. Bevel and Emboss and Outer Glow effects were applied to the Pi shape layer.

2 The gaussian curve contour accentuates the contrast of the layer effect edges by making the shadows and glows fall off more steeply.

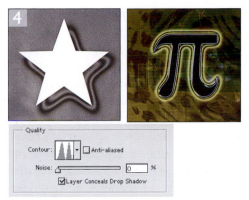

3 When applied with a slight displacement, the single ring contour can produce a subtle bevel type shadow. The Outer Glow was made with Range set to 100%.

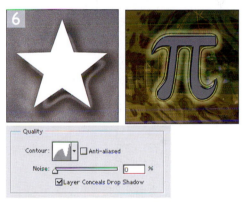

4&5 The double and triple ring shapes produce a more graphic type of layer effect. As can be seen here, the shadows look like contoured neon lights and the Bevel and Emboss resembles a chrome type of effect. The Outer Glow Range in both cases was set to 70%.

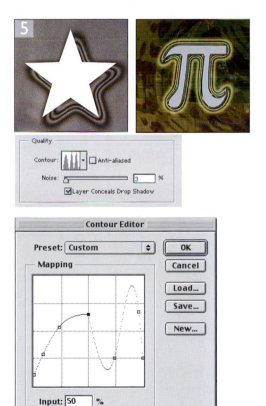

6 Click on the contour shape icon to open the Contour Editor dialog (shown opposite). Use this to load, edit and save a custom contour shape. You can create your own customized contour and save as a new contour to add to your current set. You can preview the effect the new custom contour has on the current Layer Effect. Check the Corner box to make a point an angled corner.

Transforms and alignment

Any transform you carry out can be repeated using the Edit > Transform > Again command (Command/Ctrl+Shift-T). The transform coordinate change is memorized in Photoshop, so even if other image edits are carried out in between, the Transform > Again command will remember the last used transform. When more than one layer is present, the layer order can be changed via the Layer > Arrange menu, to bring a layer forward or back in the layer stack. The full Layer menu and Layers palette shortcuts are listed back in Chapter Twelve. In addition, two or more linked layers can now be aligned in various ways via the Layer > Align Linked menu. The latter is a desirable feature for design-based work when you want to precisely align image or text layer objects in a design, although as can be seen the combination of repeat transforms and align layers provides interesting possibilities for making image patterns.

The alignment commands allow you to both distribute and align linked layers according to a number of different rules in the sub-menu list. To use this feature, first make sure the layers are all linked. The distribute command evenly distributes the linked layers based on either the top, vertical central, bottom, left, horizontal central or right axis. So if you have several linked layer elements and you want them to be evenly spread apart horizontally and you want the distance between the midpoints of each layer element to be equidistant, then choose Layer > Distribute Linked > Horizontal Center. If you next want the layer elements to align, then go to the Layer > Align Linked menu. How the align command centers or aligns the layers will be based on whichever of the linked layers is selected. The other layer elements will always reposition themselves around the active layer.

1–2 To demonstrate the repeat transform feature, I took this still life picture and made a mask defining the outline of the cheeses. I loaded this mask as a selection and made a copy layer of the cheeses: Layer > New > Layer Via Copy (or you could use the shortcut Command/Ctrl-J). The first single transform combined a slight reduction in size, a diagonal shift movement and an anti-clockwise rotation.

3 To repeat this transformation, I made use of the repeat transform feature, I kept duplicating the last transformed layer by dragging the last transformed layer down to the New Layer button in the Layers palette and chose Edit > Transform > Again, or the shortcut Command/ Ctrl+Shift-T. I ended up with six repeating transformed layers as shown in picture 3. To make the layers nestle one behind the other, I reversed the layer order above the background layer.

4 To complete the arrangement of the neatly stacked images falling behind each other, I merged all the linked layers (see the Layers palette in picture 3) and applied a layer mask to the merged layer based on the original mask selection.

Photograph: Laurie Evans.

Photograph: Laurie Evans.

Figure 15.3 These linked, layered images were arranged using the layer alignment feature. I chose Layer > Distribute Linked > Vertical Centers to evenly balance out the spacing and followed this with the Layer > Align Linked > Horizontal Centers. These alignments brought all the individual images horizontally centered around their common axis as shown in the example opposite.

Spot color channels

Photoshop is able to simulate the effect of how a spot color will reproduce in print and how a special color overlay will interplay with the underlying image. Spot colors include a wide range of industry standard colors. You use the manufacturer's printed book color guides as a reference for how a color will print and not judge this from the screen. The colors available can include those found in the CMYK gamut, but also a whole lot more that are not, including metallic 'specials'. Spot colors are used where it is important that the printed color conforms to a known standard and for the printing of small point size type and graphics in color. A four-color process mix can be used when printing larger non-serif point sizes, but not for fine type and lines as the slightest misregistration will make the edges appear fuzzy. Spot colors can be added to images as part of the graphic design or as a means of accomplishing a color not available in the CMYK gamut.

A colleague of mine once won the dubious honor of 'most out-of-gamut color of the month' award from his repro company, after presenting them with a vivid green backdrop in his RGB transparency. The image was being printed as an advert to promote his work, so they made a masked color plate, adding a spot color to the background, simulating the green in the original. Here then is an example of a spot color channel and type tool in action.

1 Choose New Spot Channel… from the Channels palette fly-out menu. You will see the dialog shown opposite. When you click on the Color box, this calls up the custom color dialog and you can choose from any of the installed custom colors including the Pantone™ color selected here. Choose a solidity percentage which matches the solidity of the custom color specified. When you change the solidity of the custom color, the effect is simulated in the image preview, matching the ink characteristics. Most custom colors are opaque (100%), whilst varnish colors are translucent (0%). To produce a faint tint, lower the opacity in the spot channel. The block shown here was created by filling a marquee selection with a light gray.

2 Now if the spot color channel remains active and the type tool is selected, any type entered will go directly into the spot color channel. As I input the text 'Oyster Bar', it first appears cutout against the Quick mask color and after I clicked Enter, the type is rasterized as a floating selection, which can be repositioned using the move tool. Once deselected, the type is now fixed in the spot color channel.

More type is added, this time using a type layer with white text. Select the composite channel (the spot color channel is therefore now deselected) and choose a white foreground color from the color picker dialog. A new font can be chosen, or combination of fonts applied in the body of text. And as type is entered, a live preview appears in the image. A type layer is using vectors to describe the shape of the type, which will not become fixed as rasterized pixels. A file saved using the PSD or PDF formats, for example, will preserve all the vector information through to the print stage.

Photograph: Laurie Evans.

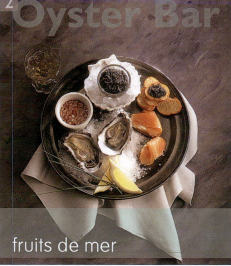

Adding type

Photoshop type is fully editable and is added to a document using vector type layers. A type layer can be rasterized or converted to a work path or shape layer. You can still place type as a selection and import EPS artwork as before (see page 364). Or you can copy and paste path outlines of logos and save these as custom shapes (see Figure 15.5).

OpenType fonts and their associated features are supported by Photoshop 6.0. The text paragraph formatting, justification and hyphenation options available in the Paragraph palette work similar to the text engine found in Adobe InDesign™. Text is entered directly in the document window and can be edited at a per-character level, i.e. change individual character color, font size etc. The fractional widths option in the Character palette options is normally left on – this will automatically calculate how to render the anti-aliased text using fractional widths of pixels. However, when setting small point sized type in Photoshop to be displayed on the screen, it is better to turn this option off. Photoshop will then round up the gap between individual characters to the nearest pixel distance. Small text rendered this way will be easier to read. The anti-aliasing settings provide three levels: Crisp, Strong and Smooth. With no anti-aliasing (None), font edges are likely to appear jagged. The Strong setting is suited for most graphics work. The Crisp setting is the least smooth and will probably prove useful when creating small point sized bitmapped text in Photoshop, which is designed to appear on a web page.

Warping text

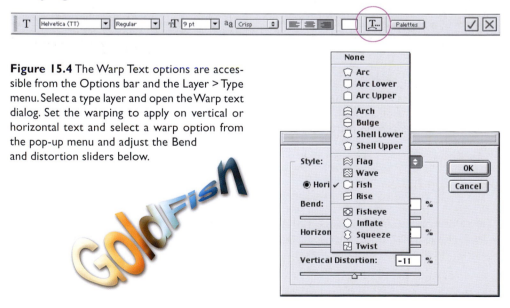

Figure 15.4 The Warp Text options are accessible from the Options bar and the Layer > Type menu. Select a type layer and open the Warp text dialog. Set the warping to apply on vertical or horizontal text and select a warp option from the pop-up menu and adjust the Bend and distortion sliders below.

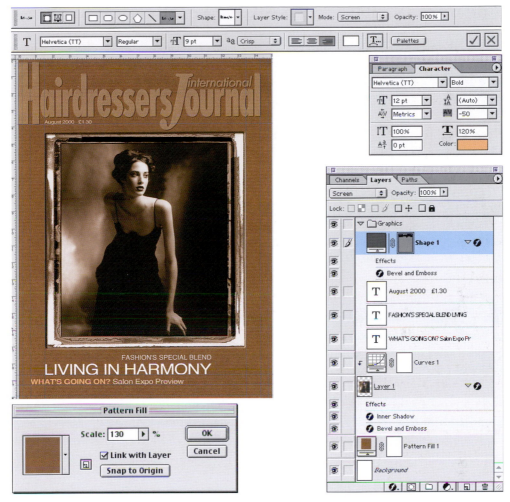

Figure 15.5 A magazine cover like this could now be designed entirely within Photoshop. The masthead was a path I copied from Illustrator and pasted into Photoshop. I then chose Edit > Define Custom Shape, to add it to the Shape presets. When saved as a Shape, I can select it at any time and add as a new shape layer and apply a Style from the Styles palette. I added a Pattern fill layer above the background, using a custom pattern, which was scaled up slightly. I then applied a couple of layer effects to the main image, to make it appear as if recessed in a card frame. I added the text on separate layers, and was able to set different point sizes and change the color of the type on a single line of text.

Vector output

The vector layer information contained in the Figure 15.5 page design can be read by a PostScript device and output the same way as vectors and type in a page layout program are normally handled. If you save a Photoshop document as a PDF, you can use the pixel compression options to reduce the file size, while the vector layer content will be preserved and will print perfectly at any resolution.

Chapter Sixteen

Filters

One important factor which separates Photoshop from other image editors and gives it an edge over the competition is Photoshop's wide-spread support for third-party plug-ins and filters. John Knoll, brother of Thomas Knoll – who originally wrote the Photoshop program, was responsible for creating many of the plug-ins which shipped with the earlier versions of Photoshop (and still survive today). The open door development policy has enabled many independent software companies to add creative tools and functionality to the Photoshop program. In turn this ongoing development has boosted the status of Photoshop as a professional image manipulation program. Even high-end retouching systems cannot match this versatility and will rely on accessing Photoshop for its plug-in rich features.

Some filters are simple one-step actions. The Noise > Despeckle filter is one such example. If you are brave enough to venture experimenting with the Custom Filter, you too can create similar types of plug-in filter effects of your own. Some sophisticated plug-ins are more like applications in their own right, operating within Photoshop. With so many filters to choose from, it is easy to get lost amongst the filter menu options. The inclusion of the revised Gallery Effects filters in Photoshop 4.0 and later versions should be enough to keep everyone happy.

In this chapter, we shall be looking at the various ways filters can enhance an image. There is not enough room for me to describe every filter present, although some – like the unsharp mask filter – you will be familiar with already. Instead I shall highlight some the more useful creative filters plus a few personal favorites.

Blur filters

The Radial blur does a very good job of creating blurred spinning motion effects. This is anything but a gimmicky filter – it has many uses, like adding movement to car wheels shot stationary in the studio. Similarly when switched to the Zoom blur setting, it does a neat impression of a zooming camera lens. The Filter dialog box offers a choice of render quality settings. This may appear quite a sluggish plug-in, but is after all carrying out a major distortion of the image. So either be very patient or opt for a lesser quality setting. The Motion blur filter is a lot faster to use and again it creates really effective sensations of blurred movement. Both the blurring angle and length of blur (defined in pixels) can be set. The blurring spreads evenly in both directions along the axis of the angle set, but that need not be a problem – the tutorial on the Adobe CD-ROM demonstrates how to create what are described as 'front flash' and 'rear flash' camera sync motion effects. Basically, if the blur is applied to a duplicate of a layer element and then positioned on the layer beneath, the blur can be shifted with the move tool as desired either side.

Fade command

Filter effects are enhanced by applying the Fade command. The accompanying examples in Figure 16.1 demonstrate modification with the Fade command used in conjunction with the Radial blur filter. Apply the Radial blur in the normal way and afterwards choose Edit > Fade Filter and experiment with different blending modes. The Fade command is almost like an adjustment layer feature, but without the versatility and ability to undo later. It makes use of the fact that the previous undo version of the image is stored in the undo buffer and allows you to calculate many different blends but without the time consuming expense of having to duplicate the layer first. Having said all that, history offers an alternative approach whereby you can do just that. If you filter an image, or make several filtrations, you can return to the original state and then paint in the future (filtered) state using the history brush or make a fill using the filtered history state (providing non-linear history has been enabled).

Smart blur

This was a new addition in Photoshop 4.0, to the blur range of filters: it blurs the image whilst at the same time identifying the sharp edges and preserving them. Used to extremes the effect becomes very graphic and can look rather ugly. In some ways its function mimics the Median Noise filter and is another useful tool for cleaning up noisy color channels or artificially softening skin tones to create an airbrushed look.

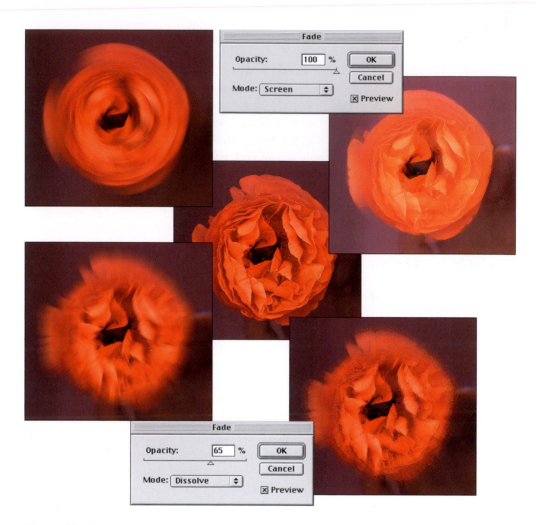

Figure 16.1 A few examples of the Edit > Fade Filter command used in conjunction with the Radial Blur. The center image is the before image. Top left a Radial Spin blur with a Screen Fade version top right. The bottom left image is a Radial Zoom blur and bottom right a Diffusion Fade version.

Noise filters

Other than the Add Noise filter, the other three filters, Despeckle, Dust & Scratches and Median, are in fact all types of noise reduction filters. The Despeckle filter is intended to remove scanning noise and artifacts which are present with all scanners to a greater or lesser degree – I have occasionally come across bad examples where the fault is more due to a poorly skilled operator. The Median filter averages out the color values of adjacent pixels, smoothing the differences between them. The minimum radius setting of 1 pixel will have quite a noticeable effect. Despeckle is like a

'gentler than 1 pixel radius' Median filter. It might get rid of the worst of the noise. I would recommend inspecting the individual color channels and applying to just those that are badly damaged. The Dust & Scratches filter is a sort of Median filter combined with a Threshold control. The higher the radius, the more spread or smoother the effect and the higher threshold levels setting, the less effective the filter is. Dust & Scratches is not, repeat not, a filter you want to apply globally to the whole image as part of the scan preparation. Where there is an area of flat tone in a picture with lots of marks on it, make a selection of that area and apply the filter to the selection only. It is a handy alternative to spending several minutes cloning with the rubber stamp tool, although don't forget there is also Russell Brown's technique which uses the Dust & Scratches filter in an intelligent way, as described in Chapter Ten.

Creative filtering

If I have a problem with filters, it is this: like many things that are supposed to expand our horizons – television, multimedia CD-ROM, the Internet etc. – the reality is if you supply people with easy to use, easily digestible information, instead of exploring more, they use it to work less.

I was talking to an art teacher from my school about this and he mentioned what he liked to call the 'Encarta' effect: if a teacher requests the students to write an essay on Van Gogh, for example, half the kids will lazily reach for their CD-ROM encyclopedia and all end up quoting from identical references. Now they could discover a broader if not mind boggling range of alternative primary sources via the Internet, but just as with going down the library, that would require too much effort sifting through the data. These are the views of a teacher who is all in favor of students using computers, but not in a way that leads to homogeneity of thought and expression. The same thing can be said about the misuse of filters. Photoshop should be seen as more than a glorified electronic 'paint by numbers' kit. Even the esteemed Kai Krause (the man who gave us Kai's Power Tools) was heard to offer a tongue in cheek apology for inflicting the ubiquitous Page Curl filter upon the world. With a little imagination, one can cumulatively combine filters and create all sorts of interesting new textures and image effects.

Comparisons of all the Photoshop filters

With so many more filters to experiment with, there is not enough room for me to show them all here, but there is on the CD-ROM. I have taken a single image and applied nearly every one of the Photoshop filters – you can click on the filter name and quickly preview the filtered outcome.

Original image.

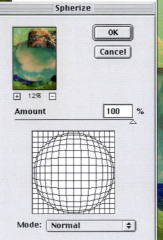

Figure 16.2 Other Distort menu filters you might want to experiment with are: Diffuse Glow, Glass, Ocean Ripple, Spherize and Twirl. These filters like many others, feature a preview window. With the larger, global type effects, try zooming out by clicking the minus button to see a scaled down preview of the whole image.

Click on the plus or minus buttons beneath the filter preview window in order to see a zoomed in or zoomed out preview of the filter outcome.

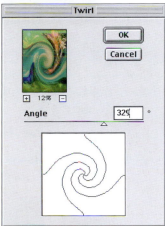

Figure 16.3 Another image partly modified this time using the Square Wave setting. If you are confused about the dialog box settings and looking for inspiration, try clicking the Randomize button to see different random options.

If you ever wondered why it is not possible to access every filter in CMYK mode. The answer is that most special effects filters can only work in RGB mode as these can have a dramatic effect on the pixel values, easily sending colors way out of the CMYK gamut. So to unleash the full creative power of Photoshop plug-ins, this is a good argument for having to work in RGB mode and convert to CMYK later.

Filters for alpha channel effects

The 'Other' Filter sub-menu contains a collection of filters, some of which I find essential for alpha channel work. The Offset filter offsets the active layer or channel. You would use this filter as part of a series of steps where, for example, you wanted to create a displaced drop shadow or maybe build a wrap around texture. The Maximum and Minimum filters I use to either choke or expand an alpha channel mask, and the High Pass filter is useful as a tool for detecting and emphasizing image areas of high contrast in preparation for converting a duplicated color channel to a mask.

1 Here in the final stages of adding a color over-lay to an image on a white background, I have the color fill on a layer above the background, using a layer mask based on an alpha channel mask prepared earlier. As masks go, it's not bad but as you can see there is still a slight halo around the object where the white background shows through.

2 To get round this, I activated/highlighted the Layer Mask icon and applied the Other > Maximum filter, at a setting of 1 pixel. Notice the filter effectively makes the layer mask shrink very slightly and now the halo has almost completely disappeared in one easy step. You can refine the layer mask with a brush to fill in or remove any sections that are still showing.

There are more ways of using filters creatively apart from single filtrations. Are you looking for a computer generated backdrop image? The answer is to explore by using a sequence of filters. The following technique demonstrates how to put KPT 5 to good use as a way of letting the software help guide you to make new discoveries.

1 KPT 5 is made by MetaCreations and complements the previous versions of Kai's Power Tools. One of my favorite KPT 5 plug-in effects is the FraxFlame. This is similar to the old Texture Explorer. You can select genetic variations of the central image and set various other parameters, affecting the outcome shapes.

2 Another interesting KPT 5 plug-in is the Blurrrr series. Here, I applied a Spiral Weave Blurrrr to the previous FraxFlame image. The spiral weave patterns are particularly beautiful when applied to almost any original. In this example the filter is beginning to break up the recognizable pattern of the FraxFlame.

3 Back to the Photoshop 5.5 plug-in set. I then added some Motion blur, which broke up the KPT 5 pattern even more. I chose to apply a horizontal blur with a large pixel distance.

4 The final version is very soft compared to the original. I applied a Hue/Saturation adjustment to take the saturation down a little and added some noise to break up any residual banding. Steps similar to these were used to prepare the silvery backdrop which featured in the montage tutorial in Chapter Eleven.

Adobe packaged the Gallery Effects collection beginning with Photoshop 4.0 and later versions. With the standard easy Install, you will find these included in the Filter menu. I have another example, which follows, demonstrating how subtle use of these filters used in combination can work well on some images.

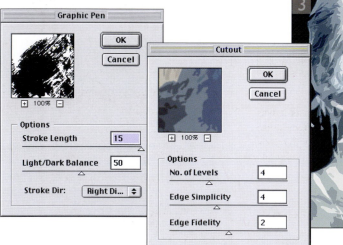

1 This was a shot I took a few years ago to illustrate the theme of what it would be like as a fish starved of oxygen in river water polluted by acid rain. The black and white print was chemically toned and scanned in as an RGB image (these creative filter effects will not work in CMYK or Indexed Color modes).

2 I began by applying the Sketch > Graphic Pen filter. The Sketch range of filters (with the exception of Water Paper) will always produce a monotone image, as shown here. These filters often work well if you follow the filtration with an Edit > Fade Filter command, in this case reducing the opacity to 30% with the blending mode remaining on Normal.

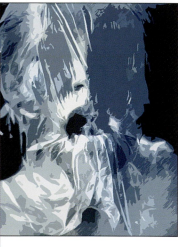

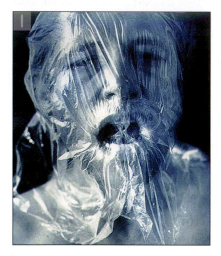

3 Next apply the Artistic > Cutout filter.

4 Afterwards, I faded the filter again. The opacity was reduced to 35% and the blending mode set to Difference. The image is darker and the highlights are lost, but this actually suits the mood of the image quite well. It is not always necessary that the levels be expanded to fit the full tonal print range.

1 I borrowed this sparkling sea shot as it was likely to show the displacement effect quite clearly. To displace an image, one needs to have a separate 'map' source image which can be any type of image (except Index color).

2 I created the basis for the displacement map as a new channel in the destination water image – it would be used later to enhance the effect. I placed an Illustrator file (File > Place...) and duplicated the channel.

Distortions and displacements

This last demonstration shows how to import a vector graphic from Illustrator and make a displacement map with which to apply the Displace filter. The displacement filter is capable of producing strong image distortions like the classic parabola shape described in the Adobe manual. Intuitive it is not. The effect works well with text effects and where the displacement map has been softened beforehand. Displacement maps are useful for generating texture patterns. You will find a large number of displacement maps contained on the Adobe Photoshop CD and these can be loaded to generate all types of surface texture patterns.

3 Gaussian blur was applied to the copy channel, which was inverted, then copied and saved as a new separate 'map' image (Select > All; Edit > Copy; File > New; Edit > Paste; Layer > Flatten Image).

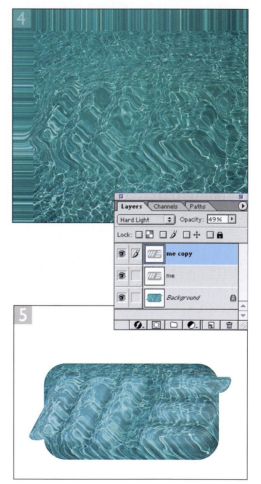

4 Back at the original image, I selected Filter > Distort > Displace. The options were set to Stretch to fit and Repeat edge pixels. After clicking OK, a dialog box asks you to find and select the map to be used. The lightest parts of the map produce no pixel movement, whilst the darker areas shift according to the parameters set.

5 Some extra finishing work was done to add emphasis to the displacement. The border was cut away and a couple of layers added based on the original logo placed and stored in the new channel. The blending modes were set to Screen at low opacity and Hard Light at 49% above.

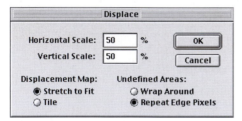

Liquify

While the outcome of the Displacement filter is determined by a prepared alpha mask, Liquify is in effect an interactive version of the Displacement filter. Liquify enables you to magnify, melt, smear and generally make all manner of distortions to an image and preview the outcome of the distortion in the preview window as you apply the various distorting tools. The distortion is then post-rendered at full resolution. I classify this as a filter, although you will find it is actually prominently located in the Image menu, next to the Extract command. The Liquify dialog will normally display the full-frame view of the image to be treated. If you wish to distort a small section of the picture only, then first use the rectangular marquee tool to marquee the area you wish to work on. Liquify will display a magnified view, based on the selection, in the preview window.

Figure 16.4 The Liquify command can be applied in various ways. In the above example I experimented with a Liquify distortion followed by an Edit > Fade command set to Difference blending mode.

Photograph: Laurie Evans.

Figure 16.5 Use the freeze tool to protect image areas from being distorted, or preserve the already distorted areas from any further distortions.

The Liquify tools explained

The Warp tool (W) provides a basic warp distortion with which you can stretch the pixels in any direction you wish. The Twirl Clockwise tool (R), as the name suggests, will twist the pixels in a clockwise direction, while the Twirl Counter Clockwise tool (L) twists the pixels in the opposite direction. A larger brush works best with these tools. The Pucker tool (P) shrinks pixels and produces an effect which is similar to the 'Pinch' filter. Warp and Reflection distortions can sometimes benefit from 'taming'. The pucker tool is therefore ideal for correcting over-distorted areas. The Bloat tool (B) magnifies pixels and is similar to the 'Bloat' filter. The Shift Pixels tool (S) shifts the pixels at 90 degrees to the left of the direction in which you are dragging. When you Option/Alt-drag, the tool will shift pixels 90 degrees to the right. When you understand how the shift tool works, you can introduce some nice rippled distortions. The Reflection tool (M) is perhaps the most unwieldy of all, copying pixels from 90 degrees to the direction you are dragging and therefore acting as an inverting lens (which if you are not careful will easily rip an image apart). Fortunately, the Reconstruct tool (E) will enable you to restore the undistorted image. If you want, you can protect areas of the image using the Freeze tool (F). Frozen portions of the image are indicated by a Quick mask type overlay. These areas will be protected from any further liquify distortion tool actions. The Freeze mask can be selectively or wholly erased using the Thaw tool (T).

Warp tool

Twirl Clockwise tool

Twirl Counter Clockwise tool

Pucker tool

Bloat tool

Shift Pixels tool

Reflection tool

Reconstruct tool

Freeze tool

Thaw tool

Figure 16.6 You can set the brush size and pressure settings in the Tool Options section. At the bottom you can check the View options which includes displaying the underlying mesh grid shown in the accompanying illustrations. When freezing an area, you can load an alpha channel as a mask with which to protect the exact areas of the picture you don't wish to distort. The reconstruction modes above provide different modes for reversing any distortions made. The Rigid mode provides one-click reconstruction; Stiff, Smooth and Loose provide varying speeds of continual reconstruction – the image mesh continues to unravel as you mouse down. Click on the Reconstruction button to observe the distortions undo progressively. Use Escape or Command/Ctrl-period to halt the reconstruction at an intermediate stage. Avoid a second click, as this will exit the modal dialog and you will lose all your work.

The underlying mesh can be made visible in the Liquify Tool Options. The grid will give you an indication of how the warp is being applied or reconstructed and readily help you pinpoint the areas where a distortion has been applied. The Liquify is a perfect tool for many types of subtle retouching such as the occasions when you might wish to gently alter the shape of someone's facial features.

Distort filters

The following tutorial demonstrates how to produce an emulsion lift-off type technique. I have used this as an exercise to illustrate what can be achieved when using the distort filters on their own. The power is there to create interesting effects when you use a combination of distortion filters like Shear, Displace and Wave. The latter has one of the most complex and bewildering dialog boxes to be found in Photoshop. The settings used here will have a very different effect on images that are not the exact same size, if these don't work at first on your images, try varying the scale sliders. I particularly like using the Wave filter, because it always produces random results and generates some often quite unusual distortions.

I Open the image, set the background color to white and enlarge the canvas size to allow enough room for the following distortions.

2 Apply the Distort > Shear filter. Add points to the shear line in the dialog box and drag to define the curve distortion along the vertical axis.

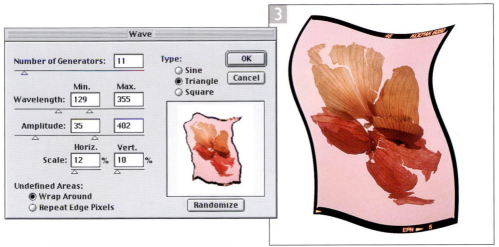

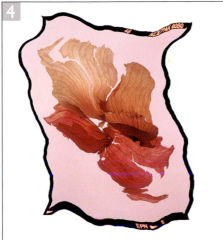

3 The Shear filter distorts the vertical plane only. To carry out any non-vertical shearing, you must always rotate the image 90 degrees (Image > Rotate Canvas > 90 degrees) apply the filter and rotate back again. In this example, I rotated the image, repeated the process with a different shear and then rotated the image back again.

4 Now enhance the distortion with the Distort > Wave filter. You can use the Triangle or Sine wave with the settings shown here, but as I said earlier, more than likely you'll have to experiment with the various controls, although I would recommend a low number of generators. The scale settings magnify the effect, so if you create a trial image at a small size, increase the scale setting when repeating at higher resolutions.

5 I created a texture channel which could also double as a displacement map. I made a new channel and filled: Filter > Render > Texture Fill. I selected a texture like 'Driven Snow' from the Textures for Lighting Effects folder on the Adobe Photoshop CD-ROM, then manipulated this texture with a combination of: Gaussian blur, Image > Adjust > Threshold, Motion blur, Levels, Image > Adjust > Invert, more Gaussian blur and a gentle Wave Distort filter. I selected the white surround of the RGB channel and filled the border of the new mask channel with black.

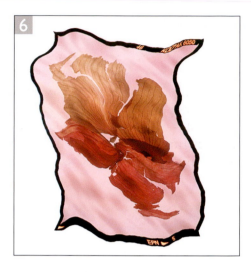

6 Load the texture channel as a selection and adjust Levels, darkening the selected areas – adding a rippled texture. This is optional, but if you want, convert the new channel mask into a separate grayscale Photoshop image and use this as a displacement map. Have the main image open only, choose Filter > Distort > Displace (keep the displacements to around 5 pixels) and proceed by opening the saved map.

Lighting and rendering

I have so far not mentioned any of the render filters, the most interesting of which is Lighting Effects. Photographers are sure to find this a really useful addition to the plug-ins arsenal. Rendering processes are normally associated with 3D design programs, yet Photoshop has hidden powers itself when it comes to rendering 3D shapes and textures. Let's look at the other rendering filters though first.

Clouds and Difference Clouds

This filter generates a cloud pattern which fills the whole image or selected area based on the foreground and background colors. The cloud pattern alters each time the filter is applied, so repeated filtering (Command/Ctrl-F), for example, will produce a fresh cloudscape every time. If you hold down the Option/Alt key whilst applying the Cloud filter, the effect is magnified. The Difference Cloud filter has a cumulative effect on the image. Applying it once creates a cloud pattern which appears based on the inverse color values. Repeating the filter produces clouds based on the original colors and so on... although after each filtration the clouds become more pronounced and contrasty.

Figure 16.7 Examples of the Render > Clouds filter (left) and the Render > Difference Clouds (right).

Lens Flare

This is another one of the render filters and a little overused perhaps, but nevertheless quite realistic when it comes to adding the effect of light shining into the lens along with the ghosting type of patterns normally associated with camera lens flare. For the purposes of illustration or adding realism to computer rendered landscapes, it is ideal. An alternative method of applying lens flare is to make a new layer above the background, fill with black and apply the filter to this layer only. Then you can set the blending mode to Screen and have the option of repositioning the flare after filtering. Here is a picture I took of Battersea Power Station with Lens Flare added.

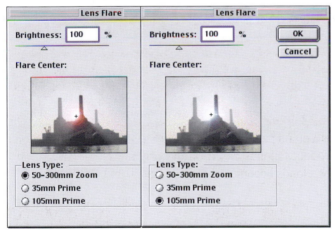

Figure 16.8 The position of the lens flare center point can be chosen in the dialog preview. Option/Alt-click in the preview to call up the above dialog and set precise mouse coordinates for where to center the lens flare effect.

Lighting Effects and Texture Fill

To back up the assertion that Photoshop has the power to render 3D objects, here is an exercise in which an image is created entirely within Photoshop utilizing the Texture Fill and Lighting Effects filter.

I To prepare the image, I made this grayscale bump map of a computer mouse in a mask channel. The dark tones represent the lower relief levels and lighter tones the peaks (although this arrangement can be reversed if you wish). To work at its best, the bump map must have really smooth tonal gradations to represent the curved surfaces. Save an extra channel representing the outline of the mouse (channel-5).

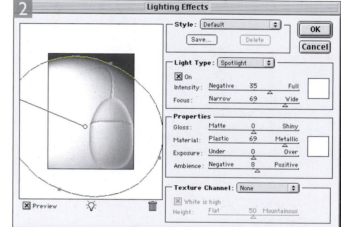

2 The texture/3D modelling feature is to be found at the bottom of the Lighting Effects dialog box. Select an alpha or color channel as the texture or 'bump' map for the lighting. In this case, select the bump map, channel-4, and click the White is High checkbox. The slider control determines how mountainous the render should be – the 50% value worked best. Position the light, in this case a single spotlight, and adjust the lighting attributes. The settings shown here were for a shiny plastic surface with a raised ambient light level.

3 The resulting render as shown here takes effect in the selected area only. The image is a bit too dark, so fade out the effect with the Edit > Fade Filter command to around 50%.

4 After this create another texture map – click the New Channel button in the Channels palette. Select > Select All and choose Texture Fill from the Render menu. Any texture image can be used, but it must be a grayscale image. You will find a whole host of textures provided on the Photoshop program CD-ROM in the Textures for Lighting Effects folder inside the Goodies folder. Selected here is the Burlap texture map.

5 Activate the RGB channel (channel-~), select the Mouse outline channel (channel-5), inverse and apply the Lighting Effects filter. This time go down to the Texture channel and select channel-6 which was just made and as shown here use a single directional light.

6 To finish off the image, the background and mouse were colored separately using the channel-5 selection and its inverse. To add a shadow, make a new layer, load the channel-5 selection and fill with black. With the Lock Transparency option switched off, apply Gaussian blur.

7 Apply the Offset filter – Filter > Other > Offset and nudge the shadow down and to the right, with repeat edge pixels selected. Lastly, load the channel-5 selection again and delete the overlapping areas and change the blending mode to Darken. You now have an offset shadow layer and completed render.

This last tutorial demonstrates that whilst Photoshop is no replacement for professionally 3D design packages, there is more to the Lighting Effects filter than first meets the eye. I thought I would begin by introducing an over the top use of the filter that does not use photography at all, just to demonstrate its potential before showing a more typical, photographic use. The following example shows how lighting can be added to an existing studio photograph – either to add emphasis or to introduce a spotlight effect in the background. I should mention that Lighting Effects is a memory hungry plug-in. You will not always be able to use it on large files unless your computer is well equipped with RAM memory.

1 This is a photograph taken for a Tresemme advertorial promotion. The Lighting Effects filter works well as a means of adding lighting afterwards to a photographic scene. A little careful control will help you achieve a more realistic effect. Here, I wanted to use the Lighting Effects filter to add spotlighting effects to the background. So to begin with I drew a path around the outline of the model and inside the border area. This was converted to a selection and feathered slightly by about 2 pixels.

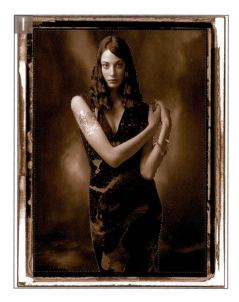

2 The Lighting Effects filter can be found under the Filter > Render section. The dialog box displays the selected area in the Preview window. I selected one of the effects presets: Crossing Down. Each light can be adjusted by dragging any of the four ellipse handles or the center point. A new light can be added by clicking on the light bulb icon at the bottom.

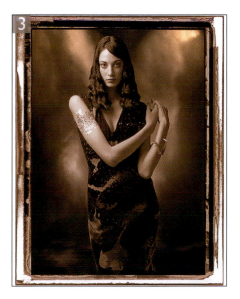

3 In this example, the two light sources are of the spotlight type. This produces an effect which is like two fresnel spots hitting the backcloth from above. The combined controls of the Intensity and the Focus slider are like the flood/spot wheel on a tungsten spotlight. Below that are the Properties sliders. This is where you can set the desired surface texture, to simulate a plastic matte or a shiny metallic type surface to reflect the added lighting. The Exposure slider governs the brightness of the individual lights, while the Ambience slider can be used to add a fill light to the overall scene.

Client: Tresemme/Hairdressers Journal.
Model: Karen at Models One.

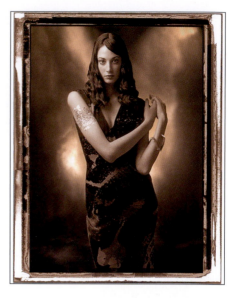

4 The Omni light source is like a round diffuse light, which when positioned centered behind the model adds an extra glow to the backdrop, although this time with a softer edge. One can also color the lights in Lighting Effects. If you double-click the swatch to the right of the lighting controls, one can choose a color from the picker, which will in effect 'gel' the light. Lighting Effects is a very powerful imaging tool. The combinations of light sources, light coloring and texture map facility offer many more opportunities than can be explained in a single chapter.

3D Transform

This is a relatively new filter effect which was introduced in Photoshop 5.0. It bears some resemblance to one of the Andromeda series of plug-in effects. The filter can be used to take an object and effectively change the perspective view relative to the remaining image. It is not an easy filter tool to master and there are restrictions on how far round you can rotate what is a '2D captured' object. The following example was done with the ciné camera on a background copy layer, with the camera carefully cut out. You'll notice that after the transform was applied part of the underlying image appeared, which was easily erased afterwards.

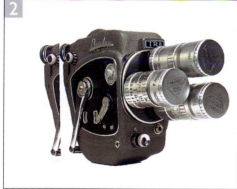

1 Take an object and isolate it from the back-drop by defining an outline selection and floating to make a new layer. The 3D Transform filter is then chosen from the filter menu to affect this layer only. The dialog box displays a monochrome preview. Select one of the object drawing tools to surround the selected area and match its perspective. Next select the view angle tool to twist the perspective.

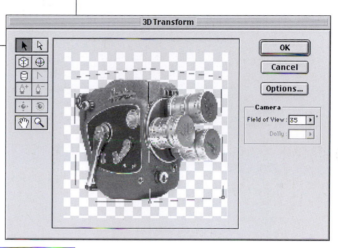

2 When the 3D Transform has finished processing, the before image may show through from below. Here I went to the background layer and deleted them, filling with white.

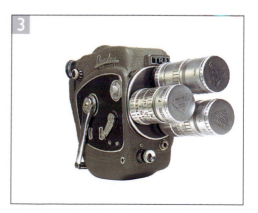

3 The cleaned-up after shot appears to show the camera as if it had been rotated toward the lens axis. Excessive 3D transforms will not work so convincingly. After all, not even Photoshop can reproduce the back of an object.

Shadow effect

Finally, the last example is not a filter effect as such, but shows how to create a lighting shadow. You need to prepare a precise outline selection first. Once that is made, the rest is fairly simple to accomplish. The amount of blurring applied to the first copy mask determines the extent of the glow. Try making a few attempts with different settings to judge which is the right one to use. The opposite effect of adding an outer glow (which was demonstrated in the previous editions of this book) is also fairly easy to achieve, but again the original mask used for the technique must be very precise.

I This photograph was taken against a red background, which was some distance behind the model. Colored gels were used to provide the blue lighting, although some further Hue/Saturation adustments were made to tweak the final colors.

2 A mask was prepared based on information existing in one or more of the color channels (see Chapter Eleven on montage techniques).The modified color channel alpha mask is shown here. I then loaded this alpha channel as a selection and applied a Select > Feather of 200 pixels.

Client: Alta Moda. Model: Melody at Storm.

3 I then saved the feathered selection as a new alpha channel. I followed this by adding the original alpha channel to the duplicate. There are several ways of doing this: you could, for example, try going Image > Apply Image, select channel-4 as the source and set the blending mode to Multiply at 100%.

4 The new alpha channel might have benefited from my adding some gaussian noise to remove any banding which might have been introduced at the feathering stage. I loaded the duplicate channel as a selection (drag the channel down to the Make Selection button) and then clicked on the Add a new layer mask button at the bottom of the Layers palette and selected Levels. This operation added a new adjustment layer and masked it at the same time. In the Levels dialog, I adjusted the settings to darken the background areas and achieved the result shown opposite.

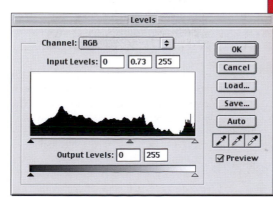

Practical applications

People either overuse Photoshop filters and techniques or dismiss them as pure fakery and having nothing to do with photography. There is a middle line where I believe there is nothing wrong with experimenting, mixing illustration techniques and photography. I would suggest that at times, when used properly, the Lighting Effects filter is an exceptional Photoshop tool for generating textures, objects or lighting fills. I once saw a good example of a floodlit hotel exterior where some of the outside lights were not working. This is a situation you are probably familiar with – the client couldn't get it together to organize replacement bulbs and the photographer had to shoot the scene as it was. Because it wasn't completely pitch black, there was plenty of shadow detail recorded and the Photoshop artist was able to apply the Lighting Effects filter to replicate the missing lights. He used one of the image color channels as a texture map to make the floodlighting appear more realistic and made the light source color match that of the other exterior lights.

So is it real or is it Photoshopped? Where the integrity of an image matters, such as in photojournalism, I would personally prefer photographers not to mess around with the subject matter. On a commercial shoot I think you should weigh up the pros and cons and make a decision based on whichever method is going to produce the best end result. If Photoshop can do something quickly and effectively, it makes sense to do it on the computer rather than waste time in the studio when you could be more productive and creative attending to other important things.

Last word

This is now the end of the book. I hope the tips and techniques demonstrated throughout have helped you understand more about the power of Photoshop as a professional quality image editor. Don't forget that the CD-ROM features some of the tutorials as movies. There is also a web site, <http://www.bh.com/focalpress/evening6>, used to promote this book where you'll find late-breaking information and active links to all the sites I have mentioned. I hope too that you find using Photoshop to be a fascinating and rewarding experience. It literally changed my life and the way I work and opened up many new avenues to explore!

Appendix

Most of the photographs you see in this book were taken by myself. Some were from commissioned assignments, others are personal shots. The last thing one needs is another computer graphics book filled with examples carried out on the author's holiday snaps (all right, I confess to using a few) – I wanted to keep the standard of image examples high and appropriate to the demonstrated techniques. I also roped in friends and colleagues to include their work too, all of whom are professional photographers. Here then is some biographical information on the other contributors whose work has been featured.

Photographer contributors

Davis Cairns

A partnership specializing in fashion accessory still-life photography with clients who include Red or Dead Ltd and Paul Smith. Davis Cairns are currently moving into more portrait and fashion-based work with an emphasis and interest in portraying creative textiles. I have worked on all the Davis Cairns computer retouching work and a number of these commissioned and personal images were used in this book.

E-mail: mail@daviscairns.demon.co.uk

Julian Calder

Julian Calder's early inspiration came from the great photo stories in *Life Magazine*. He acquired his photographic education at art college and as an assistant to several London photographers. Julian is an inveterate traveler, who enjoys the discipline of working on assignment for companies and magazines. He utilizes all the technical gadgetry available in order to realize the full potential of a picture, stretching the versatility of his camera system to the utmost to capture the picture he wants.

Tel: +44(0) 20 8780 5352. Fax: +44(0) 20 8780 2156

Laurie Evans

Laurie Evans was born in Scotland in 1955. Having studied photography at Art School he spent two or three years as a rock and roll photographer before coming to London to seek his fortune. Transferring his interests to still life, and always a passionate cook, he quickly found that he could combine work with pleasure as he discovered the joys of food photography. He works extensively in the advertising and design industry and contributes to a broad range of magazines in the UK and abroad, and has also illustrated more than 40 cook books. He is married, has two sons and lives and works in London.

Tel: +44 (0)20 7284 2140. Fax: +44 (0)20 7284 2130
E-mail: Laurie@evansphoto.demon.co.uk

Thomas Fahey

Thomas Fahey, originally from Oklahoma, opened his Atlanta studio in 1990. His photography takes him from New York to Miami and occasionally overseas to London and Milan. He is a regular cover and feature photographer for *Atlanta* magazine, among others, and his pictures have appeared in numerous advertising campaigns. Formerly, Thomas trained and worked as an archival photographic printer and worked as a photojournalist. Today he enjoys a diversified client base and relies on his Mamiya RZ, Pentax 6×7, Norman light control, and an indispensible Macintosh G4 workstation.

Tel: 001 404 355 5948
E-mail: imagist@avana.net Web site: www.thomasfahey.com

Jon Gibson-Skinner

Jon is a young photographer who lives and works in central London. Jon discovered the virtues of Adobe Photoshop 2.0 while studying for his degree at Farnham and has since embraced digital photography as well. His work as a creative crosses all boundaries from music to design and advertising. Jon is one of the founder members of LightZoo.

Tel: +44 (0)20 7402 4116
E-mail: jgs@dircon.co.uk Web site: www.lightzoo.com

Peter Hince

Peter Hince is an advertising photographer specializing in people/lifestyle. He works mainly on location throughout the world and is very experienced with big productions and 'round the globe' projects. He also has a unique style of underwater work and produces toned and textured black and white shots for his 'Ocean Images' collection. His work has won many advertising and photographic awards.

Tel: +44 (0)20 7386 0244
E-mail: peter@hince.demon.co.uk

Ian McKinnell

One of the first Macintosh owners in the UK. Ian began incorporating computer graphics for his illustration work back in the mid-eighties. He photographs mainly for editorial and design clients like *The Observer magazine*. Ian uses Photoshop and 3D package programs for nearly all his work.

Tel: +44 (0)20 7631 3017
E-mail: 100671.615@compuserve.com

Eric Richmond

Eric Richmond specializes in arts publicity photography. Despite (or perhaps because of) his being American, he loves anything beginning with Royal: Royal Ballet, Royal Opera House, Royal Festival Hall, Royal Court, Royal Albert Hall. He has worked for all these venues and thinks that all arts bodies should be named in this fashion. In the past year he has traveled to Argentina to photograph tango, and Cuba to shoot a CD cover. Digital retouching is increasingly becoming a feature of his work, and like every other photographer Eric is frantically playing catchup with new technology.

Tel: +44 (0)20 8880 6909
E-mail: blueseric@aol.com

David Whiting Photography
DWP Imaging are based in Luton, and were established in 1969. Their team of photographers are able to photograph a diverse range of subjects, often travelling afar, to serve industrial/commercial clients and advertising/design agencies. Their move into digital imaging has enabled them to keep pace with rapid changes in the industry. Their photo library, ProVISIONS from DWP, includes local scenes.

E-mail: dwp.imaging@btinternet.com

Adam Woolfitt
Adam Woolfitt has been a photographer all his life and for thirty years contributed to National Geographic and other equally famous magazines. Some ten years ago he realized that photography was being drastically reinvented and immersed himself in computers and digital cameras. He later started writing on digital matters for BJP, *Image Magazine* and *Photo District News*, in New York. Adam is a founding member and past Chairman of the UK Digital Imaging Group and a prime mover behind IDEA (the International Digital Exhibition and Awards) now in its second year. He is a serving member of the Council of the Association of Photographers and has recently accepted an Honorary Fellowship of the British Institute of Professional Photographers. Four years ago he co-founded SharpTurn Productions, dedicated to interactive photography for web and CD projects.

Tel: +44 (0)20 8444 6516
E-mail: adampix@dircon.co.uk

Rod Wynne-Powell
Rod Wynne-Powell, who helped with the checking into some of the technical aspects of this book, set up SOLUTIONS Photographic in 1986, and bought his first Mac in 1987.

SOLUTIONS Photographic came about because, after a period as a commercial/industrial photographer, and later as sales manager of a London color laboratory, many calls he received began with the words: 'Rod, I've got a problem...'

His attention to detail and dogged determination led some developers to accept his offers to beta test their graphics products. This gave him the opportunity to fashion products to meet the requirements of retouchers and manipulators, which naturally gave his clients an edge against their competitors. It allowed him to offer in-depth training very early in the product life-cycle, and gain insights into the developers' future direction.

Speaking the same language as photographers has enabled him to guide others past the pitfalls when introducing them to the digital world. He offers help from the basics of Mac housekeeping, its interface, and fault diagnostics, through to the far more enjoyable aspects of teaching techniques for the productive and creative use of Photoshop as a montaging and retouching tool. His help has been valued and respected amongst his peers in the digital arena.

SOLUTIONS Photographic is now in its fourteenth year. His work is rarely credited, but lies behind many images for book jackets, report and accounts brochures, advertisements and packaging designs. His clients tend to have completely individual understandings of his services, and so he relies on most of his work by personal recommendation; the consultancy offered varies from the *ad hoc* to the retained, and he is particularly pleased with his 'flying doctor' service over the telephone, as this allows him to utilize time which might otherwise have been a tedious waste, spent inhaling exhaust fumes on the M1 or M25 car parks! His training sessions are careful to avoid 'information overload' in these increasingly technical times, but if the student can take the pace, he will continue to provide answers! Rod has become much sought after for his grasp of color management pitfalls, as this seems to be the current 'hot potato'! In this vein, he can be found contributing to internet lists, such as ProDIG and the Photoshop list.

SOLUTIONS Photographic can be contacted by the following means:
Mobile: 07836-248126 (24 hrs/7 days a week plus messaging service).
Tel: +44 (0)1582-725065 most mornings till 10.00 a.m. (no answer service).
E-mail: solphoto@dircon.co.uk

Appendix A

Adobe ImageReady™ 3.0

ImageReady 1.0 was first introduced as a stand-alone program, for the preparation of images to be used in web page designs. Since the release of ImageReady 2.0 with Photoshop 5.5, there is now even more integration between the two programs. Version 3.0 of ImageReady is bundled with Adobe Photoshop 6.0. This packaging primarily meets the needs of web designers who use Photoshop. PSD documents created for the Web in Photoshop or ImageReady will integrate better with Adobe GoLive™ (you can output GoLive compatible HTML code or drop PSD files directly into GoLive). I have provided information in this book on all the graphic uses of Photoshop which are relevant to photographers. Web design is really a separate skill. Nevertheless, ImageReady deserves an inclusion here because it is now an important component of the Photoshop program.

Interface

Many of the ImageReady features are common to Photoshop. For instance, you will find details of the file optimization methods have already been covered in Chapter Seven. I have chosen here to concentrate on some of the unique features contained in ImageReady rather than provide a detailed step by step guide to the whole program. Many of the ImageReady tools are identical to Photoshop and Figure A1 provides you with an overview of the Tools palette layout and the keyboard shortcuts. New options include: the ability to add image maps; toggle the visibility of image maps; a rollover preview; toggle slice visibility; and preview in a default web browser. The palettes are similar too: the Optimize and Color palettes match the features found in Photoshop's 'Save for Web' feature.

Jump to

When you click on the Jump to button at the bottom of the tools palette you are able to switch editing a document between two different editing programs. The Jump to command from Photoshop will allow you to switch to editing in ImageReady or (if specified) any another graphics-editing program. The Jump to command in ImageReady will also allow you to switch between other HTML editing programs, such as Adobe GoLive. To specify additional programs to jump to place an alias of the application (Mac) or shortcut (PC) in the Adobe Photoshop 6.0 > Helpers > Jump To Graphics Editor folder. Place curly brackets ({ }) around an application to jump to from Photoshop and straight brackets ([]) around an application to jump to from ImageReady.

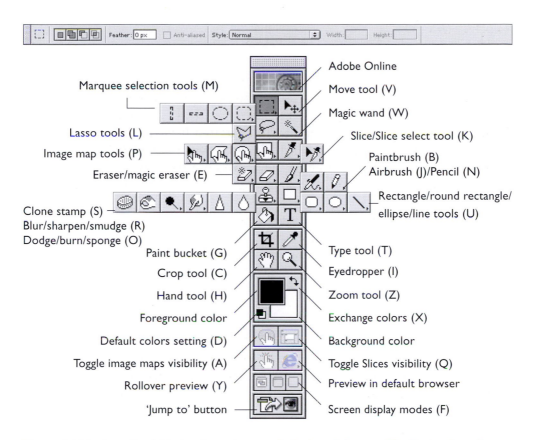

Figure A1 The ImageReady Tools palette, showing the keyboard shortcuts. The Tools palette fly-outs can now be torn off and converted into stand-alone palettes.

In ImageReady you can choose either File > Jump to > Graphics Editor or File > Jump to > HTML Editor. The auto-updating of documents between the separate applications now automatically happens in the background. This means that the jump tos between ImageReady and Photoshop are now therefore that much smoother and faster. The image is displayed in each program in its own document window and the window preview will be dimmed in the application which is inactive.

ImageReady layers

You can add layers in ImageReady just as you do in Photoshop. The layer features are shared between the two programs, so when you transfer a Photoshop image into ImageReady, all the layers, layer masks and layer effects will be preserved. The new Photoshop layer management and extended layer limit means that you can add as many layers as you want and organize them better using layer sets. While adjustment

layers can only be edited in Photoshop, the adjustment will be previewed in ImageReady. Gradient map and fill layers can be edited though (see Styles, below). Using layers in ImageReady, you can construct a sophisticated web page with dynamic content such as rollover buttons and animations, which in turn can be linked, because the HTML code associated to the images can be generated on saving.

Figure A2 The Layers palette showing several layer effects applied to layer 2. The effects controls are located in the Layer Options palette, including the new Gradient/Pattern effect, which comes with over 50 pre-installed patterns. You can add your own customized designs to the Patterns folder. These are located inside the Adobe Photoshop 5.5 settings folder. The Layer Options palette is somewhat restrictive compared with Photoshop. Click on the double-headed arrow in the palette tab to reveal extra items.

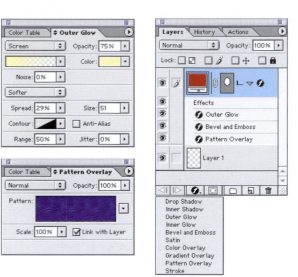

Styles

ImageReady supports all the new layer effects introduced to Photoshop 6.0 and also all the new vector-based features like Shape layers and layer clipping paths. For more information on Photoshop layer effects, refer to Chapter Fifteen. To add a layer effect in ImageReady, click on the effects button (⊘) at the bottom of the Layers palette and click on one or more of the options in the effects menu. The effect options are displayed in the Layer Options palette. Here you will find the same controls as found in Photoshop.

Single or combined layer effects can be saved as a Style. Now also a feature of Photoshop, ImageReady Styles are ideal for generating contoured 3D buttons for a web site and these can be repeatedly applied to all buttons, to maintain continuity throughout the site. Preset styles are contained in the Styles palette and these can be further controlled via the Edit > Preset Manager. The examples in Figure A3 were created by making Shape layers with a type layer added above and different preset style was applied to each layer. The shape tools include a rectangle, rounded rectangle and ellipse. As with Photoshop, these tools will create a filled layer clipped by a vector mask. The shape tool Options bar allows you to modify the roundness of the rounded rectangle corners or create a fixed size shape. To apply a style, highlight a layer and double-click a style in the Styles palette, or drag the style thumbnail from

the palette to the image window – this will apply the style to the topmost layer. Or, drag the style thumbnail on to a layer in the layers palette. If you hold down the Shift key as you do so, the current layer effects will be preserved, but only if they are not duplicated by the new style.

You can create your own styles by dragging either an individual effect icon (⊘) or Style icon (s) from the Layers palette to the list in the Styles palette or onto the New Item button at the bottom of the Styles palette. Or, you can highlight the layer in the Layers palette and click on the New Item button in the Styles palette. To name or rename a style, go to the Styles palette fly-out menu and choose Style Options... Styles can be viewed three different ways: thumbnail 'swatch' icons as shown in Figure A3, as large swatches, shown singly with a list down the side, or as a named list.

Figure A3 Examples of filled bitmapped shape layers created with the shape tools (see the Tools palette – rectangle, rounded rectangle and ellipse). A pre-set style was added to the shape layer and then a type layer was added above. A separate style was applied to the type layer.

Actions

The Actions palette works the same as in Photoshop (see Chapter Twelve) it allows you to record a sequence of steps in ImageReady which can then be replayed on other images or used to batch action a folder of files (the batch options are located in the Actions palette fly-out menu) and it is also possible to record playing an action within an action. There are some interesting preset actions installed with ImageReady – the flaming text example is shown here in Figure A4. But there are also actions which can be used to generate rollover and animation effects, which are discussed further on in this section.

Figure A4 An example of the Flaming Text action.

Image resizing

The image size dialog in ImageReady enables you to resize an image to specific pixel dimensions or as a percentage of the original size. Normally you will want to keep the Constrain Proportions option checked. The constrain options include: Width, which will constrain the proportions to the new width setting; Height, which will constrain the proportions to the new height setting; and Either, which will constrain the new size using one or other of the pixel dimensions entered. 'Either' is useful when establishing a batch action in which you wish all the images to fit within the envelope of a specific pixel size. There are two interpolation options: Jagged, which is the same as Nearest Neighbor in Photoshop and Smooth (Bicubic) interpolation.

Cropping

The crop tool is similar to the Photoshop crop tool, except you have a Hide option in the crop tool Options bar. Use Hide when working on animations where you wish to preserve elements on other layers which move in and out of the live image area. Use the Image > Trim command to make a crop removing an outer border based on transparent pixels for instance.

Color management

When you are designing a web page you have to be conscious of the fact that visitors will be seeing your graphics under a wide variety of monitor viewing conditions. Photoshop 5.0+ handles color differently compared to previous versions of the program (see color management – Chapter Four). In particular, the RGB color you edit within Photoshop can be in one of a number of spaces. So long as an ICC profile remains attached to the file, the colors you see in Photoshop can be interpreted correctly

by other ICC savvy programs. Under the View menu, choose Preview > Photoshop compensation to see the image displayed as an ICC savvy web browser would see it. Not many browsers are ICC aware yet and therefore it is sensible to prepare on-line images in a more common-ground RGB space such as sRGB. The vast majority of Internet users will be using a PC computer and the sRGB space uses a gamma of 2.2, which is typically the gamma setting used on most Windows PC machines. Mac users should choose 'Standard Windows color' and PC users should choose 'Uncompensated color'. Then you should get a good impression of how most people will be viewing the web images you create or edit in ImageReady. If you output a file with an ICC profile embedded, then so much the better (Microsoft Internet Explorer 5.0 is ICC-aware). If you choose to incorporate a color that is non-web safe, which will make a GIF image appear badly dithered, a web safe alert icon will appear in the color picker. Click on this icon to select the nearest equivalent web safe color. I should briefly mention here a problem I experienced when I began up-loading JPEG files with embedded ICC profiles. The JPEGs often got corrupted and the fault lay with the FTP software I was using to upload the files to the server. Make sure you are using the latest version of your FTP software.

Figure A5 The Dither Box plug-in can simulate non-web safe color fills by creating a dithered mosaic pattern made up of closely matching web safe colors. Choose Filter > Other > Dither Box. Select a mosaic option and click on the arrow above to generate a dithered color pattern mosaic.

Image slicing

Slicing an image is a further example of how you can use Photoshop and ImageReady in tandem to create and design dynamic web pages which will download efficiently and also produce HTML output files which can be further edited in a program like Adobe GoLive 5.0. Slicing makes it easy to specify what type of content will appear in a slice and how the image content in a slice shall be optimized.

Select the slice tool and you will notice the first slice (01) is assigned to the entire image. There are several ways to slice an image. Choose Slice > Divide Slice(s) – this opens a dialog box allowing you to divide an existing slice vertically or horizontally. This is only useful where slice symmetry is vital. When you drag with the slice tool inside the document, you are creating what is known as a 'user-slice'. As you add a user-slice, 'auto-slices' are automatically generated every time you add or edit a user-slice. User-slices can be created by dragging with the slice tool, but they can also be based on a selection, layer bounds (Layer > Create Slice From Layer), or guides (Slices > Create Slices From Guides). Note that when you create a user-slice from a layer, the slice will automatically adjust to any changes made to the layer, such as when you add an outer glow layer effect.

You can modify a slice by selecting the slice select tool and clicking on the slice you wish to edit (all slices but the active slice will appear dimmed) and using Shift-click to select multiple slices. Use the slice select tool to move a slice or resize it by dragging on one of the corner handles. A solid line border indicates that it is a user-slice and a dotted line that it is an auto-slice. It is possible to promote auto-slices to user-slices (Slices > Promote To User-Slice). Doing so will prevent it from being altered whenever a regeneration takes place. Slices can be merged together, choose Slices > Combine Slices.

Slice content

The default when slicing images is to create image content slices; however, you can create no-image slices that can have text or even solid color fills. The Background Color option will fill a no-image slice with a solid color or fill the transparent areas of an image content slice. No-image slices can also be created within the Save for Web dialog in Photoshop. HTML text can be added to a no-image type content slice via the Slice palette text box. A URL web link can also be added in the Slice palette URL text box. These slice content modifications cannot be seen directly in the ImageReady document window, you will only be able to preview these in a browser or web page editing program.

Optimizing images and image slices

File optimization was discussed earlier in Chapter Seven and the same Save for Web controls are all contained in ImageReady. The only real difference is in the interface layout. The Optimize controls can be accessed at any time via the Optimize palette and the normal image window layout can be changed to show the optimized version, 2-up or 4-up displays. When working with the optimized display, the optimized ver-

sion will want to regenerate a new preview after each editing action. To stop this happening you can deselect the Auto Regenerate option in the Optimize palette fly-out menu. If you do this, after the image is modified, a small warning triangle (⚠) will appear in the bottom right corner. To manually regenerate an optimized view, click on this warning symbol. Different compression or format options can be applied to individual slices such that areas where image detail matters most, less JPEG compression is used. Linking slices allows you to share the optimization settings between linked slices, choose Link Slices from the Slices menu.

Figure A6 A window in ImageReady, which shows a layered image that has been manually divided into slices using the slice tool. Slice 8 is a user-slice which is currently active and seen with the orange colored border. While the slice visibility is switched on, all other slices appear dimmed. Click on the toggle slices visibility mode button in the Tools palette to preview the document without the slices being visible.

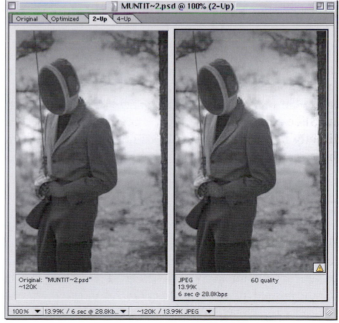

Figure A7 The Optimize palette plus the image window set to display in 2-up mode and showing the warning symbol which will appear as you edit when the Auto Regenerate option is switched off.

Photograph: Thomas Fahey.

Image maps

If you have some previous experience with designing web pages, you will probably be familiar with the use of Image maps to designate hotspots in an image that has been incorporated into a web page design. These hotspots are used to specify an internal or external link URL. ImageReady enables you to add image map hotspots, generating the necessary HTML code – the links are entered into the Image Map palette. Image maps are therefore very much like slices, except with an image map you can create specific circular or polygon shaped hotspots, not just rectangles. Image maps can be defined using either one of the image map tools or they can be layer-based. To make an image map from a layer, select the layer in the Layers palette, go to the Layer Options palette and select the image map shape type. As you change the shape of the layer, the image map will become updated.

In the Tools palette (see Figure A1) you can see all the image map tools and immediately below the foreground and background colors there is a show/hide image map visibility button, which you can use to toggle the image map display or use the keyboard shortcut (A). Image maps which have been created with one of the image map tools can be selected by using the image map selection tool. Click on an image map to select it and use the tool to reposition or drag a border handle to resize the map. Image maps can be aligned as you do with layers. Shift-click to select the image maps with the image map select tool and choose the Layer > Align Linked command and select an alignment option.

Rollovers

A rollover is a web page design feature in which an item, such as a button, will change its appearance as you perform a mouse action like mousing over, or mousing down on a designated image map hotspot or image slice area. Rollover effects contain an element of animation, which is driven by JavaScript code. Rollovers are created by using layers in conjunction with slices or image maps. It is best to begin by adding your rollover elements as separate layer elements like the example shown in Figure A8. Use the Layer-based slicing option to create the slices, as the slices will automatically adjust to compensate for any added outer shadow/outer glow layer effects you might add as a rollover effect.

Each image slice starts off being in a normal state. As you add states in the Rollover palette, you store a new version of the slice or image map and can use the Layers palette to alter the appearance of the layer when it is in a new state. For example, you can add a new rollover state and by clicking the italicized (*◉*) at the bottom of the Layers palette, add an inner glow effect, so that when the viewer mouses over the

rollover button, this will initiate a glow effect. If you add a further 'Down' rollover state, this could be associated with the inner text changing color or opacity. New rollover states are created by clicking on the New State button in the Rollover palette. This will create a duplicate state which you can now further modify in the Layers palette. In Image Ready 3.0, you can create a special type of Style, which will allow you to apply a combination of layer effects applied to rollover states as a rollover style. Rollovers can be previewed in the document window, by switching to the Rollover preview mode (Y) via the Tools palette (see Figure A1). This will show a preview of how the rollover behavior will respond as you navigate with the mouse in the document window. For absolute precision, you should preview the document using the Browser program.

Figure A8 This illustration shows a Rollover button that was created by using the 2-State button action from the Actions palette.

The Actions palette contains a basic '2-State button' action which can be applied to a file like the one shown in Figure A8, which will make the type layer have separate 'over' and 'down' states. Rollover state images are saved as individual files and the associated JavaScript is generated as a separate HTML file.

Animation

ImageReady can also be used to construct self-contained animated image files to go on a web page. The main limitation here is that the output file for a web site will be GIF only and you will therefore be limited to a 256 color palette. However, you can export animations as Quicktime movies for use in other applications, or you can even open a Quicktime movie and edit it in ImageReady.

As with rollovers, layers play a fundamental part in the preparation of an animated sequence, so that you can easily move and modify the layer elements. The animation steps are controlled by the Animation palette. To add a frame, click on the New Frame button (you should always edit the animation frames using the original view, not optimized). You can modify various aspects of the image document such as color, layer opacity or the position of a layer for each frame. You can edit the frames afterwards by selecting them in the Animation palette and making adjustments. Shift-click to select contiguous frames, Command/Ctrl-click to select discontiguous frames.

After you have produced a sequence of frames, you can then alter the time delay between each. The tweening feature will automatically add extra in-between frames and is a simple method with which to produce smoother looking animations. Tweening can be applied to individual frames or all frames. Tweening also can be applied to specific animation layers only and/or can be applied to specific layer attributes such as layer position, opacity and layer effects. Frames can easily be reordered by dragging within the palette. They can be copied and pasted using the Animation palette fly-out menu to copy and paste frames. Click the Animation palette Play button to preview the completed animation, or use the File > Preview In Command to preview them in a web browser program.

Figure A9 Click on the New Frame button in the Animation palette to add a new frame to an animation sequence. In the Layers palette, you can alter the color, opacity, position, layer effects or add new layer elements. The optimized view (as shown here) can be used at the end to check how the file will preview when saved as a GIF file ready to upload to a web site.

World Wide Web contacts list

4-Sight ... www.four-sight.co.uk
ActionXchange .. www.actionxchange.com
Adaptec ... www.adaptec.com
Adobe .. www.adobe.com
Adobe Photoshop information page www.adobe.com/prodindex/photoshop/main.html
Adobe Photoshop discussion list http://anna.lyris.net/photoshop/
Agfa ... www.agfa.com
Alien Skin .. www.alienskin.com
Andromeda .. www.andromeda.com
Apple ... www.apple.com
Association of Photographers .. www.aophoto.co.uk
Binuscan ... www.binuscan.com
British Journal of Photography www.bjphoto.co.uk
Chromagraphics ... www.chromagraphics.com
Compaq ... www.compaq.co.uk
Connectix .. www.connectix.com
Contact Images .. www.contact-uk.com
Daystar ... www.daystar.com
Exabyte ... www.exabyte.com
Extensis ... www.extensis.com
Elated Action Kits ... www.elated.com/freebies/actionkits/
Fargo ... www.fargo.com
Formac ... www.formac.com
Fractal .. www.fractal.com
Fuji ... www.fujifilm.com
Fujitsu .. www.fujitsu-europe.com
Hermstedt Ltd .. www.hermstedt.co.uk
Hitachi .. www.hitachi-consumer-eu.com
Hewlett-Packard .. www.hp.com
Iomega .. www.iomega.com
Kensington ... www.kensington.com
Kingston .. www.kingston.com
Kodak ... www.kodak.com
Kodak Photo CD .. www.kodak.com/daiHome/products/photoCD.shtml
Lexmark ... www.lexmark.co.uk
Linotype .. www.linocolor.com
LaCie .. http://www.lacie.com
Martin Evening Photography www.evening.demon.co.uk
MetaTools ... www.metatools.com

Minolta .. www.minolta.de/europe.html
Mitsubishi .. www.mitsubishi.com
Microsoft .. www.microsoft.com
New Mexico Software ... www.image-assets.com/index.html
Nikon ... www.klt.co.jp/nikon/eid/
Olympus .. www.olympusamerica.com/digital/
Panasonic .. www.panasonic.co.uk
Pantone ... www.pantone.com
Philips ... www.philips.com
Pixl/Thomas Holm ... www.pixl.dk
Polaroid ... www.polaroid.com
ProDIG digital imaging discussion list http://image.merseyworld.com/prodig
ProRental discussion list (users of 10 Mb plus digital cameras) www.prorental.com/pr_digf.htm
Quantum .. www.quantum.com
Quark .. www.quark.com
Radius ... www.radius.com
RasterOps ... www.rasterops.com
Ricoh .. www.ricoh-europe.com
Samsung ... www.samsung.com/product.html
Sanyo .. www.sanyo.co.jp/index_e.html
Scitex .. www.scitex.com
Seagate ... www.seagate.com
Sharp ... www.sharp-uk.co.uk
Signum Technologies .. www.signumtech.com
Sony .. www.sony.co.jp
Sun Microsystems ... www.sun.com
SuperMac .. www.supermac.com/index.html
Symantec .. www.symantec.com
Taxan ... www.taxan.co.uk
TDK ... www.tdk-europe.com
Tektronix .. www.tek.com
Texas Instruments ... www.ti.com
Toshiba ... www.toshiba.com/home/work.shtml
Umax ... www.umax.com
Verbatim .. www.verbatimcorp.com
Vivitar .. www.vivitarcorp.com
Wacom .. www.wacom.com
Rod Wynne-Powell ... www.solphoto.dircon.co.uk
Xerox .. www.xerox.com
Xaos Tools ... www.xaostools.com
Yamaha .. www.yamaha.com

Index